Curating Consciousness

The MIT Press
Cambridge, Massachusetts
London, England

Marcia Brennan

Curating Consciousness

Mysticism and the Modern Museum

MIT Press books may be purchased at special quantity discounts for business or sales promotional use. For information, please email special_sales@mitpress.mit.edu or write to Special Sales Department, The MIT Press, 55 Hayward Street, Cambridge, MA 02142.

This book was set in Berthold Walbaum and Futura by Graphic Composition, Inc. Printed and bound in the United States of America.

Library of Congress Cataloging-in-Publication Data

Brennan, Marcia.
 Curating consciousness : mysticism and the modern museum / Marcia Brennan.
 p. cm.
 Includes bibliographical references and index.
 ISBN 978-0-262-01378-9 (hardcover : alk. paper)
 1. Sweeney, James Johnson, 1900–1986. 2. Mysticism and art. 3. Modernism (Aesthetics) 4. Art museums–Exhibitions. I. Title.
 N72.M85B74 2010
 701'.17–dc22
 2009015566

10 9 8 7 6 5 4 3 2 1

For Scott *The Light on the Page*

And with deepest gratitude to the memory of Kermit S. Champa, who first suggested that, when I arrived in Houston, I might want to look into James Johnson Sweeney

Contents

Acknowledgments

The idea for this book first arose on a spring afternoon in 2001, just before I left Providence to go to Houston. I was walking with my teacher and advisor, Kermit S. Champa, and telling him how museum collaboration projects were going to be an institutional priority at Rice University. Kermit turned to me and said, "Well then, when you get to Houston, you might want to look into James Johnson Sweeney." At the time, I couldn't have guessed the magnitude of what sounded, at first, like one of Kermit's casual suggestions. In retrospect, however, I suspect he had a pretty good idea of where all of this would lead.

Because so much of the conceptual framework for this book is based on the transdisciplinary intersection of art history and the study of mysticism and comparative religion, I am deeply indebted to two distinguished colleagues and friends for helping to illuminate both the ground under my feet and the sky above

my head. Jeffrey Kripal has seen this project develop from the very beginning. Throughout our various collaborative teaching and research projects, our ongoing conversations, and through the superb example of his own writings, he has served as a source of profound insight, daring intellectual expression, unfailing humor, and gentle encouragement. And at the deepest level, my work has been shaped by Elliot R. Wolfson's poetic illuminations, his breathtaking paintings, his brilliant scholarship, and the gift of our friendship.

The research and writing for this book have been shaped by many gifted scholars who have shared their close readings and keen intellectual insights. I would especially like to thank Jeffrey Abt, Natalie Adamson, Jenny Anger, Jay Clarke, Linda Henderson, Michael Leja, Hajime Nakatani, Alexander Nemerov, Daniel Price, Lisa Saltzman, Kristina Van Dyke, David Ward, and Jody Ziegler. This project has also been supported by the American Council of Learned Societies, through a Contemplative Practice Fellowship; and by the Humanities Research Center at Rice University, through a Faculty Fellowship. I am especially grateful to Caroline Levander for her generous support.

At Rice, I am privileged to be surrounded by wonderful colleagues who have generously read and discussed some, most, or all of this manuscript. For their invaluable ideas and for the great care that each put into their readings, I would like to thank Bill Camfield, Leo Costello, April DeConick, Shirine Hamadeh, Gordon Hughes, Gregory Kaplan, Scott McGill, Linda Neagley, Bob Patten, and most of all, Caroline Quenemoen. Financial support for this project has been provided by Joseph Manca, formerly Chair of the Department of Art History, and Gary Wihl, formerly Dean of the School of Humanities. I also wish to thank Lucinda Cannady for her kindness and expert administrative assistance; Kathleen Hamilton, an artist who skillfully produced several of the illustrations appearing in this volume; Philip Montgomery, for making Special Collections material available at the Woodson Research Center; Ann Bazile, for her generous help with microfilms at the Kelley Center for Government Information; and especially Jet Prendeville at the Brown Fine Arts Library, who unfailingly went out of her way to build library collections relating to faculty research, while always sharing her valuable assistance and superb research skills.

This book would not have been possible without the archival and cura-torial support of many individuals. I would like to thank Kathleen Tunney and Michelle Harvey at the Archives of the Museum of Modern Art; Francine Snyder at the Solomon R. Guggenheim Museum Library and Archives; and Lorraine A. Stuart and Amy Scott of the Museum of Fine Arts, Houston Archives. The MFAH archives have been a treasure house of primary source material, and I am espe-cially indebted to Lorraine Stuart for facilitating my research in every way. Also at the MFAH, Mary Morton first provided heartfelt encouragement and crucial research materials, and Alison de Lima Greene has consulted extensively on this project and generously made object files and artworks accessible. I am also grate-ful to Jon Evans of the Hirsch Library for his valuable research support, and to Marty Stein for providing extremely helpful photographic assistance. My sincere thanks also go to Susan Halpert and Leslie A. Morris of the Houghton Library, Harvard University; Edwina Ashie-Nikoi of the New York University Archives; and Helen Harrison of the Pollock-Krasner House and Study Center.

For kindly sharing their valuable memories of James Johnson Sweeney in New York, Houston, and elsewhere, I would like to thank Jack Boynton, Bill Camfield, Ann Holmes, Karl Kilian, Edward Mayo, Pierre and Colette Soulages, Richard Stout, Jose Tasende, David Warren, and Dick Wray. Indeed, Jack Boynton not only contributed his recollections of Sweeney's exhibitions at the Guggenheim and the Museum of Fine Arts, Houston, but he produced an original drawing of *James Johnson Sweeney, Imagined from Memory* (2008, figure 1.3) to accompany this project. I would also like to express my appreciation to Aoibheann Sweeney for generously sharing her memories and perspective on her grandfather, James Johnson Sweeney, and on the Sweeney family.

Anna Brzyski kindly invited me to contribute a portion of chapter 2 to the anthology *Partisan Canons* (Duke University Press, 2007); and Ivan Gaskell and Francesco Pellizzi enabled an earlier version of chapter 5 to appear in *Res* 52 (Autumn 2007). These sections are reprinted with permission. A related essay focusing on Sweeney's relationship with his patrons, the art collectors John and Dominique de Menil, appeared in the catalogue for the twentieth anniversary cel-ebration of The Menil Collection, *A Modern Patronage: De Menil Gifts to American*

and European Museums (2007). I am grateful to Josef Helfenstein, Director of The Menil Collection, for the invitation to participate in this important volume.

At the MIT Press, Roger Conover has been a source of boundless generosity, kindness, and support; as is the case with so many authors, his nearly unseen but always strongly felt presence represents the joists under the floor on which we all stand. This text has also been shaped by Matthew Abbate's editorial expertise, by Erin Hasley's elegant sense of design, and by Anar Badalov's attention and care. It would not be the same book without them.

Closest to home, I would like to thank my husband Scott Brennan for bringing light to all that he touches. As always, he has my deepest love and gratitude.

Curating Consciousness

1

Modernism's Mystical Subjects:
An Introduction

**A house whose door is closed is different
from the same house with the door open.
—Eduardo Chillida, "Notebook Pages"**

Despite the notable differences in the character of their work, the modernist sculptors Eduardo Chillida and Alexander Calder had much in common. For much of their careers, the two artists exhibited with the same dealer, the Galerie Maeght in Paris; they openly expressed admiration for one another and exchanged works of art; and they shared a warm personal and professional relationship, not only with one another but with their mutual friend, the author and museum director James Johnson Sweeney (1900–1986, figure 1.1). While this constellation of relationships could take a variety of forms, the patterns readily seem to lend

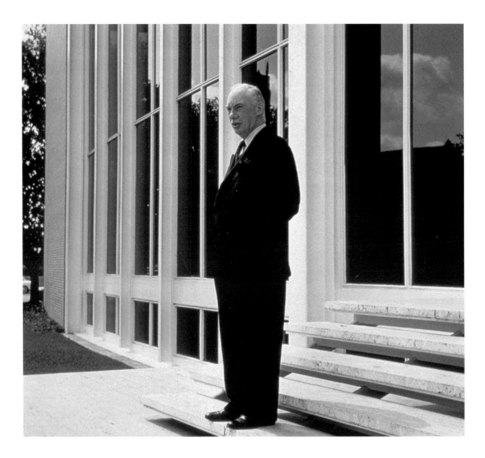

1.1 James Johnson Sweeney on the steps of Cullinan Hall, the Museum of Fine Arts, Houston, ca. 1962. Photograph by Hickey & Robertson. Museum of Fine Arts, Houston Archives.

themselves to creative graphic expressions. Thus in 1969, the Fondation Maeght assembled an exhibition of Calder's artwork with an accompanying catalogue that included original contributions by both Sweeney and Chillida (figure 1.2). As he did throughout his extensive critical writings on Calder, in this essay Sweeney emphasized the deeply interwoven relations he perceived between seemingly oppositional categories such as the "monumental" and the "miniscule," the macrocosm and the microcosm, presence and absence, gravity and levity, serious artistic accomplishment and a childlike capacity for play. Sweeney observed that

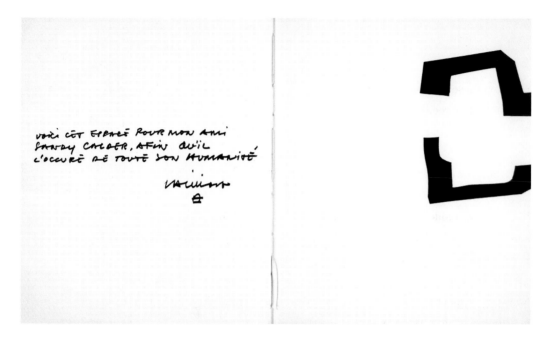

1.2 Eduardo Chillida, *Homage to Calder*, 1969. ©2008 Artists Rights Society (ARS), New York/VEGAP, Madrid.

Calder's sculptures "design space rather than occupy it," just as the artist's rigorous modernist expressions arise from an essential need for play. According to Sweeney, "the entire lyrical side of Calder's art, all of his poetry, have their source in play," which imparts a sense of lightness to objects both "real or imaginary" through forms that are "monumental or miniscule."[1] Moreover, in a slightly earlier discussion of Calder published in the University of Notre Dame's *Review of Politics* (April 1959), Sweeney not only characterized the sculptor as "a lyricist in play," but he noted that the extended definition of play in the *Oxford English Dictionary* includes notions of imagination, pleasure, representation, and "the suggestion of 'a game' because it implies rules and further suggests a matching of contraries—of 'sides' in the common sports usage."[2] Thus according to Sweeney, Calder's simultaneous engagement with the real and the imaginary, the monumental and the miniscule, represents an intricate "matching of contraries," or

coincidentia oppositorum (coincidence of opposites), within the unified field of the artwork.

In its turn, the tribute that Chillida constructed for Calder graphically reflected these paradoxes, as it displayed–to paraphrase Elliot R. Wolfson's poetic language–the reciprocal structures of enclosed openings and open enclosures that remained whole in their brokenness and broken in their wholeness.[3] Chillida's homage to Calder consisted of an elegantly spare, monochromatic drawing inscribed with the appreciative dedication: "Voici cet espace pour mon ami Sandy Calder, afin qu'il l'oeuvre de toute son humanité. Chillida" (This space is for my friend Sandy Calder, for him to work with all of his humanity. Chillida).[4] Two horizontal, geometric framing elements face one another along the right side of the sheet, while Chillida's handwritten dedication appears as a reciprocal calligraphic gesture at the left. Drawn in densely saturated black ink, the bracketed forms simultaneously evoke the broken edges of a unified frame and the unified edges of a broken frame–at once angularly rectilinear yet fluidly curvilinear, solidly grounded yet gently floating, compositionally balanced yet suggestively asymmetrical as they tilt softly at an oblique angle on the page. Chillida's homage thus contains multiple layers of internal and external complexity; stylistically, it is readily identifiable as his own even as it exhibits many of the intricacies that characterize Calder's work. That is, while Chillida's drawing is not wholly either mobile or stable (stabile), the design simultaneously evokes aspects of both through the monumental solidity of levitating dark forms that hold the unholdable in the open embrace of their flexible frames.

Taken together, Chillida's, Calder's, and Sweeney's texts and images evoke not stable categorical dichotomies but a dynamic sense of play situated within the reversible parameters of flexible frames.[5] As Sweeney noted, such a "matching of contraries" is visibly expressed in Calder's and Chillida's modernist designs, which simultaneously appear "monumental and miniscule," open and closed, unified and broken, rounded and linear, centered and decentered, dense and weightless, stable and mobile. As in so many of Calder's own works, Chillida's drawing presents viewers with an opportunity to enter *and* exit a pictorial structure from multiple points simultaneously, and thus to pass through the highly stylized open doors that

flexibly frame the symbolic edifice of the artwork. Viewed metaphorically, these paradoxical structures can be envisioned as a series of interconnected passage-ways, all of which are framed by open doors that mark aesthetically distinctive points of entry and exit into the common place (*topos*) of a shared dwelling.[6]

Such themes as the *coincidentia oppositorum*, the microcosm and the macrocosm, and the reversible parameters of flexible frames are significant not only for Sweeney's curatorial and literary practices in particular, but for the power they hold to illuminate the deep historical and conceptual connections between modernist aesthetics, spirituality, and mysticism in general. While much has been written about the ways in which spirituality has served historically as a defin-ing characteristic of modernist abstraction, considerably less attention has been paid to the ways in which the cultivation of spiritual and mystical experiences could operate as a primary curatorial goal within the transformative space of the museum.[7]

When writing for the educated, museum-going public, Sweeney's eclectic critical discourses were widely informed by a variety of philosophical and mysti-cal sources, including the pre-Socratic philosophy of Heraclitus of Ephesus, the Taoist comparativism of the Sinologist Arthur Waley and the eidetic philosophy of the Asian art curator Ernest Fenollosa, the passionate asceticism that charac-terizes the ecstatic writings of the medieval and early modern mystics Julian of Norwich and St. John of the Cross,[8] the hermeneutical discourses on Christian mysticism produced by the Benedictine abbot Dom Cuthbert Butler, and the intri-cate visionary poetics of T. S. Eliot, particularly his seminal essay on "Tradition and the Individual Talent" (1920) and the negative theology that threads through the later verses of the *Four Quartets* (1935–1942). These texts and many others provided Sweeney with a multifaceted means of engaging motifs of mysticism, that is, *the instrumental capacity of aesthetics to express—and potentially induce—trans-formational and transcendent states of being, coupled with the imaginative capacity to promote the viewer's symbolic ability to occupy multiple temporal and spatial locations simultaneously.*

Throughout his writings, Sweeney repeatedly characterized the museum as a secular temple of art, and he expressed the related belief that artworks perform

a vital spiritual service to man. Thus a museum's "basic purpose should be to stimulate the aesthetic responses of its public to a richer, spiritual life, to a fuller enjoyment of the spiritual over the material, of relationships rather than things." He also claimed that modern art and spiritual phenomena reveal "the unseen through the seen," just as works of art display the "conception of a macrocosmic unity through an assimilable microcosm."[9] In this, Sweeney was presenting an aesthetically oriented, modernist version of the Doctrine of Correspondences found within ancient philosophical formulations of hermetic mysticism. To cite a popular early-twentieth-century writer on mysticism, Evelyn Underhill, the Doctrine of Correspondences posited an underlying correlation "between appearance and reality, the microcosm of man and the macrocosm of the universe, the seen and the unseen worlds."[10]

Such conceptions of mysticism were repeatedly expressed in Sweeney's literary and curatorial projects through the themes of alchemy, androgyny, animism, corporeal transformation, pantheism, vitalism, magic, childlike wonder, and primitivism, as well as through metaphysically oriented theories of formalism and of the machine. Ideas such as the *coincidentia oppositorum* were instrumental in enabling him to situate his mystical approach, neither within purely private individual experience nor in a nebulous conception of transcendence that was devoid of content, but rather in concrete relation to the formal and conceptual structures of modernist artworks, their accompanying texts, and the museum galleries in which they were displayed. Various artists who knew Sweeney personally have affirmed that "magic" is an appropriate adjective to describe his museum installations, and that Sweeney himself was drawn to artists working in these areas.[11] Thus when discussing the works of modernist artists such as Calder, Marcel Duchamp, Alberto Burri, Pierre Soulages, Chillida, Jean Tinguely, and many others, Sweeney repeatedly focused on the artworks' capacity to engender visionary perspectives–and alternative modes of consciousness–in their viewers. By prominently advancing these themes over the course of four decades, Sweeney's professional career can be seen as an extended exercise in curating modernist consciousness itself.

Placing Modernism in a Flexible Frame: James Johnson Sweeney

Born in Brooklyn on May 30, 1900, the son of a prominent Irish family, Sweeney received his bachelor's degree from Georgetown University (1922), completed graduate work in literature at Jesus College, Cambridge (1922–1924), and subsequently studied at the Sorbonne and at the University of Siena.[12] During the early thirties, he began to curate important modernist exhibitions and produce accompanying catalogues, starting with "Twentieth Century Painting and Sculpture" at the University of Chicago (1933–1934), a project discussed in chapter 2. Sweeney subsequently held the positions of lecturer at the Institute of Fine Arts, New York University (1935–1940), director of the Department of Painting and Sculpture at the Museum of Modern Art (1945–1946), director of the Solomon R. Guggenheim Museum (1952–1960), and director of the Museum of Fine Arts, Houston (1961–1967). During the 1970s and 1980s, he served as a consultant and advisor to the National Gallery in Canberra, Australia, and to the Israel Museum in Jerusalem. On the literary side, the development of Sweeney's art criticism was shaped by an early encounter with the British formalist critic Roger Fry. In addition to writing art reviews for the *New York Times*, Sweeney was also a contributing art critic to the *New Republic* (1935), associate editor of the avant-garde art and literary review *Transition* (1935–1938), advisory editor of *Partisan Review*, and vice president (1948–1957) and president (1957–1963) of the International Association of Art Critics.[13] In addition, he was a published poet whose verse appeared in the *Irish Statesman, Transition*, and *Poetry*.

Those who were directly acquainted with Sweeney describe him as being witty, formal, courtly, passionate, austere, determined, and exuding a sense of authority and self-assurance. Artists, dealers, and journalists who knew him in New York and Houston have affirmed that he genuinely admired artists, that he frequently asked for their opinions on displayed works, enjoyed spending extended time in their studios, and generously went out of his way to facilitate introductions. The painter Dick Wray elegantly summarized the situation when he noted that the artists "thought that Sweeney was another artist."[14] His sense of discernment is reflected in Sweeney's work as a curator and museum director, as he repeatedly

advocated a highly selective, connoisseurial approach that emphasized artistic quality over a broader inclusiveness. While this acquisition method brought him considerable acclaim, it also repeatedly generated friction with museum officials and trustees. Thus while he organized a number of important exhibitions at the Museum of Modern Art during the forties–including the monographic shows "Joan Miró" (1941), "Alexander Calder" (1943), "Stuart Davis" (1945), "Piet Mondrian" (1945), "Henry Moore" (1946), and "Marc Chagall" (1946)–subsequent shifts in administrative structures and responsibilities led to Sweeney's departure from the museum in November of 1946.[15]

In 1952, Sweeney succeeded Hilla Rebay as director of the Guggenheim Museum. During his tenure he greatly expanded the museum's permanent holdings and programming and cultivated a highly distinctive approach to modernist installation and display.[16] Sweeney acquired important paintings by Cézanne, Giacometti, and Miró; recent works by the American abstract expressionists Pollock, de Kooning, and Kline; and contemporary paintings by the European modernists Appel, Burri, Mathieu, Soulages, and others. In addition, Sweeney oversaw the acquisition of sculptures by Calder, Archipenko, and Brancusi, the latter of whom was the subject of an important retrospective organized by Sweeney (October 1955 to January 1956). At the Guggenheim, Sweeney also curated the focus shows "Younger European Painters" (December 1953 to May 1954); "Younger American Painters" (May to September 1954); "Three Brothers: Jacques Villon, Raymond Duchamp-Villon, Marcel Duchamp" (February to March 1957); "Piet Mondrian: The Early Years" (December 1957 to January 1958); and "Before Picasso; after Miró" (June to October 1960).[17] In her obituary in the *New York Times*, Grace Glueck summarized Sweeney's considerable accomplishments and challenges at the Guggenheim:

In 1952, he was appointed director of the Guggenheim Museum, and served in that post during the construction of Frank Lloyd Wright's then highly controversial building. He changed the museum's narrow focus on "nonobjective" art by presenting shows and acquiring the works of pioneering modernists as well as younger European and American artists. In the words of Aline Saarinen, art critic for *The New York Times* during that period, he "symbolically as well as literally swept the place clean," painting the walls white, taking pictures out

of what he believed were distracting frames, and replacing the second-rate with world-class works kept in storage at the museum.

But Mr. Sweeney was not a fan of the Wright building, which he believed had not been designed to show pictures to best advantage. He devised a method of hanging them on rods projecting from the walls, but could not overcome the feeling that the building was less a museum than a monument to the architect. When, in 1959, visitors began to pour in, and the museum's patron, Harry F. Guggenheim, asked for a more popular educational approach to the public, Mr. Sweeney resigned. He cited "the differences" between himself and the board of trustees over "the use of the museum and my ideals."[18]

An image from this period that colorfully evokes Sweeney's progressive perspective appeared in *Vogue* magazine's July 1956 spoof of "12 famous museum directors as they would look if their favourite portraitists painted them." *Vogue* asked the museum directors to identify "whom [you would] like to do your portrait, someone represented by a portrait in your museum." While the majority of his colleagues selected venerable Old Master prototypes, Sweeney chose the broken, puzzle-like forms of Stuart Davis's contemporary painting *Cliché* (1955) for his self-representation. In the accompanying caption, *Vogue* wryly noted that "Sweeney, a big, energetic man with a varied career, has brought the Guggenheim to the top level through his beautiful installations and independent taste. (Someone said: 'Jim is *more* independent than a hog on ice.')"[19]

Such characteristic independence notwithstanding, before the impasse over the Wright building Sweeney did acquiesce to the trustees' requests for popular educational materials. In 1957, he collaborated with the filmmaker John Hubley on a ten-minute animated film entitled *Adventures of *.* Narrated from the point of view of the eponymous asterisk, who fluidly transforms from a human being to a protean, twinkling star, this cartoon was intended to instruct viewers on how to approach modern art. The fluid slippage of abstraction and representation showcased in the film's vivid colors and highly stylized forms evokes the modernist imagery of Calder, Léger, and Miró. With accompanying music by Lionel Hampton, *Adventures of *** was a prizewinner at the Venice International Film Festival of 1957, and it was widely screened across the United States between 1958 and 1959.[20]

*Adventures of *** is significant because it exemplifies Sweeney's characteristic strategy of situating mystical perspectives within a *coincidentia oppositorum*,

conjoining a critique of bourgeois culture with a corresponding emphasis on the restorative powers of play in modernist aesthetics. The narrative of the film follows a classic descent/ascent pattern, in which the creative depths of the imagination are linked to a transformed vision of the rational "upper world" of the story. Imagined at first as an infant, the asterisk faces routine challenges and disappointments as he grows up which cause his luminous vision to darken and solidify, until he becomes at last an adult engaged in a monotonous business routine. At the end of the film, however, he experiences an imaginative rebirth as he views the world through the proto-visionary gaze of his son. While the child and the adult live in a world that is restricted by walls and boundaries, the established frameworks of domestic and professional containment, the restoration of the adult's creative vision is marked by his passing through a flexible picture frame, an open portal into an imaginative world that returns him to his formerly fluid status as a radiant asterisk.

That year, Sweeney also participated in a panel discussion on "The Place of Painting in Contemporary Culture" held in conjunction with the American Federation of the Arts conference. In his opening remarks, Sweeney paired an adamant rejection of cultural conformity with an affirmation of art's ability to promote a state of imaginative transformation that enriches everyday life. He lamented: "The leaning of our civilization is towards conformity. The broadening of [mass] communications has certainly fostered this tendency. Conformity, social or aesthetic, gradually kills the spirit." In contrast, Sweeney vociferously advocated "a revolt from the established norm" as an effective means of keeping the creative spirit alive in mass-mediated American culture. In this way, he concluded, "the work of a painter, as the work of a poet, is not to find a formal equivalent to the emotions of everyday life, but to transform and to enrich them, in an imaginative order."[21] Two years later, in his essay for the *Review of Politics*, Sweeney explicitly traced the sources of his country's pervasive cultural limitations to the legacy of its "colonial beginnings: a culture that was essentially a moralizing and prosaic one, always suspicious of anything that might be regarded as a spiritual disorder or an undue emphasis on the esthetic—our heritage of that contemporary European culture which was brought by the colonists to these shores and which shared in almost equal parts a Puritan severity and an eighteenth-century rationalist

ideology." According to Sweeney, the puritan inheritance provides "a hint of why the American public has been so reluctant to accept anything in which it did not recognize a predominant solemnity, which they came to confuse with dignity and respectability, in their scrupulous avoidance of the non-utilitarian."[22] Throughout his literary and curatorial projects in New York, Houston, and elsewhere, Sweeney advocated aestheticized, mystical play as a powerful means to overcome these received cultural constraints, through creative encounters that induced transformational modes of vision and consciousness.

In various ways, the 1960s represented the culmination of Sweeney's mystically oriented modernist project. This sense of fruition is exemplified by the number and quality of the modernist artistic retrospectives that he staged at the Museum of Fine Arts, Houston (MFAH); the uniqueness of the exhibition designs that Mies van der Rohe's Cullinan Hall afforded him; the depth and development of Sweeney's own literary and critical corpus; and the convergence of these elements against a backdrop of pronounced social and cultural change. He was at the apex of a long and distinguished career when he became the director of the MFAH in January of 1961, only the third person to hold this position. Given his extensive background, Sweeney was a compelling choice for the museum directorship, and the announcement of his appointment was carried in the national news media. Thus *Newsweek* reported that "in hiring the distinguished art critic and museum director [the MFAH trustees] were initiating 'a five year plan toward building the [museum] into an art center of vitality and pioneering character . . . which will be worthy of the city's enterprise. It is to direct this vigorous program that the board has turned to Mr. Sweeney.'" Sweeney himself was decidedly sanguine about his prospects in Houston. Regarding his priorities as museum director, Sweeney told a reporter for *Newsweek*: "It will be a great challenge. The trustees and I agree that I should keep moving and see the country. I'll haunt the artists' studios all over the world. They want to find younger artists who will be great tomorrow, and to explore in the older field for works of art that aren't prohibitively overpriced. They want an exploratory business, an international and national collection, not just a regional museum. They want to reach out to the Orient and to Europe. That's just what I like."[23]

 Prior to Sweeney's arrival, the MFAH's permanent collection had con-
sisted of relatively modest and eclectic holdings whose strengths primarily
reflected the tastes of local collectors. As museum director, Sweeney undertook a
highly ambitious program that included key acquisitions which, to this day, rep-
resent crucial components of the permanent collection, and curating a series of
sensational–and innovatively installed–exhibitions in Cullinan Hall, the MFAH's
modern wing. Designed by Mies van der Rohe during the fifties, Cullinan Hall was
originally conceived as a thirty-foot-high, column-free structure that contained
10,000 square feet of flexible exhibition space. Sweeney typically treated this dra-
matic setting like a kind of theatrical set that facilitated an interactive performance
between artworks and their viewers. He elaborated on these concepts in the French
art magazine *L'Oeil* (May 1963) when he characterized the architecture of Cullinan
Hall as providing a kind of flexible frame for his museum installations, just as he
described the open, interior volume of Mies's architectural space as itself a work of
modern art.[24] Thus visitors encountered individual works of art that were placed
within the collective work of art of Sweeney's exhibition, which was itself situated
within Mies's architectural work of art. The accompanying exhibition catalogues,
elegantly designed by Herbert Matter, offered additional narrative and conceptual
frameworks to express Sweeney's creative vision.

 Sweeney's curatorial engagement with the *coincidentia oppositorum* can
also be seen in his multivalent approach to the picture frame. In 1963, he com-
mented on the ambivalent function of the frame as a coincidence of separation
and conjunction. According to Sweeney, the frame at once demarcated the edges
of an artwork, establishing a sense of internal and external closure, even as it
helped to achieve a sense of contextual integration between the individual art-
work and its ambient surroundings. As he observed, "every painting realized as
an independent unit still requires a frame to serve it in either one of these ways,
either as a fence against the encroachment of its environment, or as a link to its
background and surroundings." He maintained that his signature gesture of paint-
ing the gallery walls white promoted this "double function, namely as a frame for
each individual picture and at the same time as a frame for the total exhibition."[25]
By emphasizing the simultaneously bounding and bonding functions of the frame,

Sweeney conjoined seemingly antithetical categories in a *coincidentia opposito-rum*: as a symbolic and material boundary demarcating the work of art from all around it, and as a powerful point of entry that connected viewers to imaginative worlds.

In short, under Sweeney's guidance the MFAH went from being a largely provincial institution to an "international force" that commanded considerable attention for its innovative programming and for the stature of its modernist and ethnographic collections.[26] With the acquisition of modern and contemporary paintings and sculptures by artists such as Pierre Alechinsky, Corneille Bever-loo, Brancusi, Burri, Calder, Chillida, Robert Delaunay, Lucio Fontana, Paul Klee, Franz Kline, Joan Miró, Piet Mondrian, Robert Motherwell, Jackson Pollock, Mark Rothko, Niki de Saint Phalle, Soulages, Antoni Tàpies, Tinguely, and Mark Tobey, Sweeney assembled an unusual and highly relevant collection of modern Euro-pean and American art.

In addition to these key acquisitions, one of Sweeney's most sensational curatorial projects was his initial identification, and subsequent supervision of the excavation, of a sixteen-ton carved basalt Olmec head from a dense portion of the Mexican jungle. He then persuaded the Mexican government to lend this national treasure to the MFAH where, in 1963, it was prominently displayed in an exhibi-tion of Olmec cultural artifacts.[27] Other major undertakings include his organiza-tion of an important "Georgia O'Keeffe Exhibition" (May 28 to July 3, 1966), and his assembling of an extensive loan show featuring works by artists of pre-World War I Paris. Entitled "The Heroic Years: Paris 1908–14," this monumental exhibi-tion opened in Houston in the autumn of 1965.[28] As Edward Mayo, who served as the museum's registrar during Sweeney's tenure, succinctly observed, "Sweeney brought modernism to Houston in a way that it had never been brought before."[29] By 1966, the journal *Art Voices* credited him with the "cultural boom" that was tak-ing place in Houston: "The influence of James Johnson Sweeney is unquestionably one of the greatest factors in the Houston museum's excellence. Coming to the museum from the directorship of the Guggenheim in 1961, Sweeney has contrib-uted much in the imaginative and superbly mounted exhibitions he has created in the last four years."[30]

At the MFAH, Sweeney cultivated relationships with key supporting patrons, especially John and Dominique de Menil; orchestrated intricate negotiations with colleagues and dealers; and secured strategic acquisitions that were integral to the building of the museum collection. Not surprisingly, his high-profile presence and progressive exhibitions elicited spirited responses from contemporary audiences. In 1963, two years into his tenure as museum director, Sweeney was the recipient of *Art in America's* Annual Award for an Outstanding Contribution to Modern Art. The citation acknowledged that Sweeney

has, through the years, consistently sought the best in advanced and often controversial art, and given the emerging artist a forum at major exhibitions. He has served the museum and the artist handsomely in inventive installations. He has traveled extensively in America and abroad to bring into international focus the varying strands of art expression. As president of the International Association of Art Critics he has worked for the spread of vital art information around the world. His own scholarly and daring writings on artists, architects and museum practices are respected and read in several languages. In taking the directorship of the Houston Museum of Fine Arts he devotes his brilliant career to the major challenge of a museum outside the New York arena.[31]

In turn, prominent Houstonians recognized the important, if often challenging, nature of Sweeney's modernist enterprise. The same year that he received the *Art in America* award, the Houston Chamber of Commerce boasted: "Under the brilliant guidance of its internationally famous Director James Johnson Sweeney (formerly of the Guggenheim), the Museum has become a lively and nationally admired art center."[32]

At the same time, the public response to his modernist project remained highly ambivalent, with both genuine admiration and pronounced resistance from contemporary viewers. This polarizing dynamic—another cultural and professional instance of the *coincidentia oppositorum*—contributed to his visible success and to his subsequent departure from his position as museum director. According to various knowledgeable individuals, Sweeney did not go out of his way to cultivate relationships with important patrons in Houston as fully as he might have. This situation was exacerbated by his frequent travel and extended absences from the city.

As a result, support eroded for his various initiatives. Ultimately, sufficient resources were lacking for the purchase of many of the artworks that Sweeney brought to Houston on approval as potential acquisitions, and there were insufficient funds to cover the expenses incurred in producing his exhibitions and catalogues. Thus in July of 1967, the museum trustees asked Sweeney to step down from his full-time post as museum director.[33]

Once again, these complex interrelationships lend themselves to striking visual expressions. Jack Boynton, one of the artists featured in Sweeney's "Younger American Painters" show at the Guggenheim (1954), has produced a sketch of *Sweeney, Imagined from Memory* (2008, figure 1.3) that portrays him as a person of great thoughtfulness and sensitivity, with traces of poignancy and resignation associated with the various challenges that he encountered professionally.

From a different perspective, in an image simply entitled *OUT!* (1966, figure 1.4), the Texas artist Frank Freed depicted Sweeney standing authoritatively in the MFAH gallery, on whose signature "Sweeney white walls" hang abstract paintings by Franz Kline and Adolph Gottlieb.[34] The museum director vigorously points to the doorway, essentially banishing a cowering young artist who has committed the error of presenting a conventional landscape for the director's consideration. Himself a figure painter, Freed might be expressing the frustrations that many Houstonians experienced over Sweeney's singularly modernist vision. Thus as much as *OUT!* is a satirical portrait of Sweeney, it can be viewed more broadly as a pointed period commentary on the cultural politics of Houston during the sixties, a subject discussed throughout this study.

Mysticism in a Modernist Context

In short, Sweeney's intellectual commitments sometimes notably conflicted with his work as a museum administrator, as his innovative if controversial curatorial approach came up against the practical reality of the art museum as a social signifier fully embedded in an haut bourgeois world, one in which Sweeney could form strategic alliances but never a lasting arrangement. Thus just as his modernist project was characterized by the subtlety, lightness, and fluidity of the *coincidentia oppositorum*, his intellectual and professional activities both reflected

and inverted established modernist conventions. This pattern is evident in the paradoxical dynamic of self-inscription and self-erasure of his own professional engagement, as he repeatedly positioned himself at once in and not in the museum world. Yet his curatorial and philosophical approaches can also be situated within the broader cultural engagement with mysticism, spirituality, and religion that threads through midcentury modernist thought.

Within the contemporary art community, Sweeney was certainly not alone in addressing these themes. Indeed, he shared a deep intellectual and professional engagement with them with his colleagues at the Museum of Modern Art, Alfred H. Barr, Jr., and William C. Seitz.[35] In particular, Sweeney's commitment to the *coincidentia oppositorum* as a form of mystical aesthetics resonates strongly with the discussion of abstract expressionism that Seitz formulated in his 1955 Princeton doctoral dissertation. Seitz stated in his preface that the aesthetic goal of abstract expressionist painting reflects "the need to encompass multiple dualisms and levels of existential, rational, and mystical experience within a reciprocal unity." In a subsequent discussion of "the problem of opposites" in New York School painting, he questioned: "Is the dualistic formulation a product of our cultural pattern, or is it more deeply embedded in the human personality? Why, in the form criteria of equivocal space and flatness, confrontation of opposing stylistic poles, and emphasis on 'tension,' has duality become so intrinsic a principle of progressive painting? . . . But whatever the reasons for thinking in terms of oppositional concepts and principles may be, our psychic state is surely revealed by it."[36] Seitz thus identified patterns of thematic oppositions in both the formal qualities of New York School paintings and in their accompanying bases in rational and mystical thought, just as he saw these issues as being shaped by, and correspondingly revealing, larger cultural and psychic tensions.

Sweeney's writings can also be situated within this discursive context, as he repeatedly sought to engage and to transcend an aesthetics of polar opposition. Thus on the one hand, he frequently pitted conceptions of normative social and cultural repression against the liberating potential of imaginative, mystically oriented aesthetic experience. In so doing, like so many prominent modernists from Alfred Stieglitz onward, he productively leveraged an instrumental social critique to promote an avant-garde aesthetic project. Yet on the other hand, Sweeney

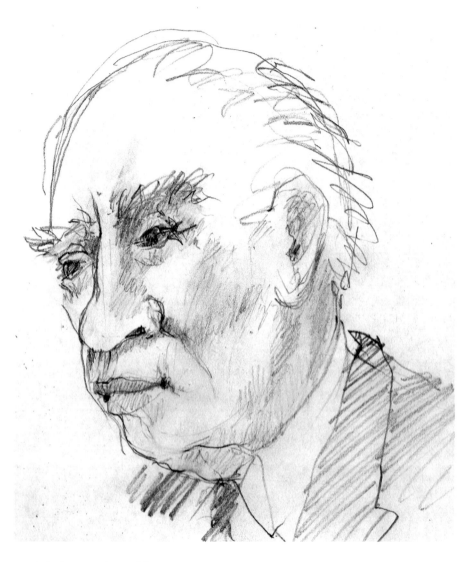

1.3 Jack Boynton, *James Johnson Sweeney, Imagined from Memory*, 2008. ©Jack Boynton, 2009.

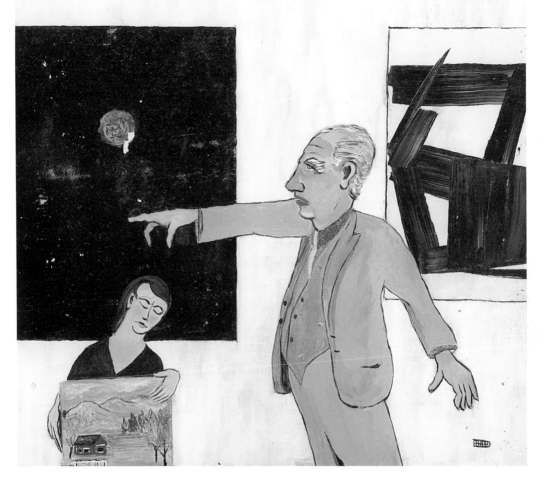

1.4 Frank Freed, *OUT!*, ca. 1966. Oil on wood panel. The Museum of Fine Arts, Houston; Gift of the Eleanor and Frank Freed Foundation.

also repeatedly characterized the creative potentialities of modernist artworks and their corresponding museum spaces as encompassing and transcending the dualistic qualities of the *coincidentia oppositorum,* as these structures exhibited a fluidly nondual capacity for transforming into their opposites. As we shall see, these themes variously became expressed in the multivalent qualities of Duchamp's androgynes, in the interchangeability of sacrality and abjection in Burri's burlap *sacchi,* and in the "flying sparks" that Sweeney saw as uniting mass and light in Chillida's sculptures.

Notably, in March of 1948 Barr invited Sweeney to participate in "a group of 'earnest' thinkers who have been meeting two or three times a year to discuss the relations between art and religion in the contemporary world." This art seminar was a subgroup of the Conference on Science, Philosophy, and Religion. Along with Barr himself, its membership included the Protestant theologian Paul Tillich, the modernist sculptor Jacques Lipchitz, the Yale art historian George Kubler, and the scholar Louis Finkelstein of the Jewish Theological Seminary, who served as its chair. Subjects of discussion ranged from questions concerning ecclesiastical taste, to the historical and psychological issues associated with iconoclasm, to "the problem of the work of art as a religious symbol, as a dogmatic symbol, as a focus for devotion or meditation, as a presentation of legend and as a secular expression of religious feeling or faith." Barr concluded by informing Sweeney, "I proposed your name because I felt that you could speak authoritatively on behalf of the modern artists from the point of view of the Catholic layman who previously had been interested in the use of the artist by the Church."[37] Sweeney responded positively to Barr's invitation, thanking him and informing him that, "as to joining the group of 'earnest' thinkers you refer to, I will be very glad."[38] In turn, Barr remarked to Finkelstein, "I am very happy that Mr. Sweeney is willing to join us because he is one of our best scholars in the field, knows personally and intimately many of the leading artists in the world today and is moreover interested in the problem of modern religious art in general and the possibilities of the modern artist's collaboration with the churches."[39]

During the following decade, Sweeney also served on the board of directors of the Religious Art Center of America, Inc., a nonprofit organization chaired by the Reverend William Granger Ryan, president of Seton Hill College, a Catholic

liberal arts college in Greensburg, Pennsylvania. Although it was never instituted, the center was designed to promote and "encourage contemporary religious art."[40] During the sixties Sweeney received honorary doctorates from a number of Catholic institutions, including the College of the Holy Cross (1960), the University of Notre Dame (1961), and his alma mater, Georgetown University (1963).

As all of this suggests, Sweeney's thinking was deeply informed by his Irish Catholic background, and his colleagues repeatedly called upon him to represent this perspective within larger contemporary discussions of the relations between art, spirituality, and religious traditions. Yet Sweeney's extensive engagement with mystical traditions was considerably more complex than this. While clearly shaped by his longstanding interest in Christian mysticism, his individually oriented conception of mystical aesthetics did not conform to the established conventions of any orthodox religious structure.[41] Rather, his interpretive approach corresponded to what Barr loosely termed the "modern spiritual culture" that broadly informed developments in midcentury intellectual history.[42]

Such privileging of subjective experience is consistent with modernist constructions of mysticism as primarily an individual, subjective, and often paradoxical phenomenon. As traced most notably in the writings of Michel de Certeau, during the premodern period conceptions of mysticism were situated more generally within Neoplatonic thought, and later within the traditional liturgical, scriptural, and doctrinal contexts of the Christian church. However, with the revolutionary developments of modernity during the sixteenth and seventeenth centuries, formulations of mysticism became loosened from established bases of faith and authority to function positively as comparative abstractions that could be located within independent, subjective experiences.[43] During the twentieth century, it should also be emphasized, the term "spiritual" similarly functioned as a modernist signifier that carried strong individualist and aesthetic associations. The conceptions of the spiritual that thread through the nineteenth-century literary genealogy of Emerson and Whitman became foundational to what the critic Van Wyck Brooks identified as a "usable past," a literary and philosophical heritage that could productively underpin modernist cultural production.[44] Thus during the early decades of the twentieth century, the first American avant-garde sought to invest their abstracted modernist artworks with elevated spiritual, and

often erotically charged, associations. Such conceptions of the spiritual were dis-associated from established religious traditions and institutions, performing the paradoxical task of connecting twentieth-century artists to venerable cultural pre-cedents while simultaneously affirming the sanctified status of their progressive modernist artworks.[45]

Sweeney's engagement with these spiritual and mystical concepts can be seen in his contribution to a "Symposium on Music and Art" held at Bennington College in the spring of 1955. In a paper on "Recent Trends in American Painting," he advanced a conception of abstracted modernist painting as a *coincidentia oppo-sitorum* that presented a visible microcosmic representation of larger macrocosmic unities, a paradoxical phenomenon that he associated with larger devotional pur-poses. Sweeney praised modern paintings for displaying "a sense of unity dominat-ing multiplicity, a microcosme [*sic*] of the greater macrocosm—a sense of stability. And in an age such as ours—an age in which we are so conscious of the confusion of philosophical outlook which surrounds us—I often wonder if one of the reasons why so many of our artists today are so zealously paring away the peripheral inter-ests of a painting . . . is not an unconscious desire to find in such an approach a reassurance of the essential stability of existence, and, by setting up such models and reminders, to build a causeway over which we may move through this age of decayed faith?"[46] Thus Sweeney conjoined a Heraclitean conception of the world as existing in a chaotic state of eternal flux with a vision (*pace* Thomas Aquinas's *Summa Theologica*) of "a quiet order" in which unity is achieved from diversity:[47] a powerfully ambivalent theorization of modernist aesthetics as a mystical and aesthetic *coincidentia oppositorum* that attached heightened spiritual value to the underlying structural order that he perceived within abstracted modernist forms. Thus paradoxically, Sweeney appeared to be adopting a conservative perspective that affirmed notions of unity, stability, order, and faith, just as these very ideas established a solid foundational base that supported innovative developments—and radical departures—in contemporary pictorial practice.

By adopting this interpretive approach, Sweeney's texts also resonated with the groundbreaking contemporary inquiries into the relations between mys-ticism and aesthetics that represented some of the most progressive currents of

mid-twentieth-century thought. In his study of the distinguished scholars of religion Gershom Scholem, Mircea Eliade, and Henry Corbin, Steven M. Wasserstrom has followed their various responses "to the thirst for transcendence and totality" that accompanied the deep-seated sense of cultural anxiety and alienation following the Second World War. In particular, Wasserstrom has traced the intricate, and sometimes contested, ways in which each of these thinkers adopted an aesthetic approach to the study of religion that was based on "the epistemological centrality of symbols." These symbols were positioned within a metahistorical framework that "placed as a mystery at the heart of that gnosis a *coincidentia oppositorum*, a godhead unifying opposites, transcendent but apprehensible through symbols."[48] Thus just as contemporary writers formulated aesthetic approaches to the study of mysticism, Sweeney can be seen as reflecting *and* inverting this conceptual framework as he promoted a mystically oriented approach to aesthetics.

As all of this suggests, the concept of the *coincidentia oppositorum* encompasses multiple temporal and conceptual reference points simultaneously as it extends backward and forward in time, from the fragments of Heraclitus and the texts of the fifteenth-century philosopher Nicholas of Cusa to the twentieth-century writings on mystical experience by the psychologist and philosopher William James, the psychoanalytic discourses of Carl Jung, and the comparative histories of religion of Eliade, Scholem, and Corbin.[49] Thus the *coincidentia oppositorum* is at once an established feature of ancient mythical and religious language and of progressive modern thought. To draw on the theoretical language of Michael A. Sells, such reciprocal crystallizations and dissolutions of form and meaning, presence and absence, abstraction and figuration may aptly be conceptualized in terms of apophasis and kataphasis, or the "mystical languages of unsaying," of "saying the unsayable."[50] As Sells has observed, a complementary tension between affirmation and negation–as manifested in corresponding patterns of speaking and unsaying, appearance and disappearance, or kataphasis and apophasis–arises as mystical language attempts to name a subject that lies beyond words, inherently unnamable. As a result, apophatic discourses tend to generate radical paradoxes– such as the coincidence of opposites–as language and form turn back on themselves. Equally radical formulations concerning the envisioning of the invisible,

the saying of the unsayable, and the (dis)embodiment of gendered embodiment are expressed throughout Elliot Wolfson's writings—as are the aesthetic dimensions of these paradoxes. Applying these concepts to the visual arts, the historical construction of modernist abstractions can be viewed in part as an aesthetic expression of apophaticism, that is, a creative negation that collapses the categorical boundaries distinguishing presence and absence, subjectivism and objectivism, while promoting a movement toward a kind of radical transcendence that sometimes negates and transcends the very notion of transcendence.

Saying the Unsayable, Saying the Unsaid

By engaging these themes, *Curating Consciousness* represents an extension of the scholarly project that I have pursued in my books *Painting Gender, Constructing Theory* and *Modernism's Masculine Subjects.* There I traced the various ways in which conceptions of gendered subjectivity historically informed the production and reception of abstracted modernist painting, just as these ideas crucially shaped period understandings of the relations between the physical and metaphysical domains of modernist aesthetics. Despite the differences among Alfred Stieglitz's, Clement Greenberg's, and James Johnson Sweeney's artistic and critical projects, each productively situated his highly influential vision of modernist aesthetics within a generative critique of American culture that vociferously rejected conceptions of conventionality, repression, materialism, and utilitarianism. These oppositional critical discourses created an opening for—and indeed, seemed inevitably to demand—innovative artistic and philosophical responses that privileged the erotic body, the heroic subject, and numinous mystical experience.

 In this context, it is significant to note Robert Nelson's observations on how museums have perpetuated an inverse relation between the artistic and religious qualities of their displayed objects. As Nelson has remarked, during the late nineteenth and twentieth centuries, just as religious artworks were removed from their original sacred contexts and entered secular museum collections, the increased aesthetic valuation of the pieces corresponded to the diminishment of their religious significance.[51] As I show throughout this study, Sweeney's critical and curatorial project functioned both in contrast and as a complement to this secularizing

trend, as he advanced an approach in which the aesthetic and spiritual qualities of artworks could meaningfully enhance one another in the secular space of the modern museum. Such interpretations became pronounced during a period when the symbol itself was deeply in crisis: a historical moment when a literal–or even symbolic–approach to traditional religious symbolism was no longer tenable for modern secularized intellectuals. In this context, aestheticized conceptions of apophasis could provide a compelling means of approaching spiritual and mystical concepts through comparative abstractions that were seen as linking ancient and modern imagery.

As this suggests, engaging Sweeney's multifaceted career is necessarily a transdisciplinary enterprise that encompasses not just modernist art history and museum studies but aesthetics, literary criticism, intellectual history, mystical philosophy, and the history of religions. Such an inquiry raises a number of suggestive questions, perhaps most notably: Within the methodologically diverse discourses of modernist art history, with their characteristic embrace of interdisciplinary modalities, why is it that the theoretical discourses of the study of religions have largely been excluded from the conversation? This question is especially striking because, while we are perfectly comfortable discussing desublimated corporeality, abjection, and excess, we remain decidedly uneasy about issues of metaphysics and spirituality.[52]

Commenting on these themes, Rosalind Krauss incisively noted: "In the increasingly de-sacralized space of the nineteenth century, art had become the refuge for religious emotion; it became, as it has remained, a secular form of belief. Although this condition could be discussed openly in the late nineteenth century, it is something that is inadmissible in the twentieth, so that by now we find it indescribably embarrassing to mention art and spirit in the same sentence."[53] Modernist thinkers such as Daniel Bell, Jacques Barzun, and Wallace Stevens have commented on the various ways in which the production of avant-garde art is associated with the quest for religious belief–that is, for formulating a site of the sacred in the secular modern world.[54] Yet Krauss's remarks shed light on the ways in which the complex relations between aesthetics, metaphysics, and mysticism have often been overlooked–if not altogether excluded–from rigorous critical

discussions of modern art and their corresponding museum practices. Questions of "the spiritual in art" are typically addressed as supplementary iconographic or collateral traditions that exerted a formative influence over certain key developments in late-nineteenth- and twentieth-century modernism.[55] Yet while spirituality and mysticism represent acknowledged aspects of the historical record, these same topics nonetheless remain decidedly uncomfortable—even, as Krauss says, "indescribably embarrassing" and thus virtually undiscussable—for many of the most rigorous critical discourses produced during the last quarter-century. It is indeed a short distance from the indescribable to the unsayable to the unsaid.

Rather than engaging with the abstract, often intangible ideals associated with the metaphysical realm, a privileged emphasis has instead been placed on formulating a more robustly materialist—and implicitly heroic—account of modernist aesthetics. The resulting narratives tend to interrogate vigorously the various cultural constructions that contributed to period formations of subjectivity and their firm embeddedness in an accompanying socially contextualized base, one largely comprised of politics, markets, ideologies, and their related cultural histories. Other theoretically sophisticated art historical discourses characteristically present desublimated—and instrumentally deconstructive—postmodernist readings of modernist artworks. Such revisionist approaches initially offered important opposition to the formalist criticism that was so prominent during the sixties and seventies, and today these discourses continue to represent valuable methodological interventions into art history's established interpretive traditions. As a cultural extension of this philosophical critique, the museum has repeatedly been identified as a particularly contentious, ideologically charged site whose very institutional structures are seen as serving the privileged interests of an established power base.[56]

Yet it is also important to preserve a sense of conceptual latitude, so that we may continue to rethink received patterns of interpretation and formulate approaches that offer significant departures from established methodological modalities. Throughout this study, I trace the conceptual structures that Sweeney engaged historically—particularly in his readings of the negative theology and nondual philosophy associated with apophasis, kataphasis, and the *coincidentia*

oppositorum–not to advocate an art history based on negative theology or any particular religious paradigm, but to deconstruct predictable, stable, or hierarchical oppositions between the physical and metaphysical domains. Building on an underlying structure of period criticism, I examine Sweeney's career as a compelling case study of the complex ways in which the historical base of modernist aesthetics contained powerful conceptual tools that can open up new ways to approach the unsaying, unseeing, and unforming that so deeply informed modernist art and the museum galleries in which it was showcased. I believe the time has come for a critical formulation of modernist aesthetics that can accommodate the historical and philosophical complexities–and the accompanying destabilizations–associated with the reciprocal dynamics of the *coincidentia oppositorum*, with the assertions and erasures, seeing and unseeing, saying and unsaying that unfolded within a vision of midcentury modernism that placed the numinous at its core.

To reconstruct the canonical bases underpinning these historical and philosophical developments, this study begins with a discussion of Sweeney's engagement with two central figures in modernist art: Barr and Duchamp. In chapter 2, I examine Sweeney's and Barr's intellectual and professional activities during the 1930s and 1940s, and the complementary theorizations of modernism that they developed at that time. The two men were then close colleagues at the Museum of Modern Art, and they published early canonical texts that placed dialogical theorizations of modernist creativity within a larger masculine androgynous ideal. Building on these double-edged themes of ambivalence and androgyny, in chapter 3 I focus on Sweeney and Duchamp's artistic and curatorial collaborations from the 1930s through the 1960s. As we shall see, their various exchanges reveal (and conceal) their ongoing, shared engagement with a metaphysical, and often highly transgressive, vision of modernism that hinged on a reciprocal dynamic of seeing the "not seen and/or less seen."[57]

The second part of this study focuses on Sweeney's interactions with four remarkable artists who are somewhat less familiar to American audiences: the Italian collage and mixed-media artist Alberto Burri, the French abstract painter Pierre Soulages, the Swiss motion sculptor Jean Tinguely, and the Spanish Basque

modernist sculptor and printmaker Eduardo Chillida. Chapters 4 through 7 can thus be viewed as comparative case studies in saying the unsaid and seeing the unseen through the prism of Sweeney's and the artists' mystical engagements with modernist aesthetics. These themes variously took the form of Burri's innovative reenvisioning of hermetic alchemy and the blood miracles of Christian incarnational theology; Soulages's creative transmutations of the sacred stones of Romanesque churches and ancient pagan monuments into gestural abstract paintings; Tinguely's kinetic experiments with reciprocal patterns of creation and destruction through animated sculptures that were characterized at once as agents of apocalypse and as toys from a parallel world; and Chillida's visual translations of negative theology and Heideggerian conceptions of absent presence into sculpted fields of light.

Despite the diversity of these materials, shared themes thread through this artistic work. They include Duchamp's, Burri's, and Tinguely's animated aesthetic appropriations and paradoxical redemptions of ordinary discarded materials; and Soulages's and Chillida's apophatic transformations of ancient formations of stone and light, absence and presence, into architectonic modernist compositions that recreated aspects of these familiar structures, making them anew without completely erasing their underlying reference points. Taken together, these subjects instantiate the various ways in which the physical and metaphysical, material and mystical domains were conceived historically, not as dualistically oppositional categories, but rather as distinctive aspects of a multifaceted aesthetic experience. That is, because the dense materiality of solid masses, corporeal physicality, and abject, discarded items were repeatedly imbued with mystical qualities that nonetheless remained inextricably attached to the phenomenal bases of the artworks, the resulting conceptions of aestheticized mysticism and mystical aesthetics were marked by an ongoing engagement with these categorical differences *and* with their constant overcoming. In turn, the expressive effects of these *coincidentiae oppositorum* were enhanced by the duality of modernist aesthetic structures that allowed the transcendent to emerge and recede through the making and unmaking of their accompanying frames. And in these ongoing dynamics we can locate the convergence of phenomenological and dialectical approaches that established and

sustained the curatorial arena as a space of beginnings and ends, a common place (*topos*) in which the finite is turned back toward the infinite, and vice versa.

Ultimately, the multivalent idea of "curating consciousness" turns in part on a suggestive paradox: How can modernist aesthetics be reconnected with a complex mystical tradition from which it has never been separated? The answer seems to lie in the equally paradoxical project of making the invisible visible while saying the unsayable, or saying what has, at least until now, remained unsaid within the dominant discourses of modern art.

2

The Nude Descending a Flowchart:

Alfred H. Barr, Jr., and Marcel Duchamp

Among the familiar images of modernist art history, the flowchart that Alfred H. Barr, Jr. constructed as the cover design for the exhibition catalogue *Cubism and Abstract Art* at the Museum of Modern Art remains one of the most prominent (1936, figure 2.1).[1] In this diagram, Barr famously outlined a series of connections among the various movements of modern art, culminating in the categories of "geometrical abstract art" and "non-geometrical abstract art." Given its longstanding historical significance, it is not surprising that Barr's flowchart has become a focal point for much partisan debate, as scholars have examined the ideological investments underpinning his modernist project and its legacy for a present-day audience. Indeed, Barr's vision of modernism has been interpreted as representing everything from a scholarly model of "historical truth and internal coherence" that served as a powerful "proselytizer" of "the Gospel of modern art," to a codified

statement of gender oppression reflecting the historical exclusion of female art-
ists, to a myth-making declaration in support of the modernists' elitist "quest for
purity" at the expense of the "colonized subjects [who] play the Other to the idealist
dialectics of abstraction."[2]

While such critical discourses have shed much light on the networks
of privilege and exclusion that have underpinned the modernist project histori-
cally, the familiar polemic between traditionalist modernist accolades and their
corresponding revisionist critiques largely overlooks another, more subtle yet
extremely powerful aspect of Barr's project: namely, the dialogical–and indeed
androgynous–theorization of gendered subjectivity embedded within the aesthetic
structures of canonical modernism. In the more than seventy years since its ini-
tial publication, Barr's flowchart has been called many things, but to the best of
my knowledge it has yet to be called an androgyne. Yet the diagram can be read
as a complex and powerful formulation of androgynous masculine creativity that
extended, both temporally and conceptually, forward to embrace innovative devel-
opments in modern art, and backward to evoke venerable classical and biblical
archetypes.

While *Cubism and Abstract Art* occupies a unique if controversial position
in the history of modernism, it has an important precedent in a much less famil-
iar text, Sweeney's *Plastic Redirections in 20th Century Painting* (1934).[3] There
Sweeney presented a stylistic and theoretical model of modern art that he had ini-
tially developed during the early thirties and would refine and expand throughout
his career. The resonance between Sweeney's and Barr's texts is not surprising.
During the thirties, the two men were close colleagues at the Museum of Mod-
ern Art; Barr was the founding director of the museum, and Sweeney organized
a number of high-profile exhibitions and served as a member of the museum's
Advisory Committee. In the acknowledgments to *Cubism and Abstract Art*, Barr
thanked Sweeney for his assistance in assembling the exhibition and preparing the
accompanying catalogue.[4] Sweeney also anonymously loaned a painting from his
personal art collection, Mondrian's *Composition with Large Red Plane, Blue, Gray,
Black and Yellow* (1921), for the show.[5] Moreover, the personal correspondence
that Sweeney and Barr exchanged throughout the thirties clearly indicates their
shared avid interests both in non-Western art and twentieth-century modernism.[6]

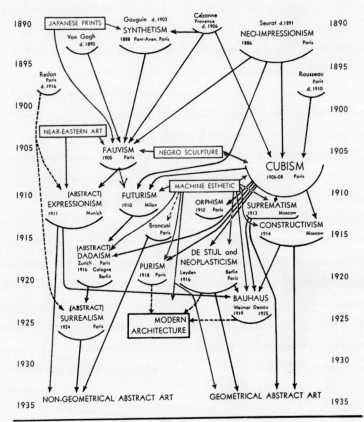

1890	JAPANESE PRINTS	Gauguin d.1903 SYNTHETISM 1888 Pont-Aven, Paris	Cézanne Provence d. 1906	Seurat d.1891 NEO-IMPRESSIONISM 1886 Paris	1890

1890 1890

JAPANESE PRINTS Gauguin d.1903 Cézanne Seurat d.1891

Van Gogh SYNTHETISM Provence NEO-IMPRESSIONISM

d. 1890 1888 Pont-Aven, Paris d. 1906 1886 Paris

1895 Redon Rousseau 1895

Paris Paris

d. 1916 d. 1910

1900 1900

NEAR-EASTERN ART

1905 FAUVISM NEGRO SCULPTURE CUBISM 1905

1905 Paris 1906-08 Paris

MACHINE ESTHETIC

1910 (ABSTRACT) FUTURISM ORPHISM SUPREMATISM 1910

EXPRESSIONISM 1910 Milan 1912 Paris 1913 Moscow

1911 Munich Brancusi CONSTRUCTIVISM

Paris 1914 Moscow

1915 1915

(ABSTRACT) DE STIJL and

DADAISM NEOPLASTICISM

Zurich Paris PURISM Leyden Berlin

1916 Cologne 1918 Paris 1916 Paris

Berlin

1920 1920

BAUHAUS

Weimar Dessau

(ABSTRACT) 1919 1925

1925 SURREALISM MODERN 1925

1924 Paris ARCHITECTURE

1930 1930

1935 NON-GEOMETRICAL ABSTRACT ART GEOMETRICAL ABSTRACT ART 1935

REPRODUCED FROM THE JACKET OF THE ORIGINAL
EDITION

2.1 Alfred H. Barr, Jr., chart prepared for the jacket of the exhibition catalogue *Cubism and Abstract Art* (New York: Museum of Modern Art, 1936; reprint edition, Arno Press for the Museum of Modern Art, 1966). The Museum of Modern Art, New York, NY, U.S.A. Digital Image ©The Museum of Modern Art/Licensed by SCALA/Art Resource, NY.

Thus while Barr has repeatedly been singled out in discussions of canonical modernism, his analysis belonged to a complex discourse that also included Sweeney's contemporary theorizations of aesthetics and gendered subjectivity. In their texts, both men adopted a genealogical approach for tracing the evolutionary development of the plastic sequence in modern art, and for mapping its corollary characteristics onto conceptions of modernist selfhood. Much like the chronological axis of Barr's flowchart, Sweeney's narrative extended from developments in later nineteenth-century impressionism to the abstract psychological works of "Superrealism" (what we now call surrealism). Of the two, Barr's model of modernist aesthetics and subjectivity may have worn its dialectics more visibly on its sleeve (of the book jacket). Yet both Sweeney's and Barr's texts were based on parallel conceptions of modernist subjectivity that encompassed the material, ethical, aesthetic, and spiritual domains. In their writings, the abstract qualities of modernist artworks were repeatedly characterized as symbolic analogues of an idealized conception of male selfhood, a coincidence of opposites that encompassed a multivalent capacity for rationality and emotion, intellect and intuition, logical calculation and mystical ecstasy. And as discussed in this chapter and the next, perhaps nowhere are the androgynous dynamics of the *coincidentia oppositorum* more apparent than in the works of another close friend and associate of Sweeney's and Barr's for nearly four decades, Marcel Duchamp.

Alchemy, Androgynes, and the End of Philosophy

In interviews with the curator Lanier Graham in 1967 and 1968, Duchamp commented suggestively on the mystical and philosophical perspectives underpinning his creative production. In particular, he noted that his artistic vision entailed "an Alchemical understanding. But don't stop there! If we do, some will think I'll be trying to turn lead into gold back in the kitchen [laughing]. Alchemy is a kind of philosophy, a kind of thinking that leads to a way of understanding. We may also call this perspective Tantric (as Brancusi would say). . . . The Androgyne is not limited to any one religion or philosophy. The symbol is universal. The Androgyne is above philosophy. If one has become the Androgyne one no longer has a need for philosophy."[7]

Characteristically enigmatic and allusive, Duchamp's comments raise a number of intriguing questions, perhaps most notably: What might it mean to "become the Androgyne," and thus, to be beyond the need for philosophy? While many works in Duchamp's oeuvre suggestively engage themes of androgyny–some of the most familiar being his image of emergent masculine presence in his alternative representation of Leonardo's *Mona Lisa, LHOOQ* (1919),[8] and the artist's internally fractured, bigendered construction *The Bride Stripped Bare by Her Bachelors, Even (Large Glass)* (1915–1923)[9]–in this study I will focus on such images of internal multiplicity as his *Rotary Glass Plates* (1920, figure 3.2), rotoreliefs (1935, figure 3.3), the custom-made, readymade *Door* that he had constructed for his Parisian apartment (1927, figures 3.6 to 3.8), and the multiple versions of the *Nude Descending a Staircase* motif, including the sensational painting of 1912 (figure 2.2) and the artist's later reconceptualization of this subject in Hans Richter's film *Dreams That Money Can Buy* (1946–1947, figures 3.4, 3.5).[10]

A different type of androgynous formulation can be located between these last two Duchampian moments, in the ambivalent constructions of the modernist canon that Sweeney formulated in *Plastic Redirections* and that Barr presented in *Cubism and Abstract Art* (figure 2.1). Viewed as comparative case studies, Sweeney's and Barr's texts can be seen as alternative, schematic representations of an androgynous ideal which, to this day, remains highly influential for the theorization of modernist aesthetics. What is especially striking about these dual–and sometimes dueling–conceptions of the androgyne is the distinct work that each performed historically, and the theoretical possibilities that each make available today. Thus identifying the idealized male androgyne embedded within these various sources provides an instrumental means of exposing the subtle, and highly ambivalent, formulations of gendered presence contained within seemingly familiar models of canonical modernism.

In contrast to the linear structures underpinning Barr's progressive, taxonomical vision in particular, Duchamp's works present multiform displacements of gendered corporeality; through these aesthetic gestures, the nude or partially nude body appears as an embodiment of the successful failure of gendered oppositions. In the process, Duchamp's androgynous images become correspondingly situated in a complex unsaying of gendered ideals. As the artist himself observed

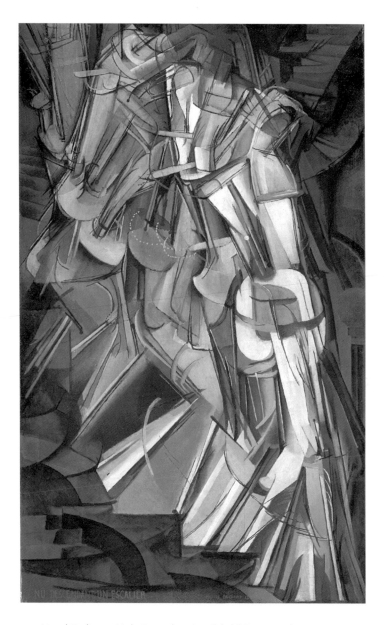

2.2 Marcel Duchamp, *Nude Descending a Staircase (No. 2)*, 1912. Oil on canvas, 57 ⅞ × 35 ⅛ inches (147 × 89.2 cm). The Louise and Walter Arensberg Collection, 1950. Philadelphia Museum of Art, Philadelphia, Pennsylvania, U.S.A. The Philadelphia Museum of Art/Art Resource, NY. ©2008 Artists Rights Society (ARS), New York/ADAGP, Paris/Succession Marcel Duchamp.

of the polyvalent qualities of his artworks, "My view is beyond and back. Some get lost 'out there.' My frame of reference is out of the frame and back again."[11] In Duchamp's various conceptions of the androgyne, gender becomes a figuration of metaphysical difference that is simultaneously located within *and* beyond difference, opening up radically hybrid possibilities for transporting viewers "out of the frame and back again." Jean Tinguely, who had worked directly with Duchamp, later observed that the artist "was totally against obsessive masculinity. He certainly knew about the perfect balance of the masculine-feminine, that masculinity alone is completely idiotic and pure femininity equally foolish. The only happy solution is the hermaphrodite, whether it be in a visible or invisible form. That moves in the direction of the transvestite, but I don't mean that. It's necessary to have both elements, both genders, that's clear, isn't it? Otherwise you can't see beyond your own limitations."[12]

At the outset, it is helpful to provide some background on the androgyne as a recurrent–albeit decidedly unstable–motif in ancient myths, classical sources, and modern artworks. To begin with the word itself, the *Oxford English Dictionary* notes that it derives from the Greek *andros*, or "man," and *gune*, or "woman." Taken together, the conjoined term signifies "male and female in one," and thus "a being uniting the physical characteristics of both sexes; a hermaphrodite."[13] Notably, the word androgyne, or "man-woman," is a rather prosaic, etymologically sublimated, and more socially acceptable term than hermaphrodite, the latter connoting a certain unnatural disfigurement even as it evokes the magical presences of Aphrodite, the goddess of beauty and sexual passion, and Hermes, the winged god of communication, and thus, of hermeticism and alchemy.[14]

The expanded entry on "Androgynes" in the *Encyclopedia of Religion* notes that, in "the visual image, androgynes may be horizontal (with breasts above and a phallus below)," as often found in Hindu typological images of the Shiva/Shakti androgyne, or "more often, vertical (with one side, usually the left, bearing a breast and half of a vagina, and the other side bearing half of a phallus)"–as in the morphological typologies that recur in alchemical texts. The entry continues: "Androgynes may be regarded as . . . symbolically successful, when the image presents a convincing fusion of the two polarities . . . that is, when it is [not] a mere juxtaposition of opposites [but] a true fusion."[15] As we shall see, this key distinction

between juxtaposition and fusion sheds valuable light on some of the important differences between the artist's and the critics' respective formulations. Moreover, Duchamp, Barr, and Sweeney would have been familiar with various conceptions of the androgyne, as the symbol recurs broadly throughout avant-garde modernism and is particularly prominent in surrealist aesthetics. Indeed, a detailed article on the androgyne appeared in the surrealist periodical *Minotaure* (Spring 1938, figure 2.3), on whose editorial board Duchamp served.[16]

Perhaps most significantly, the figure of the androgyne is central to biblical accounts of the first human being. According to the book of Genesis, on the sixth day of creation "God created man in his [own] image, in the image of God created he him; male and female created he them" (Genesis 1:27).[17] Thus the biblical image of the original human being—the initial anthropomorphic schema of Adam—represents a figural typology of gender dimorphism in which the female is contained within the male.[18] Androgynes appear in classical sources as cosmic embodiments of the duality *and* the union of the sexes. In Plato's *Symposium*, for example, the androgyne is characterized as a "third sex" incorporating a union of man and woman, a "being whose double nature" is imagined as conjoined in a circular body. These mythic creatures were later severed by the gods and divided into two parts, thereby establishing the ancient desire for "reuniting our original nature, making one of two, and healing the state of man."[19] In both classical and modern accounts, the androgyne variously appears as a mystical figure of wholeness and fragmentation, of sacrality and transgression, whose metamorphic processes of separation and reintegration mark the fractured limits and interwoven boundaries of humanity itself.[20] Throughout its various incarnations, the androgyne thus instantiates extraordinary states of being that engender an ambivalent sense of difference within, and beyond, difference.

For Duchamp, this sense of difference within and beyond difference was emphatically articulated in his decided indifference to the sexual and gendered identity of the figure featured in his famous painting, *Nude Descending a Staircase No. 2* (figure 2.2). As Duchamp told a reporter for the New York *Evening World* (April 4, 1916), "Is it a woman? . . . No. Is it a man? No. To tell you the truth, I have never thought which it is. Why should I think about it? My pictures do not represent objects but abstractions. 'The Nude Descending a Stairway' [*sic*] is an abstraction

2.3 *Adam Androgyne avant la chute,* appearing in Albert Béguin, "L'androgyne," *Minotaure* 11 (Spring 1938). Photograph courtesy of The Fondren Library, Rice University.

of movement."[21] Here it should be noted that the French word "nude," or *nu* as it appears in the painting's original title, *Nu descendant un escalier*, is a masculine noun; yet in Duchamp's later, cinematic restaging of the nude descending a staircase motif, the figure is decidedly female, a transposition which, once again, suggests a sense of fluid interchangeability between gendered subject positions.

Nude Descending a Staircase No. 2 is a multifaceted figural construction, an animated study of jointed and disjointed gestural motion that is visualized in complementary shades of gold, brown, and black. Much like alchemical processes, which are consistently represented in both metaphorically embodied and gendered terms, the painting evokes a complex experiment in which lead and gold are transformed into a composite presence of flesh and light. A lively conglomeration of linear elements is configured in an almost accordion-like pattern of bending and collapsing forms that unfold along a diagonal axis. As the artist himself remarked of this image, "Painted, as it is, in severe wood colors, the anatomical nude does not exist, or at least cannot be seen, since I discarded completely the naturalistic appearance of a nude, keeping only the abstract lines of some twenty different static positions in the successive action of descending."[22] While a diminutive staircase appears in the upper right corner of the painting, stairlike elements are also visible at the upper left. Significantly, these dual staircases suggest a multidirectional sense of presence and possibilities, of having "two sides"–the left and the right–simultaneously available as alternative pathways.

As Duchamp stated, the nude is neither a woman nor a man. Instead, the figure is sexually undecidable, seemingly a body beyond gender. More broadly, the nude is at once emphatic and unstable, as its movements are imaged through a sequence of transitional states of form, a series of dissolving boundaries that appear as a continuum of connection and disconnection. As a highly abstract figure poised between the fusing and splitting impulses of imago and iconoclasm, *Nude Descending a Staircase No. 2* can be viewed as Duchamp's intensive study of broken interwovenness, of the formlessness within form.

In its simultaneous assertions and erasures of absence and presence, multiplicity and unity, masculinity and femininity, fusion and fragmentation, *Nude Descending a Staircase No. 2* can be characterized not simply as an androgyne but as an apophatic androgyne: that is, as a nude that is actively engaged with the

saying of its own unsaying. Significantly, the philosophical dimensions of apopha-sis resonate with the formal qualities of Duchamp's painting, as the artist him-self has affirmed the formative influence of cubist compositions that depicted the decomposition of form.[23] In turn, *Nude Descending a Staircase No. 2* can be seen as a visually compelling embodiment of the simultaneously splitting and fusing androgyne, not male or female, and thus potentially both and neither. Display-ing a body that is present and absent, solid and insubstantial, *Nude Descending a Staircase No. 2* instantiates a *coincidentia oppositorum* in which painted flesh con-currently crystallizes and dissolves as it becomes clothed in the transformational art of becoming its opposite. This powerfully ambivalent apophatic formulation allowed the artist to "say the unsayable," while iconoclastically unsaying what had previously been said about the nude in canonical art history.

Sweeney and Barr: Overlapping Circles and Intersecting Grids

While Duchamp's aesthetic project actively entailed the provocative dissolution and creative transformation of familiar categorical boundaries, Sweeney and Barr pursued a complementary yet contrasting interpretive approach during the thirties, as they translated the dynamic field of contemporary art into the stable, schematic frameworks of canonical modernism. In the summer of 1934, Sweeney organized an important exhibition of contemporary artworks at the Renaissance Society of the University of Chicago. Entitled "A Selection of Works by Twentieth Century Artists," this exhibition seems to foreshadow Barr's much larger and better-known show. An image of Alexander Calder's organic yet mechanomorphic mobile sculpture *Object with Red Disks* (1932, figure 2.4)–another work that would later become part of Sweeney's personal art collection–appeared prominently on the cover of the catalogue.[24] In addition to two Calder mobiles, the show also fea-tured works by Arp, Brancusi, Braque, Gris, Hélion, Léger, Miró, Mondrian, and Picasso. Sweeney arranged the selection and installation of the exhibition, and his critical writings are quoted at length in the accompanying catalogue. That same year, his *Plastic Redirections in 20th Century Painting* was published jointly by the Renaissance Society and the University of Chicago Press.

A SELECTION OF WORKS BY
TWENTIETH
CENTURY
ARTISTS

THE RENAISSANCE SOCIETY
OF
THE UNIVERSITY OF CHICAGO

JUNE 20 TO AUGUST 20, 1934

2.4 Alexander Calder, *Object with Red Disks,* 1932, appearing on the cover of E. W. Schütze, *A Selection of Works by Twentieth Century Artists* (Chicago: Renaissance Society of the University of Chicago, 1934). ©2008 Calder Foundation, New York/Artists Rights Society (ARS), New York.

Sweeney and Barr also moved in overlapping professional and intellectual circles during the mid-thirties. Both participated in a highly selective, informal study group organized by the art historian Meyer Schapiro. On March 8, 1935, Schapiro invited Barr to take part in the group, proposing an outline of its goals and a potential list of its membership:

Would you be interested in the formation of a group for the discussion of modern, and especially contemporary, art? It would consist of several scholars and writers, meeting informally once a month in New York. I have in mind the following persons—yourself, Sweeney, Panofsky, Goldwater, Jerome Klein, myself, Tselos, Lozowick, Abbot, and others whom you might suggest. Mumford would probably be interested, and there are perhaps several people in Philadelphia and New Haven who might be desirable members of such a group. The number should be sufficiently small to permit informal discussion, and large enough to produce variety of opinion and alert criticism. Papers would be read and submitted for discussion, or an informal talk on a general question of common interest would open a discussion. Tell me if you are sufficiently interested to wish to participate in such a group.[25]

Three days later Barr not only responded positively to Schapiro's invitation, but offered to make the facilitates of the Museum of Modern Art available as a host location for the gatherings. As Barr told Schapiro: "I think that if the meeting were held in the evening I could offer the Museum Library as a place. It has a very large oval table about which we could sit and its location might be conveniently between uptown and downtown. Books in the Library would, of course, be immediately available."[26]

In addition to this shared intellectual forum, during the mid-thirties Sweeney also had a pedagogical framework available for the expression of his modernist ideas through the graduate courses he taught at New York University's Institute of Fine Arts.[27] Sweeney's course "Tendencies in Modern Art," offered twice from 1934 to 1936,

considers from a plastic point of view and in their relationships to the society and culture of the period those directives in painting which mark the first three decades of the twentieth century. The lectures begin with a brief consideration of the nineteenth-century background and a cursory résumé of the developments in painting that led up to Impressionism. The

plastic approach of Impressionism and those movements immediately succeeding it will be analyzed. The discussion will consider the work of Cézanne and Van Gogh, the theories of Serusier, and of the "Symbolists" and the "Art Nouveau" and "Jugendstil" groups as well as the art of primitive peoples, in its influence on and importance for twentieth-century painters up to Fauvism. Such phases of twentieth-century development as cubism, futurism, dada, neoplasticism, expressionism, constructivism, Superrealism, the "new romanticism," and the "new objectivism" will be studied in relation to the general social and cultural character of the period.[28]

The following year, he participated in a team-taught course that examined "Aspects of Modern Art" from the 1890s to the present; Sweeney's portion of the class was devoted to developments in recent painting.[29] Significantly, the audience for Sweeney's class extended directly to Barr himself.[30] In a letter to Sweeney dated September 11, 1934, Barr told Sweeney that his wife "Marga looks forward to attending your course at New York University. I hope I can join her."[31]

Sweeney's graduate courses followed much the same historical and inter-pretive trajectory that he outlined in *Plastic Redirections*. That study established an evolutionary formal model for tracking the plastic sequence in modernism, and associated contemporary artistic developments with a corresponding conception of modernist subjectivity that placed a dual emphasis on intuitive psychic ener-gies and formal plastic organization, atavistic archaism and innovative modernist renewal. In this, Sweeney situated the development of modernist painting within a paradoxical framework that was based on the integration of a series of collapsed dualisms, describing modern artworks as complementary embodiments of matter and spirit, subjectivity and objectivity, instinctive emotion and structural balance, expressive virility and decorative form. The artworks themselves became charac-terized as "subjective representation[s] by plastic means," and thus as symbolic expressions of the creative subjectivities that produced them.[32]

Invoking the language of zeitgeist, Sweeney asserted at the very outset of *Plastic Redirections* that the twentieth century has been characterized by "a revi-sion of spiritual values," a tendency that "is especially evident in the plastic arts."[33] He anchored this theme in dramatic images of historical disjunction and organic renewal. While the nineteenth century saw the ascendancy of science, reason, and

Cartesian philosophy, the twentieth required a "complete severance from all the dominant trends of the preceding century–a break and a new beginning. It was realized that a new epoch could grow only out of a new archaism. The surface soil had become exhausted. It had to be turned deeply and completely to produce anything young in vigor or sap."[34] At the conclusion of this essay, he extended this theme by advocating an instinctive, almost primordial mode of expression in the visual arts: "The final years of the nineteenth century marked the close of the rationalistic era. In it, art had been conceived as a rational ideal–a painful striving toward intellectual perfection. The period ended with an acute consciousness of its own sterility. To the future, it offered no illusions, no hopes, no creeds. The twentieth century has been characterized by a gradual return to origins, to a new archaism–a prelogical mode of expression–to art as something necessary and organic: a vital element in the world about us, not merely a reflection of it."[35]

Thus in *Plastic Redirections*, Sweeney self-consciously addressed the current perception of modern art's relationship to its times. Situating modernist aesthetic production within an overarching narrative that contrasted outdated propensities toward rationalist sterility with the unfolding, vital promise of archaistic renewal, he established the specific positions of the various avant-garde movements. In response to a sense of disenchantment with impressionism's "disinfected scientific documentation," he wrote, the postimpressionists cultivated instead "a return to structural interests in painting." This could be seen in the pronounced pictorial emphasis that Cézanne placed on the geometrical forms that he perceived as underlying natural objects.[36] According to Sweeney, "It was this that made Cézanne so popular when the Cubists were feeling their way back to structure by analytical methods."[37]

Yet this emphasis on structure, geometry, and analytical reasoning represented only a portion of the modernists' pictorial innovations; another crucial component lay in the artists' exploration of the instinctive and emotional qualities of non-Western art. Sweeney wrote that, in addition to Cézanne, the cubists' structural analyses of pictorial forms were also shaped by Seurat's "intuition of formal relationships." Yet while Seurat's followers became mired in "pseudo-scientific color experimentation," Gauguin "point[ed] the way out" by "submit[ting] readily to the influences of the Orient." Sweeney wrote that Gauguin's practice initiated

"a new plastic direction" that Matisse subsequently pursued through his "frank profession of the major tenets of oriental plasticism" and his emphasis on "the purely decorative function of painting."[38] As a result, modern European art became infused with vitality through its contact with the imagery of non-Western cultures. In African sculpture and the paintings of Matisse and Picasso, Sweeney perceived similar subjective and emotional responses embedded within tightly crafted architectonic compositions, just as the artists' intuitive impulses ostensibly guided the formal processes of pictorial organization.[39]

In particular, Sweeney identified such "intensity of visualization" "in primitive Negro art." He reproduced in *Plastic Redirections* an African copper, brass, and wood ancestor figure that Barr subsequently exhibited in the "Cubism and Abstract Art" show (figure 2.5). According to Sweeney, in such "primitive" sculpture and in abstract modernist paintings, the viewer encountered "the same scrupulous craftsmanship, the same sensibility to plastic fundamentals, and the same intuitive interest in the architectonic interplay of abstract forms."[40] Sweeney further noted that the influence of African sculpture extended from the German expressionist paintings of the Brücke group to Picasso's proto-cubist experimental figures, such as *Danseuse* (*The Dancer*) of 1907 (see figure 2.5). Significantly, Picasso's *Danseuse* was reproduced in both *Plastic Redirections* and in *Cubism and Abstract Art*, where it was similarly juxtaposed with an image of an African copper and wood reliquary figure.[41] Sweeney's comparison to Picasso in *Plastic Redirections* was meant to demonstrate the extent to which "the Negro image-maker intuitively resolved his volumes into their constituent elements, with every inessential shorn away. Nevertheless, the whole was held in an architectonic unity by the artist's single-minded intensity of emotion."[42] Thus in African sculpture and in archaistic examples of European modernism, Sweeney identified a similar synthesis of aesthetic and subjective qualities that encompassed intuitive emotion and rational structural clarity.

Once the European modernists had internalized the powerful example of African art, the next step in their developmental trajectory entailed the rejection of naturalistic reproduction. According to Sweeney, this step was realized in Picasso's and Braque's analytical cubist experiments of 1909, which displayed "a sort of mosaic of such perspective 'boxes' or areas, more or less fused–their

PLATE V. AFRICAN FETISH, GABON, OGOVE RIVER DISTRICT

PLATE VI. PABLO PICASSO, "DANSEUSE," 1907

2.5 Reliquary figure, Kota, Gabon, or People's Republic of the Congo, wood, copper, and brass; and Pablo Picasso, *Danseuse (The Dancer)*, 1907, oil on canvas, appearing in James Johnson Sweeney, *Plastic Redirections in 20th Century Painting* (Chicago: University of Chicago Press, 1934). ©2008 Estate of Pablo Picasso/ Artists Rights Society (ARS), New York.

organization based solely on formal or chromatic relationships."[43] Such progressive formal simplification of elemental pictorial units subsequently led to "a new sense of clean surfaces and a plastic organization stripped of all extra-plastic, sensuous, or associational charms." For Sweeney, the final turn in the modernist narrative entailed a shift in emphasis away from the external world and toward the internal one: "Only one further step now remained: to carry the integrity of the plastic conception, out of the objective, into the subjective." In the art of the surrealists, particularly Chirico, Ernst, Arp, and Klee, Sweeney identified "the magic realism of the dream-world."[44] He found comparable, albeit pictorially distinct,

examples of such complete artistic freedom in the stark planar simplicity of the de Stijl group's imagery, such as Mondrian's *Composition with Large Red Plane, Blue, Grey, Black and Yellow* of 1921–a work that was illustrated in both *Plastic Redirections* and *Cubism and Abstract Art*. Sweeney likewise praised Miró's fantastic, lyrical paintings, images in which "no intellectual control whatsoever seems to come between the artist's free intuitional response to his materials and the plastic result."[45] One such example can be found in Miró's *Composition* of 1933, a dialogical, biomorphic abstraction that was exhibited both in Sweeney's 1934 show at the Renaissance Society and, two and a half years later, in Barr's groundbreaking exhibition "Fantastic Art, Dada, Surrealism" (Museum of Modern Art, 1936–1937). Following the latter show, Sweeney acquired this painting from the Pierre Matisse Gallery for his personal art collection.[46]

The idealized conception of modernist identity that Sweeney described in *Plastic Redirections* was an implicitly gendered one, as all of the artists discussed in the study were male. And if there were any question about this gendering, the masculinist associations became explicit both in the Renaissance Society's exhibition catalogue (1934) and in a related article that Sweeney published in the *New Republic* the next year. Critiquing the pervasive tendency toward naturalism in the visual arts, he observed: "Nature, as Nietzsche warned us she would, has taken her revenge on us for disregarding the myth, for allowing it to decline to a 'fairytale,' for not bringing it back to virility. In short, for 'the abstract character of our mythless existence.' Esthetically we have become a dry, colorless people . . . our art has decayed either into a hackneyed academicism, or an illustrational attitudinizing, both finally dependent on technical virtuosities." In order to transcend this state of cultural "decadence" and achieve the restoration of "virility," it is necessary to "learn to see with young eyes to respect the intensity of intuitions."[47] In his piece for the *New Republic*, Sweeney remarked that "men like Matisse, Braque, Vlaminck and Derain in the opening years of the century were looking to all sides for a suggestion toward some idiom in which to assert their protest against academicism and impressionism other than in the emasculate decorative tradition of Serusier, Denis and Signac. The expressionistic as well as the more strictly formal sides of primitive art appealed to them as in keeping with [the] formal and expressionistic sides of their so-classed 'Fauve' work of the same period." Thus by rejecting the

"emasculated" decorative qualities of their European counterparts and productively embracing the vital example of "primitive art," the fauves found an "antidote for the weakness of our esthetic expression" that fostered the production of "exquisite sensibility and creative genius."[48]

As these quotations exemplify, the term "decorative" functioned as an ambivalent signifier in Sweeney's writings. Just as he praised Matisse's emphasis on "the purely decorative function of painting," he subsequently critiqued what he perceived to be the Nabis' "emasculate decorative" tendency toward superfluous ornamentation devoid of underlying structural depth. Yet whether the decorative was assigned a positive or a negative valuation, in all instances the term was deployed to reinforce a multivalent conception of masculine creativity. Indeed, the discursive production of gendered modernism in Sweeney's text was achieved precisely through such placement and displacement of key descriptive terminology, which permitted the incorporation of "feminine" qualities into an expanded conception of masculine subjectivity.[49] So, too, was the case for Barr.

"The Shape of the Square Confronts the Silhouette of the Amoeba"

Viewed historically, *Cubism and Abstract Art* proved to be so appealing in part because it presented a clear, chronologically organized, schematic overview of the various movements of modern art, a complex subject that still lacked just such conceptual clarity for many contemporary viewers. The flowchart on its cover traced an elaborate network of artistic developments that extended from postimpressionism through fauvism, cubism, and other contemporary European avant-garde practices, evoking a progressive teleological model for the development of modern art. Yet Barr's catalogue also offered its readers something more: a parallel theorization of modernist aesthetics and creative masculine subjectivity. This complementary interpretive structure becomes evident in the important transitional section of Barr's text, at the conclusion of his introductory discussion of modernism and just prior to his in-depth analysis of its specific artistic movements. At this crucial interpretive juncture, Barr presented his vision of the "Two main traditions of Abstract Art":

At the risk of grave oversimplification the impulse towards abstract art during the past fifty years may be divided historically into two main currents, both of which emerged from Impressionism. The first and more important current finds its sources in the art and theories of Cézanne and Seurat, passes through the widening stream of Cubism and finds its delta in the various geometrical and Constructivist movements which developed in Russia and Holland during the War and have since spread throughout the World. This current may be described as intellectual, structural, architectonic, geometrical, rectilinear and classical in its austerity and dependence upon logic and calculation. The second—and, until recently, secondary—current has its principal source in the art and theories of Gauguin and his circle, flows through the *Fauvisme* of Matisse to the Abstract Expressionism of the pre-War paintings of Kandinsky. After running under ground for a few years it reappears vigorously among the masters of abstract art associated with Surrealism. This tradition, by contrast with the first, is intuitional and emotional rather than intellectual; organic or biomorphic rather than geometrical in its forms; curvilinear rather than rectilinear, decorative rather than structural, and romantic rather than classical in its exaltation of the mystical, the spontaneous and the irrational. Apollo, Pythagoras and Descartes watch over the Cézanne-Cubist-geometrical tradition; Dionysus (an Asiatic god), Plotinus and Rousseau over the Gauguin-Expressionist-non-geometrical line.[50]

Barr conceded that "often, of course, these two currents intermingle and they may both appear in one man." After this formal concession, however, he returned to his previous dialogical formulation, placing the central formations of modernism—its rigid geometry and its primordial organicism—in a state of mutual stylistic opposition in which "the shape of the square confronts the silhouette of the amoeba."[51]

As these passages reveal, one of the most suggestive ways in which both Barr and Sweeney established a dialogical aesthetic and subjective framework for modern art was by drawing on a Nietzschean critical discourse that contrasted Apollonian and Dionysian art forms. In *The Birth of Tragedy* (1871), Nietzsche identified the classical gods Apollo and Dionysus as two dominant typological embodiments of the "mystical doctrines of art."[52] Nietzsche wrote that Apollo is associated with conceptions of tranquillity, morality, control, order, rationality, restraint, wisdom, light, philosophical interpretation, and cognitive power. In contrast, Dionysus is linked to enchantment, awe, intoxication, emotion, extravagance, excess, rapture, organicism, pantheism, passion, imagination, freedom, and the glorious transports of mystical ecstasy. While both gods were personified as male

deities, Dionysus is directly associated with phallic power through the symbols carried in his ceremonial festival processions. In *Cubism and Abstract Art*, Barr identified Dionysian mystical and ecstatic energies as being evident in the curvilinear, decorative, organic, biomorphic forms of "non-geometrical abstract art." In contrast, he characterized architectonic, classical, Apollonian elements as the bases for "geometrical abstract art."

Although they were positioned as contrasting elements, these dualistic qualities became productively synthesized within the overall structures of Barr's theoretical model. This occurred in two ways. As Barr himself acknowledged, in certain instances the two stylistic "currents intermingle" and may "appear in one man." The curator identified just such a porousness of categorical boundaries in a select group of modernist artists that notably included Duchamp.[53] Indeed, in Barr's initial diagrams Duchamp's name appears under both the "geometrical abstract art" category of cubism and the "biomorphic" or "non-geometrical abstract art" category of dadaism, a bimodal positioning that reflects the artist's ability to navigate both sides of the flowchart.[54] Moreover, the androgynous *Nude Descending a Staircase No. 2* was one of five works by Duchamp that Barr exhibited in the "Cubism and Abstract Art" show.[55]

Yet another, highly suggestive way in which the distinctive strands of Barr's theoretical model became productively conjoined was in the overall structures of the flowchart itself. Prima facie, Barr's chart appears to be a rather rigid linear document fixed in its classifications. Yet the flowchart is built on the contradictory premise of a dualism that is, ultimately, unstable. It posits an ideal, organic sense of unity even as it overtly displays the patterns of its own internal disjunctions. When the chart is viewed as a whole, a series of categorical differentiations and generative interconnections becomes evident between the rational and spiritual domains of modernist aesthetics, between austere logical calculation and intuitive imagination, and between sublimated intellectual theorization and passionate organic vitality. The result is a highly ambivalent sense of rupture and unification, of duality and the reconciliation of duality, within Barr's typological formulations of masculine creativity and in the organizing taxonomic structures of canonical modernist art history itself.[56]

As this suggests, an idealized conception of gendered subjectivity is clearly at stake in both Sweeney's and Barr's visions of modernism. Not only did their critical models apply almost exclusively to male artists, but in their writings modern art itself was constructed as a kind of symbolic masculine presence whose generative qualities were hyperbolically differentiated yet dualistically synthesized in the production of a vital new art.[57] For both writers, this interpretive process specifically entailed a deep intertwining of ambivalent aesthetic categories that attached a heightened cultural value to the masculine subject position.[58] Throughout Sweeney's and Barr's texts, these thematic structures encompassed notions of the rational and the mystical, the modern and the primitive, reason and passion, abstraction and organicism, the analytical and the spontaneous, intellect and emotion, formal purity and physical sensuousness. Thus through the sustained discursive efforts of their writings, Sweeney and Barr actively dislodged associations that had previously been ascribed to the feminine subject position in order to recuperate them within a revised, and powerfully paradoxical, conception of modern masculine subjectivity. The new typological model of the male artist was one that successfully managed to merge *and* to separate these ambivalent gendered qualities. Such a dialogical formulation of masculine creativity left little space for modern female artists, however.[59] Indeed, the great success of Sweeney's and Barr's aesthetic models seemed to be based in part on the displacement of the feminine so that a range of traditionally masculine and feminine qualities could be absorbed within an expanded conception of androgynous masculine subjectivity.[60]

With its marked absorption and incorporation of the feminine into an idealized conception of the masculine, Barr's flowchart emerges as a decidedly androgynous construction. On the one hand, with its internally divided spheres and categorically differentiated domains, the flowchart appears as a fractured androgyne. Yet when viewed as a whole, the diagram's internal trajectories are at once schematically separated *and* integrally interwoven to constitute a powerful state of wholeness, as ostensibly feminine qualities are restored to a prevailing vision of masculine creative agency.[61] We thus seem to have returned to the ancient prototype of the androgyne in the book of Genesis, a structural formulation

of duality and nonduality in which the feminine is contained within the masculine, thereby "making one of two."

The Multiplicity of Unity: Modernism's Androgynous Genealogies

Not surprisingly, *Plastic Redirections* and *Cubism and Abstract Art* generated similar responses from contemporary critical reviewers. In a discussion of *Plastic Redirections* in the *New York Times* (August 26, 1934), Sweeney was praised for "present[ing] his argument in a scholarly fashion, carefully annotated and documented. A valuable feature of the book (whose first edition, we learn, was virtually sold out before the work went to press) is a set of biographical notes, which should prove extremely convenient for reference."[62] Three months later, *Plastic Redirections* was awarded a second review in the *New York Times* (November 25, 1934), in which the critic Edward Alden Jewell noted Sweeney's proclivity for constructing a formalist teleology for modern art, an interpretive approach that was evident in "the writer's desire to communicate a sense of its inevitable development out of what had preceded and to set forth the various phases that have resulted from a radical breaking of fresh ground."[63] Writing in the *Chicago Daily Tribune*, the curator Daniel Catton Rich similarly affirmed that *Plastic Redirections* "must be read by any one who wants to dip beneath the superficial chatter of galleries and studios to discover the seriousness of modern masters. . . . Books on modern art are too often dilute, obscure, or feverish. Mr. Sweeney has written one that is packed with original thought, clear in its expression, and level in its judgments."[64] Barry Byrne also endorsed Sweeney's volume in *Commonweal* (November 1934): "We are indebted to Mr. Sweeney for a critical estimate which, while limiting itself to esthetic considerations, within those limits maintains a high plane. He has not regarded himself as either priest or prophet of these movements. That in itself is an indication of the culture and detachment with which the work is assayed. With the publication of these lectures comes the promise of a continued appearance of thoroughgoing art criticism allied to a distinctive literary style."[65]

As positive as these reviews are, Sweeney's most important intellectual endorsement came from the eminent art historian Erwin Panofsky, another

proposed member of Schapiro's reading group. Writing in the *Bulletin of the Museum of Modern Art* (November 1934), Panofsky praised *Plastic Redirections* as "one of the few attempts at approaching the problems of contemporary art from the standpoint of scholarly art history.... Mr. Sweeney, combining detachment with subjectivity, has now proved that it is, after all, possible to apply the methods of art-history to contemporary art."[66] As the critical reception of *Plastic Redirections* clearly indicates, during the thirties Sweeney was able to promote a powerfully ambivalent discourse that seamlessly conjoined the dignified professionalism and erudition of his interpretive approach (or, in Panofsky's and Byrne's ambivalent term of self-inscription and self-erasure, his "detachment") with the liberating promise of intuitive, archaistic impulses (thus engendering an expanded conception of modernist "subjectivity"). Even if critics did not fully restate Sweeney's position in their reviews, they implicitly supported it through their positive reception of the text.[67]

Similar critical rhetoric greeted Barr's *Cubism and Abstract Art* two years later. In an extended appreciation in the *New York Times* (June 7, 1936), Jewell observed that Barr's catalogue "represents a work of permanent value within its field, especially as a volume for source references. Mr. Barr, in his always painstaking manner, has gone into this subject with thoroughness, providing a general survey of the still controversial movement itself and engaging in documented consideration of artist protagonists who may be esteemed of major and minor importance to the modern movement's growth."[68] Barr's study was similarly praised in *Commonweal* (July 1936) for its careful enumeration of the various classificatory categories of modern art, which led the reviewer to characterize Barr himself as performing the quasi-divine act of evolving "beauty and the splendor of order" out of "comparative ugliness" and chaos. [69]

Notably, the one rigorous challenge that Barr received came from within his own intellectual circle. Writing in *Marxist Quarterly* (1937), Meyer Schapiro drew on Barr's canonical leitmotifs in order to call his theorization of modernism into question. Schapiro pointedly emphasized the necessity of historicizing abstract art rather than presenting modernism as an aestheticized expression of pure form. Yet he began on a conciliatory note by characterizing Barr's book as "the best, I think, that we have in English on the movements now grouped as abstract art. It

has the special interest of combining a discussion of general questions about the nature of this art, its aesthetic theories, its causes, and even the relation to political movements, with a detailed, matter-of-fact account of the different styles. But although Barr sets out to describe rather than to defend or to criticize abstract art, he seems to accept its theories on their face value in his historical exposition and in certain random judgments. In places he speaks of this art as independent of historical conditions, as realizing the underlying order of nature and as an art of pure form without content."[70]

As Schapiro insightfully remarked, coextensive with Barr's conception of formalist aesthetics was a preoccupation with primitive society and collective spiritual life. Noting pronounced shifts in the historical valuation of this material, Schapiro observed: "What was once considered monstrous, now became pure form and pure expression, the aesthetic evidence that in art feeling and thought are prior to the represented world. The art of the whole world was now available on a single unhistorical and universal plane as a panorama of the formalizing energies of man." As a result, "in the distorted, fantastic figures [of primitive art] some groups of modern artists found an intimate kinship with their own work; unlike the ordering devices of ornament which were tied to the practical making of things, the forms of these figures seemed to have been shaped by a ruling fantasy, independent of nature and utility, and directed by obsessive feelings. The highest praise of their own work is to describe it in the language of magic and fetishism."[71] Anticipating postcolonial critical discourses, Schapiro argued that such assertions overlooked the historical relationship between the development of modern art and the workings of "colonial imperialism," particularly its economic and cultural exploitation of "subjugated peoples."[72] Ultimately, Schapiro criticized Barr's conclusion that "by a remarkable process the arts of subjugated backward peoples, discovered by Europeans in conquering the world, became aesthetic norms to those who renounced it. The imperialist expansion was accompanied at home by a profound cultural pessimism in which the arts of the savage victims were elevated above the traditions of Europe. The colonies became places to flee to as well as to exploit."[73] Thus just as Sweeney's and Barr's dialogical constructions of modernism combined qualities traditionally associated with

masculine and feminine subject positions, Schapiro reconstructed the parallel ways in which the modernists appropriated the qualities associated with subjugated, colonized peoples.

As this indicates, Barr's most rigorous critique came from a colleague who placed a strong emphasis on the ideological formations underpinning social class relations and their manifestation in the domain of modern art. Yet while Schapiro's critique of *Cubism and Abstract Art* has become a veritable centerpiece in subsequent deconstructionist accounts of the modernist canon, it was Barr himself who offered the initial provocation over the meaning of artistic iconography and its relation to the social sphere. In *Cubism and Abstract Art,* he expressly stated that the study was conceived "not in a controversial spirit," yet in the introduction he conspicuously challenged Schapiro's interpretation of cubism. In particular, Barr had observed that artistic subject matter was of "little conscious interest" to the cubists. In a lengthy footnote appearing prominently at the bottom of the page, Barr wrote: "In spite of the fact that the Cubists themselves and their most ardent admirers attached little importance to subject matter, Meyer Schapiro of Columbia University advances an interesting theory that consciously or unconsciously the Cubists through their subject matter reveal significant preoccupation with the bohemian artistic life." Barr felt that the primary evidence of the paintings did not support such a theory, though he concluded that "the iconography of Cubism should not be ignored."[74] Thus while Schapiro's revisionist critique has received significant scholarly attention, it should be noted that his commentary represented a reactive polemical response to Barr's initial interpretive challenge.

As this suggests, both the conceptual content and the critical reception of Sweeney's and Barr's studies seem almost to anticipate the internal tension of opposing forces that characterizes the epistemologically fragile boundaries between modern and postmodern production.[75] Yet at the time of their publication, Sweeney's and Barr's texts provided a contemporary audience with structurally reassuring guides for the intellectual comprehension of challenging modernist artworks, and with highly imaginative–albeit ideologically fraught–models for the active reconceptualization of modern masculine selfhood. Moreover, as prominent cultural mediators and active creators of the modernist canon, Sweeney and Barr

moved fluidly between the domains of avant-garde modernism and archetypal primitivism, between the specialized, esoteric world of scholarly discourse and a broader, exoteric engagement with the educated general public. Just as they cultivated the dignified bearing of their professional identities—personas that served them well in the context of New York's elite culture—both men worked dynamically between the intellectual rationalism of their analytical methodologies and the transformative potential of modernist aesthetics.

As their more astute critics recognized, Sweeney and Barr perceived a multifaceted conception of modern subjectivity as being visibly evident in the formal structures of modernist artworks. As such, the artistic objects displayed in their exhibitions became symbolically invested with subjective human attributes. Sweeney and Barr thus established a further philosophical resonance between canonical modernism and mysticism, as they formulated an alternative conception of subjectivity that collapsed modern and premodern perspectives.[76] Sweeney identified one such example of traditional magical structures in the practices of ancestor worship associated with the African reliquary guardian figure that he reproduced in *Plastic Redirections*, and which he displayed in his next major exhibition at the Museum of Modern Art, "African Negro Art" (spring 1935); as noted above, Barr also exhibited this work in "Cubism and Abstract Art" (figure 2.5). Discussing this and similar objects, Sweeney observed that "ancestor-worship is elaborated primarily among peoples who through seeing men wielding great power in this world come to feel that the souls of the great should still be powerful after death. This is the cult that in many regions of Africa has been productive of the finest sculpture, not only through symbolizing the dead as in the stylized burial fetishes of the Ogove River district in Congo (Nos. 378–387), but also through actual portraits."[77] Just as Sweeney was aware of the magical functions that such objects performed as mediators between the world of the living and the spirits of the dead, Barr too drew on the suggestive notion that the presence of powerful guardian figures were intrinsically associated with works of modern art. Thus he wrote that the mythic and historical figures of Apollo, Pythagoras, and Descartes "watch over" the geometrical tradition of abstract art and are associated with its defining characteristics, just as Dionysus, Plotinus, and Rousseau perform a comparable function for nongeometrical abstract art.

Significantly, Sweeney's and Barr's invocations of venerable artistic prede-
cessors are consistent with the various meanings associated with the term "canon."
According to the *Oxford English Dictionary*, these encompass the designation of
consecrated persons and authentic and sacred texts, as well as the rational, sys-
tematic classification of knowledge.[78] As a result, canonical processes both of ritual
sanctification and of intellectual codification simultaneously connote a privileged
sense of cultural authority. The definitional boundaries between sacred subjects,
intellectual codes and practices, and broader accounts of social and cultural values
become so fragile—both for Barr and Sweeney, but also within the creation of the
modernist canon itself—that they collapse entirely, leaving seemingly distinctive
domains not merely coextensive but, much like the androgyne, entwined in their
mutual significations.

Ultimately, the paradoxes embedded in Sweeney's and Barr's modern-
ist narratives can be located within larger dialogical patterns that thread through
modern intellectual history, from Nietzsche to Freud.[79] As these writers have
famously observed, just as the demands of modernity placed a privileged empha-
sis on rationality, progress, reason, discipline, and control, a counterdiscourse
advocated an alternative conception of ideal subjectivity associated with personal
liberation, uninhibited self-expression, and individual autonomy. Thus in different
yet complementary ways, Sweeney's and Barr's texts addressed precisely the long-
standing relationship between the conflicting anxieties and desires of modernist
subjectivity. Both writers drew on and actively constructed a common corpus of
artistic imagery—the canon of modern art—as they rehearsed the familiar tropes
of modernism's oppositional dualisms and offered potential solutions to the con-
flicting impulses of modernist selfhood. In so doing, the discourses they advanced
in *Plastic Redirections* and *Cubism and Abstract Art* posited a conceptual model
in which works of art could serve as visual analogues of modernist subjectivity
itself, as impelled by its own highly ambivalent, reciprocal capacity and desire for
splitting and fusing, for dualism and integration. The resulting vision of modern
art was also an androgynous vision of the ideal modern masculine self, a dynamic
subject who remained multiple and yet unbroken.

3

Seeing the One "Less Seen":
James Johnson Sweeney,
in Light of Marcel Duchamp

Like a spinning rotorelief (figure 3.3), this chapter begins—and ends—with alternating patterns of lights and shadows, with openings and closings that raise significant questions concerning the visibility and invisibility of persons or things "not seen and/or less seen" within the intersecting grids and concentric spirals of canonical modernism.

Toward the end of his life, a monographic exhibition of Marcel Duchamp's work was assembled under the enigmatic title "Not Seen and/or Less Seen of/by Marcel Duchamp/Rrose Sélavy 1904–64" (1965). Organized by the Cordier & Ekstrom gallery in New York, the show consisted of ninety primary artworks, including paintings and drawings dating from the formative period of 1905 to 1912 that had not previously been seen in the United States.[1] This "unseen" selection was supplemented by thirty-five additional readymades, later sculptures, and

various printed materials. The exhibition traveled widely during the mid-sixties, and Sweeney brought both the show and Duchamp himself to Houston in February of 1965 (figures 3.9 and 3.10).

Duchamp's emphasis on the "not seen and/or less seen" resonated strongly with Sweeney's mystical philosophy of modern art, the purpose of which was to reveal "the unseen through the seen."[2] Yet while Duchamp remains one of the most visible and celebrated figures in modern art, today Sweeney, despite the extremely influential roles that he played historically and philosophically, has become "not seen and/or less seen." By examining Sweeney and Duchamp's extended collaborations over three decades, this chapter brings to light a visibly invisible presence that has fallen into the shadows of canonical modernism.

A Few Drops of Savagery and Civilization

Sweeney and Duchamp first met in October of 1935, at a tea at the photographer Man Ray's apartment. The following summer Sweeney, as associate editor of *Transition*, asked Duchamp to contribute "some creative prose" to the magazine, particularly inviting him to share his memories of America during the First World War.[3] While Duchamp initially declined Sweeney's offer, citing his reluctance to write, the following year the artist provided the cover image for the 1937 issue of the magazine (figure 3.1). Elegantly poised on *Transition*'s cover, Duchamp's readymade silver dog comb bore the enigmatic inscription: "3 ou 4 gouttes de hauteur n'ont rien à faire avec la sauvagerie" (3 or 4 drops of height have nothing to do with savagery).[4] In keeping with the "transmutational" character of Duchamp's readymades, the *Comb* can be seen as a subtle allegory of deception regarding the intrinsic character of an object versus its external appearance.[5] Paradoxically, the *Comb* represents the affirmation of a negation that pivots around issues of elevated or diminutive stature: just as a small dog can be more ferocious than a large one, a seemingly insignificant object can assume monumental proportions when it is designated and presented as a work of art.[6]

Sweeney and Duchamp's exchanges extended to other avant-garde publications as well. Arturo Schwarz's catalogue raisonné of Duchamp's work lists a single item in Sweeney's collection: the back cover of the winter 1935 issue of

3.1 Marcel Duchamp, *Comb*, 1916, appearing on the cover of *Transition* 26 (1937). Photograph courtesy of The Fondren Library, Rice University. © 2008 Artists Rights Society (ARS), New York/ADAGP, Paris/Succession Marcel Duchamp.

Minotaure; Duchamp had signed Sweeney's copy under the inkblot illustration of the bull's head.[7] Assuming the symbolic form of the minotaur, Duchamp's gestalt design, much like the readymade *Comb*, can be seen as a few well-placed drops of aesthetic savagery and civilization that took on monumental status when displayed as the public face of an avant-garde periodical.

During the mid-forties, Sweeney and Duchamp also served on the advisory board of the progressive modern art quarterly *View*, the entire March 1945 issue of which was devoted to Duchamp. Their collaborations extended to a number of curatorial projects as well. In the autumn of 1942, Sweeney and Peggy Guggenheim were among the sponsors of the "First Papers of Surrealism" exhibition, which was curated by Duchamp and André Breton.[8] During the forties, the two men served as advisors to Guggenheim for projects that she undertook at her progressive Art of This Century gallery; Sweeney proved to be so significant that Guggenheim dedicated her memoir, *Out of This Century* (1946), to him.[9] Moreover, as Duchamp's biographer Calvin Tomkins has noted, shortly after becoming director of the Department of Painting and Sculpture at the Museum of Modern Art (1945–1946), Sweeney "became the prime mover behind the trustees' decision to purchase [Duchamp's 1912 painting] *The Passage from the Virgin to the Bride* from Walter Pach in December 1945–the painting, which had belonged to Pach ever since Duchamp gave it to him in 1915, was the first major work by Duchamp to enter a public collection."[10]

Throughout the forties and fifties, Duchamp assisted Sweeney in arranging various loans and purchases for exhibitions held not only at the Museum of Modern Art but at the Sidney Janis Gallery, the Guggenheim Museum, and the Musée d'Art Moderne in Paris.[11] During the mid- and later forties, Duchamp and Sweeney saw one another regularly, as the curator conducted numerous interviews with the artist in preparation for a lengthy monograph that he was planning to write. As Duchamp told Henri-Pierre Roché in August of 1945, "I often see James Sweeney ... and he too is also going to write a fairly long monograph on me. I tell him my life story like he was my confessor and this has been going on for 6 months now for 2 hours a week!!"[12] Sweeney worked on the text intermittently over the next four years; in January of 1949, Barr sent Sweeney photostats of Duchamp's handwritten autobiographical notes. Shortly thereafter, Sweeney expressed his thanks to Barr

and informed him that "as soon as I get the Georgia O'Keeffe text behind me, I plan to get back to work full time on Marcel's."[13] Regrettably, neither the Duchamp nor the O'Keeffe monographs were ever published.

However, two important interviews that Sweeney conducted with Duchamp did appear during the forties and fifties. The first was published in Sweeney's exhibition catalogue *Eleven Europeans in America* (Museum of Modern Art, 1946); the second consisted of a gallery conversation that Sweeney held with Duchamp at the Philadelphia Museum of Art in 1956, an exchange that was filmed for television by NBC. *Nude Descending a Staircase No. 2* (1912, figure 2.2) served as a leitmotif in both interviews, just as it had in Sweeney's earlier study *Plastic Redirections in 20th Century Painting* (1934). While *Plastic Redirections* was published a year before Sweeney and Duchamp actually met, from the outset Sweeney was struck by the artist's creatively destructive imagery of the nude. In that book Sweeney characterized Duchamp himself in paradoxical terms, as an artist who stood outside of established modernist traditions such as cubism and futurism, just as he took these foundational movements as a point of departure for his own creative practice. According to Sweeney, just as futurism took its lead from impressionism and cubism, these movements "first pointed out the way for Marcel Duchamp to turn the depiction of movement as he conceived in the turning handle of his early 'Coffee Mill' to a means for shattering form as exemplified in his later 'Nude Descending the Stairs.'"[14] Thus beginning in 1934, Sweeney located Duchamp's work in an artistic trajectory that spanned impressionism, cubism, futurism, and dada. In so doing, the curator reaffirmed the artist's position within a canonical modernist genealogy, even as Duchamp shattered its categorical boundaries by fragmenting the cubists' and futurists' visions of fragmentation.

In the interview for *Eleven Europeans in America*, Duchamp similarly emphasized the apophatic nature of his creativity, which was expressed formally, in the desire to "decompose" forms, and art historically, in the impulse to absorb and deconstruct previous artistic developments. As Duchamp told Sweeney: "The basis of my own work during the years just before coming to America in 1915 was a desire to break up forms—to 'decompose' them much along the lines the cubists had done. But I wanted to go further—much further—in fact in quite another direction altogether. This was what resulted in *Nude Descending a Staircase*, and

eventually led to my large glass."[15] Duchamp emphasized a central paradox under-
pinning the nude descending a staircase motif, namely that his "aim was a static
representation of movement." This paradoxical condition of dynamic stasis and
static dynamism produced a creative decomposition of the composition, just as
the artist reportedly "turned inward" in order to represent the external forms of
the body. As Duchamp commented, "Reduce, reduce, reduce was my thought,—but
at the same time my aim was turning inward, rather than toward externals." In
so doing, "I wanted to get away from the physical aspect of painting. I was much
more interested in recreating ideas in painting.... I wanted to put painting once
again at the service of the mind." In privileging the mind over the body, the art-
ist constructed a "metaphysical" art that nonetheless became expressed through
the conjunction of corporeal and noncorporeal reference points. Summarizing the
effects of these "purgative" physical and metaphysical processes, Duchamp told
Sweeney:

Dada was an extreme protest against the physical side of painting. It was a metaphysical
attitude. It was intimately and consciously involved with "literature." It was a sort of nihil-
ism to which I am still very sympathetic. It was a way to get out of a state of mind—to avoid
being influenced by one's immediate environment, or by the past: to get away from clichés—
to get free. The "blank" force of dada was very salutary. It told you "don't forget that you
are not quite so 'blank' as you think you are." Usually a painter confesses he has his land-
marks. He goes from landmark to landmark. Actually he is a slave to landmarks—even to
contemporary ones.

 Dada was very serviceable as a purgative. And I think I was thoroughly conscious
of this at the time and of a desire to effect a purgation in myself.[16]

"'Blank' force," "nihilism," "purgation," "decomposition": Duchamp's leitmotifs of
negation bespeak a powerful affirmation of apophatic creativity, just as the artist's
saying of an unsaying became a signature aesthetic statement.

 Two years later, Sweeney expanded on these apophatic themes in "Mod-
ern Art and Tradition," a lecture that he delivered at the Yale University Art Gallery
(March 1948) in conjunction with Katherine Dreier's gift of the Société Anonyme
art collection.[17] Along with essays by Dreier herself and the Russian constructiv-
ist sculptor Naum Gabo, Sweeney's lecture was published the following year in

the collection *Three Lectures on Modern Art* (1949). Both the title and content of Sweeney's talk were based on T. S. Eliot's seminal essay "Tradition and the Individual Talent" (1920); Duchamp also explicitly drew on Eliot's critical formulation in his own slightly later paper on "The Creative Act" (1957).[18]

In the Yale address, Sweeney again identified Duchamp as a primary reference point in the development of modern art in general, and of the Société Anonyme collection in particular.[19] Echoing Duchamp's assertions regarding the "metaphysical attitude" of Dada, Sweeney took Duchamp's art as a point of departure for an extended critical reflection on "the spiritual value of art." He began by citing Eliot's iconically iconoclastic conception of an "impersonal theory of poetry," a formulation in which "the poet has, not a 'personality' to express, but a particular medium, which is only a medium and not a personality, in which impressions and experiences combine in peculiar and unexpected ways." Thus through a creative practice of self-overcoming, the artist engages with an artistic medium in order to become an artistic "medium." Sweeney further noted Eliot's assertion that "the more perfect the artist, the more completely separate in him will be the man who suffers and the mind which creates; the more perfectly will the mind digest and transmute the passions which are its material."[20] As this suggests, nested within Eliot's critical formulation are layers of paradox concerning the relations between assertion and surrender, self-inscription and self-erasure.

A related affirmation of a negation arose from Eliot's conception of the multiple structures of simultaneous time. As Sweeney noted, Eliot had observed that "the historical sense compels a man to write not merely with his own generation in his bones, but with a feeling that the whole of the literature of Europe from Homer and within it the whole of the literature of his own country has a simultaneous existence and composes a simultaneous order. This historical sense, which is a sense of the timeless as well as of the temporal and of the timeless and of the temporal together, is what makes a writer traditional. And it is at the same time what makes a writer most acutely conscious of his place in time, of his contemporaneity."[21] At the conclusion of "Tradition and the Individual Talent," Eliot refuted the notion that his essay entered into mystical or metaphysical terrain. As Eliot wrote, "This essay proposes to halt at the frontier of metaphysics or mysticism, and confines itself to such practical conclusions as can be applied by the responsible

person interested in poetry."[22] Yet Eliot's explicit disavowal of "metaphysics or mys-
ticism" represents an emphatic assertion of a negation, a powerfully apophatic
statement in speaking about a subject while expressly refusing to do so, thereby
offering an unsaying that is also a saying.

Building on Eliot, Sweeney emphasized modern art's capacity to present a
dynamic sense of conceptual and temporal multiplicity, a multifaceted vision that
could seemingly provide a model of order and stability during socially turbulent
times, when "we see all around us chaos and a lack of standards. Our 'civilization,'
so called, is a mob civilization." In such an unsettled period, works of art can "exert
a power of purgation over all blood begotten beings who come near them. A work of
art combines a unity of general form with a variety in its elements. And the satisfac-
tion that this combination gives is essentially a binding together of our responses
into a unified whole, providing us a model for the organization of our emotional
life and problems of daily existence. This is what we loosely term 'beauty' in a
work of art."[23] Like Eliot, Sweeney appeared to be adopting a conservative critical
perspective that affirmed notions of unity and stability, yet this underlying sense of
structural order paradoxically provided a foundation for innovative developments–
and radical departures–in contemporary art. Along these lines, Sweeney located
"the spiritual value of art" in its ability to reconcile categorical oppositions, thereby
promoting "a spiritually unifying experience for man" through its nondual capac-
ity for "binding together" "tradition" and innovation, unity and variety, apophatic
"purgation" and kataphatic creation.[24] Not surprisingly, underpinning this extended
interpretive formulation of the *coincidentia oppositorum* is a complementary rela-
tion between time and timelessness. Again paraphrasing Eliot, Sweeney affirmed
the "simultaneous existence" and the "simultaneous order" of the timeless and the
temporal in Duchamp's artistic practice, as discussed below. Thus, reading devel-
opments in modern art through the prism of T. S. Eliot provided Sweeney with a
compelling means of expressing modern art's mystical ability to occupy multiple
symbolic and temporal locations simultaneously, thereby collapsing *and* preserv-
ing the boundaries between ostensibly oppositional terms, as art's "living tradition"
became contemporary while contemporary art became traditional.[25]

For Sweeney, Duchamp's work represented such an ideal fusion of oppos-
ing forces.[26] In "Modern Art and Tradition," he characterized Duchamp's art as an

apophatic wedding in which "formal integrity" became equated with "the time-less element in art; while the representational means and commentary" gave his "work its temporal—in fact its contemporary character."[27] Expanding the narrative trajectory that he had initially established in *Plastic Redirections* and *Eleven Euro-peans in America*, in "Modern Art and Tradition" Sweeney identified Duchamp as a modernist artist in "the tradition of Cézanne," and "a follower of the cubists and futurists in his earlier work, who became one of the pioneers of Dada and a precursor of surrealism through his emphasis on satirical and poetic associations in the subject matter of his work."[28] Thus in the Yale lecture, Sweeney presented Duchamp as occupying multiple positions simultaneously in an unbroken artistic genealogy that became broken, purged, and creatively transformed in the artist's unique reconstruction of the modernist canon. Quoting from *Eleven Europeans in America*, Sweeney emphasized Duchamp's assertion of Dada's apophatic or "pur-gative" value, which "was the point of view that underlay the now familiar work of Marcel Duchamp subsequent to his famous *Nude Descending the Stairs* [*sic*]. And yet out of this Dada-nihilist liberation from the immediate past we find Duchamp producing a model of order for our modern period such as his great glass *The Bride*, a model of order . . . in the true traditional manner as thoroughly as any works of art of our time."[29] Sweeney thus situated Duchamp's work as breaking free of temporal and historical constraints in order to attain a transcendence of tempo-rality that was nonetheless compellingly rooted in its own contemporary moment. This sense of internal multiplicity allowed Duchamp's artworks to be seen as being in time and beyond time at the same time.[30] Moreover, this complementary sense of multiple temporalities and temporal multiplicities shared key characteristics with the androgyne, as both structures instantiated a dynamic capacity for unifying the multiple and multiplying the unified, as they incorporated the other into the self.

To illustrate his arguments, Sweeney's essay was accompanied by two photographs showing multiple states of Duchamp's *Rotary Glass Plates (Precision Optics)* (1920, figure 3.2), a motion sculpture in the Société Anonyme's permanent collection. This work consists of painted glass plates set on a metal frame attached to an electric motor.[31] When stationary, the plates appear to be individuated and fragmented; in motion, they form a unified spiraling design. The dynamic effects of the sculpture can thus be seen as a visual analogue of the *coincidentia oppositorum*

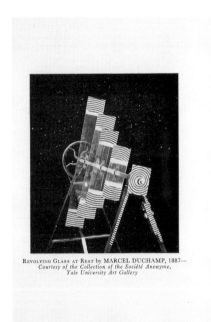

REVOLVING GLASS AT REST by MARCEL DUCHAMP, 1887—
*Courtesy of the Collection of the Société Anonyme,
Yale University Art Gallery*

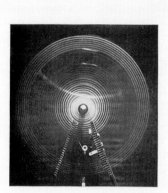

REVOLVING GLASS IN MOTION
by MARCEL DUCHAMP, 1887
*Courtesy of the Collection of the Société Anonyme,
Yale University Art Gallery*

3.2 Marcel Duchamp, *Rotary Glass Plates (Precision Optics)*, 1920, appearing in Katherine S. Dreier, James Johnson Sweeney, and Naum Gabo, *Three Lectures on Modern Art* (New York: Philosophical Library, 1949). ©2008 Artists Rights Society (ARS), New York/ADAGP, Paris/Succession Marcel Duchamp.

that Sweeney had emphasized throughout his essay. According to the curator, just as the "spiritual value of art" lay in its nondual conjunction of time and timelessness, apophatic purgation and kataphatic binding, a corresponding sense of order arose through a complementary dynamic of unity and variety, making and unmaking, fusing and splitting, as forces breaking things apart merged in a precision rotation with the oppositional impulses of the forces holding them together.

Comparative Androgynes: Dreams That Money Can Buy

In the supplementary materials that accompanied *Eleven Europeans in America*, Duchamp mentioned his involvement in an avant-garde film project, Hans

Richter's *Dreams That Money Can Buy* (1946).[32] The movie was initially financed by Peggy Guggenheim and produced by Art of This Century Films.[33] According to the catalogue accompanying the cinematic release, Richter produced and directed this award-winning film and wrote the plot, in which "Joe, a poor young poet, elicits ... dreams from 7 different people." The dream sequences were "shaped after the visions of 7 contemporary artists" who collaborated with Richter. They included Max Ernst's erotically disintegrating dream of "Desire"; Fernand Léger's humorous, musical-mechanical sequence "The Girl with the Prefabricated Heart"; Man Ray's mordant meditation on issues of psychic projection in the movies, "Ruth, Roses, and Revolvers"; two dreams by Alexander Calder, including a choreographed "Ballet" of his mobile sculptures and a performance of his mechanical "Circus"; Richter's own psychologically inflected dream of "Narcissus"; and a fantasy sequence in which shots of Duchamp's spinning rotoreliefs are delicately interspersed with a kaleidoscopic restaging of the nude descending a staircase.[34] In the film's promotional materials, Duchamp's painting *Nude Descending a Staircase No. 2* (figure 2.2) was juxtaposed with a still frame from the movie displaying a kaleidoscopic procession of female nudes. The accompanying caption directly associated the nudes with the rotoreliefs, stating that "Marcel Duchamp's flat color disks assume three dimensions, moving rhythmically across the screen. Their movements are timed with those of nudes descending a staircase–an animation of his famous painting."[35] Significantly, Duchamp's cinematic reprise of the nude descending a staircase represented a return to one of the painting's critical points of origin, which, as the artist emphasized, lay in nascent developments in film and photography: "The final version of the *Nude Descending a Staircase*, painted in January 1912, was the convergence in my mind of various interests among which [were] the cinema, still in its infancy, and the separation of static positions in the photochronographs of Marey in France, Eakins and Muybridge in America."[36]

Duchamp's dream sequence opens with Joe, the dream dealer and narrator, observing that this particular dream belongs to a gangster and "man of action" just as it is the "delicate dream" of a poet manqué. Thus from the outset, the dream is framed as incorporating two seemingly distinctive aspects of masculine subjectivity. Recalling the spinning disks of Duchamp's earlier experimental film, *Anemic Cinema* (1926), the viewer is initially presented with an image of a black and white

3.3 Marcel Duchamp, *Rotorelief (Optical Disk)*, 1935. Film still from Hans Richter, *Dreams That Money Can Buy*, 1946. ©2008 Artists Rights Society (ARS), New York/ADAGP, Paris/Succession Marcel Duchamp.

rotorelief spinning counterclockwise, followed by a sepia-toned rotorelief revolving clockwise (figure 3.3). The scene then shifts to a faceted, kaleidoscopic configuration of multiple images of a seminude female, whose white skin is selectively covered by the black circles of her stylized bikini costume. The figure appears at once amplified and fragmented through the simultaneous presentation of her multiple presences descending a staircase (figure 3.4). The dream then returns to images of colored rotoreliefs turning clockwise and counterclockwise, suggesting a reversibility of being through spiraling loops that alternately spin in both directions. The scene abruptly shifts again, as droplets appear over a partially obscured camera lens to create another broken, faceted vision in which multiple images of a topless female descend a staircase (figure 3.5). Through Richter's use of prismatic camera lenses, the images of the descending nude become formally analogous

3.4 Marcel Duchamp, *Nude Descend-ing a Staircase*, 1946. Film still from Hans Richter, *Dreams That Money Can Buy*, 1946. ©2008 Artists Rights Society (ARS), New York/ADAGP, Paris/Succession Marcel Duchamp.

with the structures of the rotoreliefs, both motifs displaying highly stylized configurations of dark and light elements that appear as intricate, animated patterns. The repeated cross-cutting between these motifs evokes an interplay of apophasis and kataphasis, of the simultaneous crystallization and dissolution of nude bodies and abstract, spiraling forms as concurrently materializing and dematerializing presences. The final shots consist of various spiraling, colored rotoreliefs, circles within circles appearing in red, brown, black, and white, followed by lingering trace images in which the crumbling stability of the nude dissolves into a multiplicity of spectral forms.[37]

Significantly, in Duchamp's film sequence the female nude is contained within the consciousness of the dreaming male, where she represents a vision of the other who is not quite other enfolded within the self. Thus the psychic con-

5.5 Marcel Duchamp, *Nude Descend-
ing a Staircase*, 1946. Film still from Hans
Richter, *Dreams That Money Can Buy*,
1946. ©2008 Artists Rights Society
(ARS), New York/ADAGP, Paris/Succes-
sion Marcel Duchamp.

struction of the dream represents an altered state of consciousness that allows
a sense of multiplicity within unity: of the female within the male, the dreamer
and poet within the man of action, the alternating clockwise and counterclock-
wise motions of the rotoreliefs. This echoes the visual hermeneutics of Duchamp's
artworks, which not only imaginatively perform androgynous processes of split-
ting and fusing differences, but potentially induce these conceptual possibilities in
the (male) viewer. Much like the painting of the nude descending a staircase that
originally inspired the dream sequence, Duchamp's cinematic vision can be seen
as an expression of androgynous consciousness, bespeaking its complexity while
saying the unsayable.[38]

 In Duchamp's imagery, the androgyne serves as a powerful embodiment
of the *coincidentia oppositorum,* a subject suspended within and beyond gender

that both heightens and dissolves gender differences. In its assorted incarna-
tions, the androgyne variously appears as a painted body that is neither male nor
female, or as a composite construction that is repositioned beyond the familiar
frameworks of gendered boundaries. These forms are alternatively instantiated
through the containment of the feminine in the masculine, thereby producing a
seemingly biblically authorized account of phallic power; or as a complex figural
construction that is radically hybrid and categorically transgressive, thereby rais-
ing the question of how a being can embody a state that is fractured and unified,
temporal and timeless, apophatic and kataphatic at once. The crucial point is that
the androgyne is itself an androgynous concept, one that is capable of assuming
different forms depending on how one spins a symbol that spins in multiple direc-
tions simultaneously.

Yet in all instances, the androgyne serves as a metaphor for a being that
is manifold and mobile, possessing the mystical capacity to change from one state
of being to another, to become this and then that. As such, the androgyne is instru-
mental in dissolving received categorical boundaries in order to create space for
new constellations of possibilities. Depending on how one establishes their episte-
mological parameters, it is possible to view Duchamp's androgynes, to paraphrase
the artist, as embodying a form of philosophy "beyond philosophy."[39] On the one
hand, the very notion of a philosophy beyond philosophy arguably represents
another form of philosophy, a kind of metaphilosophy that can be apprehended
conceptually through analytical frameworks. Yet on the other hand, these concepts
supersede the limits of a strictly logical understanding, as the androgyne instanti-
ates a metaphysical perspective that both exemplifies and attempts to move beyond
duality and difference. Thus in the androgyne, gendered embodiment becomes
a figuration of metaphysical difference that is simultaneously located within and
beyond difference, just as androgyny represents a kind of sexualized nonduality
that connotes a knowing beyond knowing, a form that mirrors the paradox of a
philosophy beyond philosophy. As Duchamp himself was well aware, such trans-
formational magic extended well beyond the familiar boundaries of established
philosophical frameworks to venture "out of the frame, and back again," while
fusing forms, breaking brokenness, and splitting the difference.[40]

"The Labyrinth beyond Time and Space": Descending Duchamp's Staircase

Dreams That Money Can Buy itself represented a complex hybrid that traversed the boundaries of elite and popular culture. During the forties and fifties, so too did Duchamp. This multiple positioning is exemplified by a feature article on the artist in *Life* magazine entitled "Dada's Daddy." The piece included reproductions of five rotoreliefs as well as an image of the *Nude Descending a Staircase* juxtaposed with a "repetitive flash" photograph that bore the suggestive caption "Duchamp Descends Staircase."[41] (While posing for the photo, the casually attired, sixty-four-year-old artist reportedly quipped to *Life* photographer Elias Elisofon, "Don't you want me to do it nude?")[42]

The *Life* article demonstrates the popular cultural appeal associated with Duchamp's gestures of multiplicity, duplicity, and disavowal. Critic Winthrop Sargeant paradoxically characterized Duchamp as a modernist patriarch, as "Dada's Daddy" and the "spiritual leader" of an apophatic system "dedicated to the destruction of all systems." Yet he also described Duchamp as a cosmopolitan embodiment of "disarming courtesy and polished charm" who "seems to regard his complete abandonment of art as in itself an artistic achievement. He has pursued this achievement with admirable tenacity for nearly 20 years, and as a result enjoys an almost oracular position among today's avant-garde artists, dealers and critics of Manhattan." Despite the artist's numerous repudiations, "[Duchamp] seems to believe strongly in two things: esthetics, which in his mind takes the place of religion; and absolute individualism, which is the core of his way of life."[43] Duchamp's artistic renunciations were thus presented as compelling affirmations that proved to be highly fashionable during the fifties, a period when "oracular" aesthetics could represent a form of secular spirituality as long as it was clothed in the hallowed rhetoric of "absolute individualism."

Such interwoven leitmotifs of cultural affirmation and negation, creation and destruction, returned four years later in the interview that Sweeney conducted with Duchamp for NBC at the Philadelphia Museum of Art. Like the *Life* article, the NBC interview represented a melding of elite and popular culture. Walking through the museum galleries, the two men once again reconstructed the genealogy

underpinning Duchamp's art, from his brief experimentation with impressionism to his more sustained engagement with Cézanne, cubism, futurism, and mechanical drawing.[44] With this canonical modernist lineage firmly in place and just waiting, as it were, to be demolished, Duchamp proceeded to characterize Dada as "a negation—a refusal to accept anything like [its predecessors], to deny the validity of [their] theoretical interests." The artist then offered a stringent critique of "a repetition of the same thing long enough to become taste," of a painterly self-imitation that ossifies into a predictably formulaic style. At an early point, he explained, he came "to the conclusion that you either are a professional painter or not. There are two kinds of artists: the artist who deals with society, who's integrated with society; and the other artist, the completely freelance artist, who has nothing to do with it—no bonds." Affirming the position of the latter, Duchamp advocated the necessity of preserving a sense of mutability that can only be maintained when "the thing itself is very very plastic. . . . In other words, painting should not be only retinal or visual; it should have to do with the gray matter of our understanding, not alone the purely visual. It is that way with my life in general. I didn't want to pin myself down to one little circle. I have tried to be as general as I could."[45]

Thus in the Philadelphia interview, Duchamp's oeuvre again became situated within a canonical modernist genealogy, even as the artist simultaneously positioned himself well outside of its categorical limitations. This position of privileged detachment only further confirmed Duchamp's status as an avant-garde insider. Nested within this construction are layers of paradox, as Duchamp's critique of conventional taste represented a highly fashionable popular discourse during the fifties. Such negative affirmations led to the conclusion of the interview, at which Duchamp expressed his belief in art as a transcendence of normative frameworks of time, space, and humanity's "animal state." As he told Sweeney: "As you know, I like to look at the intellectual side of things, but I don't like the word 'intellect.' For me intellect is too dry a word, too inexpressive. I like the word 'belief.' In general when people say 'I know,' they don't know, they believe. Well, for my part, I believe that art is the only form of activity in which man, as man, shows himself to be a true individual who is capable of going beyond the animal state. Art is an outlet toward regions which are not ruled by time and space. To live is to believe, that's my belief."[46]

Throughout the fifties and sixties, Duchamp's own statements on the numinous quality of his oeuvre remained characteristically fluid and paradoxical. Indeed, his response to the question of the relation between aesthetics and metaphysics is itself symbolically androgynous, as he repeatedly intertwined oscillating strands of negation and affirmation in a *coincidentia oppositorum* that transported viewers "out of the frame and back again." Thus just as he affirmed the "metaphysical" aspects of Dada and, slightly later, the "mediumistic" nature of the creative act, he explicitly dismissed the "great religious reverence" with which people approached art. He was also conspicuously indifferent to the art historical canon, which he described as "the purgatory of art history." As Duchamp told Tomkins in 1965, "I'm afraid I'm an agnostic in art. I just don't believe in it with all the mystical trimmings. As a drug, it's probably very useful for a number of people—very sedative—but as religion it's not even as good as God."[47] Yet Duchamp, being Duchamp, was characteristically equivocal on the question. During a 1963 interview, William Seitz asked the artist to provide an adjective to describe his art: "Aesthetic?" "Philosophical?," to which Duchamp replied "No. No. 'Metaphysical,' if any."[48] Throughout his various statements, Duchamp leveraged the power of contradiction to preserve the integrity of apophasis, offering an unsaying that strategically enabled him to maintain multiple perspectives on the issue simultaneously. The critic Cleve Gray neatly summarized the situation in 1969, the year after Duchamp's death, when he recalled that "one of the few privileges Duchamp always insisted upon was the right to contradict himself. 'Anti and pro are two facets of the same thing.'"[49]

In 1957 Duchamp's simultaneous negations and affirmations recurred in two other prominent venues, as he and Sweeney collaborated on the exhibition "Three Brothers: Jacques Villon, Raymond Duchamp-Villon, Marcel Duchamp" at the Solomon R. Guggenheim Museum (January 8 to February 17, 1957) and participated in the American Federation of the Arts conference that spring.[50] As if foreshadowing Sweeney's career trajectory, the exhibition traveled from the Guggenheim to the Museum of Fine Arts, Houston (March 8 to April 7, 1957), where it was characterized as "a collaborative effort of the Guggenheim and Houston museums."[51] In the accompanying catalogue, Sweeney emphasized the ambivalent themes that threaded through his exchanges with Duchamp. In particular, he characterized

the artist as both a reactionary outsider and a consummate insider, a renunciate painter who represented the ultimate "artist's artist." As Sweeney observed:

Painting is only one aspect of art in Duchamp's view. "I have always had a horror of being a 'professional' painter," he will explain. "The minute you become that you are lost." This is a temptation to which Duchamp has never succumbed. For all that he remains in one sense a painter's painter–or more correctly an artist's artist. He feels that since the time of Impressionism the visual creations of painters for the greater part have had no deeper communication than to the retina of the observer. Impressionism, fauvism, cubism, abstract art have all been "retinal" painting. "Their preoccupations have all been physical, the reactions of colors and the like, always relegating to second place intellectual responses."[52]

In short, in the "Three Brothers" catalogue Sweeney again presented Duchamp as apophatically unsaying an established artistic genealogy that kataphatically enabled the ongoing performance of modern art.

Coinciding with the "Three Brothers" exhibition, the American Federation of the Arts conference was held in Houston in April of 1957. For the conference Duchamp presented an important paper on "The Creative Act," while Sweeney moderated a panel discussion concerning "The Place of Painting in Contemporary Culture."[53] As if picking up where he had left off in the NBC interview, Duchamp echoed T. S. Eliot as he noted that, "to all appearances, the artist acts like a mediumistic being who, from the labyrinth beyond time and space, seeks his way out to a clearing. If we give the attributes of a medium to the artist, we must then deny him the state of consciousness on the esthetic plane about what he is doing or why he is doing it. All his decisions in the artistic execution of the work rest with pure intuition and cannot be translated into a self-analysis, spoken or written, or even thought out." Whether Duchamp's words are read as a serious or a subversive statement–or both, as a seriously subversive or a subversively serious statement–the artist described a paradoxical form of creativity that was achieved through the simultaneous acts of self-inscription and self-erasure.[54] Moreover, just as Sweeney had cited Eliot's "Tradition and the Individual Talent" in his Yale address (1948), Duchamp quoted from this same essay at the Houston conference: "T. S. Eliot, in his essay on 'Tradition and the Individual Talent,' writes: 'The more

perfect the artist, the more completely separate in him will be the man who suffers and the mind which creates; the more perfectly will the mind digest and transmute the passions which are its material."[55] Thus, in keeping with both Eliot's and Sweeney's previous discussions, Duchamp characterized "the creative act" as turning on a paradoxical conception of affirmation and rejection, presence and absence, as artistic achievement is realized through an act of passive receptivity and creation emerges through the surrender of the creative act itself. In this *coincidentia oppositorum,* unsaying becomes saying and saying becomes unsaying, just as the medium becomes the medium.

As if completing the circle by leaving it open, Duchamp identified a "gap" or "missing link" as a crucial element in the creative act—an opening that served as a portal through which the spectator could enter to attribute meaning to the artwork: "The creative act takes another aspect when the spectator experiences the phenomenon of transmutation; through the change from inert matter into a work of art, an actual transubstantiation has taken place, and the role of the spectator is to determine the weight of the work on the esthetic scale."[56] Duchamp's leitmotifs of medium, transmutation, and transubstantiation represent mystical signifiers that express the transformative capacity of aesthetics to engender multiple states of being simultaneously. Or, to phrase this complex proposition another way, Duchamp's transmutational "gap" or "missing link" can be seen not just as an open door, but as a door that somehow manages to remain open and shut simultaneously.

A Door That Is Both Open and Shut: Closing with an Androgynous Opening

"Out of the frame and back again" incisively characterizes Sweeney and Duchamp's final collaboration, for the exhibition "Not Seen and/or Less Seen of/by Marcel Duchamp/Rrose Sélavy 1904–64."[57] Initially displayed at the Cordier & Ekstrom gallery in New York, the entire show had been purchased by the collector Mary Sisler prior to its traveling to Houston. Sweeney arranged for the artist and his wife Teeny (Alexina) to attend a gala reception celebrating the opening at the MFAH in February of 1965,[58] and he held screenings of the NBC interview (1956) to supplement the museum display and promote public education.[59]

In the press release that Sweeney produced for the exhibition, he empha-
sized both the controversial status of Duchamp's artwork and the libratory promise
of Dada's "metaphysical attitude." Like Duchamp, Sweeney once again confirmed
and subsequently deconstructed the modernist genealogy underpinning the artist's
creative production, thereby reaffirming Duchamp's ambivalent canonical posi-
tion. As Sweeney informed his Houston audience:

During the first decade of the 20th century, Duchamp's paintings were imitative of the works
of the Impressionists, but he rejected the precepts and techniques of these men as he would
subsequently reject the manner of the Fauves and even that of the Cubists. The culmination
of Duchamp['s] experimentation with the breakdown of forms is in his now famous "Nude
Descending a Staircase," a series of overlapping, simplified figures (in the Cubist tradition)
which appealed to his abiding interest in the visual expression of motion. The "Explosion in a
Shingle Factory," as it was called by some critics, was a highlight of the Armory Show of 1913.
Protesting the course of the First World War which some artists interpreted as signifying that
European culture had lost all meaning, Duchamp became intimately associated with the so-
called "Dada" movement. Dada, according to Duchamp is "a metaphysical attitude, a way to
get out of a state of mind, get away from clichés, to get free."[60]

Sweeney noted that Duchamp promoted both the destruction and the
continuation of the modernist tradition through the artistic construction of Rrose
Sélavy and the complex gesture of the readymades. As Sweeney wrote: "Developing
a completely separate facet of his artistic personality in those inter-bellum years,
Duchamp, in the guise of Rose Sélavy (c'est la vie) created his 'Ready-Mades.' He
rejected the veneration of art accorded to official masterpieces, believing that the
artist through the centuries had become the slave of his own hand."[61] Thus just as
Sweeney simultaneously positioned Duchamp in a creative and destructive rela-
tion to canonical modernism, the transgendered presence of Rrose Sélavy is char-
acterized as embracing a rejection in order to reject an embrace, in this instance
the narcissistic embrace of the artist's own hand. In the broader context of the
sixties, just as the breakdown of established categories was repeatedly described
as underpinning the apophatic trajectory of Duchamp's project, Sweeney's critical
formulation itself can be seen as replicating Duchamp's androgynous logic, simul-
taneously saying and unsaying the genealogy that it (de)constructed.[62]

In Houston, these paradoxes extended into the social sphere as well. The opening reception for the "Not Seen and/or Less Seen" exhibition was a formal black tie affair during which Sweeney cultivated the cachet of Duchamp's iconoclastic oeuvre.[65] Indeed, the event itself can be seen as a kind of alchemical sublation–as Duchamp's radical breaks with tradition became an occasion for elite social celebration–and as a conceptual artwork–Sweeney and Duchamp performing the androgynous logic of the *coincidentia oppositorum*, affirming their elevated positions as cultural insiders by presenting themselves as outside of conventional social boundaries.

The title of the show also reflected its deliberately ambiguous positioning. Like the paratextual presence of the title of a readymade, the hybrid construction "Not Seen and/or Less Seen of/by Marcel Duchamp/Rrose Sélavy 1904–64" designated a monographic exhibition that encompassed a porousness of categorical boundaries–an internal play of unity and multiplicity, masculinity and femininity, visibility and invisibility, revelation and concealment, seeing and unseeing–just as it conveyed the artist's and viewer's capacity to occupy multiple locations simultaneously. Building on these Duchampian themes, I will close this chapter with an androgynous opening by focusing on the *Door* (1927, figures 3.6 to 3.8, plate 1) that Duchamp designed, and had installed, in his Paris studio at 11 rue Larrey. At the MFAH, this paradoxical, custom-made readymade could be seen as nothing less than a subtle embodiment of an architectural androgyne.

First, it is important to consider the special significance that this work held for Duchamp himself. In August of 1964, when planning the design of the "Not Seen and/or Less Seen" catalogue, the artist discussed the *Door* at length with the dealer Arne Ekstrom. As Duchamp emphasized, he had devoted considerable thought and care to the selection and printing of the embossed color photograph of the *Door* that he wished to have appear on the cover of the catalogue (figures 3.6 and 3.7):

I am really sorry you don't like the idea of the "door" for the front cover of the catalog. It seems to me, first of all, that the exhibition is not defined in the catalog as the exclusive exhibition of the S[isler] collection but (far more importantly), as a collection of things "*not seen or less seen*" for 60 years not necessarily having to go in X or Y collection. Another idea for you

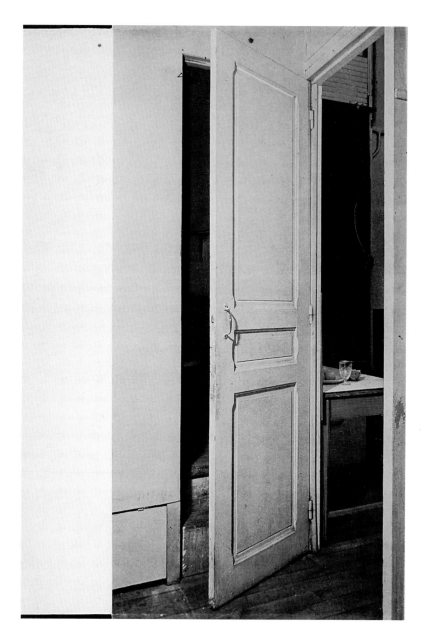

5.6 Marcel Duchamp, *Door, 11 Rue Larrey*, 1927, appearing on the front cover of Richard Hamilton, *Not Seen and/or Less Seen of/by Marcel Duchamp/Rrose Sélavy, 1904–64* (Houston: Museum of Fine Arts, 1965). ©2008 Artists Rights Society (ARS), New York/ADAGP, Paris/ Succession Marcel Duchamp.

3.7 Marcel Duchamp, *Door, 11 Rue Larrey,* 1927, appearing on the back cover of Richard Hamilton, *Not Seen and/or Less Seen of/by Marcel Duchamp/Rrose Sélavy, 1904–64* (Houston: Museum of Fine Arts, 1965). ©2008 Artists Rights Society (ARS), New York/ADAGP, Paris/ Succession Marcel Duchamp.

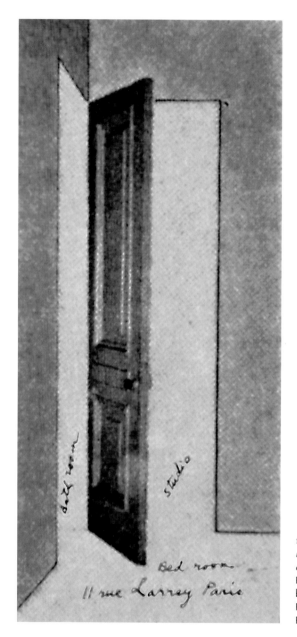

3.8 Marcel Duchamp, *Door, 11 Rue Larrey, Paris. La porte qui peut être ouverte et fermée,* appearing in *View 5* (1945). Photograph courtesy of The Fondren Library, Rice University. ©2008 Artists Rights Society (ARS), New York/ADAGP, Paris/Succession Marcel Duchamp.

to exploit is that of buying this door for the collection. For I'm the one who had it made and it doesn't belong to the "architecture" of the house or the studio, 11 rue Larrey, Paris V. Furthermore, Isabelle Walberg (Mrs. Patrick Walberg), who lives there now, would certainly let me take it away if I paid for having it replaced with a copy made by a carpenter. Also, the fact of our having the [Arturo] Schwarz transparency at our disposal will reduce expenses considerably. Richard [Hamilton], with whom I've discussed this, is also convinced that the idea is an important one and directly related to the "*NON SEEN*." He also says that with the plastic cover stapled on and overshooting by a centimeter top and bottom maximum, there would be no problems of "binding and breaking." As well as the transparency, I would like the reproduction of the door to be lightly "embossed" i.e. so that the main lines appear slightly in relief, which would not imply huge costs but should make a "good cover."[64]

Following Duchamp's specifications, a color photograph of the *Door* appeared on the front of the catalogue, while the back cover presented a reverse image in pure ("enamel") white that traced the framework of the door yet remained devoid of its material substance. Thus the verso intaglio print produced a complementary ghost impression of the *Door*'s simultaneous sense of inscription and erasure, as the artwork's presence of absence was reciprocally reflected in its absence of presence.

In so doing, the *Door* "provides cover" just as it exposes the opening of the text. Not surprisingly, these reciprocal associations hinged on the paradoxical nature of the work itself. As Richard Hamilton explained in the accompanying catalogue, the *Door* represents an "original ready-made: [a] wooden door fitted by a carpenter to Duchamp's specification. . . . While M.D. occupied an apartment at 11 Rue Larrey he had a door installed at a junction between three rooms in such a way that it served to close an opening between bedroom and studio or between bedroom and bathroom—but it could not close both at the same time. A color reproduction appears on the front cover of this catalogue. The door has now been removed from 11 Rue Larrey to be replaced by a substitute—a major philosophical problem is posed; has the artwork been transported to New York or does it remain in the pair of alternative gaps in two walls in Paris?"[65] Three decades earlier André Breton had similarly reflected on Duchamp's remarkable door in his essay "Lighthouse of the Bride" (1935); Breton's article was published in both the special Duchamp issue of *View* (March 1945) and in Sweeney's "Three Brothers"

catalogue (1957). As Breton recalled, "In the apartment entirely constructed by Duchamp's hands, there stands, in the studio, a door of natural wood that leads into the room. When one opens this door to enter the room, it then closes the entrance to the bathroom, and when one opens it to enter the bathroom, it closes the entrance to the studio and is painted with white enamel like the interior of the bathroom. ('A door must be either open or closed' had always seemed to be an inescapable truth; but Duchamp had managed to construct a door that was at the same time both open and closed.)"[66]

A door that is both open and closed. At the MFAH, Sweeney positioned Duchamp's *Door* as a focal point of the exhibition, at once surrounded by, and enclosed within, the open expanse of Cullinan Hall (figures 3.9 and 3.10). In so doing, Sweeney presented the *Door* as paradoxically framing an opening and opening a frame that provided multiple perspectives on the exhibition simultaneously. Such ambivalence was highly appropriate. Throughout his curatorial installations and writings on Duchamp, Sweeney repeatedly differentiated *and* collapsed the binary categories of inside and outside, the timeless and the temporal, the esoteric and the exoteric, creation and destruction, the physical and the metaphysical, the seen and the unseen. By overtly displaying what had been not seen and/or less seen of/by Duchamp/Rrose Sélavy, Sweeney presented an androgynous curatorial vision that contained modernism's breaks while breaking the containment of its unitary framing enclosures.

Both embodying and performing these themes, the *Door* similarly instantiated a structure with the capacity to occupy multiple locations simultaneously. That is, the *Door* frames and covers, reveals and conceals, an opening that is always open and always closed. Like the androgyne, this ambivalent construction hinges on a flexible frame that contains its opposite within itself. And just as Duchamp's *Door* is always open and closed, the spaces it conjoins and delimits are always fragmented and unified, split and fused. In this mixed marriage of opposing typologies, the sublimated eros of the *Door* can be seen as a *conjunctio oppositorum,* a kind of meta-androgynous formulation of splitting and fusing that conjoins the integrity of its internal oppositions while embracing the unity of their difference.

As Hamilton noted in the accompanying catalogue, in Duchamp's Parisian apartment the *Door* framed the intersection of three interpenetrating spaces, the

3.9 Installation photograph of the exhibition "Not Seen and/or Less Seen of/by Marcel Duchamp/Rrose Sélavy," 1965. Photograph by Hickey & Robertson. Museum of Fine Arts, Houston Archives.

3.10 Installation photograph of the exhibition "Not Seen and/or Less Seen of/by Marcel Duchamp/Rrose Sélavy," 1965. Photograph by Hickey & Robertson. Museum of Fine Arts, Houston Archives.

passageways separating and connecting the studio, the bedroom, and the bathroom. Significantly, in *View* Breton reproduced a drawing labeling the interior spaces of "11 rue Larrey, Paris. *La porte qui peut être ouverte et fermée*" (figure 3.8).[67] Like the photograph on the front cover of the exhibition catalogue, the door is presented from the perspective of Duchamp's bedroom. This suggestive location provides the symbolic foreground on which the viewer imaginatively stands, and from which vantage point they confront the choice of turning either left, into the bathroom, or right, into the studio. At this transitional point, one is poised at the threshold of the bedroom, a space of repose and intimate encounter, facing the option of entering either the apophatic space of the bathroom (a "white enamel" area of cleansing

and "purgation"), or the kataphatic space of the studio (an active arena of creative production). As a practical and symbolic point of simultaneous entry and exit, the *Door* thus served as a porous membrane—or, in Derridean terms, a hymen—situated within the interstitial junctures of Duchamp's residence.[68] The museum both reiterated and reversed these complementary structures, as the unseen became seen and the private became public in the open enclosure of the gallery. And if the accompanying exhibition catalogue is viewed as a correlative textual dwelling, then placing the *Door* on its covers simultaneously revealed and concealed the viewer's points of entry and exit into and/or out of Duchamp's/Rrose Sélavy's androgynous zones.

4

Blood Miracles and Fire Magic:

The Transmutational Arts of Alberto Burri

At the end of his life and work—in 1991
he had four years left to live—Burri was
expressing what had ultimately always
been his statement of poetics. Pointing
out that it is from the end that one begins.
That one always proceeds backwards,
that in art the future is an impossible
goal. From here it was a brief step to
make him admit what can be considered
his slogan, "My last painting is the same
as my first."
—Giuliano Serafini, *Burri: The Measure
and the Phenomenon*

In my end is my beginning.
–T. S. Eliot, "East Coker," *Four Quartets*

The beginning is the end.
Ξυνὸν ἀρχὴ καὶ πέρας
–Heraclitus, *Fragments,* 70

On November 11, 1961, thirteen Italian airmen, all members of a United Nations military force operating within the Democratic Republic of Congo, were murdered by troops from the Congolese National Army (ANC). After delivering cargo at Kindu airfield, the Italian soldiers went to a nearby officers' mess, which ANC troops subsequently surrounded and looted. The soldiers were taken prisoner, beaten, and brought to Kindu prison. Citing a United Nations report filed a few days later, the *New York Times* chronicled the horrific details of the ensuing events:

According to [local] sources, the Italian crew members who were captured at the Malayan mess were brutally beaten, dragged to trucks and brought to Kindu prison, where they were immediately shot and then cut to pieces by the soldiers.

Pieces of the bodies were distributed to the large crowd that had gathered to watch the massacre, and some parts of the bodies were also flung at non-Congolese who were present. Two mutilated bodies were dragged through the main street of Kindu and exhibited until November 12. All the remains of the bodies were then thrown into the river.[1]

Alberto Burri was greatly moved by this tragedy, especially since the artist himself had served as a medical doctor in the Italian army during the Second World War. Burri had been taken prisoner of war in North Africa, and it was during his internment at a POW camp in Hereford, Texas that he made the decision to abandon medicine to pursue a career in art. Shortly after the incident at Kindu, he composed a monument to the slain soldiers, a collage constructed of burlap, canvas, and oil entitled *Grande sacco: Congo Binga* (1961, figure 4.1, plate 2).

Two years later, organizing a major retrospective exhibition of Burri's artworks at the MFAH, James Johnson Sweeney highlighted this elegiac work to convey the depths of Burri's personal vision and the power of his social commitments. Yet for Sweeney the significance of this collage both encompassed and transcended

4.1 Alberto Burri, *Grande sacco: Congo Binga*, 1961. Burlap and canvas. The Museum of Fine Arts, Houston; Museum Purchase.

its specific points of origin. Thus in the press release publicizing the exhibition, he noted that "the consistency of his vision and integrity of his expression is evident when one realizes that when Burri was touched by the massacre of thirteen Italian U.N. soldiers in November, 1961, it was through a burlap composition such as he had first explored nine [*sic*] years earlier that he composed his elegy in the monumental *Grande Sacco: Congo Binga* of that year."[2] In a review of the Houston exhibition in *Artforum*, the critic Charlene Steen similarly noted that Burri's "growth within the limitations of a single medium is demonstrated by his 1961 burlap elegy for the 13 massacred Italian U.N. soldiers, 'Grande Sacco: Conga Binga,' a kind of proof of the infinity of expression one artist can find within a given medium. It is almost breathtaking in evocative power and monumentality within the greatest economy of means."[3]

Measuring more than eight feet in length by five feet in height, *Grande sacco: Congo Binga* is indeed a monumental work. It is an example of Burri's *sacchi*, or collages constructed from burlap sacks that are mounted on canvas. While the *sacchi* are among his most celebrated works, this piece holds an especially significant position within his oeuvre. Thematically, it is a relatively anomalous commemoration of a specific historical event; art historically, it is one of the last *sacchi* that Burri would create. The collage conjoins multiple layers of associations to produce a powerful allegory of loss and return, beginnings and ends. It also represents a return to a medium which, in many ways, stood at a critical point in Burri's artistic origins and early success, one that he had worked with for more than twelve years. As a tribute to the slain Italian soldiers, *Grande sacco: Congo Binga* draws on the realm of the physical to reference the metaphysical, the absent presences and present absences of the dead within the world of the living.

The work is composed of rough burlap coffee sacks whose frayed and stitched surfaces are prominently stamped with the words "Congo Binga," a reference to the airport within the Democratic Republic of Congo from which the shipment originated. When Burri began using burlap sacks in 1949, he adopted an artistic practice that reflected the historical circumstances of the postwar period, when the United States sent foreign aid to European countries under the Marshall Plan. Burri's use of such modest materials has led some critics to identify him as a precursor of the Italian art movement of Arte Povera, or "impoverished art."[4] Matthew Gale has noted that "the *sacchi* also speak for a wider context of impoverishment or, more accurately, of necessary frugality—the use, patching and reuse of which stretches a material beyond the limits of its function. The sack is patched with other, smaller pieces salvaged from disintegrated remnants. Much has, rightly, been made of the contrast between the (implied) wealth of the supplier—often New World countries—and the tattered frugality of the recipients."[5]

While Burri acknowledged the influence that his art exerted on the Arte Povera movement, he disavowed any such categorization of his own work: "It is useless to speak about paintings. Painting is explained only by painting. I don't like labels on things like '*arte povera*' or 'trans-avant-garde.' It's fashion, a way to justify criticism."[6] Rather, the artist emphasized the conjunction of pragmatic and aesthetic concerns within his creative production: "I choose to use poor materials

to prove that they could still be useful. The poorness of the medium is not a symbol; it is a device for painting. . . . Technique is no problem—you find what you need."[7] Highly attuned to the expressive qualities of his media, in 1956 Burri said of the burlap sacking, "I could obtain the same brown [with other means], but it wouldn't be the same because it wouldn't contain everything I want it to contain. . . . It must respond as a surface, as a material and as an idea. In sacking I find a perfect match between shade, material and idea which would become impossible in paint."[8]

Paradoxically, the violated boundaries of the patched burlap sacks enhance the distinctive formal and existential qualities of the artworks. In the *sacchi*, large units of form are stitched together, and the fragments are affixed to a unified painted background, just as their seams—the palpable sites of the sacks' breakage and joining—are left clearly showing. In an intricate play of layers of signification, depths of meaning are conveyed through an expressive range of surface forms. The holes and tears in the fabric appear muted and dramatic at once, exposing the burlap as worn, dirty, and shaped by the unique vicissitudes of life itself. Adopting materials that were meant to be discarded once they had fulfilled their practical function, Burri transmuted their characteristic rips, tears, and holes into a source of expressive power, an enduring statement on the aesthetics of ephemeral fragility.[9] Much like the skin of a body, burlap sacks are exterior surfaces that enclose interior forms and substances. Metaphorical wounds become windows, portals that allow meanings to circulate fluidly through the open boundaries of their ragged frames.

Grande sacco: Congo Binga is both extraordinary and typical of the multifaceted coincidence of opposites that Sweeney and other critics identified throughout Burri's oeuvre, a quality they found especially evident in the *sacchi*. As we shall see, the *sacchi's* expressive power lay in their self-reflexive and self-deconstructing complexity. As such, this body of artwork incorporated a powerfully apophatic aesthetic whose ends lay in its beginnings. Burri's artworks in general can be seen as compositions that actively display the construction of their own deconstruction, as they both showcase and collapse the terminal points of the creative process, the beginnings and the ends of generative inspiration and abject decomposition.[10] Whether they take the form of the symbolically wounded surfaces of the burlap sacks or the artist's alchemical transmutations of burnt wood, iron, or plastic,

Burri's artworks repeatedly retain raw qualities of visceral experience, just as they transform elements of transient fragility into durable expressions of aesthetic redemption.

The Beginning of the Beginning

By opening with Sweeney's highlighting of *Grande sacco: Congo Binga* at the Houston retrospective of 1963, this story begins at the end. Indeed, by the time Sweeney staged the MFAH exhibition, he had been a friend of Burri and an admirer of his unconventional artworks for more than a decade. As Carolyn Christov-Bakargiev and Maria Grazia Tolomeo have noted, 1953 represented the start not only of Sweeney and Burri's personal relationship but of a wave of international recognition of Burri's work.[11] Giuliano Serafini reconstructs this story of auspicious beginnings:

It was with his "discovery" by James Johnson Sweeney that Burri finally entered the international limelight. Sweeney had come to Italy accompanied by the dealer Kurt Valentin. He had to retrieve some drawings by Kandinsky that his museum had lent to Colla for an exhibition at the Fondazione Origine. Colla himself "diverted" him to Burri's studio, where he was instantly struck by [the painting] *ZQ1*. Between the end of December 1953 and February 1954, *Composizione* was presented at the Guggenheim (where it is currently housed) in [Sweeney's show] "Younger European Painters: A Selection," the exhibition that constituted the first American survey of young European art after the war.[12]

Indeed, Sweeney was instrumental in promoting Burri's works both in the United States and in Europe, and in establishing key themes that would recur in accompanying critical discourses on the artist.[13] Complementing Sweeney's support, between 1953 and 1955 Burri's works were also displayed in Chicago at the Allan Frumkin Gallery; in California, at the Oakland Art Museum; in Pittsburgh, at the Carnegie Institute; and in New York, at the Helena Rubinstein Collection, the Stable Gallery, the Martha Jackson Gallery, and the Museum of Modern Art, the latter in conjunction with the group exhibition "The New Decade: 22 European Painters and Sculptors" (1955).

 As Serafini has noted, Sweeney included Burri's *Composition* (*Composizione*, 1953, figure 4.2) in the "Younger European Painters" exhibition that he staged

4.2 Alberto Burri, *Composition (Com-posizione)*, 1953. Oil, gold paint, and glue on burlap and canvas, 33⅞ × 39½ inches. Solomon R. Guggenheim Museum, New York. 53.1364.

at the Guggenheim (December 2, 1953 to February 21, 1954). The show traveled extensively through mid-1956, ultimately reaching ten venues throughout the United States.[14] This painting was also featured in the "Images at Mid-Century" exhibition that Sweeney organized at the University of Michigan's Museum of Art (April 13 to June 12, 1960).[15] According to the Guggenheim's annual Director's Report for 1957, a second painting by Burri was also purchased for the museum, *Wood and White, Combustioni* (1956).[16] An additional work by Burri, *Black-White-Black* (1955), was included in the Guggenheim International Award exhibition of 1958.

Much like *Grande sacco: Congo Binga, Composition* displays a conglomerative arrangement of frayed burlap sacking, which the artist has modified through the application of oil paint, gold paint, and glue on canvas. Bright red spatters appear to seep from the base of a large brown burlap rectangle, while scattered hints of red emerge from a tear in an adjacent, golden-brown patch. From the outset, these suggestive formal configurations invited anthropomorphic comparisons. When James Fitzsimmons reviewed "Younger European Painters" for *Art Digest*, he vividly described *Composition* as "burlap patched with burlap, with a livid scar running down the middle."[17] In a review of Burri's solo show at the Stable Gallery, Fairfield Porter likewise noted the "skin like texture" of Burri's canvases, in which "some tears and holes, patched from behind, and hollow and smooth with glue and paint, look like abrasions, blisters or scars healing from the edge."[18] Thus from an early point, the symbolic corporeality of the *sacchi* proved central to critical interpretations of Burri's work. Much as the distressed surfaces of the burlap evidenced the fabric's wear and tear prior to its incorporation into Burri's paintings, these very qualities seemed to preserve the existential life of the object within the aesthetic life of the artwork.

Sweeney's support of Burri extended well beyond the Guggenheim Museum, as he served as a key advocate for the artist internationally. Sweeney wrote an essay on Burri for the catalogue that accompanied a solo exhibition of the artist's work at the Galleria del Cavallino in Venice (1956), and he served on the board of art critics that selected pieces—including works by Burri—for the exhibition organized by the Rome-New York Art Foundation (1957). In addition, Sweeney's personal art collection included an example of a Burri *Ferro* (1958), or composition in sheet iron. Much later, in December of 1981, Sweeney attended the presentation of the permanent collection of the Burri museum at the Palazzo Albizzini in Umbria's Città di Castello; Sweeney would donate two *legni*, or wooden compositions of 1959 and 1960, to the collection.[19]

On a personal level, both Sweeney and his wife Laura enjoyed a warm friendship with Burri and his wife, the American dancer and choreographer Minsa Craig. Throughout the sixties, Burri sent the Sweeneys Christmas cards featuring original artworks, a gesture that repeatedly led Sweeney to express his admiration

and appreciation of "our 'little Burri' gallery."[20] The Sweeneys also visited the Burris periodically during trips to Rome and New York, and they invited the artist and his wife to stay with them at their home in Ireland.[21] The tenor of their friendship is expressed in the affectionate conclusion of Sweeney's letters, which characteristically ended by sending the Burris "all our love to you both, as ever, James Johnson Sweeney."[22]

Sweeney produced a series of exhibitions and monographs encompassing Burri during the fifties and sixties. In 1955 he published the first monographic text ever on Burri's paintings.[23] Shortly thereafter, he organized the first major retrospective of Burri's work, with an accompanying catalogue, for the Carnegie Institute in Pittsburgh (1957); the show traveled through 1958 to the Arts Club of Chicago, the Albright Gallery in Buffalo, and the San Francisco Museum of Art.[24] An abbreviated version of Sweeney's essay appeared as the introduction to Burri's paintings in the catalogue for the twenty-ninth Venice Biennale (1958).[25] In the fall of 1963, Sweeney staged a larger and more comprehensive retrospective at the MFAH, a show he described as a selection of works that Burri had compiled from the past fifteen years of his own production, and thus, "a choice of his choices."[26] The MFAH exhibition subsequently traveled to the Walker Art Center in Minneapolis, the Albright-Knox Art Gallery in Buffalo, and the Pasadena Art Museum, whose director Walter Hopps reported to Sweeney that the show was "a stunning success."[27]

Finally, as director of the MFAH, Sweeney arranged to add works by Burri to the museum's collection. In December of 1962 he informed Burri of his desire to purchase three paintings for the permanent collection, including a large upright plastic composition, a large *ferro*, and a *legno*. As he told the artist, "I would like Houston to have fine examples and these three are as fine as I can recall of their various types." After inquiring about prices, Sweeney concluded, "I will start work at once toward keeping them here."[28] During Sweeney's tenure as museum director, three works by Burri entered the MFAH's permanent collection: *Grande sacco: Congo Binga*; *Legno* (1958, figure 4.3, plate 3); and *Bianco B.4* (1965, figure 4.4). Regrettably, the latter two pieces were later deaccessioned in March of 1981, a gesture that reflected the priorities of a new museum director.

4.3 Alberto Burri, *Legno*, 1958. Wood and canvas. The Museum of Fine Arts, Houston; Museum Purchase.

The St. Januarius of the Collage

Burri benefited greatly from Sweeney's advocacy, not least because the artist himself was so notably reticent about his own work. Indeed, in one of his most important and often-cited comments, he expressed a characteristic disavowal of language: "Words are no help to me when I try to speak about my painting. It is an irreducible presence that refuses to be converted into any other form of expression. It is a presence both imminent and active. This is what it stands for: to exist so as to signify and to exist so as to paint. My painting is a reality which is part of myself, a reality that I cannot reveal in words."[29] Sweeney confirmed Burri's rejection of language; as he told Martin Friedman, director of the Walker Art Center, Burri "is very reluctant to talk about [his work] at any time."[30]

Sweeney, however, embraced the creative power of language to affirm the "irreducible presence" of Burri's paintings. Alluding to the artist's previous career as a surgeon, Sweeney opened his monograph on Burri with an epigraph

4.4 Alberto Burri, *Bianco B.4*, 1965.
Burned plastic on composition board,
plastic sheet, composition board, and
pine stretcher. The Museum of Fine Arts,
Houston; Museum Purchase.

by the Belgian poet and artist Henri Michaux, a beginning that evoked the haunt-
ing presence of wounded beauty: "Qui laisse une trace, laisse une plaie" (That
which leaves a trace, leaves a wound). "But," Sweeney continued, "out of a wound
beauty is born. At any rate in the case of Burri. For Burri transmutes rubbish into
a metaphor for human, bleeding flesh. He vitalizes the dead materials in which he
works, makes them live and bleed; then sews up the wounds evocatively and as
sensuously as he made them."[31] Jarring and poetic, Sweeney thus began the mono-
graph by presenting a string of sutured oppositions, a *coincidentia oppositorum*
of wounded flesh and sensuous beauty, dismemberment and wholeness, debased
rubbish and "dead" materiality, all of which became transmuted into the redemp-
tive presences of "living" artworks.[32]

Adopting this mystically oriented, embodied formalist critical model enabled Sweeney to locate the incarnational aesthetics of Burri's collages within the abstract formal and conceptual structures of the images themselves.[33] Thus reversing familiar pictorial and conceptual reference points, Sweeney observed: "Burri through his collages provides a sense of carnality in an age of avowed reduction and abstraction." Drawing on the vitalist theme of symbolic animism, Sweeney characterized Burri's painting as nothing other than "a living organism: flesh and blood. The representation of the human form in keeping with the trend of our times may not appear in his pictures; but a suggestion of what gave that form life still remains—a suggestion of flesh and blood; and more important still, a deep sense of order which relates the human form to a higher level of things, the spiritual." In Sweeney's critical formulation, the metaphorical bodies of Burri's nonfigural artworks lay in the "avowed reduction" of their abstraction, just as their abstract structures became metaphors for symbolic flesh and intangible spirit. As we shall see, much like the mysticism of the *via negativa*, in Burri's evocative canvases Sweeney perceived the wounded beauty of an apophatic body—a surface that materializes through its own dematerialization, thereby saying its own unsaying as numinous corporeal presence arises from the corresponding depths of its own dissolving absence.[34]

As the Burri monograph unfolded, Sweeney became even more mystically imaginative, equating the abstract structures of Burri's transformational canvases with the blood miracles of Christian incarnational theology: "Actually Burri is the St. Januarius of the collage: one can imagine on his feast day every red gash in his compositions liquefying and streaming blood. The martyr's blood in the phials of the Cappella del Tesoro of the Cathedral in Naples melts and bubbles only when put in sight of the head of the Saint himself on certain religious occasions during the year. But the flesh of Burri's pictures pulses in the sight of the sympathetic viewer, everywhere."[35] These evocative metaphors require some explanation. According to Herbert Thurston, S.J., the author of the entry on the saint in the *Catholic Encyclopedia* and of the contemporary study *The Physical Phenomena of Mysticism* (1952), the latter of which dealt extensively with the extraordinary bodily states associated with sanctified corporeality, St. Januarius was a martyred, fourth-century bishop of Beneventum whose relics are housed in the cathedral at Naples. At established

intervals during the year, a silver bust believed to contain the head of the saint is placed on an altar near a small silver reliquary. The reliquary holds two glass phials of a darkened, opaque substance that is thought to be the saint's blood. When the relics are brought into proximity, the blood sometimes reportedly turns liquid, growing bright red and bubbling up. Once this transformation occurs, the reliquary is presented to worshippers for veneration.[36] Thus the sobriquet "the St. Januarius of the Collage" provided Sweeney with a vivid metaphor—not only for characterizing Burri's abstract artworks as symbolically embodied and alive, but for imaginatively evoking these mystical visions in their modernist viewers.

As this suggests, the conceptual shifts that Sweeney identified in Burri's art unfolded through a series of related boundary crossings, as transitional pathways of meaning inverted and transposed the limits between inside and out. The key to this interpretive formulation lay in the viewer's ability to navigate freely between the intrinsic and extrinsic realms, so that their categorical distinctions melted and fused. The exterior structures of Burri's collages were seen as flowing surfaces that disclosed dynamic interior forms, like liquid bleeding through matter, so that a corporeality became visible through the burlap's porous membranes. Reversing the metaphor, skin serves as a porous fabric that frames one's existence in the world, just as it represents an ambivalent site that marks the subject's separation from and yet conjunction with its surroundings.[37] Sweeney observed that Burri "is an artist with a scalpel—the surgeon conscious of what lies within the flesh of his compositions and moved by it to the point that he can make the observer also sensitive to it. He knows that the surfaces he has sewn together with his sutures enclose a world of invisible forms, mysterious and vital."[38] Sweeney thus portrayed Burri—the doctor turned artist—as a modern mystic who made the unseen seen. As "the St. Januarius of the collage," Burri achieved the reanimation of dead materiality within modernist aesthetics: "Burri is a poet, a surgeon who knows and feels with intense visualization what lies within the fleshy surface of his compositions and an artist who is able to suggest this to the sympathetic observer." Thus just as the red paint splatters of Burri's *Composition* recall blood seeping through the bandages that serve as temporary membranes for binding wounded flesh, so the creative morphologies of the *sacchi* stand as apophatic bodies, as ambivalent aesthetic vessels that simultaneously

Plate 1 Marcel Duchamp, *Door, 11 Rue Larrey*, 1927, appearing on the front cover of Richard Hamilton, *Not Seen and/or Less Seen of/by Marcel Duchamp/Rrose Sélavy, 1904–64* (Houston: Museum of Fine Arts, 1965). © 2008 Artists Rights Society (ARS), New York/ADAGP, Paris/ Succession Marcel Duchamp.

Plate 2 Alberto Burri, *Grande sacco: Congo Binga*, 1961. Burlap and canvas. The Museum of Fine Arts, Houston; Museum Purchase.

Plate 5 Alberto Burri, *Legno*, 1958. Wood and canvas. The Museum of Fine Arts, Houston; Museum Purchase.

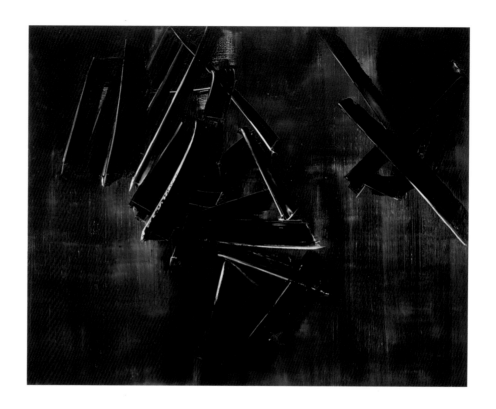

Plate 4 Pierre Soulages, *August 22, 1961*
(*22 août 61*), 1961. Oil on canvas. The Mu-
seum of Fine Arts, Houston; Museum Pur-
chase. © 2008 Artists Rights Society (ARS),
New York/ADAGP, Paris.

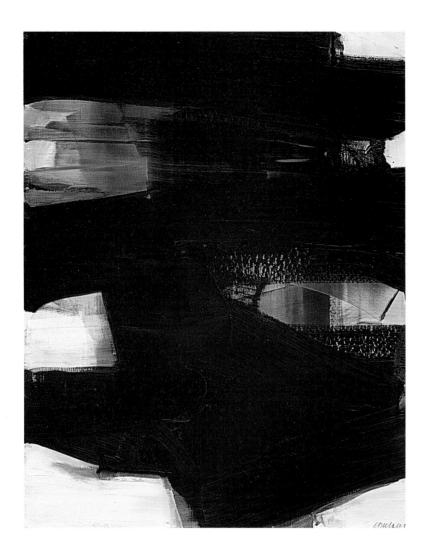

Plate 5 Pierre Soulages, *July 3, 1965* (*3 juillet 65*), 1965. Oil on canvas. The Museum of Fine Arts, Houston; Gift of Mr. and Mrs. S. I. Morris, Jr. © 2008 Artists Rights Society (ARS), New York/ADAGP, Paris.

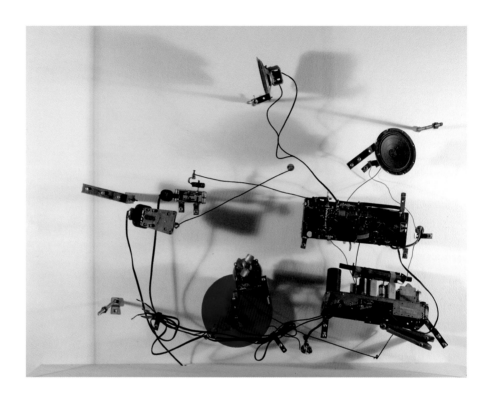

Plate 6 Jean Tinguely, *Radio Drawing*, 1963. Clear sheet plastic support, two radios, two electric motors, electric wires, and red plastic flywheel. The Museum of Fine Arts, Houston; Gift of Alexander Iolas. © 2008 Artists Rights Society (ARS), New York/ADAGP, Paris.

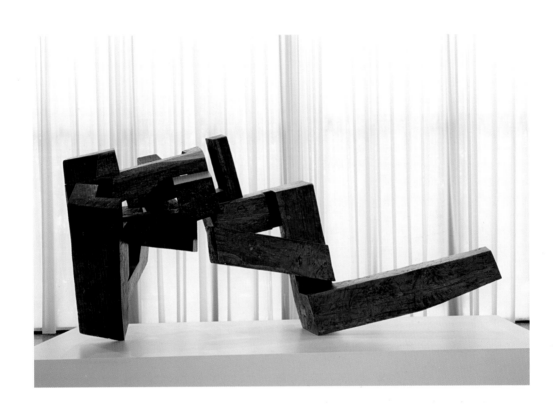

Plate 7 Eduardo Chillida, *Abesti gogora I*
(*Song of Strength*), 1960–1961. Oak. The
Museum of Fine Arts, Houston; Museum
Purchase. © 2008 Artists Rights Society
(ARS), New York/VEGAP, Madrid.

Plate 8 Eduardo Chillida, *Abesti gogora V*
(*Song of Strength V*), 1966. Granite. The
Museum of Fine Arts, Houston; Gift of the
Houston Endowment, Inc. in memory of
Mr. and Mrs. Jesse H. Jones. © 2008 Artists
Rights Society (ARS), New York/VEGAP,
Madrid.

contain and overflow the boundaries of their own significations. Through the flexible frameworks of hermeneutics and aesthetics, Sweeney offered his readers nothing less than a practice of creative visualization in which the *sacchi* could be seen as simultaneously inscribing and erasing the shifting boundaries of the forms between forms.

On the fluctuating surfaces of Burri's canvases, finally, Sweeney perceived not only the allusive traces of apophatic bodies, but the transformational presences of mystical landscapes. According to Sweeney,

At one moment his pattern of sewn lines, side by side with bleeding wounds and scarifications suggest sutures. The picture is living flesh; the artist, the surgeon. Another moment and these sewn lines take the character of landscape contours accented with red, gold, and white light splotches—but always a landscape that is alive, that has the quality of living flesh. His earth is not a thin dust-layer on a hard rock base. It is living and humanized. It is a deep soil that holds a welling life within it. It is Gaea, the palpitant earth, the offspring of Chaos; the same sense of life and order that underlies his surface rubbish of old rags and burlap and gives it its living quality.[39]

In short, in Sweeney's mystically oriented, embodied formalist discussions of Burri's artworks, the critic identified a metamorphic form of creativity that traversed the boundaries of bodies and landscapes, abstraction and iconography, the sacred and the profane, the living and the dead.

Burnt Haloes

The conclusion of Sweeney's 1955 monograph signaled the beginning of the next phase of his mystical interpretation of Burri, a narrative in which the body and the landscape were seen as interchangeable fields of living light. In the essay that he produced two years later for the Carnegie Institute (1957), Sweeney described Burri's recent collages in wood as alchemical landscapes, as the dynamic products of fire magic.[40] In another symbolic embodiment of the *coincidentia oppositorum*, these works were seen as conjoining the expressive categories of ancient sacrality and progressive modernism. Much like the blood miracles of Christian incarnational theology, the ancient hermetic science of alchemy provided Sweeney with a

compelling image of a transmutational creative practice in which multiple states of being became simultaneously visible within the unified field of the artwork. Indeed, fire can be seen as the ultimate apophatic medium, as it burns away old conditions while creating new possibilities of expression.

Once again, the mystical terminology in play requires some explication. According to the *Oxford English Dictionary*, alchemy is "the chemistry of the Middle Ages and 16th century. It is now applied distinctively to the pursuit of the transmutation of baser metals into gold, which (with the search for the alkahest or universal solvent, and the panacea or universal remedy) constituted the chief practical object of early chemistry." The second entry in the *OED* defines alchemy as "Magic or miraculous power of transmutation or extraction."[41] Building on these themes, Sweeney began the Burri catalogue by quoting a cryptic line from a medieval alchemical text that evoked mythical creatures and magical transformations: "The asshes of a cokatrice be acountyd good and proffytable in working Alkamye."[42] According to the *OED*, this enigmatic phrase appears in John de Trevisa's translation of the fourteenth-century monk Bartholomeus de Glanvilla's *De proprietatibus rerum* (Treatise on the Properties of Things). As Sweeney observed: "Artists have always been the true alchemists in their transmutation of base metals. Sewed gunnysacks were once enough for Burri. Now in keeping with the tradition of the 'Egyptian art' he has called in fire. And in his 'combustioni' he gives us the contrasting black earth of the Nile, which was Khem, and the pale desert sand, with the red of the flame occasionally licking through and the white of the ash beneath and around."[43]

The British critic, poet, and curator Herbert Read echoed these ideas in his introduction to the catalogue for the "Alberto Burri" exhibition at the Hanover Gallery in London (March 29–April 29, 1960). Like Sweeney, Read emphasized themes of corporeal miracles and alchemical transformations in Burri's artworks. In particular, Read observed that Burri stitched his burlap sacks "as a surgeon sews up incisions or wounds. The cicatrices were somehow expressive of where pain had been, of where miraculous healing had taken place. ... Whatever he does–and this is the wider aesthetic significance of his work–his sensibility dominates the intractable material, to such an extent that a transmutation takes place, an alchemical process in which rubbish is redeemed in the alembic of the artist's

sensibility, to become the 'perfect body' of a work of art. I could carry this alchemi-
cal analogy much farther, for art has always been a kind of alchemy, and the work
of art a 'treasure hard to attain.'"[44]

Such an analogy proved especially effective in describing Burri's *com-
bustioni,* or burnings–collages in which the artist employed fire as an agent of
creative destruction and destructive creation. In 1956 Burri began to scorch wood
to produce his *legni,* or compositions in wood. Sweeney exhibited a selection of
the *legni* at the 1957 Carnegie show, and slightly later he acquired an easel-sized
collage in wood and canvas for the MFAH's permanent collection (figure 4.3,
plate 3).

Among Burri's artworks, the *legni* display a strong thematic resonance
with the *sacchi.* In both instances, he salvaged discarded materials (burlap sacks
or wooden crates)–disintegrating containers that featured distinctively battered
and rough-hewn surfaces–and integrated their disparate elements into the uni-
fying framework of his collages.[45] Paradoxically, his arrangements of individual
wooden scraps create a sense of compositional integrity without sacrificing the
distinctively fragmented qualities of the split wooden pieces. Tonally, the cracked
strips of the *legni* range from weathered white to honeyed brown to deep amber,
while the craggy fiber of the wood grain appears in an assortment of rippling, stri-
ated patterns that have become increasingly pronounced with age. Just as the *legni*
are formally united within the frames of the collages, the uneven contours of the
boards' jagged silhouettes are heightened when displayed against the contrasting
dark backgrounds of the canvases. Similarly, while the *sacchi* are sutured together
with coarse thread, the individual segments of the *legni* are conjoined by metal
staples, fasteners that represent sites both of breakage and of joining, uniting the
boards even as they emphasize their individual state of fragmentation.

Besides the existential traces of wear and tear, Burri incorporated a fur-
ther element of creative destruction into the *legni* as he selectively burned sections
of the wood, producing charred ovoid forms that roughly mirrored the circular
patches on the burlap sacks. Reflecting on Burri's imaginative experimentation with
fire, Sweeney described the *combustioni* as aesthetic translations of an alchemical
process. Just as the dark, painted backgrounds of the collages were characterized
as "the contrasting black earth of the Nile," the lighter-toned wood became "pale

desert sand," and the red and white burn marks the residual embodiments of the lingering traces of fire, of "flame occasionally licking through and the white of the ash beneath and around."

Building on Sweeney's themes, *Houston Post* art critic Eleanor Kempner Freed similarly emphasized the MFAH *legno*'s conjoined associations of abstraction and embodiment: "This work has thin sheets of wood, interestingly veined, attached to a black ground. There are two large gaping holes with black charred circles and blood red interiors. Burri, an Italian surgeon in World War II, did not start to paint until he became a prisoner of war in Amarillo, Texas. Much of his work contains design references to incisions and injuries."[46] A circular burn mark appears in the lower-left section of the composition, spanning the surfaces of two boards. In this evocative detail, fire serves as a locus of the *coincidentia oppositorum*, a force that destroys yet also conjoins. In both this burn mark and another positioned on the right-hand side of the composition, the charred wooden sections appear as reversed haloes, apophatically marking the presence of a flame that is known through the lingering traces of its absence. Just as the dark accents of the burnt haloes visually intertwine the various scorched areas of the boards, they also resonate tonally with the dense painterly background that provides the underlying foundation of the collage. And much like the metal fasteners that conjoin the individual wooden strips, the inverted haloes display a powerful form of apophatic creativity, as forces that appear to be breaking substances apart paradoxically hold them together.

Burri's experimentations with fire as a medium of creative destruction were not limited to the *legni*. Another collage that Sweeney acquired for the MFAH, *Bianco B.4* (1965, figure 4.4), exemplifies Burri's *plastiche*, a group of *combustioni* that the artist created by burning plastic on canvas.[47] This artwork features scorched, transparent sheets of plastic set over white composition board mounted on a pine stretcher. In 1962, Harriet Janis and Rudi Blesh offered an informative discussion of Burri's various combustion collage practices:

A *grande combustione legno* consists of thin strips of wood scarred with holes burned by a blowtorch then "healed" by being fitted back together in a manner suggesting the sewing of wounds and splints for bones.

The collages of burned paper called *combustioni* must be considered one of the most original technical concepts evolved in modern art. Holding a sheet of paper, Burri ignites it at one corner and then, as it bursts into flame, allows it to fall upon the surface that will form the background. This surface has been prepared by heavy coating with a slow-drying, noninflammable vinyl plastic. Settling into this wet plastic, the paper burns itself out and congeals into the chance arrangements it assumed in fire and fall. The whole is then fixed with more of the colorless, transparent vinyl. Accident, crisis, and healing are perfectly symbolized in abstract pictorial terms in the *combustioni*.[48]

While the burn marks of the *legni* appear against the relative solidity of dense wooden planes, the delicate vinyl surfaces of the seared *plastiche* are contrastingly thin, fragile, and transparent. However, both bodies of artwork turn on paradoxical creative processes of addition through subtraction, inscription through erasure. In short, the *combustioni* vividly embody the apophatic aesthetics of making through unmaking. The collage *Bianco B.4* displays voids hovering allusively within other voids, marking the site where one surface has burned and fused with another, as solid matter and molten plastic became fluidly interchangeable.[49] Notably, the term *bianco* not only signifies "white" but also "clean" and "empty," adjectives that express the artwork's creative point of origin: a pristine void composed of multiple layers of whiteness, the uppermost strata of which is a textured sheet of translucent plastic.

In striking contrast to this expansive blankness, the charred, blackened patch that runs vertically through the center of the composition suggests a keyhole or a doorway, a potential point of entry like an opaque opening. The uppermost sheet of plastic is noticeably warped and buckled, its shimmering, contoured surface pulling inward to create a wrinkled pattern that corresponds to the place where burning matter fell on the smooth plastic sheet. This darkened swath marks the internal path cut by flames through a translucent field of whiteness. This strip is mottled and uneven, appearing lighter along the top and becoming heavier and denser as the burning progressed. A pale orange seam hovers at the center of the composition, a charred aureole that suggests an opening nestled precariously within an opening.

While wholly abstract, *Bianco B.4* is intensely evocative: in the concave creases of the artwork, a central void appears as a dark slit flanked by two adjacent, white wings. Thus, much like the sutured burlap fabric of the *sacchi* or the scorched wood of the *legni*, the transparent, charred surfaces of the *plastiche* appear as surrogate skins that clothe and animate the symbolic bodies of the artworks. Yet Sweeney notably invested this body of work with decidedly gendered connotations. In the MFAH catalogue, he described the seared surfaces of the *plastiche* as "almost feminine in their savage sensibility."[50] Implicit in his comment is the notion that these works evoke a transgressive, veiled feminine space, a highly abstracted yet curiously archetypal vaginal structure, such as one encounters in Courbet's iconic *Origin of the World* (1866, figure 4.5).[51] In both its abstract and iconographic incarnations, a dark, occluded opening draws the viewer's gaze inward toward imaginary depths that represent a generative point of origin. Significantly, the burnt halo appearing in *Bianco B.4* both reproduces and inverts these associations, as this darkened passageway simultaneously represents the incendiary beginning of the artwork and its creatively destructive end. In both instances, Burri's collages incorporated these ambivalent associations so powerfully that negative and positive spaces became intimately intertwined and ultimately interchangeable, just as solid matter became fluid when touched by a flame whose presence was both consumed and consuming.

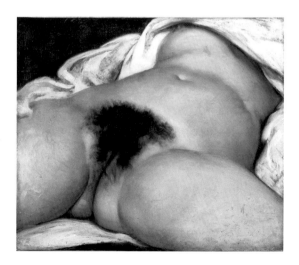

4.5 Gustave Courbet, *The Origin of the World*, 1866. Oil on canvas. Photograph: Hervé Lewandowski. Musée d'Orsay, Paris. Réunion des Musées Nationaux/Art Resource, NY.

The Irreducible Presence of the Light Inside

**The sacred is exactly comparable to
the flame that destroys the wood by
consuming it.** [52]
–Georges Bataille, *Theory of Religion*

Whether the redemption of symbolically torn or burned flesh in the *sacchi* or the *plastiche*, or the alchemical transmutation of earthly matter in the *legni*, Sweeney identified a process of aesthetic transformation in Burri's artworks that was achieved through purifying encounters with wounds and flames. His engagement with these themes did not begin with the visual arts, however, but with the literary criticism that he produced during the early forties. Indeed, his most extensive critical exploration of these mystical concepts can be found in his analyses of "East Coker" and "Little Gidding," the second and fourth poems that comprise T. S. Eliot's *Four Quartets*.

Just as art historians and critics have widely acknowledged the significance of Sweeney's writings on Burri, literary scholars have similarly recognized his mystical interpretations of Eliot. Perhaps most notably, in the introduction to her *T. S. Eliot's Negative Way* (1982) Eloise Knapp Hay suggests "that we consider this challenge [of Eliot's poetry] under two headings, both signaled by the poetic phrase 'the negative way,' which James Johnson Sweeney taught us to take as the key to Eliot's culminating poem, *Four Quartets*."[53] In turn, Sweeney's early literary essays shed valuable light on his interpretations of modernist artists.

The centerpiece of Sweeney's analysis of Eliot's "East Coker" is the mystical phrase "In my end is my beginning." Variations of this aphorism appear at the beginning and the end of Eliot's poem, where they evoke a sense of both difference and continuity situated within multiple conceptions of time and being. Tracing the recurrence of the phrase throughout "East Coker," Sweeney noted that versions of this theme also appear as a motto embroidered on the chair of state of Mary, Queen of Scots; in the pre-Socratic writings of Heraclitus, the "philosopher of flux and fire" (in Sweeney's translation: "The beginning and the end are common"); and in the negative theology of the Christian mystic St. John of the Cross (1542–1591).

As Sweeney observed, throughout Eliot's poem "we find this theme given two contrasting interpretations: a spiritual one, and a material or temporal one." While the "end" or goal of spiritual seeking "is the knowledge of the Divine Order, or God, which can only come by intuition, through love," the worldly interpretation "stresses the cyclic nature of history, the temporality of material achievement, and the mortality of man."[54]

According to Sweeney, in "East Coker" Eliot situated the conjoined oppositions of body and spirit, darkness and light, endings and beginnings in the mystical journey of "*The Dark Night of the Soul*, that passive night, that intense purification with which God, according to St. John of the Cross, visits the soul."[55] The end of the process—which is marked by both "agony" and "purity of vision"—represents a new beginning, a "rebirth" into a transformed state.[56] According to both the poet and the saint, the path through the dark night takes the form of the *via negativa*, the "negative way" of affirmation through negation, of knowing through not knowing. The *via negativa* thus encompasses an experience of unity beyond duality, a *coincidentia oppositorum* that is expressed through the paradox of the infinite enclosing the finite. Discussing Eliot's poetic engagement with negative theology, Sweeney quoted lines from "East Coker" that were directly based on the teachings of St. John of the Cross: "In order to arrive at what you do not know / You must go by a way which is the way of ignorance."[57] For Eliot and for Sweeney, modernist aesthetics served as a powerful medium for expressing such conceptions of apophatic transcendence—the knowing of unknowing as a state in which presence and erasure, darkness and light ineffably become one. "In my end is my beginning."

Sweeney extended his reading of Eliot's engagement with the *via negativa* in his analysis of "Little Gidding." Quoting the study *Dante and Aquinas* (1913) by the English theologian, economist, and literary critic Philip H. Wicksteed, he observed that the "followers in the *via negativa* 'taught that the return of the soul to God (its end and its beginning) is effected by successive denials and abstractions: the initiate must leave behind all things both in the sensible and in the intelligible worlds. Only in this way will he enter that darkness of nescience that is truly mystical—the "Divine darkness" which surrounds God, the absolute No-thing which is above all existence and all reason,' that unimaginable summer beyond sense, that is inapprehensible."[58] In Sweeney's early readings of Eliot and St. John of the Cross,

the way through the darkness entails a purifying process of fleshly renunciation, expressed through the symbolic imagery of wounding and flames. As Sweeney noted, "Eliot feels with St. John of the Cross that we must undergo not only the mortification of the flesh by *The Ascent of Mount Carmel* but also the trial of *The Dark Night of the Soul*, before we can hope for that perfect union of the soul with God in love, and for the divinization of all our faculties described by St. John of the Cross in *The Spiritual Canticle* and *The Living Flame of Love.*"[59]

In Sweeney's reading of Eliot's modernist poetry and Christian mystical literature, the body and the world are characterized as breaking apart in order to be reconfigured anew, transformed through the fiery piercings of wounded flesh and intense, consuming flames that burn away impurities to affect a kind of spiritual alchemy. Sweeney moreover notes another thematic conjunction of Heraclitus and St. John of the Cross that recalls Burri's own practice as a "poet-surgeon." As Sweeney remarked, "we have another echo of Heraclitus: 'The physicians, therefore . . . cutting and cauterizing, and in every way torturing the sick, complain that the patients do not pay them fitting reward for thus effecting these benefits–and sufferings' ([*Fragments*], 58). The soul, according to St. John of the Cross, during *The Dark Night* is 'under medical treatment for the recovery of its health, which is God Himself.'"[60] In each of these examples, the *via negativa* marks a trajectory of experiential and corporeal abstraction as a contemplative route to mystical consciousness. Notably, Sweeney later extended and inverted these themes as he enlisted mystical experience as an interpretive framework for advanced modern art. In the aesthetics of the *via negativa*, the formidable unforming that underpins self-abnegation could thus be seen as an instrumental path of creative self-production.

A decade and a half after his critical readings of "East Coker" and "Little Gidding," Sweeney embraced the evocative power of negative theology as a compelling interpretive framework for Burri's apophatic artworks. Indeed, in Burri's creative corpus Sweeney identified a union of mystical ways. In the sensuous presence of the artworks' physical structures, he perceived a kataphatic or affirmative way, while in their simultaneous dissolution and destruction he saw apophatic expressions of unmaking, unsaying, and unknowing. While Burri largely refused to speak about his own artworks, affirming instead their "irreducible presence"

as "a reality that I cannot reveal in words," Sweeney said the unsayable as he described interiors becoming exteriors, the mundane becoming mystical, and ends becoming beginnings, as abject physicality died and became reborn in an overflow of light bleeding through matter.[61]

It is precisely here, in the illuminated metaphors of interior vision, that the laconic Burri's own words are especially suggestive. Just as, early on, the artist affirmed the "irreducible presence" of his painting as "both immanent and active," he later emphasized the instrumental role of his artistic materials in expressing his vision of internal light. In an interview that Hunter Drohojowska conducted in Burri's studio outside of Perugia (1990), the artist commented: "A true painter doesn't need perfect light in the studio. It's the light inside that he wants. I'm not an Impressionist painter who needs the colors of nature. All my colors come from inside."[62] Thus at the end of his career, the artist again evoked a *coincidentia opposi- torum* that emerged through an interchangeable series of boundary crossings, as he affirmed the intrinsic power of interior vision to produce an external embodi- ment of "the light inside."

Inverted Endings: Grounding the Sky

In another fluid categorical transgression between subjects and objects, the human and nonhuman realms, Sweeney described Burri's artworks themselves as symbi- otically merging with their viewers. Throughout his texts, Sweeney characterized Burri's abstract compositions as symbolic analogues of human subjectivity that encompassed the physical, intellectual, and emotional spheres. In the Carnegie Institute essay, Sweeney posited that the "sensuality in Burri's approach does not in any way preclude an elegance or intellectual organization in the final product. As a matter of fact these are both striking characteristics of all that is most character- istic of Burri." As a result, "an unashamed, natural sensuality [becomes] both con- trolled and refined by an intellectual ideal for his work."[63] In the MFAH exhibition catalogue, he observed that "three characteristics may be said to dominate Burri's work throughout his mature career to date: the carnality of his surfaces, with their fleshiness slashed, scarred, sewed, or bleeding that is almost embarrassing; by the serenity of his structural organizations on a rectilinear base; and the overtone

of quiet sadness in his rhythms and his colors."[64] Through this expressive group-
ing, Burri's abstract compositions were thus made to correspond to the vulnerable
surfaces of the body, the analytic rationality of the intellect, and the poignancy of
affective emotion.

Moreover, these categories were not presented as isolated or fragmented
attributes, but as holistically interwoven aspects of Burri's ambivalent practice.
That is, just as the destructively creative processes of cutting and stitching, burn-
ing and melting, served as catalysts for fluidly transitional states of being, so the
complex surfaces of his artworks were identified as generative locations where
an element alchemically fused with its opposite. And just as the evanescent, tran-
sitional states of wounding and healing, burning and melting became visible on
the seemingly stable surfaces of the collages, so these transmutational processes
marked the shifting, internal midpoint of the *coincidentia oppositorum.*

According to Sweeney, Burri achieved these effects by actively collabo-
rating with his artistic materials. As he wrote in 1957, "Burri enjoys his art like
every other true artist. He plays in it: plays with the materials he employs, allows
them to play with him, to collaborate in the final expression, even to dictate some
of the forms which seem his most personal."[65] In 1963 he added that "the materi-
als he employs become almost animate in their expressiveness."[66] Burri's artistic
materials thus seemed imbued with a sense of agency that made them appear
animate and alive, just as the surfaces of the works became the active sites of a
collaborative encounter. Again evoking Burri's former career as a surgeon and the
burlap sacks as symbolic, wounded flesh, Sweeney opened the MFAH catalogue
with a play on the doubled meanings of the French verbs *penser* (to think) and
panser (to bandage or bind, as one would a wound), quoting a line from the poet
Arthur Rimbaud's letter to his teacher, Georges Izambard: "C'est faux de dire: Je
pense. On devrait dire: On me pense." (It is wrong to say: I think [my thoughts].
One ought to say: They think me/They bandage [or bind] me.)[67] Following this
epigraphal slippage between thought and flesh, expansion and containment,
Sweeney continued:

Before a painting by Alberto Burri, as in Rimbaud's poem and his play on the words "penser"
and "panser," one does not think, one is fed.–Or at any rate one is fed first.

The impact of a picture by Burri is primarily sensuous. More than sensuous, Burri's painting is carnal. But what holds us after the first impact is an inherent order that is never flawed, that seems to come spontaneously from the artist and remains as a framework, a pattern which holds the observer's attention while he continues to be fed. Gradually he begins to think about what is feeding him and, through thinking about it, becomes intimate with it, until eventually he becomes merged with it in his enjoyment.[68]

Thus, just as Burri's artworks were presented in animate terms as presences that conjoined body, intellect, and emotion, notions of intermediacy and immediacy became similarly transposed to produce a complementary conception of aesthetic nonduality, as viewers became one with the artworks they encountered. Through such imaginative processes of looking, feeding, thinking, and ultimately merging, the spectator experienced a state of intimate conjunction, reaching a place where communication became communion and the self became one with what it saw. Once again this apophatic aesthetic formulation melted any discrete boundaries between self and other, exterior and interior, beginnings and endings, as intrinsicalness and alterity became assimilated through the gaze that transcends the gaze.[69]

In addition to evoking these mystical states textually, Sweeney implemented them physically in the installation strategies that he adopted in the "Alberto Burri" retrospective in Cullinan Hall (October 16 to December 1, 1963, figure 4.6). While the Carnegie Institute exhibition had included thirty-nine artworks, all dating from a relatively narrow six-year period (1951–1957), the Houston exhibition featured fifty pieces that Burri produced between 1948 and 1963. Walter Hopps hailed the retrospective as "a stunning success" in Pasadena, yet the reviews in Houston were mixed. Writing in the *Houston Chronicle*, Ann Holmes contextualized Burri's career and offered advance praise for the "exhibition in Houston– comprising 50 paintings–[which] will be the largest group of Burri's works seen in the United States to date."[70] In *Artforum*, Charlene Steen admired this "highly significant" exhibition, in which "every selection, without exception, is a major one." Steen concluded that, "viewed in its entirety, the Burri exhibition really is impressive, for it shows the artist's organized and comprehensive explorations into a wide variety of media resulting in consistent[ly] personal, potent expressions."[71] In the

4.6 Installation photograph of the exhibition "Alberto Burri," 1963. Photograph by Hickey & Robertson. Museum of Fine Arts, Houston Archives.

Houston Post the conservative Campbell Geeslin, however, expressed a decided distaste for Burri's raw and challenging compositions, flatly stating, "I find that, like many of the works which Mr. Sweeney has acquired for the Museum of Fine Art[s], Burri's fabricated objects are exceedingly decadent." The critic objected both to Burri's debased materials and to his apparently unrefined craftsmanship, calling "his sewing inept, his welding crude. Fragments of thin wood are stapled onto some of the pictures. There is little refinement in technique." Yet at the same time, Geeslin was oddly prescient in his condemnation of Burri's "decadent" paintings; indeed, the critic unwittingly paraphrased Sweeney's own Heraclitean rhetoric in commenting that "Burri's work seems quite clearly to be the end rather than the beginning of something." Despite his professed distaste for Burri's collages, Geeslin conceded that "the exhibit looks splendid in Cullinan Hall. That room is so pre-

cise and perfect that it lends authority to anything that is set down in it. The more uneven and unpolished and crude the work is, the more the setting does for it."[72]

Indeed, the Burri exhibition was aesthetically striking, all the more so because it marked one of the first times that Sweeney adopted his signature installation technique of suspending artworks from the ceiling. As period display photographs reveal (figure 4.6), Sweeney hung Burri's paintings from slender nylon wires embedded in the ceiling. The paintings were presented in three successive levels of receding depth, as well as more traditionally secured to the gallery's perimeter walls. This novel arrangement invited the imaginative experience of paradox, as viewers encountered solid objects ethereally hovering in the open, illuminated spaces of the gallery.

Sweeney's installation was significant not only from a curatorial perspective but from a philosophical one as well, as the show materially and conceptually restructured the familiar phenomenal relations between figure and ground. With the paintings levitating from the floor yet anchored in the ceiling, Sweeney's display offered a suggestive parallel to the processes of conversion and transformation that he had identified within Burri's works themselves. As we have seen, Sweeney and other contemporary critics emphasized the material debasement and carnal sensuousness in Burri's compositions—qualities that encompassed the lacerated and sutured surfaces of the burlap *sacchi*, the seared wooden *legni*, and the "savage," transparent *plastiche*[73]—yet saw them as retaining and transmuting these raw visceral associations, so that abject physicality became united with the elevated and spiritual. Thus both formally and philosophically, Burri's apophatic artworks simultaneously pointed to the ground and to the sky, transposing and exchanging the two so seamlessly that they continually turned back on themselves.

Through the curatorial alchemy of his installations, Sweeney transformed the MFAH itself into an ambivalent site of affirmation and reversal. That is, he presented the gallery as a symbolic point of entry into visionary experience, an ascent into an ethereal realm through the aesthetics of the *via negativa*. By artfully inverting accustomed figure/ground relations, Sweeney's hangings can be seen as the curatorial equivalents of a mystical paradox. By lifting the paintings off of grounded walls and securing them in the ceiling, he transposed the familiar relations between the earth and the sky. The luminous, shifting reflections appearing

on the museum's highly polished terrazzo floor further contributed to the impression that viewers walked not on the ground, but in the heavens.

Thus the visual effects of Sweeney's installations can be seen as evoking the ancient cosmological concept of the firmament, the sphere that separates yet conjoins the earth and the heavens. Various biblical and classical sources describe a mystical journey of ascent that entails standing on a glittering floor, a surface that resembles water or crystal but which is solid, while looking down through the transparent air of the firmament.[74] As floors became ceilings and ceilings became floors, Sweeney's exhibitions provided a template for recreating mystical experiences through the dynamic interchange of the terrestrial and celestial domains. With the earth raised to the sphere of the heavens, entering his installations thus entailed crossing a threshold into a world that grounded mystical aesthetics in the museum, just as it placed viewers' feet in the sky.

5

Illuminating the Void, Displaying the Vision:
Pierre Soulages

The White Cube as the Modernist Period Room

As the discussions of Duchamp and Burri demonstrate, a powerful paradox seems to underpin our ongoing cultural fascination with modern art. While the modern period produced some of the most conflicted, fragmented, and alienated of art forms, the public display of modern art seems to reaffirm the considerable extent to which museums function as numinous sites of aesthetic contemplation within our secular culture. A *New Yorker* cartoon (February 28, 2005) turns on this paradox. A group of people is visiting an exhibition of abstract paintings; as the viewers circulate through the show, the pictures become progressively lighter in tone, until, having reached the end of the exhibition, one man sinks to his knees before a pure white canvas, seemingly overcome by its spectacular display of pristine blankness.

5.1 Installation photograph of "Pierre Soulages: Retrospective Exhibition," 1966. Photograph by Allen Mewbourn. Museum of Fine Arts, Houston Archives.

The artist employs gravity and levity to comment on the various shades of gray associated with gradations of cultural illumination. While this cartoon appears within postmodern visual culture, the conception of the museum as a secular temple of art represents a trope of modernism in general and of Sweeney's literary and curatorial practices in particular—perhaps nowhere more explicitly and ambivalently than in his engagement with Pierre Soulages.

In addition to authoring two monographs on this artist, Sweeney staged the first comprehensive retrospective exhibition of Soulages's work in the United States.[1] "Pierre Soulages: Retrospective Exhibition" was held at the MFAH from April 20 to May 22, 1966 (figures 5.1, 5.9). In various ways, this show exemplifies Sweeney's paradoxical approach to the sacred aspects of modernist aesthetics. As against dimly lit period room reconstructions of a temple or chapel, installation

shots of the Soulages exhibition reveal the white walls and dynamic floating light surrounding Sweeney's elegantly spare modernist arrangement in Houston. This mode of display can be seen as the modernist equivalent of the museum period room, even as its purposeful decontextualization makes it the very antithesis of a traditionally reconstructed religious setting. Instead of recreating the venerable darkness of a sacred void–a recurring typology in many traditional religious set-tings–Sweeney cultivated the creative possibilities of international modernism's signature style, in which transparent glass walls served to frame a pristine white cube.[2] In his installations, Sweeney transformed the illuminated absences of the open "negative" spaces of the gallery into a crystalline container for the palpable presences of modernist artworks–a luminous void to frame modernism's simulta-neous expressions of categorical transgression and aesthetic transcendence.

Of his relationship with Sweeney, Soulages recounted: "I first met James Johnson Sweeney . . . just after the war. He was the first museum director who ever came to visit me in my studio."[3] Sweeney included Soulages's dark abstract gesture painting *May 1953 (Peinture, mai 1953)* in the "Younger European Painters" show that he assembled at the Guggenheim Museum (1953, figure 5.2).[4] As the critic and curator William Rubin appreciatively remarked, "it was under the aegis of Guggen-heim director James Johnson Sweeney that a number of the now best-known Euro-pean painters were introduced to the New York art world."[5] Sweeney also acquired *May 1953* for the museum's permanent collection, as well as a second painting by Soulages, *November 20, 1956*, which he purchased four years later. Sweeney included *May 1953* in the "Images at Mid-Century" exhibition that he organized at the University of Michigan's Museum of Art (April 13 to June 12, 1960), while addi-tional works by Soulages were featured in the Guggenheim International Award exhibitions of 1958 and 1960.[6] In 1962, one of the paintings included in the latter show, *March 14, 1960*, entered the Sweeney family's personal art collection, where it joined a second painting by Soulages, *August 27, 1961*, which Sweeney had pur-chased the previous year.[7] Notably, both pictures, along with the two that Sweeney had acquired for the Guggenheim, would be prominently exhibited in the Soulages retrospective in Houston.[8]

Sweeney and his wife Laura also shared a longstanding friendship with Pierre and Colette Soulages. During the sixties, the two couples traveled extensively

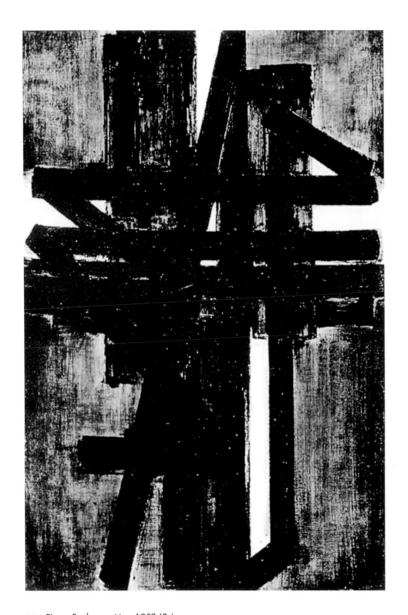

5.2 Pierre Soulages, *May 1953* (*Peinture, mai 1953*), 1953. Oil on canvas. 77 3/8 × 51 1/4 inches (196.5 × 129.9 cm). Solomon R. Guggenheim Museum, New York. 53.1381. © 2008 Artists Rights Society (ARS), New York/ADAGP, Paris.

together around France, and they visited one another's homes in Paris and Ire-
land. The characteristic warmth of their interactions is expressed in a March 13,
1962 letter in which Sweeney thanked the Soulages for their kindness and for "the
enjoyment we have always had with you," and closed by sending "All our love to
you both. As ever, James Johnson Sweeney."[9]

The Soulages retrospective at the MFAH included seventy-seven artworks,
ranging from paintings and drawings to prints and etching plates. Typically of
Sweeney's museum events, this exhibition was imbued with an aura of glamour
and cultural cachet, reflecting modern art's status as a cultural spectacle. Pierre
and Colette Soulages flew in to attend the opening, and various social activities,
including a formal dinner, were planned in conjunction with the event. The indi-
vidual lenders to the exhibition included such Hollywood celebrities as the film
director Otto Preminger and the musical composer Richard Rodgers, the latter a
social acquaintance of the Sweeneys. Thus when Sweeney asked to borrow the
Rodgers' painting *February 13, 1960*, Dorothy Rodgers not only agreed to the loan
but cordially told Sweeney, "We miss you in New York but I hear you are doing an
outstanding job for Houston."[10]

Sharing his memories of the show, former museum registrar Edward
Mayo emphasized that Sweeney "had an impeccable eye, and he personally
placed every object in an exhibition, down to a gnat's eyelash. He would move
a painting one-eighth of an inch, and everything would fall into place."[11] Under
Sweeney's direction, the museum's interior walls and ceiling were painted bright
white, and the galleries were adorned by the occasional presence of a carefully
sited potted plant. As with the Burri exhibition, one of Sweeney's most striking
curatorial strategies was to present Soulages's paintings both in a traditional
manner, hanging from the walls, and in the more unaccustomed mode of being
suspended from the ceiling on slender nylon wires. As Mayo commented, "That
was probably the one thing [Sweeney] did that made his exhibitions closer to
unique than anything else."[12]

Elements of Sweeney's suspended installation technique seem to have
been anticipated by the architect Mies van der Rohe himself. In his illustration
of a "Museum for a Small City" (*Architectural Forum*, May 1943), Mies presented

a museum design that featured a flexible open floor plan. As he explained, this approach allowed sculpture to be viewed against the local landscape formations that would be visible through the gallery's plate glass outer walls, transparent expanses whose surfaces were supported by a steel frame construction. While Mies himself did not propose suspending paintings from the gallery's ceiling, he did envision that "small pictures would be exhibited on free-standing walls." Along these lines, as part of the original design of Cullinan Hall, Mies had devised mobile partitions for hanging paintings in the gallery's curatorially challenging, open interior space. Yet Sweeney found these partitions awkwardly proportioned and unworkable, and he quickly discarded them in favor of his suspension hanging method.[13]

Thus, while there are certain suggestive precedents in Mies's earlier installation designs, Sweeney apparently devised this innovative hanging technique in conjunction with Tom Deer, who then served as the MFAH's building superintendent.[14] The artist Richard Stout, who was employed at the MFAH and personally assisted Sweeney in exhibition installations, has noted that, while Sweeney's approach was consistent with Mies's design, it was the curator who made the final decisions about the hangings. As Stout explained, Sweeney always considered the placement of the artworks as they would appear from the front of the gallery. As a result, Sweeney was "strict in his ways of installing, and very inventive," as the exhibitions represented a form of "choreographed balancing." Stout incisively observed that Sweeney "thought of the gallery as a chess set," in which the individual artworks were like "chess pieces seen from God's point of view." From this symbolic perspective, the gallery installation could be envisioned as a kind of "orchestration that leads to unorthodox conclusions."[15]

As period installation shots reveal, at the MFAH Sweeney hung Soulages's paintings three rows deep, floating in planes that ran parallel to the back wall of the gallery. Suspending the paintings from the ceiling allowed him to display a comparable number of artworks while preserving the sense of openness that was essential to the gallery's modernist ambience. As Sweeney himself noted, through this mode of display, the luminous interior volume of Mies's architectural space was itself exhibited as a work of modern art.[16]

The Apophatic Void of the Romanesque Church

Once again, Sweeney's progressive curatorial vision found a complementary mode of expression in his writings. Sweeney commented at length on the creative processes underpinning the production of abstract painting, particularly the ways in which formal elements of pattern and light converged with psychic structures of memory, consciousness, and intuition.[17] Citing Soulages's work as a prime example of these processes, Sweeney emphasized the generative connection he perceived between the artist's wholly abstract gesture paintings and the consecrated spaces of Sainte-Foy de Conques, the twelfth-century Romanesque pilgrimage church near the artist's hometown (figure 5.3). Sweeney recalled their joint visit to this site:

Saint Foy is an austere Romanesque structure with a profound interior space, heavy masculine columns, a rich darkness, cut by almost straight beams of light falling from the high triforium windows. I was standing in the back of the church admiring the mystery, power and drama of the vaulted apse, the dark stone and the contrasting shafts of honeyed light, when Soulages said to me, "It was just here, in this spot, that I decided to be a painter—not an architect, a painter." And I have never since seen a painting by Soulages without recognizing the memory that seems to have been bitten into his creativeness by that experience. And the recognition of it has always helped me to come closer to his work.[18]

Sweeney noted the intimate relations between the consecrated architectural spaces of Sainte-Foy and the radiant tonal structures of Soulages's paintings: "In Soulages' handling of his paint there is again something which recalls the warm darkness of that Romanesque interior of Ste. Foy. For there it was no dead blackness, but a live and gently palpitating dark suffused with a subtle illumination which reached its fullness in the slashes of light from the high narrow windows and the soft glow where it struck the floors and walls."[19] By highlighting the "soft glow" illuminating the church's floor and walls, Sweeney emphasized the transformation of tangible stone surfaces into patterns of radiant light. In his curatorial display in Houston, he implemented his own version of these material and ethereal transactions between painting and architecture. Elsewhere Soulages himself affirmed the formative role that Sainte-Foy de Conques played in his creative development, recalling that from an early point he "learned to look at Romanesque

5.3 Abbey church of Sainte-Foy, nave toward east. Conques, France, built 1050–1120. Photograph ©SCALA/Art Resource, NY.

art, the cathedral [*sic*] of Conques for example, where [I] was overwhelmed by the proportions of the interior."[20]

Significantly, at this interpretive juncture the tenor of Sweeney's text has become quiescent and almost mystical, as he recreates the ways in which Soulages translated the seemingly animate presence of stone and light into a comparable set of abstract painterly forms. That is, just as Soulages's abstract paintings were seen as embodying a dialogical play of "live palpitating darkness" and dramatic "illumination," so his modernist painting process itself became a metaphor for the sacred act of creation. The gendered associations ascribed to space and light are striking. According to Sweeney, the church's "profound interior" is a darkened space of generative absence, a sacred void that evokes the structures of a feminine eros. He characterized the "warm darkness" of this "vaulted" interior space as "live and gently palpitating," and noted the weighty phallic forms of the "heavy masculine columns" and the "shafts of honeyed light"–the substantial columnar bulk rhythmically alternating with ethereal illumination. Sweeney expressed his admiration for the "mystery, power and drama" he witnessed, as the cavernous nave of Sainte-Foy is "cut," "slashed," and "suffused" by this "subtle illumination," emissions of light forming a radiant presence within the darkened space of the inner void. Through this implicitly gendered *conjunctio oppositorum*, this unification of two seemingly opposite states of being, Sainte-Foy became a source of literary and artistic inspiration for both Soulages and Sweeney.

Sweeney imbued Soulages's paintings with additional sacred associations when he described them as being inspired in part by the ancient Celtic stone carvings housed in the nearby Rodez museum. As he wrote, "if Soulages recalls even today the impression made on him when he was twelve or fourteen years of age by the interior of Ste. Foy de Conques, his recollection of the sculptures, menhirs and graffiti of the Musée Fenaille in Rodez is equally deep-seated. One almost feels them behind the enigmatic vertical forms of his early paintings."[21] The gendered features of these ancient carved stones are again striking. The phallic forms of the upright stone menhirs are thought to have served as ceremonial markers of space and time, sacred associations that resonated deeply with Sweeney's discussions of Sainte-Foy and with Soulages's paintings themselves.[22] Throughout his writings, Sweeney identified such layers of archetypal convergence as carved in space and

extending through time, from Soulages's modernist abstractions to the forms of the Romanesque church and to the prehistoric archaeological artifacts of the adjacent countryside.

Well before his engagement with Soulages's paintings, Sweeney had expressed an interest in the sacred and sacrificial associations ascribed to ancient carved stones. In an early article on primitive Christian art in Ireland, he related larger patterns in Irish history and archaeology to the abstract and zoomorphic designs found in medieval Irish manuscript illuminations and in ancient stone carvings.[23] According to him, the geometric and serpentine patterns displayed in the high crosses of Ireland reflected a hybrid yet unified decorative style that subsequently served as a source of inspiration for modern artists. Sweeney returned to these themes in his and Alexander Calder's collaborative book project, *Three Young Rats and Other Rhymes* (1944, figure 5.4). In his introduction to the volume, Sweeney traced the origins of the nursery rhyme "London Bridge is broken down" to foundation sacrifices, ancient ritual offerings in which living people were buried in the foundations of monasteries or beneath temple or bridge pillars in order to propitiate a deity.[24]

Like many prominent collectors and curators of the era, Sweeney assembled extensive collections of ethnographic, ancient, and modern art, which he did not hesitate to combine in various shows (figure 5. 5). This program of acquisition and display can be placed within the context of a larger modernist project that sought to bridge the gap between Western and non-Western cultures, between ancient and modern aesthetics, through the elaboration of shared formal and spiritual qualities.[25] But the sacred conjunction of blood and stone in modern and "primitive" art were not merely fashionable tropes in modernism in general; they were historically evident in Soulages's oeuvre in particular. Not only do consummately sacrificial themes lie at the heart of the Christian incarnational theology practiced at Sainte-Foy de Conques and elsewhere, but they emerge in Soulages's personal art collection, which included an Aztec stone sculpture depicting a human skull (figure 5.6).[26] This Mexican ceremonial object would originally have served as a decorative element affixed to a platform on which sacrificial victims were displayed in Aztec religious rites. While culturally distinct in its point of origin, the carved head in Soulages's collection nonetheless evokes a familiar

LONDON BRIDGE is broken down,
 Dance o'er my lady lee,
London Bridge is broken down,
 With a gay lady.

How shall we build it up again?
 Dance o'er my lady lee,
How shall we build it up again?
 With a gay lady.

98

5.4 Alexander Calder, drawing of "London Bridge Is Broken Down," in Alexander Calder and James Johnson Sweeney, *Three Young Rats and Other Rhymes* (New York: Museum of Modern Art, 1946). © 2008 Calder Foundation, New York/Artists Rights Society (ARS), New York.

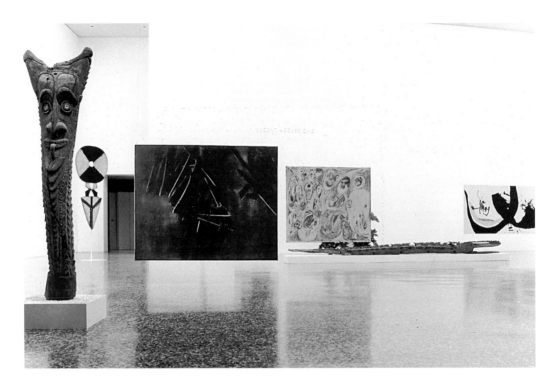

5.5 Installation photograph of the exhi-
bition "Some Recent Accessions," March–
April 1962. Photograph by Hickey & Rob-
ertson. Museum of Fine Arts, Houston Ar-
chives.

dynamic between stylized carved forms and the profoundly somatic dimensions of
ancient ceremonial sacrality. Thus, whether the underlying reference points were
seen as prehistoric, Celtic, or medieval Christian monuments, Sweeney repeat-
edly associated Soulages's wholly abstract images with the dynamic processes
of transubstantiation and transmutation, the capacity to move between and inte-
grally fuse distinctive states of form and matter. Significantly, Soulages's paint-
ings retained these sacred associations though they did not overtly reference *any*
identifiable vestiges of traditional religious iconography, situated instead within
an ongoing textual play between their symbolic reinscription and their formal
transcendence.

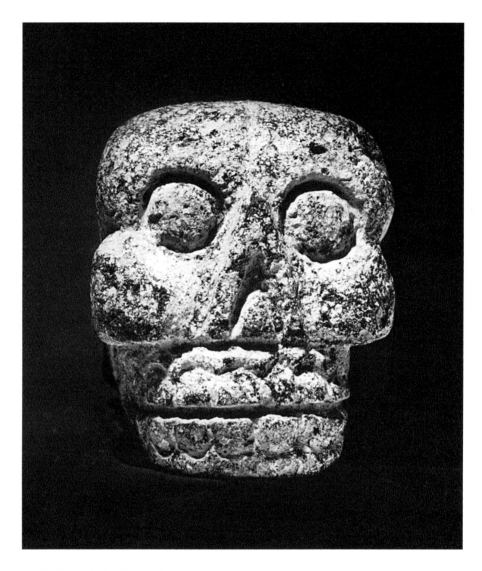

5.6 Death's head, volcanic stone, Mexico, Aztec (1300–1521). In *Arts primitifs dans les ateliers d'artistes* (Paris: Musée de l'Homme, 1967). Photograph courtesy of The Fondren Library, Rice University.

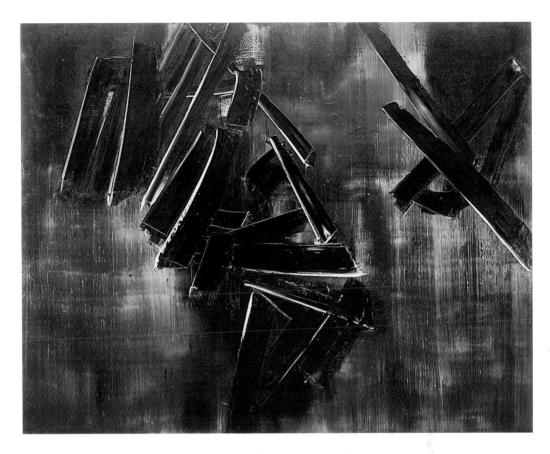

5.7 Pierre Soulages, *August 22, 1961* (*22 août 61*), 1961. Oil on canvas. The Museum of Fine Arts, Houston; Museum Purchase. ©2008 Artists Rights Society (ARS), New York/ADAGP, Paris.

The Light behind the Light: Soulages's Paintings

The two paintings that Sweeney acquired for the MFAH—*August 22, 1961* (*22 août 61*, figure 5.7, plate 4) and *July 3, 1965* (*3 juillet 65*, figure 5.8, plate 5)—not surprisingly were prominently positioned in the main gallery of the Soulages retrospective; indeed, they were among the first that viewers encountered upon entering the show. Much like Sweeney's description of Sainte-Foy de Conques, *August 22, 1961* is an abstract image that reads metaphorically as a palpitating space of illuminated

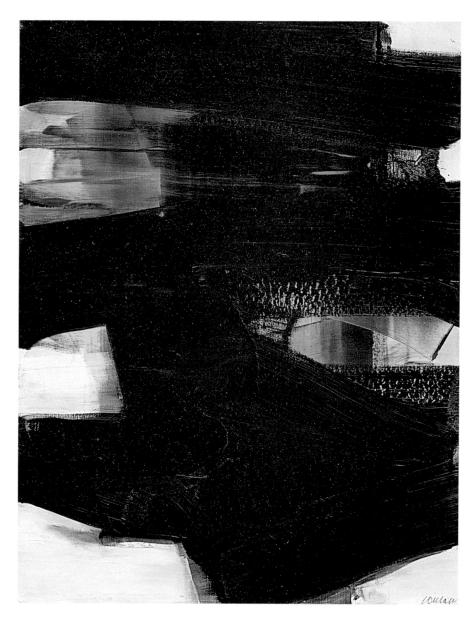

5.8 Pierre Soulages, *July 3, 1965 (3 juillet 65)*, 1965. Oil on canvas. The Museum of Fine Arts, Houston; Gift of Mr. and Mrs. S. I. Morris, Jr. ©2008 Artists Rights Society (ARS), New York/ADAGP, Paris.

darkness.[27] The picture displays a nearly monochromatic combination of black, white, and gray tones, emphatic gestural brushstrokes appearing as structurally distinct units within a dark, amorphous color field. The defining contours of these overlapping forms are accented by white stripes along their edges. The interwoven brushstrokes form black lattice patterns that collect into an arcing staircase form, as the graduated layers of paint appear to be suspended against an indefinite dark background. This interlaced strata of solids and voids evoke a kind of cosmic staircase suspended within a radiant abyss, as the viewer's gaze shuttles back and forth along an ascending and descending path of light.

The formal and metaphorical structures of *August 22, 1961* resonate strongly with Sweeney and Soulages's shared engagement with visionary architecture. In a letter to the artist dated December 15, 1967, Sweeney thanked him for sending a copy of the eighteenth-century French architect Etienne-Louis Boullée's *Treatise on Architecture*, along with the exhibition catalogue *Les architectes visionnaires de la fin du XVIIIe siècle.*[28] The catalogue featured reproductions of Boullée's fantastic architectural drawings, in which dramatic contrasts of dark and light served as the primary structuring elements of grandiose, visionary environments that were designed to lift viewers beyond the confines of normative modes of consciousness. In this, Boullée's extraordinary "mysterious light" could be seen as resonating with the fluid spatial and temporal qualities of Soulages's paintings. Sweeney made these associations explicit in his later monograph on the artist (1972), in which he described Soulages's paintings as "almost drowned in an infinitude of somber tones, but usually brightened in one quarter or another by a surprise gleam of light. And we are reminded of the statement of the visionary XVIIIth century French architect Etienne-Louis Boullée in his *Treatise on Architecture*, which Soulages admires: 'If I can prevent the daylight from arriving direct and make it penetrate without the spectator seeing where it comes from the resultant effects of this mysterious light produce a wonderful impression, a sort of magic, truly enchanting.'"[29]

While *August 22, 1961* employs primarily monochromatic means to achieve its luminous pictorial effects, the dramatic power of *July 3, 1965* is conveyed through vivid configurations of dark painterly forms that are positioned both against and within a glowing field of colored light. The most striking feature of this

painting is its heavy, purposeful massing of broad swaths of black brushstrokes. These dark tonal fields initially appear to be richly and deeply solid, their painterly density made palpable through layers of textured brushwork. On closer inspection, however, it becomes apparent that they are porous and dissolve internally to reveal lacy configurations formed by the remaining traces of broken brushstrokes. The painting's accumulated massing of dark gestural forms is thus infused with an internal *and* an adjacent sense of delicacy, as warm, transparent colors surround the determined armature of the composition, embedding the central darkness within a field of tonal radiance. These contrasts are particularly apparent in the peripheral sections of the canvas, where delicate areas of white intermingle with touches of brown and black to become transmuted into shades of cream. An additional layer of warm umber staining illuminates the painting with a kind of afterglow. Thus *July 3, 1965* can be seen at once as an abstract painting and a consummate reflection on relational states of being: an intimate merger of presence laid atop the reciprocal depths of its corresponding absence, and a sustained meditation on the color behind the color, the light behind the light.

These themes are manifested in Sweeney's curatorial presentation of these works (figure 5.9). Influenced by his longstanding relationship with the artist, Sweeney adopted an installation strategy that enabled him to curate not only the exhibited artworks but also the air and light of the gallery itself, as he "sculpted" the space around the solid matter of which the works are made. The reflections appearing on the highly polished terrazzo floor of Cullinan Hall also markedly contributed to the ethereal effects of the paintings as hovering presences suspended in a shimmering void.[30] By placing Soulages's paintings in an arrangement that alternated physical levitation and suspension with the familiar stability and materially grounded presence of the wall, Sweeney's installation raised fundamental questions about the conventions that structure the phenomenal relations between physical bodies and the spaces they inhabit.

One of the primary ways these effects were achieved was through the animated, variable presence of light. Just as Sweeney saw Soulages as translating the sacred, luminous effects of Sainte-Foy de Conques into his abstract paintings, Sweeney's discussion of visiting this site with the artist reveals his own desire to establish himself as a middleman, translating the solid matter of Soulages's

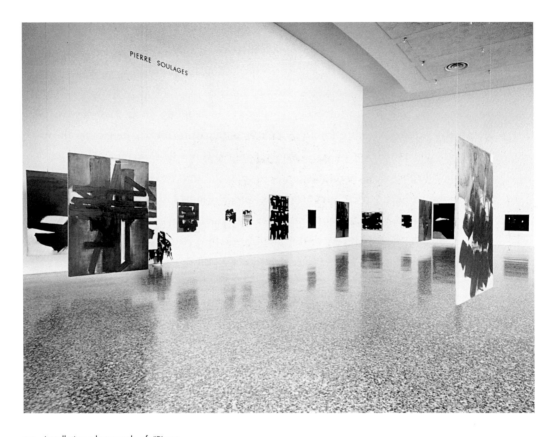

5.9 Installation photograph of "Pierre
Soulages: Retrospective Exhibition,"
1966. Photograph by Allen Mewbourn.
Museum of Fine Arts, Houston Archives.

paintings into the intangible aesthetic experience of a museum visit. As Sweeney
remarked in the French art magazine *L'Oeil*, when placed within the unique set-
ting of Cullinan Hall, "a painting by Pierre Soulages, with its simplified forms,
submits to luminous effects."[51] In the Houston museum, the gallery's ceiling illu-
mination combined with a constantly shifting play of light and shadow issuing
from the expansive glass curtain wall that comprised a prominent design feature of
Mies's facade. This protean sense of lambent illumination enhanced the paintings'
dynamic appearance in the gallery and their seemingly mystical capacity for trans-
mutation, for moving between various states of form and matter, time and space.

This expressive play between fixity and floatation was mirrored in Sweeney's writings, as he emphasized the ongoing reinscription and transcendence of the venerable reference points of the Romanesque church and prehistoric Celtic stone carvings that lay behind Soulages's abstract imagery.

Soulages himself praised Sweeney's installation. In an interview with the artist in the *Houston Chronicle*, fine arts editor Ann Holmes noted that the artist "calls James Johnson Sweeney's installation in Houston's Museum of Fine Arts the finest display of his paintings he has ever seen," and he considered Cullinan Hall to be "the most perfect spatial setting [the paintings] have ever had."[32] In a review in the *Houston Post*, Eleanor Kempner Freed quotes Soulages as telling her, "The installation comes off very well. I am fully satisfied with it."[33] More recently, the artist has noted that he and Sweeney worked together in hanging the pictures in space rather than against the walls, although it was Sweeney's idea to hang the paintings back to back.[34] Thus in the alternative, miniature world of the museum, Sweeney's carefully orchestrated presentation of Soulages's paintings let viewers immerse themselves in multiple layers of aesthetic experience. Not only could they selectively engage with the individual paintings on display, but they could also inhabit a work of art from within, as it were, as they circulated through the composite work of art that was the Soulages retrospective itself.

Interwoven Fragmentation: The "Cutting of Space into Pieces of Time"

Sweeney's suspended display of Soulages's modernist paintings can itself be seen as an abstraction of the historical museum, as Sweeney presented a curatorial metanarrative that conflated the prehistoric, the Romanesque, and the modern periods to offer viewers a sustained meditation on the fluidity of temporality and spatiality as relational states of being. As Sweeney himself was well aware, the viewer's experience in the gallery unfolded not only in space but in time. The latter emphasis is particularly appropriate, given that the titles of Soulages's paintings were based on temporal referents (the dates on which the paintings were created). Sweeney commented on the deep interwovenness of the spatiotemporal correspondences in Soulages's abstract paintings: "Soulages feels that if his paint-

ing succeeds without figurative anecdote it owes this to the importance which he gives to the rhythm—to this 'beating of forms in space,' to this 'cutting of space into pieces of time.'"[55] Thus, underpinning both the formal and symbolic structures of Soulages's paintings and the viewer's encounter with them in the museum were paradoxical conceptions of fragmentation and interwovenness, of the "cutting of space into pieces of time," as tangible objects and specific moments materialized in the museum only to appear suspended against conceptions of the transhistorical and the metaphysical. Viewed as a whole, both the works of art and the setting in which they were displayed enhanced the mystical quality of the museum visit, even as they eschewed overt references to traditional religious iconography.

The complexities associated with this exhibition raise a number of important questions about the relations between mysticism, sacrality, and the status of the museum in modern culture. As Ivan Gaskell has observed, works of art "allow a variety of modes of address," and a corresponding multivalency of associations, just as "the uses of art objects are shaped to an appreciable extent by the varied institutional contexts of these uses," either "in a sacred or a profane setting."[56] Within the museum context, the distinctions between sacrality and secularity are not prescriptively established or essentially determined. Rather, they turn on a range of historically and culturally specific issues and practices involving both curators and their audiences. Thus in the museum setting, the sacred and the secular remain epistemologically fluid rather than ontologically fixed categories. Sweeney himself recognized and productively cultivated these multivalent meanings, as he negotiated his own complex version of modernism's relation to the sacred. As Gaskell has observed, Sweeney's curatorial "practice raises the awkward question of whether there is a difference in kind between human access to a transcendent realm via religion on the one hand, and via aesthetics on the other." Gaskell concludes:

If one conceives of the sacred as concerning a relationship between humans and the divine in which the latter is an active agent, aesthetic transcendence, however spiritually enriching, will inevitably fall short of the sacred, for it brings the subject no closer to any actual deity but only to what that subject might assume to be its workings. By contrast, if one conceives of a transcendent spirituality in which divine agency is impossibly remote, the sacred and the

aesthetic can appear as good as one, and indistinguishable. Sweeney, in the case of Soulages, would seem to have propounded the latter course, contriving with great curatorial skill in his 1966 Houston exhibition to emphasize both the capacity of his museum space (by Mies van der Rohe) and Soulages's paintings together to evoke a transcendence associable in particular with the unquestionably sacred site of the Romanesque pilgrimage church of Ste. Foy in Conques.[37]

Enfolded within the specific example of Sweeney's engagement with Soulages is a larger question that recurs within modernist art history: What happens when the seemingly distinct spheres of the sacred and the profane become ambivalently constituted within the unified context of the museum exhibition? Ultimately, I believe that such a powerful aesthetic and spiritual convergence was possible precisely because Sweeney presented multiple versions of artistically numinous themes, without ever adhering to the orthodox tenets of any given religious system. Operating within this highly ambivalent modernist equation, Sweeney positioned Soulages's enigmatic abstract paintings as privileged objects of aesthetic contemplation for a culturally elite secular audience. In this way, the museum encompassed the realms of the sacred and the profane, the spiritual and the secular, while transcending *any* fixed or final demarcation between these categories. In so doing, the museum itself can be seen as an embodiment of the mystical capacity to occupy multiple conceptual domains simultaneously, and thus to serve as a powerfully convergent site of self-affirming and self-transcending spirituality.

As both the *New Yorker* cartoon and Sweeney's modernist curatorial displays exemplify, the conceptual structures of the museum can be seen as turning on a powerful paradox: its characteristic spaces of display can be envisioned as a kind of generative void that instantiates the absence that allows for presence, and the presence that allows for absence. In short, the curatorial arena can be characterized as a paradoxically kataphatic and apophatic space, a simultaneous site of saying and unsaying, of abstraction and erasure, a locus that creates the reciprocal possibilities of plentitude and emptiness, allowing equally for the palpable solidity of material surfaces and the corresponding depths of an impalpable void.

Just as these aesthetic and conceptual patterns thread through the historical record on the Soulages exhibition, they are characteristic features of mystical

discourses. Viewed in this light, the classic white cube and transparent glass walls that comprise the distinguishing features of the international modernist style in general, and of Mies's Cullinan Hall in particular, can—but need not necessarily—be seen as a quintessentially modernist version of the sacred void. When placed in broader cultural terms, this apophatic curatorial arena can be seen as empowered by the language of its own unsaying. By remaining a secular cultural space of a unique kind rather than a traditional religious site, the modern museum manifests a distinctive capacity to engender multiple significations, in part through its ability to cultivate a state of consciousness that can simultaneously be experienced as sacred and as profane. In this way, the museum suggestively offers an imaginative means of seeing beyond the seen, while sometimes negating it. And when engaging abstract paintings and sculptures in these curatorial settings, viewers often find themselves contemplating substantial surfaces that have been envisioned and instantiated as insubstantial forms, even as these forms are materially manifested as concrete sensuous presences. In so doing, modern artworks and the museum galleries in which they are displayed can be seen as suggestively imposing a form on that which has no form, thus allowing the invisible to become visible, or as Sweeney put it, revealing "the unseen through the seen."[58]

By embodying this ambivalent conceptual approach, the Soulages exhibition instantiates a larger paradox that seems to lie at the heart of much modernist museum practice: namely, the project of establishing a sense of sacredness that simultaneously asserts and erases the affective power of its own presence. This proposition at once represents a reversal and a reiteration of Sweeney's experience at Sainte-Foy de Conques. In the luminous, transparent galleries of Cullinan Hall, Sweeney presented secular modernist exhibitions in which presence and absence, revelation and concealment, could be seen as reciprocally enfolded aspects of an aesthetically informed theophany. The ever-elusive status of modernism's numinous presences thus appeared as allusive reflections of their ever-present absences.

6

Studies in Self-Creation and Creative Destruction: Jean Tinguely

Reflecting on James Johnson Sweeney's unprecedented—and often quite spectacular—efforts to bring modern art to the city of Houston, Ann Holmes, formerly fine arts editor of the *Houston Chronicle*, recalled in particular an exhibition featuring the works of the Swiss motion sculptor Jean Tinguely. The "Jean Tinguely: Sculptures" show was held at the MFAH from April 3 to May 30, 1965 (figures 6.1 and 6.2). The evening before the opening, the museum held a members' preview that included a cocktail buffet followed by an outdoor garden party, complete with discotheque. Tinguely and his partner, the sculptor Niki de Saint Phalle, flew in for the gala event. As Holmes recounted:

Sweeney did terribly exciting things that were so completely characteristic of him.... He was in Paris and he saw a Tinguely show and he thought that we ought to have this here.

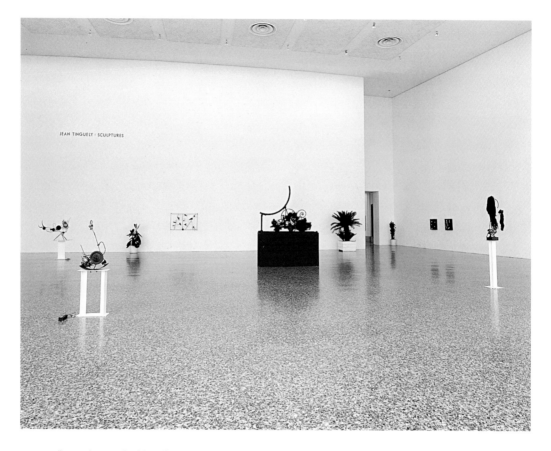

6.1 Installation photograph of the exhibition "Jean Tinguely: Sculptures," 1965. Photograph by Hickey and Robertson. Museum of Fine Arts, Houston Archives.

He called John de Menil, and John said, "Buy the whole show." I had heard that he bought eleven [motorized sculptures] and that [the dealer Alexander] Iolas gave one more for an even dozen.[1] He had this incredible opening night. I was there at the opening gun, at eight o'clock. Sweeney still had the doors closed, and he was in there making sure that every little tag, that everything was exactly right. We could see him in there making adjustments. Then he plugged everything in, and it all started going at once.

Everybody zoomed in and saw the show and went mixing in and out. And then Niki de Saint Phalle appeared in a monkey fur coat. It had long hairs, and when she moved it was exactly like one of the plug-ins. She stood there at the main door at Bissonnet Street, and she was so fascinating herself. Some of the kids were so excited, they jumped in the Mecom

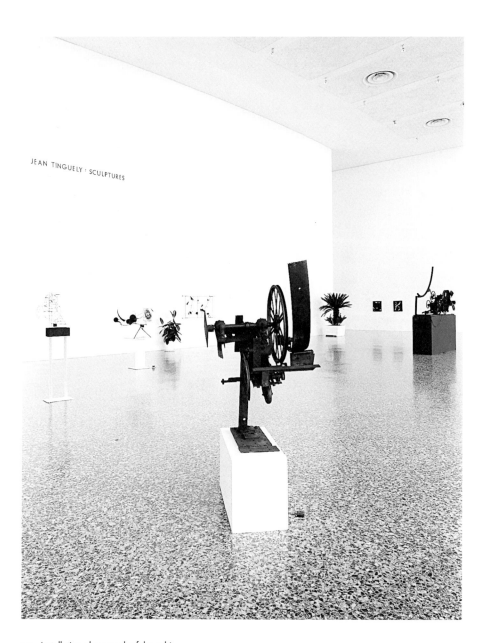

6.2 Installation photograph of the exhibition "Jean Tinguely: Sculptures," 1965. Photograph by Hickey & Robertson. Museum of Fine Arts, Houston Archives.

Fountain, and they were arrested. It was quite a night for art, you know. It was so typical of how someone like John de Menil and Sweeney together were a perfect match.[2]

In various ways, "Jean Tinguely: Sculptures" can be viewed as a metaphor-in-microcosm for Sweeney's career in Houston. Not only does the event shed valuable light on his ongoing aesthetic involvement with mystical themes, but the archival record reveals his and Tinguely's deep engagement with simultaneous patterns of creation and destruction. Despite the considerable differences in their professional practices, both men had a decided flair for artistic showmanship, and they took great delight in experimenting with the highly volatile, creative energies of modern art. By playing with modernism's edges and deconstructing its established boundaries, Sweeney's and Tinguely's unorthodox projects shared a dynamic capacity to promote provocatively destabilizing, and potentially visionary, modes of consciousness.

These ambivalent qualities can be seen in the formal and conceptual structures of Tinguely's sculptures themselves. As works of art rather than conventionally functional machines, Tinguely's sculptures draw on familiar aspects of mechanized urban modernity, while using "energy as a pictorial medium" in order to deconstruct accepted conceptions of the modern world.[3] Reciprocal patterns of self-creation and creative destruction informed both the artistic and curatorial production, and the critical reception, of Sweeney's and Tinguely's enterprise.[4] In turn, such purposefully destabilizing practices were seen historically as a metaphor for the larger modernist program that Sweeney so publicly and prominently advanced in Houston. Within this broader cultural context, Holmes's description of the opening of the "Jean Tinguely: Sculptures" exhibition exemplifies the charged atmosphere of excitement and controversy that Sweeney's and Tinguely's presences generated during the sixties. It was indeed as though Sweeney had "plugged everything in, and it all started going at once."

Tinguely ex Machina

During the sixties, Tinguely's best-known and most sensational work was his *Homage to New York: A Self-Constructing and Self-Destroying Work of Art Conceived*

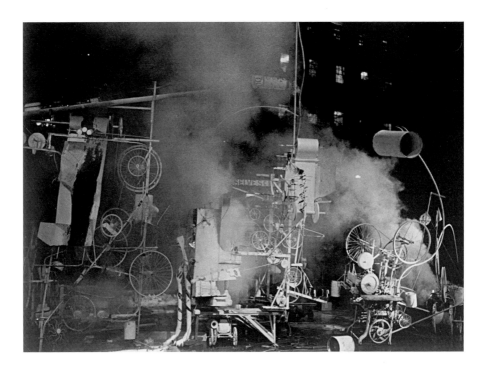

6.3 Installation view of the exhibition "Homage to New York: A Self-Constructing and Self-Destroying Work of Art Conceived and Built by Jean Tinguely," Abby Aldrich Rockefeller Sculpture Garden, Museum of Modern Art, New York, March 17, 1960. Photographic Archive, The Museum of Modern Art Archives, New York. ©David Gahr. The Museum of Modern Art, New York, NY U.S.A. ©The Museum of Modern Art/Licensed by SCALA/Art Resource, NY, ©2008 Artists Rights Society (ARS), New York/ADAGP, Paris.

and Built by Jean Tinguely (1960, figure 6.3). This complex kinetic sculpture was set in motion during what the British art critic David Sylvester wryly characterized as a "tuxedo Dada" performance at the Museum of Modern Art.[5] Niki de Saint Phalle recalled how Tinguely

seduced the cultural world of the Museum of Modern Art in New York, which was rather conservative, and managed to impose in a few weeks your imperious dream. You wanted to make an *Homage to New York*, an insane machine, beautiful and auto-destructive, which would consume itself and commit suicide in the courtyard of the Museum of Modern Art in a spectacle which lasted thirty minutes.

Today, more than thirty years later, I still ask myself how it was possible to have had them accept such a folly. Bravo Jean!

A few days before the machine was to explode, one of the directors of the museum, Peter Selz, came and asked you, "Promise me you won't make it destroy the museum too." You gave your word of honor, but everyone in the museum was trembling, and at the same time they were under the spell of your crazy genius.[6]

Tinguely assembled *Homage to New York* from cast-off items collected at various dumps and electrical supply shops in New York and New Jersey, including wheels from discarded bicycles and baby carriages, electric motors, steel tubing, a washing machine drum, an orange meteorological weather balloon, a radio, and a piano. On March 17, 1960, the machine was set in motion in the sculpture garden of the Museum of Modern Art. Describing the event two years later, Calvin Tomkins noted that problems in Tinguely's execution of the work produced the suggestive paradox of "a spectacle that failed to fail."[7] More recently, Eugénie de Keyser has aptly characterized this artistic performance as representing Tinguely's "vision of a (comic) apocalypse."[8]

In a prepared statement, Alfred H. Barr, Jr. introduced Tinguely's project by emphasizing the transgressive yet venerable tradition of Dada performance art, identifying an artistic genealogy that encompassed the works of Jules Verne, Paul Klee, Alexander Calder, Leonardo da Vinci, Rube Goldberg, and Marcel Duchamp, among others. Barr concluded with the proclamation: "TINGUELY EX MACHINA / MORITURI TE SALUTAMUS" ("Tinguely from the machine / We who are about to die salute you").[9] The first of these phrases referred to a familiar theatrical device in Greek tragedy, the *deus ex machina* or god who descends from the heavens on a mechanical device in order to offer providential solutions to various dilemmas left unresolved in the plot (with Tinguely's name here substituted for the god).[10] Barr's second phrase playfully paraphrased the Roman writer Suetonius, who recorded these as the words the gladiators spoke to the emperor prior to entering the ring for combat.[11] Barr thus invested the elaborate stagecraft associated with *Homage to New York* with simultaneous references to classical and avant-garde performances, the latter of which incorporated a rigorous critique of the very institution of art itself. In so doing, Barr imbued Tinguely's *Homage to New York* with the reciprocal

energies of creative destruction and destructive creation, a simultaneously kata-
phatic and apophatic proposition that reaffirmed the cultural vitality of the modern
museum even as it potentially threatened its very structures.[12] Himself a longtime
elite cultural warrior, Barr presciently recognized that symbolic gladiatorial com-
bat represented a genuine moment of self-creation, as the performing contestants
glided perilously along the edge that joined life and death, imminent destruction
and glorious triumph.[13] These themes were also notably evident in Sweeney's "Jean
Tinguely: Sculptures" exhibition in Houston.

Sweenguely

In December of 1964, John de Menil attended the opening of the "'Méta' Tinguely"
retrospective exhibition at Alexander Iolas's Paris gallery. Impressed by what he
saw, he "alerted Jim to it and in early January, he confirmed my impression."[14] Both
Sweeney and de Menil immediately recognized the exceptional opportunity that
the show presented to obtain a representative selection of Tinguely's sculpture.[15]
In an interview in the *Houston Post*, Sweeney told Campbell Geeslin: "In Paris last
winter, I was taxiing down the Boulevard St. Germain when throngs pouring into
a gallery blocked our way. I hopped out and inched my way in to find the reason
for such excitement. It was Tinguely. The show had a unity. It represented 10 years
of the artist's explorations, a cross-section of his work—not just a single expression.
It was the sort of selection a museum should offer to represent a sculptor's efforts
and achievements."[16] While anecdotally engaging, this version of the story does not
reveal the full complexity of the strategic maneuvers and collaborative interactions
through which the curator ultimately secured this high-profile acquisition for the
Houston museum. In order to reconstruct that portion of the story, it is necessary
to turn to unpublished archival sources.

Shortly after viewing the Iolas exhibition, Sweeney contacted John and
Dominique de Menil; in 1962 the de Menils had donated a mixed-media assem-
blage by Niki de Saint Phalle, *Gorgo in New York*, to the museum's permanent
collection. Sweeney learned that the de Menils had already purchased one item
from the show, Tinguely's automatic drawing machine *Méta-matic no. 9 (Scor-
pion)* (1958, figure 6.9), a work they would later donate to the MFAH as part of the

Tinguely acquisition. Sweeney consulted privately with John de Menil regarding the price he had paid Iolas for the sculpture. On December 20, 1964, de Menil responded encouragingly; as he told Sweeney: "I checked the price we paid for the Tinguley [*sic*]. It is quite a bit higher than I had told you . . . still unexpensive though and the total should be of the same order of magnitude: in the thirties perhaps, instead of the twenties. Merry Christmas, Jean."[17] De Menil's allusion to "the total" suggests that, from the outset, he and Sweeney had discussed the possibility of obtaining the Tinguely show in its entirety for the museum. Supporting this proposition is a document preserved in the exhibition files of the MFAH archives, a modest scrap of yellow paper that contains the brief notation, written in Sweeney's hand: "Tinguely @ Iolas. Buy whole exhibition. Jean de Menil's suggestion."[18] Sweeney avidly followed up on this prospect in a Western Union telegram that he sent the de Menils from Paris on January 7, 1965, in which he wired: "Agree enthusiastically. If possible take all. Sweenguely."[19] The fictive signature that Sweeney devised is particularly notable, as it represents a humorous, even poetic conflation of Sweeney's and Tinguely's surnames—a linguistic unity dissolving the boundaries between the artist's and the curator's individual identities. It also provided Sweeney with a witty pseudonym as he kept John de Menil in on the game as the transaction with Iolas unfolded.

Displaying considerable market acumen, Sweeney negotiated with Iolas to leverage an advantageous price for the purchase of the entire show. In a letter to the dealer dated January 30, 1965, Sweeney characterized the details of their interactions to make it appear as though the idea of acquiring the Tinguely exhibition as a whole originated with the Iolas Gallery, rather than with the de Menils or with Sweeney himself. In particular, Sweeney told Alexander Iolas that it was Bénédicte Pesle—a gallery associate who was also a niece of John de Menil's—or perhaps even Iolas himself who had initially suggested "that it would be good for a Museum to acquire the Tinguely exhibit as an integer."[20] Sweeney concluded by asserting: "What the matter finally turns on is the price. Keeping in mind the common advantages of such a transaction to all of us, what is the lowest price you can ask for the exhibition—exclusive of course of the piece Mr. and Mrs. De Menil have already acquired?"[21] By February 12, 1965, Sweeney and Iolas had reached a mutually

satisfactory price for the nine available sculptures. As part of the agreement, Iolas was to donate Tinguely's *Radio Drawing* (1963, figure 6.11, plate 6) to the museum, while the artist himself would later offer an additional piece (figure 6.13).[22]

On learning of the purchase, Tinguely contacted Sweeney directly to express his gratitude and delight. In a telegram sent from Paris, Tinguely wrote: "Sweeney I am amazed. I congratulate my machines. You make them very happy. I thank you[,] you are wonderful and I am happy to tell you so. Tinguely."[23] Shortly thereafter, Sweeney warmly responded: "You were very kind to cable me as you did from Paris. I was very touched by your message. Actually the gratification is ours— to have what I hope you will agree with me is a good representation of your work and a very proud addition to our Museum Collection."[24] In short, the acquisition of the Tinguely show represented a major coup for all of the players involved. News of the purchase was of sufficient magnitude that it was reported in the *New York Times* (March 7, 1965). Discussing the acquisition with a *Times* reporter, Sweeney playfully alluded to Tinguely's proclivity for creative destruction. Implicitly contrasting the works he had just obtained for the Houston museum with *Homage to New York*, the curator observed, "None of them are self-destroying . . . so they're really a much better investment."[25] The following month the "Jean Tinguely: Sculptures" exhibition opened at the MFAH, with all of the accompanying flourishes that Holmes described.

Toys from a Parallel World

The Tinguely exhibition provided Sweeney with another important opportunity to present the Houston public with a mystically oriented conception of modernist aesthetics. In the essay that he produced for the accompanying catalogue, Sweeney advanced a highly imaginative interpretation of Tinguely's sculptures in terms of a Heraclitean "unity of opposition" in a universe of ceaseless flux. Sweeney saw such an interplay of contrasting elements as investing Tinguely's sculptures with a vital sense of transformational presence: "For Tinguely, as he stated, 'Life is play, life is movement, life is continual change. The moment life is fixed it is no longer true; it is dead, it is uninteresting.' And again, 'everything transforms itself, modifies itself ceaselessly, and to try to check life in mid-flight and to recapture it in the form of a

work of art, a sculpture or a painting, seems to me a mockery of the intensity of life?
But Tinguely succeeds in recapturing this in the intensity of his machines, these
playthings of his–these playthings which preserve their vitality in their embodi-
ment of movement and in their respect for his Heraclitean outlook that change is
the one aspect of reality that can be called permanent."[26]

 Sweeney provocatively characterized Tinguely's sculptures in whim-
sical yet metaphysical terms, as "toys from some fabulous workshop of a world
we have not yet reached, or a world of the imagination which is, and will always
be, parallel to our workaday world, which can only be entered by those willing
to step out of ours into it, even briefly: the flexible, the believers, the children of
any age."[27] According to Sweeney, these associations arose as seemingly opposi-
tional elements became meaningfully conjoined in the apophatic performances
of Tinguely's kinetic artworks.[28] In particular, Sweeney emphasized the circuitry
of imaginative contradictions that drove the physical and conceptual motors of
Tinguely's motion sculptures:

Wheels–And an apparent random movement, an apparent wildness–but only apparent.
Really a meticulous planning in every detail. Chance is an essential element of Tinguely's
art. But nothing is left to chance; chance is put to work to the artist's ends.

 Jean Tinguely is no mad mechanic, unless madness is understood as a divine
frenzy. And then the frenzy is not in the artist but among the mechanical elements he puts
together, but which never fit together to an everyday end. Wheels conscientiously mismated,
tracks that lead nowhere, radios blaring familiar but unintelligible sounds, adapted to evi-
dent rhythms which have nothing to do with the familiar rhythms of speech. Machines which
serve no familiar purpose but may even, on occasions, emanate odors. Elements which, at
first glance, may appear frenzied and purposeless, but which on second consideration emi-
nently serve their organizer's purpose to entertain, to delight. Playthings from some metame-
chanical workshop–"metamechanical" in the artist's own description: beyond, above bare
mechanical ends.[29]

Thus according to Sweeney, Tinguely's sculptures encompassed a Heraclitean
interplay of unified oppositions. Simultaneously evoking the Dionysian and Apollo-
nian dimensions of art famously outlined in Nietzsche's *Birth of Tragedy* and later
recapitulated in Barr's flowchart, Sweeney characterized Tinguely's sculptures as

encompassing "apparent wildness" and "meticulous planning"; "random move-
ment" and purposeful order; "divine frenzy" and the calculated logic of "mechani-
cal" discipline; "continual change" and enduring permanence; "humour" and
"dignity"; the "unintelligible" and the familiar; the high and the low. Further recall-
ing the alchemical and redemptive qualities of Burri's collages, Sweeney noted
that, in Tinguely's creative works, the artist transformed the debased elements of
modern culture–its discarded "scrap material"–into objects displaying "the intrin-
sic beauty" of "traditional sculptural quality." Thus in Tinguely's art, the "dump
heaps of urban civilization" became conjoined with the elite spaces of the modern
museum. As if enlivened by these transformative processes, Tinguely's sculptures
were described as displaying an animate sense of presence, which Sweeney per-
ceived "in the intensity of his machines, these playthings of his–these playthings
which preserve their vitality in their embodiment of movement."[50] As such, the
mystical "life force" of Tinguely's kinetic sculptures was seen as being manifested
in the physical and philosophical qualities that comprised the complementary
aspects of their aesthetic performance.

Although Sweeney did not discuss Tinguely's sculptures individually, his
description of their unity of oppositions and animate sense of presence can be seen
in their formal and iconographic qualities. The eleven sculptures that comprised
the MFAH Tinguely acquisition ranged chronologically and stylistically from the
cerebral fragility of *Prayer Wheel* (1954, figure 6.4) to the erotically inflected, indus-
trial aesthetic of *Eos* (1964, figure 6.5) and *M.K. III* (1964, figure 6.6). The delicate
kineticism of *Prayer Wheel* is realized through an intricate arrangement of thin
metal wires and rods set atop a black wooden base. When animated by a 110-
volt electric motor, the sculpture's slow and jerky turning movements evoke an
interwoven configuration of rotating circles, as one wheel sets the next in motion.
Compared to the other Tinguely sculptures, *Prayer Wheel* is notably ascetic in its
spare, schematic appearance. Thematically, it recalls Buddhist sacred practices, in
which prayer wheels are spun continuously to engage the blessings of a spiritual
being who is thought to be the embodiment of compassion, awakening in turn
the spiritually powerful sense of compassion that resides within the higher self
of human beings. *Prayer Wheel* thus draws simultaneously on associations of the

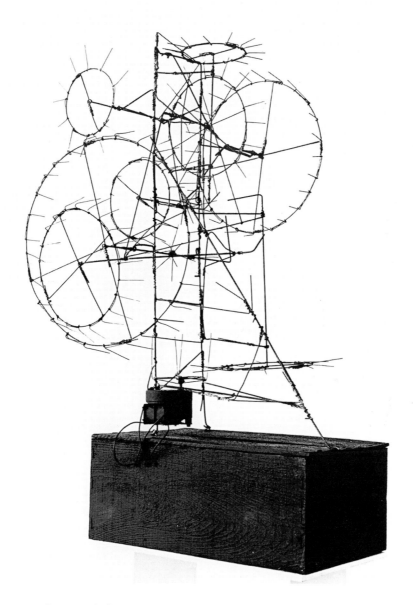

6.4 Jean Tinguely, *Prayer Wheel*, 1954. Steel wire, wood base, and electric motor. The Museum of Fine Arts, Houston; Gift of D. and J. de Menil. ©2008 Artists Rights Society (ARS), New York/ADAGP, Paris.

6.5 Jean Tinguely, *Eos*, 1964. Steel plate, iron and steel spoked wheels, slant line pulleys, rubber V-belt, and electric motor. The Museum of Fine Arts, Houston; Gift of D. and J. de Menil. ©2008 Artists Rights Society (ARS), New York/ADAGP, Paris.

ancient and the modern, the mechanical and the spiritual, the secular and the sacred, as its rotary motions evoke the transcendent patterns and orbiting motions of a dynamic universe.[31] As such, it can be seen as a multidimensional meditating machine: a mechanical device that seems to engage in prayerful or meditative practices, just as its kinetic sculptural forms are designed to inspire contemplative states in its viewers.

If *Prayer Wheel* engages mechanical forms to reference the spiritual domain, *M.K. III* and *Eos* remain physically grounded in their erotic associations, as both works enact mechanized, parodic performances of human sexual

6.6 Jean Tinguely, *M.K. III*, 1964. Steel, steel pipe section, iron wheels, rubber V-belt, flat belt, and electric motor. The Museum of Fine Arts, Houston; Gift of D. and J. de Menil. © 2008 Artists Rights Society (ARS), New York/ADAGP, Paris.

behaviors. In an interview with the critic Alain Jouffroy for *L'Oeil*, Tinguely said that he had come to make "machines 'that kiss.'" The critic asked, "Your large 'copulators' or 'masturbators' of today?" Tinguely affirmed: "There it is: I have found in their coming and going [movements] the spirit of Sisyphus, the idea of always being condemned to do the same thing. . . . There is a desperate side to the plight of these machines:—they are free, yes, they are joyous, yes, but they are also desperate. They are condemned to make the same movements, always the same movements, within the space of a restrained area."[52] Resonating with the themes of Sweeney's

catalogue essay, Tinguely thus emphasized the paradoxical ways in which despair and ecstasy became coextensive propositions in these works.[33]

Eos prominently features a black metallic arm suspended in space. When activated by an electric motor, the repetitive trajectory of the sculpture's swinging limb mimics a masturbating gesture. Similar associations are evident in *M.K. III.* This sculpture consists of various steel elements, a steel pipe section, iron wheels, and tracks that are set on a wooden base. The device is propelled by a rubber belt, a flat belt, and a 110-volt electric motor, all of which trigger a series of repeated movements that cause the car to travel vainly back and forth on tracks to nowhere. The recurring, futile motions of the car are mirrored in the full title of the artwork: *Char M.K. III.*[34] While the image of the "char" or car evokes associations of the charnel or the carnal, the term "char" is also an abbreviation of chariot, and thus an allusion to the "bachelor machines" appearing in Marcel Duchamp's masterwork, *The Bride Stripped Bare by Her Bachelors, Even,* or *The Large Glass* (1915–1923). Much like Duchamp's chariot, the futile, repetitive motions of Tinguely's *Char* are humorous in their onanistic implications. In this context, it should be noted that Tinguely was extremely familiar with Duchamp's work. In April of 1955 the two artists exhibited together in Paris at the Galerie Denise René show "Le mouvement," which was devoted to the theme of motion in art. During the sculptor's subsequent visit to New York in 1960, Duchamp personally escorted him through the permanent installation of his works at the Philadelphia Museum of Art, a display that prominently featured the *Large Glass.*[35]

Sweeney, in turn, was simultaneously engaged with both Duchamp and Tinguely during the winter and spring of 1965. The exhibition "Not Seen and/or Less Seen of/by Marcel Duchamp/Rrose Sélavy 1904–64" had closed at the MFAH on March 28, less than a week before the "Jean Tinguely: Sculptures" show opened on April 3. In the Tinguely exhibition catalogue, Sweeney identified an affinity between the two artists. Citing Duchamp's comments on Tinguely, Sweeney wrote: "Of Tinguely, Duchamp has said: 'I feel with him a closeness and a rapport that I have felt with few artists. He has the great thing, a sense of humour–something I have been preaching for artists all my life. . . . I believe in humour as a thing of great dignity and so does Tinguely.'"[36]

6.7 JeanTinguely,*Méta-Malévitch*,1954.
Shallow wooden box, metal attachments,
wooden pulleys, round rubber belt, and
electric motor. The Museum of Fine Arts,
Houston; Gift of D. and J. de Menil.©2008
Artists Rights Society (ARS), New York/
ADAGP, Paris.

Additional artistic homages can be found in Tinguely's sculptures *Méta-Malévitch* (1954, figure 6.7); *Méta-Kandinsky II: Polychrome Relief* (1955, figure 6.8); and *Méta-matic no. 9* (1958, figure 6.9). Evoking a self-conscious aesthetic revisionism, these works draw on venerable artistic precedents in order to rework inherited conventions. Thus in *Méta-Malévitch* Tinguely translates the Russian suprematist's well-known minimalist forms into a series of seven rectangular strips of white metal that are set in a shallow black wooden box. Concealed within the box are wood pulleys, a rubber belt, and an electric motor. When engaged, Tinguely's kinetic sculpture transforms the stasis of Malevich's suspended forms

6.8 Jean Tinguely, *Méta-Kandinsky II*, 1955. Wood panel, polychrome wood, metal, wooden pulleys, round rubber belt, and electric motor. The Museum of Fine Arts, Houston; Gift of D. and J. de Menil. © 2008 Artists Rights Society (ARS), New York/ADAGP, Paris.

into an animated configuration of shifting patterns, presenting an imaginative parody of the latent capacity for movement suggested by Malevich's highly charged, tensional forms (a quality that the suprematist had expressed in both literary and visual imagery through the leitmotif of flight). A similar dynamic occurs in the polychrome relief sculpture *Méta-Kandinsky II*, as assorted bits of colored wood and metal move at random due to the irregular intermeshing of the sculpture's gear mechanism. In so doing, *Méta-Kandinsky II* recalls the colorful floating forms

6.9 Jean Tinguely, *Méta-matic no. 9,*
1958. Round rubber belt, steel rods,
painted sheet metal, wire wooden pul-
leys, two clothespins, and electric motor.
The Museum of Fine Arts, Houston; Gift of
D. and J. de Menil. © 2008 Artists Rights
Society (ARS), New York/ADAGP, Paris.

of Kandinsky's paintings, just as it animates the traditionally stable format associ-
ated with the painted surface.

The notion of mechanizing modernist painting is taken a step further in
Tinguely's *Méta-matic no. 9, Scorpion.* Displaying a provocative combination of
humor, paradox, and creative originality, Tinguely invented a machine which,
when plugged in, would automatically produce "original" abstract pictures.[37] In-
deed, the resulting drawings typically display a suggestive accretion of marks that

resemble impressionistic, highly abstract landscape fields. By simultaneously en-
gaging the themes of authenticity and reproduction, the sculptor again mobilized
the concept of the *coincidentia oppositorum* as he offered a pointed commentary
on the contemporary production of abstract gesture paintings and on the surre-
alists' practice of automatic drawing.[38] As Tinguely polemically observed of his
metamatic drawing machine in 1965: "As far as those who conform to a move-
ment which is already past are concerned—let us say the conformists to abstrac-
tionism—I think their assembly-line production is futile. And in making machines
which draw I have been commenting ironically on this; I know what I've done
has been terrible because of the great hostility which I've encountered on the part
of those happy abstract painters, so calmly commercial."[39] At the same time, his
Scorpion can be viewed as creatively reaffirming while also radically deconstruct-
ing modernist painterly practices and their accompanying aesthetic values. As
if reverse-engineering the mystical concept of the aura in the age of mechanical
reproduction, Tinguely resituated privileged conceptions of artistic authenticity
within the motorized sculpture's repetitive gestures.[40] As a result, both the appeal
and the affront of his artwork lay in precisely the same location. Just as viewers
could admire *Scorpion's* elegant formal and Heraclitean conceptual interwork-
ings, they simultaneously remained aware of the creature's formidable capacity to
deliver a sharp sting.

　　Another work that features a destabilizing combination of contemporary
political commentary and seductive aesthetic appeal is Tinguely's welded sculp-
ture *Fourrures* (1962, figure 6.10). This piece is constructed of steel rods, fur pelts,
horse hair, and a 110-volt electric motor attached to a sheet steel base; when the
sculpture is activated, the dangling furs appear to engage in a kind of ritual dance
performance. The furs seem at once fetish-like and anthropomorphic; the wild
dancing motions of the sculpture both evoke and actively deconstruct primitivist
ritual associations. This piece belongs to a group of works known as the *Baluba*
series. As various scholars have noted, in the *Baluba* works Tinguely, like Burri,
referenced the chaotic political situation in the Congo during the early 1960s.
Regarding this sculpture in particular, Heidi E. Violand-Hobi has noted the exoti-
cized associations of "the trance-like frenzy of tribal dancers, with ringing bells,
shaking toys, fluttering feathers and rattling rubbish. Tinguely sympathized with

6.10 Jean Tinguely, *Fourrures*, 1962. Sheet steel base, steel rods, fur pelts, horse hair, and electric motor. The Museum of Fine Arts, Houston; Gift of D. and J. de Menil. ©2008 Artists Rights Society (ARS), New York/ADAGP, Paris.

the efforts of the Balubas, a Bantu tribe led by [the fallen leader] Patrice Lumumba in the 1960 Congo war. The wild choreography of the 'Balubas' set to a noisy musical score was a salute to those Congolese freedom fighters."[41] For others writers, the *Baluba* group evoked less a political commentary than a sustained reflection on the complex dynamics of the modernist fetish. Writing in the Tinguely catalogue raisonné, Franz Meyer has observed that Tinguely "release[s] the primitive element of animal vitality–for example in the *Baluba* group with its joyful impetuosity and excesses of frenzied dancing, inspired by his experiences in Africa and Brazil."[42] And just as Sweeney had noted the "apparent wildness" and "divine frenzy" of Tinguely's artworks, Ann Holmes drew on themes of salacious parody in her review of the Tinguely exhibition in the *Houston Chronicle*. In particular, she noted that "the 'Furrier,' a clutch of ratty old fur scarves attached to a piston and a machine that shakes them wildly, is uproariously funny, and downright scandalous in some unspoken way."[43]

While *Fourrures* drew on the kinetic performance of ritual dance, Tinguely's *Radio Drawing* (1963, figure 6.11, plate 6) represented another type of modernist sensory experience, that of the sound collage. A mixed-media, acoustically oriented construction, the piece is composed of a red plastic flywheel, electric wires, two electric motors, and two radios. The radios' typically concealed internal elements are exposed to the viewer's gaze beneath a sheet of clear plastic. The radio knobs are continually turned by small attached motors, so that the device picks up a shifting selection of broadcasts. These random sound fragments evoke the cacophonous noises of modern life itself. Thus like so much of Tinguely's oeuvre, *Radio Drawing* eschews conventional notions of sculptural form, just as it provides its audience with an alternative perspective on modern life and the creative ability to navigate between–and potentially inhabit–multiple points of shifting consciousness.

The Meta-Phorics of Degradation: "Some Unhappy Time in the Trashcan"

Just as Tinguely's sculptures engaged their audience in a range of interactive encounters, the works themselves were seen as being invested with a sense of

6.11 Jean Tinguely, *Radio Drawing*,
1963. Clear sheet plastic support, two
radios, two electric motors, electric wires,
and red plastic flywheel. The Museum of
Fine Arts, Houston; Gift of Alexander Io-
las. © 2008 Artists Rights Society (ARS),
New York/ADAGP, Paris.

animate presence. Significantly, Tinguely himself actively advanced this inter-
pretive position. Throughout his career, the sculptor explored the analogical
associations between human beings and machines, a complex subject that car-
ried significant social and philosophical implications.[44] After learning of the Iolas
purchase, for example, Tinguely told Sweeney, "I congratulate my machines. You
make them very happy."[45] Later that year, in an interview with Laura Mathews for
Paris Review, he remarked: "In making something move, however, one feels inside
daily life; one doesn't admit it, but one knows very well that in moving machines

one is faced with life against death."[46] As his statements suggest, Tinguely attributed a sense of anthropomorphic presence to his metamatic sculptures, and with it, a symbolic life force that seemingly extended to the competing drives of eros and thanatos.[47]

Not surprisingly, the conception of Tinguely's kinetic artworks as symbolically living entities also threads through period assessments of the artist. In particular, his "animated" sculptures were characterized as being replete with the energies of life itself; as a contemporary reviewer noted, "Tinguely's created 'life' by its very nature ambiguously predicts, accepts, and sometimes even includes death."[48] Evoking these themes in the Iolas Gallery catalogue, the curator Pontus Hultén remarked that Tinguely's "machines are unique beings," that they are "new creations of art [that] live with an enviable freedom."[49] In the MFAH catalogue, Sweeney similarly observed that "movement for [Tinguely] is the essential of a living sculptural expression."[50] The following year *Life* magazine echoed these concepts in an article on kinetic sculpture suggestively entitled "Sculptures in Motion: Spirited Machines Thrust Kinetic Art to New Popularity."[51] The piece prominently featured several photographs of Tinguely's "spirited" artworks, including the Houston museum's *M.K. III.* Writing at the end of the decade in his pioneering study *Origins and Development of Kinetic Art*, Frank Popper similarly observed that "from Tinguely's point of view, the machines which he devises are living creatures which inspire him at one stage with fear, and at another with astonishment or admiration. He expects this to be so for the spectator as well."[52]

The dynamic themes of Tinguely's sculptures resonated with Sweeney's own interactive approach to museum installations, which often included making the audience an integral part of the exhibition. Writing about his curatorial strategies and objectives in the journal *Curator* (1959), shortly before assuming the museum directorship in Houston, Sweeney noted that his approach to "exhibition installation" was guided by the perspective that, in a museum, the "visitor actually moves through the exhibition and becomes part of the installation." Thus in order to be successful, each show must "speak primarily to the senses of the observer, and each in the end, to have its effect, must be assimilated or digested intellectually."[53] This interactive curatorial approach, which apophatically melted the conventional boundaries between subjects and objects, can be seen throughout

Sweeney's museum installations, including the Tinguely exhibition. Sweeney typi-
cally treated Cullinan Hall like a kind of theatrical set that facilitated an interactive
performance between artworks and their viewers. Installation photographs of the
"Jean Tinguely: Sculptures" show (figures 6.1, 6.2) reveal the ways in which view-
ers could engage in a focused encounter with each of Tinguely's kinetic works in
turn as they proceeded through the "parallel world" that Sweeney constructed in
his elegantly spare arrangement. Needless to say, such a participatory dynamic
marked a critical departure from traditional modes of museum display that were
structured by fixed boundaries and discrete framing mechanisms, which tended to
preserve a sense of physical distance and aesthetic detachment between spectators
and works of art. Their play of simultaneous multiplicity–the symbolic ability to
occupy multiple parallel locations simultaneously–allowed Sweeney's exhibitions
to perform, aesthetically and hermeneutically, the mystical qualities that he had
identified as intrinsic to Tinguely's artworks themselves.

 In short, in this group of kinetic sculptures, both Sweeney and Tinguely
provided contemporary audiences with a valuable gift as well as a formidable
interpretive challenge. While some viewers were open to such engagement, oth-
ers decidedly were not. During the sixties Ann Holmes remained one of Sweeney's
most steadfast and vocal supporters. In her review of the Tinguely exhibition in
the *Houston Chronicle*, she recapitulated many of the themes he had advanced in
his exhibition catalogue. Thus in an article provocatively entitled "Wild Spasms,
Rituals of Tinguely's sculptures," Holmes appreciatively remarked: "Today with
this thrusting, rattling, swirling, jittering show, a fascinating crystallization of an
artist's visions, and a commentary of course upon the machine age, Sweeney now
possesses an enviable collection of a contemporary sculptor of international impor-
tance." Echoing the leitmotifs of experience and innocence, ritual performance and
childlike play, Holmes further noted: "Some of the creations have a surprisingly
involved program or ritual which they go through, return and perform again. It is
more enchanting than old Dr. Coppelius' toy shop when all the mechanical dolls
start to working at once." Anticipating–perhaps even proactively responding to–
the controversy stirred by the exhibition, she concluded: "It is perfectly obvious,
though his works may seem humorous or occasionally virtuosic tours de force,
that Tinguely is a deeply serious artist, more concerned with construction than

destruction."[54] Indeed, it was precisely this reciprocal dynamic of "construction and destruction"–the polarization of kataphatic affirmation and apophatic negation–that characterized the public response to the show.

Other reviewers were less positive in their assessments. "Art from the Scrap Yard: Tinguely Mechanizes Museum" was the headline for a front page story in the *Houston Post*. Previewing the MFAH show, the conservative Campbell Geeslin suggested that a pathological sense of classicism informed Tinguely's artistic production. Geeslin quoted the artist as saying: "'I am making space and movement, space and movement. It's just classic, you know.' (His classic was pronounced class-sick, with the accent on the last part.)"[55] As Geeslin wryly concluded: "Some critics have noted the onomatopoetic nature of the artist's name, and it certainly fits. The only possible way to describe these machines is to say that they are tinguely."[56] For Geeslin, it seemed, the most appropriate response to Tinguely's "scrap yard" art was a visceral one. Other prominent viewers also offered pointed critiques of the show. As David Warren, formerly the director of the MFAH's American decorative arts wing Bayou Bend, recalled: "No one understood the Tinguely show. One of the trustees . . . characterized the Tinguely show as a 'chamber of horrors.'"[57] Indeed, it seems that contemporary opinion was sharply divided between those who saw it as a "chamber of horrors" and those who saw a chamber of wonders.

The pronounced ambivalence toward Tinguely's work is consistent with larger cultural attitudes of the period, as the machine was simultaneously perceived as a source of anxiety and of desire. In the catalogue for his important exhibition of kinetic art, "The Machine as Seen at the End of the Mechanical Age," at the Museum of Modern Art, Pontus Hultén noted the range of historical responses to machines, some perceiving them as marvels, magical objects, or toys, others as agents of alienation and "enemies of humanistic values, leading only to destruction. Most of these contradictory ideas persist, in one form or another, in the twentieth century and find their reflection in art." Hultén observed that Tinguely's sculptures in particular represented "an attempt to establish better relations with technology," and that they "lead us to believe that in the future we may be able to achieve other, more worthy relations with machines."[58] Within this contemporary context, the term that Tinguely adopted for his kinetic works–metamatic–is significant.

Etymologically, "metamatic" means acting to transform or transcend.[59] Applied to the kinetic sculptures, this term suggests that the artworks were acting to move viewers above and beyond the limitations of the old mechanical systems.

The mixed public response to the Tinguely exhibition is also indicative of the larger sense of controversy that characterized Sweeney's career in Houston. By July of 1965, two months after the Tinguely show had closed, Holmes reported on the heated internal conflicts generated by Sweeney's practices as museum director. Writing in the *Houston Chronicle*, she noted: "The Museum of Fine Arts of Houston has become a focal point of ferocious controversy. Serene as it may seem upon its isle of green lawns, surrounded by sculptures apparently ageless and unaware of day to day strife, the museum—because of its exhibition and accession program—is a place embattled." To readers today, the charges leveled against Sweeney seem extremely predictable. As Holmes reported: "A number of citizens in Houston are vocal indeed in their dislike—and disapproval of—the accessions program which has brought what some feel are 'so many crazy modern paintings into the collection.'" Among the works singled out for special questioning were the Tinguelys (though Holmes was among their supporters: "Sweeney bought, with gift money, 12 of these mechanized sculptures. It was hardly a whim. Tinguely is a serious artist and the Houston museum now owns an enviable group of them").[60]

Central to the debate surrounding Sweeney's exhibition and accessions policy were fundamental questions regarding the museum's criteria for determining artistic value. A handful of letters preserved in the MFAH archives strikingly document the genuine confusion raised by Tinguely's art, in particular, over the categorical differentiations separating fine art from ephemeral trash. According to archival records, the "Jean Tinguely: Sculptures" show consisted not only of the group of kinetic sculptures that Sweeney had acquired from the Iolas Gallery, but an additional twenty-one drawings. Of these works on paper, thirteen were on loan from the Iolas Gallery, while Tinguely personally carried eight drawings on his visit to Houston.[61] During the first week of the show, one of the Iolas drawings disappeared from its place on the wall. While Edward Mayo initially assumed that a theft had occurred, he soon learned that "the drawing was not stolen, but was damaged when it fell to the floor from its hanging place and subsequently found

its way inadvertently to the trash can."[62] Mayo contacted the museum's insurance company to notify them of the accident, and sought the services of a paper conservator to restore the drawing after its "unhappy time in the trash can." In addition to this evocative tale of mistaken identity, a related story emerges in Sweeney's correspondence with the Iolas Gallery. In April of 1965 the gallery requested that Sweeney send some spare parts for Tinguely's machines. Declining to provide these materials, Sweeney informed the gallery: "Mr. Tinguely did leave some thin rubber bands for us to repair breakages in his Mobiles. Unfortunately we have already used up all of it except a single piece 8′ long. For this reason I am afraid we cannot spare any as we have had several breakages and the exhibition still has three weeks to go."[63] In short, the archival record reveals a deeply ingrained and highly contentious dynamic between valuation and degradation, force and fragility, successful performance and chronic dysfunction.

"He Plugged Everything In, and It All Started Going at Once"

It should be emphasized that these challenges were not specific to a Houston audience, but broadly typical of period responses to kinetic art. A 1965 cartoon in the *New Yorker* depicted a group of people at a cocktail party standing in front of a large kinetic sculpture. One viewer turns around and poses the question: "But what about spare parts?"[64] Indeed, the unsettling tendency of motion sculpture to destabilize conventional relationships between artworks and their audience, disrupting established paradigms of spectatorial detachment and aesthetic containment, represented a leitmotif in the period's visual culture. In a related *New Yorker* cartoon, also of 1965, an unsuspecting man is literally swept off his feet in his encounter with kinetic sculpture, as an emphatic series of spiral blurs indicates that the device has spun out of control and taken its unfortunate viewer with it. With gaping mouth and bulging eyes, the man appeals wildly for help. A woman standing nonchalantly nearby, sipping from a steaming coffee cup, dryly replies, "So much for kinetic art, eh, Leo?" This image can be seen as an exaggerated parody not only of the machine run amok but of Sweeney's curatorial philosophy of making the viewer an integral part of the installation.

The following year, *Arts Magazine* offered its own humorous commentary on kinetic sculpture's indecorous tendency to breach the established boundaries of curatorial propriety. This cartoon features a sculpture that closely resembles Tinguely's *Bascule* works, an example of which the Houston museum had acquired through the initial Iolas purchase (1960, figure 6.12). Another related work, *La bascule VII,* entered the museum's collection in 1968 (1967, figure 6.13) as a gift from the artist. Tinguely's *Bascule* series references the swinging motions of a scale or seesaw. In the MFAH's initial *Bascule,* the sculpture's wheels vigorously rock back and forth on steel rods and an aluminum pulley. This frenzied performance is further enhanced by the ringing of a brass bell attached to the tip of the sculpture's extended steel wire. While the *Bascule* works thus evoke Tinguely's "masturbating" machines of the sixties, for the most part the sexual connotations of these pieces could not be openly discussed at the time. The *Arts Magazine* image playfully engages in the paradox of saying the unsayable, as the kinetic sculpture's repetitive rocking motions have become a source of viewer anxiety. Thus while a background sign conveys the usual admonition to museum visitors, "Do Not Touch Works of Art," a harassed man in a neat suit and tie anxiously grabs a gallery guard and, pointing to the sculpture, indignantly replies: "It touched me!" While the diagram does not explicitly indicate *where* the sculpture touched the man, the implication is that the customary boundaries between artworks and their viewers have collapsed, as an excessively interactive kinetic sculpture engages in some unspecified form of inappropriate contact.

These cartoons make explicit some of the underlying, provocative implications of Tinguely's kinetic sculptures in particular, and of Sweeney's innovative, mystically inflected curatorial practice in general. Just as both Sweeney's and Tinguely's modernist enterprises contained the potential for the creative destruction of normative boundaries and expectations, they simultaneously transgressed and transformed the familiar parameters of aesthetic experience. Throughout his literary and curatorial projects, Sweeney often drew on such mystical and poetic concepts to foster an expanded sense of consciousness in his audience, and to express insights and connections that lay at once within and beyond the visible, physical presences of the displayed works. By acquiring and prominently

6.12 Jean Tinguely, *Bascule*, 1960. Steel rods and wire, aluminum pulley, brass bell, round rubber belt, and electric motor. The Museum of Fine Arts, Houston; Gift of D. and J. de Menil. © 2008 Artists Rights Society (ARS), New York/ ADAGP, Paris.

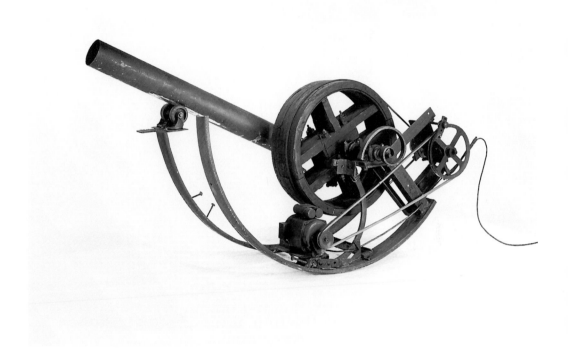

6.13 Jean Tinguely, *La bascule VII*, 1967.
Mixed media. The Museum of Fine Arts,
Houston; Gift of the artist. © 2008 Artists
Rights Society (ARS), New York/ADAGP,
Paris.

exhibiting Tinguely's progressive modernist artworks at the MFAH, Sweeney
placed himself directly on the fault line of that city's internally divided cultural
politics. Yet if Sweeney was the impresario orchestrating these events, his star play-
ers were indisputably the artworks themselves. Indeed, Tinguely's kinetic sculp-
tures delivered an unforgettably Heraclitean performance of unity in opposition, as
these metamechanical devices staged a series of destructive breakdowns that also
represented powerfully subversive acts of self-creation.

7

"A Spark of Light Darting through Empty Space": Eduardo Chillida

Beginning at the Edge of the Limit

"A house whose door is closed is different from the same house with the door open."[1] Taken from Eduardo Chillida's notebook pages, this aphorism provides an ideal point of entry into the artist's creative work. Just as a house is transformed by an open door that simultaneously frames and delimits a passageway, Chillida's artworks can be envisioned as open doorways that conjoin seemingly oppositional internal and external elements into complementary mystical and aesthetic expressions. Thus just as Duchamp's *Door* (figures 3.6 and 3.7) somehow manages to remain open and shut simultaneously, the alternating patterns of solids and lights, positive and negative spaces that structure the designs of Chillida's sculptures and lithographs can be approached as doorways that stand open and closed at once.

For the artist himself, the image of a house with an open door resonated on multiple levels simultaneously. At the foundation lay Chillida's biography. Between 1943 and 1946, he studied architecture at the University of Madrid, before definitively abandoning the field the following year to pursue a career in sculpture. At the same time, both Chillida and his supporter James Johnson Sweeney repeatedly emphasized the ways in which Chillida's artworks retained a deeply architectonic sensibility. In 1966 Sweeney asserted that "Chillida's art owed its essential character and quality to . . . a sense of the architectonic–that is, a basic feeling for architectural organization."[2] In turn, the sculptor located the architectural quality of his works in the ongoing dialogue between the solidity of their liminal edges and the corresponding openness of their interior spaces. As Chillida noted, "A dialectic exists between the empty and full space [of my artwork] and it is almost impossible for this dialogue to exist if the positive and material space is not filled, because I have the feeling that the relation between the full and empty space is produced by the communication between these two spaces."[3] Chillida characterized himself as "the architect of inner space," and he described his artworks as material and spiritual enclosures whose open interiors form "the vacuum in which the soul of the work crystallizes."[4] As with Sweeney, the conceptions of spirituality that thread through Chillida's writings are replete with references, both direct and indirect, to the ecstatic philosophy and negative theology of the sixteenth-century Spanish visionary St. John of the Cross. Echoing the mystical language of the saint, Chillida repeatedly described his artistic process as a constant wandering into the unknown, just as he characterized the "spirit" of his artwork as a presence that is contained within the visible absence of its "inner space," the emptiness that houses the overflowing promise of interior plentitude.

Besides Sweeney's sustained critical and curatorial engagement with Chillida, the artist's works inspired commentary from distinguished contemporary critics and philosophers, including Gaston Bachelard and especially Martin Heidegger. Viewed comparatively, these poetic and philosophical texts help to situate Sweeney's and Chillida's creative productions within a broader context of aesthetic and spiritual reflection. Reconstructing the relations between these contemporary literary and visual works–that is, placing the overlapping edges of the texts and images within a mutually meaningful relation–is much like building a house

with several open doors that are shaped like Chillida's sculptures and lithographs. Taken together, these entryways form interconnected passageways as each essay and exhibition, each drawing and sculpture, leads into the next, and all stand invitingly open.

Building "from Within": Sweeney and Chillida

Sweeney played a crucial role in promoting Chillida's work in the United States, as he did for so many of the artists examined in this study. Perhaps most notably, Sweeney organized the artist's first important retrospective, with an accompanying catalogue, in Houston during the autumn of 1966. Jose Tasende, director of the Tasende Gallery in La Jolla and directly acquainted with both Sweeney and Chillida, aptly summarized the curator's contribution: "The intellectual authority of Sweeney is what made Chillida's reputation in the United States. . . . People like Sweeney make an enormous impact. Sweeney was a great authority, and he understood better than anybody else, and before anybody else, the importance of Chillida."[5] The art historian Peter Selz has similarly observed that "it was Sweeney, formerly the director of the Solomon R. Guggenheim Museum, who introduced Chillida's work in the United States with an exhibition at the Museum of Fine Arts, Houston, in 1966."[6]

 The two men's collaboration began during the mid-fifties, following Chillida's first international, one-man exhibition at the Galerie Maeght in Paris (autumn 1956). Among the artworks featured in the show was Chillida's forged iron sculpture *Desde dentro* (*From Within*) (1953, figure 7.1). In the spring of 1958, Sweeney exhibited this piece at the Guggenheim Museum's group show "Sculptures and Drawings from Seven Sculptors," along with two other iron sculptures by Chillida and a selection of his drawings.[7] Sweeney subsequently acquired *Desde dentro* for the Guggenheim's permanent collection; he would later display it at the Houston retrospective. Also in 1958, Chillida received the Graham Foundation Award for Advanced Studies in the Fine Arts, a prize whose jury included Sweeney and Mies van der Rohe, among others.[8] Chillida and his wife Pilar visited Sweeney at the Guggenheim that October.[9] The following year, Sweeney was again in contact with the Galerie Maeght regarding Chillida's iron sculpture *Ikaraundi (Grand*

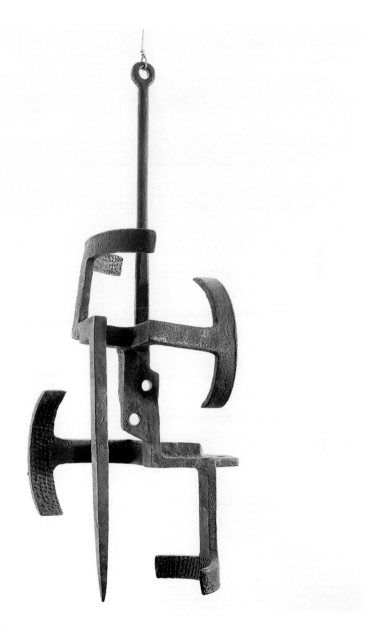

7.1 Eduardo Chillida, *Desde dentro (From Within)*, March 1953. Iron, 38¾ inches (98.4 cm) high. Solomon R. Guggenheim Museum, New York. 58.1504.

Photo by Robert E. Mates ©The Solomon R. Guggenheim Foundation. ©2008 Artists Rights Society (ARS), New York/ VEGAP, Madrid.

tremblement) (1957) which, he informed the gallery, he wished to present to the Guggenheim's Acquisitions Committee.[10] Clearly engaged with Chillida's work, Sweeney wrote a lyrical essay on the artist for the March 1961 issue of the Maeght's luxury publication *Derrière le Miroir,* which was devoted to Chillida. Produced between 1946 and 1982, *Derrière le Miroir* (Behind the Mirror) featured original works by major modern artists, paired with texts by distinguished contemporary writers. Among the pieces displayed in the March 1961 issue was Chillida's monumental carved oak sculpture *Abesti gogora I* (*Song of Strength,* 1960–1961, figures 7.3, 7.9, 7.10, and plate 7). From the outset, Sweeney was particularly impressed with this work, feeling that it demonstrated the artist's skill as an "architectural precisionist and magician of poised masses," and he acquired the sculpture the following year for the MFAH's permanent collection.[11]

Edward Mayo has noted that, along with Calder's bright red, riveted steel sculpture *Crab* (1962, figure 7.2), Sweeney's favorite piece in the MFAH's collection "was the Chillida wood sculpture, which he put on a high pedestal."[12] Sweeney prominently featured *Abesti gogora I* in the exhibition "Three Spaniards: Picasso, Miró, Chillida" that he assembled in Houston in the winter of 1962 to "represent three generations of twentieth-century Spanish art" (figure 7.3).[13] In a dramatically spare installation that Mayo characterized as "a masterpiece of minimalism," *Abesti gogora I* was displayed alongside Miró's series of blue paintings, *Blue I, Blue II,* and *Blue III* (1961); Picasso's contemporary oil painting *Nude under a Pine Tree* (1959), which was shown there for the first time in the United States; and Picasso's multi-figure sculptural group *Bathers* (1958).[14] Notably, Picasso's six bronze bathers were installed in and around a simulated swimming pool, complete with diving board, that Sweeney had constructed on the museum's north lawn (figure 7.4).[15] Missing no opportunity to display *Abesti gogora I* in Houston, Sweeney exhibited it in "Some Recent Accessions" (March 8 to April 9, 1962); in "Sculpture from the Museum of Modern Art, New York" (December 12, 1963 to April 23, 1964); and in the "Eduardo Chillida Retrospective Exhibition" (October 5 to November 20, 1966).

After his retirement from the MFAH, Sweeney's engagement with Chillida continued until the very end of Sweeney's life. Sweeney included two of Chillida's collages, both dating from 1972, in an exhibition that he organized, "Contemporary Spanish Painters: Miró and After–A Selection" (Washington, International

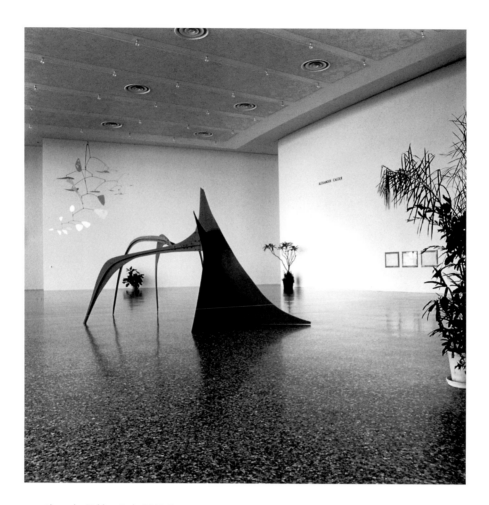

7.2 Alexander Calder, *Crab*, 1962. Installation photograph of the exhibition "Alexander Calder: Circus Drawings, Wire Sculptures, Toys," 1964. Photograph by Hickey & Robertson. Museum of Fine Arts, Houston Archives. ©2008 Calder Foundation, New York/Artists Rights Society (ARS), New York.

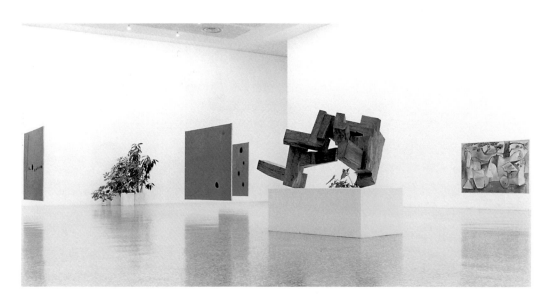

7.5 Installation photograph of the exhibition "Three Spaniards: Picasso, Miró, Chillida," 1962. Photograph attributed to Hickey and Robertson. Museum of Fine Arts, Houston Archives.

Exhibitions Foundation, 1975–1976). And Sweeney based his final essay on Chillida, "The Wind Combs–An Explication," on an interview that he conducted during a January 1984 visit to the artist's home in San Sebastián, Spain. Published the year of Sweeney's death, the essay appeared as a postscript to Selz's *Chillida* monograph (1986). Acknowledging Sweeney's long-standing commitment to Chillida, Selz dedicated the volume "To James Johnson Sweeney with high esteem."[16]

Going "behind the Mirror": The Concordance of the Two Blacks

Opening the cover of the March 1961 edition of *Derrière le Miroir* is a bit like entering another world, a dedicated enclosure housing Chillida's aesthetic. In this journal, text and image are generously spaced on the page, while Chillida's scattered drawings are interspersed throughout Sweeney's essay. Like other issues of *Derrière le Miroir* produced after 1960, this one was printed in a deluxe limited edition

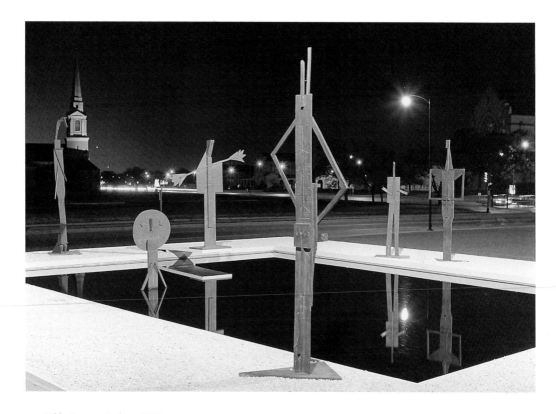

7.4 Pablo Picasso, *Bathers*, 1958. In-
stallation photograph of the exhibition
"Three Spaniards: Picasso, Miró, Chi-
llida," 1962, exterior photograph show-
ing Picasso's *Bathers* installed around
Sweeney's custom-made swimming pool.
Photograph by Hickey & Robertson. Mu-
seum of Fine Arts, Houston Archives.
© 2008 Estate of Pablo Picasso/Artists
Rights Society (ARS), New York.

of 150 copies on wove, cream-colored Arches paper, while the unfolded sheets of
the oversize folio measure fifteen by twenty-two inches.[17]

Among the original prints featured in this issue are Chillida's *Concordance*
(1960, figure 7.5) and *Les deux noirs* (1961, figure 7.6). Situated at the center of the
volume, *Concordance* is located literally at its heart. Such positioning is highly
appropriate. While the image itself is wholly abstract, the concept of concordance
signifies a harmonious state of being: either a condition of mutual agreement, or a

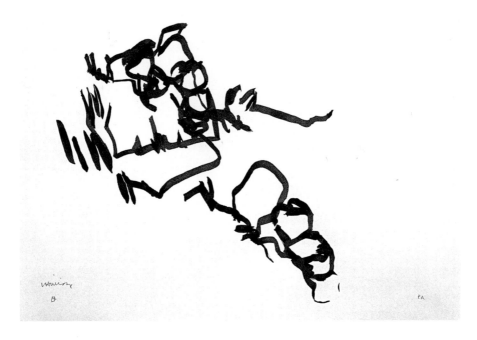

7.5 Eduardo Chillida, *Concordance,*
1960. In *Derrière le Miroir* (March
1961). Photograph courtesy of The Fon-
dren Library, Rice University. ©2008
Artists Rights Society (ARS), New York/
VEGAP, Madrid.

combination of melodious tones that are heard simultaneously. The word derives
from the Latin *concordantia,* composed of the prefix *con* ("with" or "together") and
the root *cor* ("heart"):[18] thus, a state of hearts being together. In turn, these themes
resonate with Chillida's creative process, which he described as tracing a path of
"primal corpo-reality that I call *el corazón de la obra*–'the heart of the work.'"[19]

 Translated into the visual structures of Chillida's imagery, the interlace
of interior forms and metaphorical associations becomes especially suggestive.
Printed in golden-brown ink, the burnished metallic design of *Concordance* echoes
the appearance of Chillida's iron sculptures. The lithograph displays a delicately
stark arrangement of lines that coalesce into an intricate pattern of loops and folds,
while discrete areas of the composition are punctuated by the flanking accents of

7.6 Eduardo Chillida, *Les deux noirs,*
1961. Lithograph. The Museum of Fine
Arts, Houston; Gift of Mr. and Mrs. Alvin
S. Romansky. ©2008 Artists Rights Soci-
ety (ARS), New York/VEGAP, Madrid.

individual brushstrokes. Like so many of Chillida's works, *Concordance* consists of
two primary clusters of forms that are positioned in a carefully balanced dialogue;
together they form a lightly poised configuration of calligraphic presences that
float gracefully within the leaves of the text.

 Viewed schematically, the formal structures of *Concordance* evoke an
abstract piece of modernist lace, an interwoven design that displays an elaborate
tracery of solids and voids. The underlying cream-colored field both separates and
conjoins the two wings of the composition, while the interwoven lines perform
a comparably (non)dual function. Commenting on the ambivalent role of line in
his artworks, Chillida noted, "The line serves to unite the world, but at the same
time divides it–drawing is at once beautiful and terrible."[20] As the artist observed,

line represents a powerful *coincidentia oppositorum* of union and division whose edges demarcate a space in which something is positioned in intimate proximity to something else. In the process, solids and voids, presences and absences, closings and openings, conjunctions and separations are brought into a complex state of agreement, thereby forming the concordance they name in their intricately inter-laced coincidence of opposites.

Finally, as "a cord or string used for drawing together two edges," lace itself is an intrinsically relational object that simultaneously demarcates and inter-weaves the shared edges of two boundaries. Formally and conceptually, the dual *and* nondual structures of lace incorporate void and presence within a unified fabric of being. Significantly, the word "lace" derives from the Latin term *laqueus* ("snare–more at delight"). In turn, to "delight" (from the prefix *de* and the root *lacere*) is to allure.[21] Interweaving these associations, Chillida's *Concordance* can be seen as a lure that allures as the image unites the various meanings ensnared within the open mesh of its interlaced forms.

As an "architect of inner space," Chillida demonstrated considerable expertise in devising such paradoxically interwoven structures, spaces in which bright openings lay nestled between the solid, dark contours of burnished metal or the deep expanse of "the two blacks." These themes are evident in Chillida's *Les deux noirs* (The Two Blacks), another original lithograph published in the March 1961 edition of *Derrière le Miroir*. In 1965, a copy of this print (number 65 of an edition of 150) entered the permanent collection of the MFAH, where Sweeney exhibited the work the following year at the Chillida retrospective.

Printed in densely saturated black ink on cream-colored paper, in this image black emerges as an almost reified presence that conveys a blocky sense of three-dimensional mass. Closely resembling Chillida's collages, the silhouette of the composition appears to have been formed by an arrangement of overlap-ping layers of cut and torn paper. Individual sections are fitted together to form a conglomeration of relational presences through the puzzle-like silhouettes of the two primary interlocking pieces. Within the interior pattern of the print, crisply cut lines contrast sharply with torn edges whose feathery textures palpably reveal the underlying grain of the paper. Thus the lithograph's "two blacks" form

a *coincidentia oppositorum* of geometric and organic forms, darks and lights, closings and openings, which collectively evoke the nocturnal and the diurnal, mass and light. Yet just as they fuse into a single unit, the distinctive presences of "the two blacks" can only be known in relation to one another, and thus through the open, negative spaces of the unnamed bridges of white that simultaneously unite and divide them.

Sweeney perceived the open spaces of Chillida's artworks not as empty but as repositories of living light. In 1961 the critic characterized Chillida's works on paper as exemplifying "his tendency towards elision in the composition of forms and . . . the delicate tension established between the edges of an empty space from which a spark must spring so that this art of elision can obtain the living energy ever present in Chillida's work."[22] The vitality of Chillida's interior spaces–the elisions that create a charged arena for sparks of "living energy"–can be seen in *Concordance* and *Les deux noirs*, compositions whose open spaces are positioned between, and within, monochromatic dark masses, just as the interlaced blanknesses of their white fields glimmer like houses with open doors.

Sweeney's mystically oriented discussion of the metaphorical sparks flying throughout Chillida's inner spaces resonated strongly with the artist's contemporary description of the open, interior spaces of his compositions as "the vacuum in which the soul of the work crystallizes."[23] Building on these themes in "L'espace, la limite" (The Space and the Limit), a text composed entirely of entries from Chillida's notebook pages that appeared in a slightly later edition of *Derrière le Miroir* (February 1970), the artist noted, "There is a common problem in the major part of my work, that of 'inner space,' which is both the consequence and origin of positive exterior volumes. To define these inner spaces, it is necessary to envelop them, thus making them altogether inaccessible to the spectator situated outside of them."[24] Thus according to both Chillida and Sweeney, the inner spaces that imaginatively hold the "springing sparks" or the "soul of the work" can only be known from within, *desde dentro,* even as these charged interiors are necessarily enveloped in solid external structures that must be approached from without. For Chillida, these formal and conceptual apertures created nothing less than open, mystical passageways for "all those who wander."

"All Those Who Wander": Sweeney and Chillida on St. John of the Cross

For more than thirty years, Chillida described the processes of constructing the inner spaces of his artworks as a journey into the unknown. One particularly poetic expression of this can be found in a 1984 letter to Peter Selz in which Chillida described his continual effort to

Seek to visualize where I do not see;
Strive to recognize what I cannot discern;
Attempt to identify within the realm of the unknown.[25]

Throughout his writings, Chillida repeatedly emphasized the compelling allure (*lacere*) of the unknown:

In the face of the unknown we are always alone. (1967)[26]

One never knows enough. Thus in the known, the unknown too is found. (1970)[27]

Wonder before the unknown, such was my master. Attending to this immensity, I have tried to look, I do not know if I have seen. (1979)[28]

I am not a philosopher but I have many philosopher friends and I have seen that these people have something special. They want to know what they don't know. And I am the same way. I am close to the philosophers, although I work in different media and work in an absolutely different way. (1987)[29]

My works are questions, . . . not answers. The way I understand art is as a question. (1988)[30]

[Preliminary studies are] not formal, but spiritual exercises. If I had the exact idea for a work in my mind and refused to waver from that idea, why do the work? . . . It is already done! One approaches a work with an idea, but how it will function, exist, that is the mystery that must be discovered by the artist. (1988)[31]

Couldn't art be a consequence of a beautiful, difficult need that leads us to try and make what we do not know how to make? (1997)[32]

Chillida's most explicit remarks on the unknown and on unknowing were made at a 1993 symposium on "Depression and the Spiritual in Modern Art" that was organized by the psychiatrists Joseph J. Schildkraut (Harvard Medical School) and Aurora Otero (University of Barcelona). After stating that he was unable to speak directly about his spirituality, Chillida proceeded to discuss the sources of his beliefs and inspirations, particularly quoting from St. John of the Cross's *Spiritual Canticle*. Chillida's statement deserves to be quoted in its entirety:

I haven't talked about spirituality so far, but I have experimented with it in order to move closer to a subject that is as fundamental for me as spirituality. Now, I can't talk about my own spirituality. What I can do is tell you some curious things that I have observed in the world of art, and particularly in poetry, in mysticism. For example, and most particularly, in St. John of the Cross, with whom I have been involved for a long time. He says surprising things in this sense. I know it by heart, so I am going to recite something concrete that is very moving if you analyze it from the standpoint of this seminar. You probably all know it: the spiritual canticle:

"Y todos cuantos vagan
de ti me van mil gracias refiriendo
y todos más me llagan
y déjame muriendo
un no sé qué que quedan balbuciendo."

["All those who wander
are telling me of your innumerable graces
and all wound me more and more
and something leaves me dying
I know not of what they are stammering."]

There is no translation for this. I apologize to those of you who don't understand Spanish, but I don't think it could have been translated into any language. Poetry of this level is untranslatable, but this man wants to touch on certain points, and for all of us who want to do likewise a simple analysis of this says all there is to say.

Who are those who wander? All those who wander, might they not be everyone who is trying to reach the unreachable, who wants to know the unknown, and wouldn't artists, some of

them more or less unbalanced, others balanced, belong to this group that St. John of the Cross called "all those who wander"?[33]

As for Sweeney, for Chillida the idea of the unknown–the open terrain of "those who wander"–was deeply invested with mystical and aesthetic associations. Indeed, Chillida had been moved by St. John of the Cross's mystical writings for more than three decades; as Pierre Volboudt observed in 1967, Chillida "quotes St. John of the Cross and his inspired visions" frequently when discussing his artwork.[34] In his symposium remarks, the artist specifically recited the seventh stanza of St. John of the Cross's *Spiritual Canticle*, an ecstatic poem that traces the soul's quest for a state of divine union that is achieved by wandering into, and passionately embracing, the unknown. Yet Chillida's engagement with St. John of the Cross was not limited to the unlimited terrain of "all those who wander." "Silent Music" (*Musica callada*), a paradoxical phrase found in the fifteenth stanza of the *Spiritual Canticle*, provides the title of an iron sculpture (1955) that Sweeney exhibited in the Chillida retrospective in Houston. And toward the end of his life, the artist produced a series of images dedicated to St. John of the Cross, including *My Beloved, the Mountains* (1991); *And All Who Wander* (1991, 1992); and four drawings in ink and cord entitled *Homage to St. John of the Cross* (1991–1993). As Chillida himself repeatedly emphasized, in many ways his artistic practice can be seen as an extended devotional act of wandering into the unknown, following an evanescent path of light cut between the darkness of the two blacks, a *via negativa* that materialized *entre les deux noirs*.[35] Moreover, as Chillida designed the visible, external facades of his artworks, he simultaneously constructed invisible inner spaces that "must possess a kind of spiritual dimension."[36] Contained within their openness, works such as *Concordance* and *Les deux noirs* abstractly embodied such a juxtaposition of the known and the unknown as they formed illuminated pathways for "those who wander."[37] Such too was the case with Chillida's sculptures.

Unspoken Sounds in the Place of Silences

Among the works that Sweeney exhibited in the Chillida retrospective at the MFAH is *Lugar de silencios* (*Place of Silences*) (1958, figure 7.7), a wrought-iron sculpture

7.7 Eduardo Chillida, *Lugar de silencios* (*Place of Silences*), 1958. Wrought iron. The Menil Collection, Houston. Photograph by Hickey & Robertson, Houston. ©2008 Artists Rights Society (ARS), New York/VEGAP, Madrid.

that was loaned by his friends and patrons, John and Dominique de Menil.[58] Much like *Concordance* and *Les deux noirs, Lugar de silencios* can be seen as a material expression of a mystical and aesthetic paradox, an apophatic (un)saying of extraordinary silence.[59] And like *Concordance*, the interwoven limbs of this slender metal sculpture resemble a configuration of iron lace (*laqueus*) that evokes the *coincidentia oppositorum* of unuttered sound captured in a snare that delights and allures.

Measuring fifteen and a half by sixteen and a half by sixteen inches, *Lugar de silencios* is a tabletop sculpture that features a conglomeration of intricately floating geometric forms carefully balanced on three foundational points. While the sculpture is highly abstract, the wrought-iron elements of *Lugar de silencios*

appear almost creaturely, as the work evokes a silent being whose angular legs and frame prop up an elongated, projecting limb. Within the body of the sculpture, a network of intersecting metal forms reveals spaces enclosing other spaces, forms opening onto other forms. Chillida achieved this effect by crafting minute open passageways throughout the intricate joinery of his sculpture, placing adjacent iron elements in close proximity to one another without their actually touching. These breathing spaces form a network of interior passageways, an open framework for a house of silence.

As discussed in chapter 4, Sweeney, like Chillida, was drawn to St. John of the Cross's conception of the *via negativa*, to an apophatic unsaying that enabled viewers to discern the absence that holds an unseen presence. In Chillida's works in particular, Sweeney perceived an apophatic openness that housed the tensions that gave forth sparks of light. Thus when describing iron sculptures such as *Lugar de silencios* in *Derrière le Miroir*, Sweeney characterized the complex interplay of their surfaces and voids as engaging in an imaginary silent dialogue, a saying that is an unsaying, through mobile volumes that created a visible infrastructure of invisible forms. As Sweeney observed, "tensions between forms or lines can suggest links between elements that are not really present," just as "in his sculpture Chillida has found a way of suggesting invisible or at least virtual planes."[40] For Sweeney, this silent conversation between presences that were not actually present held the potential to induce in viewers a form of contemplative envisioning so powerful that it brought forth sparks of light. Thus in Chillida's artworks Sweeney identified an "absence [that] endows the language of sculpture with greater suppleness by multiplying the possibilities of contrasts between filled areas and arbitrary spaces or gaps, which draw their power from the tensions suggested; and these may be sufficiently evocative to force the attention of the observer, like a spark of light darting through empty space."[41]

Six years later, Chillida elaborated on these themes:

I am not concerned with the space which lies outside the form, which surrounds the volume and in which the shapes dwell, but with the space actually created by the shapes, which dwells in them and is all the more effective when it works in secret. I might perhaps compare it to the life-giving breath which causes the forms to swell up and contract and make

visible that inner psychic space which is hidden from the outside world. To me this space is not something abstract, but forms a reality as concrete as the reality of the volumes which enclose it. It must be as tangible as the form in which it is revealed, for it has a character of its own. It sets in motion the matter which encloses it; it determines its proportions and scans and regulates its rhythms. It must find a corresponding echo in us and it must possess a kind of spiritual dimension.[42]

Thus just as Chillida characterized his sculptural practice–his repeated wanderings into the unknown–as a process of constructing material forms to house illuminated inner spaces, he maintained that this same open space mobilizes and animates the matter that encloses visible forms. As he described this phenomenon, "I sense something which, for lack of a better word, I have to call incarnation of the form."[43] For the artist, the "incarnation of the form" thus entailed the production of a body that is not actually a body but rather a material embodiment of the immaterial, an aesthetic embodiment of the void, the structure containing "the vacuum in which the soul of the work crystallizes."[44] Openly enclosing the space within mass and the mass within space, *Lugar de silencios* can be seen as a secular modernist translation of St. John of the Cross's negative theology, a place where the music of (un)spoken sound is voiced in the language of silence.[45]

"A Cloud of Birds": *Anvil of Dreams V*

"A cloud of birds in the sky is better than a single one in the hand." This saying appears on the wall of his studio. For Chillida it is a motto, a challenge to achieve the impossible, and he lets it guide his thoughts and way of life. . . .

"In the work which you see here in the studio or in a few museums or galleries I have occasionally managed to ensnare one of these 'clouds of birds.' Others have slipped through my fingers. When I'm sure of one of them and have it firmly in my grasp, my thoughts have already turned to the next one and to all the others which I dream about. I never know which of the clouds I shall manage to capture. Gradually it begins to take shape–at first I can scarcely make it out, then it becomes clearer and then sometimes vanishes again. But when I've once captured the idea I never let it go. All I have to do is to leave it to develop."[46]

Another work featured in the March 1961 *Derrière le Miroir* was Chillida's *Anvil of Dreams V* (*Yunque de sueños no. 5*, 1954–1958, figure 7.8), a sculpture that

7.8 Eduardo Chillida, *Anvil of Dreams V* (*Yunque de sueños no. 5*), 1954–1958. Wrought iron and wood. The Menil Collection, Houston. Photograph by Mardyks, Paris. ©2008 Artists Rights Society (ARS), New York/VEGAP, Madrid.

is now also in the Menil Collection.[47] Reviewing the Galerie Maeght exhibition in *Art International,* John Ashbery noted: "The smallest works in the show are called 'Anvils of Dreams.' Chillida says that he intends them as designs for a monument to poets–'Poets need anvils for their poems. They must strike heavy blows.' These are beautiful strong fantasies–half seagull, half the wind that it cleaves."[48] Ashbery's lyrical description of the *Anvil of Dreams* series as simultaneously encompassing mass and space, the bird and the wind that surrounds it, echoes the words appearing on the wall of the artist's studio. Both statements conflate product and process, solid presence and the empty space that it contains and which is, in turn, contained within it–the interlace of the bird and the snare (*laqueus*) in which it is captured.

These themes also appear in Gaston Bachelard's slightly earlier account of Chillida's suspended iron sculptures in *Derrière le Miroir* (October-November 1956). In an essay entitled "Le cosmos du fer" (The Cosmos of Iron), Bachelard evocatively described the interwoven structures of Chillida's hanging sculptures, such as *Desde dentro* (figure 7.1), as repositories of dreams and as cages for imaginary birds. As Bachelard remarked, these pieces "are so solidly composed that one forgets the wire that holds them. There is a kind of freeness of symbols in them. Every dreamer can enclose his dreams inside them. For me, these works of flying iron are bird-cages, caged birds, cages poised to fly away; but I will not force anyone to dream as I dream, to read as I do the destiny of such works as these which create a synthesis of substance and movement. With iron, strong movement has found its true substance. And Chillida certainly makes dreaming iron awake in freedom."[49] Bachelard thus saw the interlaced lattices of Chillida's suspended iron sculptures as configurations of animate presences: as caged birds and bird cages that fluttered interchangeably between the container and the contained. Chillida himself was so moved by Bachelard's discussion that, shortly thereafter, he created a sculpture honoring the philosopher, *Articulated Dream: Homage to Gaston Bachelard* (1958).

For Bachelard, as for Sweeney, these interwoven formal and metaphorical associations were visibly conveyed through the artist's touch. As Bachelard wrote in 1956, for the blacksmith, "each hammer blow is a signature."[50] Five years later Sweeney similarly characterized Chillida's ironwork as a mystical practice of transmission that "unfailingly evokes the blacksmith, the alchemy of the forge,

the striking of the hammer. By the direct contact of his hand he communicates his own living impulse to the inner metal. Hammer blow by hammer blow, he covers what might at first sight seem a flat surface with countless subtle facets. In reality it becomes a visual imprint which restores for us the very rhythms of the act of creation. And beneath his hammer the iron acquires a tension, a power, whose virility contrasts with the softness and gentleness of a shape of molten metal."[51] Thus through the transformative presence of the flame that empowers the mystical "alchemy of the forge," Sweeney characterized Chillida as fusing masculine "virility" with the feminized qualities of "softness and gentleness." Through the combined effects of these "alchemical" processes, the artist infused vital force into inanimate matter, endowing inert material with a "living impulse" that was transmitted through the creative act of touch. Works such as *Lugar de silencios* and *Anvil of Dreams V* were thus seen as symbolic embodiments of Chillida's distinctive "signature" (Bachelard), and three-dimensional translations of "Chillida's personal handwriting" (Sweeney).

Like *Lugar de silencios*, *Anvil of Dreams V* is a vertically oriented, tabletop sculpture that measures seventeen and one-eighth by eight and a half by nine and a half inches. At the sculpture's base are small, wooden steps that suggest a miniature staircase, gradations that subtly evoke the platform of a temple. Perched atop this platform base, the body of the sculpture consists of a series of interconnected iron axes. Taken together, the metal elements form a balanced configuration with multiple meeting points, a complex crossroads that connects an imaginary set of intersecting planes. Cubes appear whose edges remain suggestively open, as their curving volumes cradle a series of mutually embracing voids. Regarding the intricate interpenetration of these absent presences, Sweeney remarked that "Chillida's sculptures in metal are equally physical indications of intersections of planes which remain invisible but which the observer is led to recreate in his imagination."[52] As the curator suggested, *Anvil of Dreams V* appears to oscillate between the real and the imaginary through the containment and release of all that the anvil's outstretched, curving limbs hold and all that they relinquish. Juxtaposing material density with a flotational lightness of being, the iron anvil couples the groundedness of the earth with the buoyancy of Chillida's "cloud of birds."[53]

Symbolically, the open containment of *Anvil of Dreams*' interior axes evokes a nexus of dreams and reality–the combined imagery of the dreamcatcher– just as it suggests a kind of ancient sundial with multiple gnomons that mark mani- fold systems of time.[54] In *Derrière le Miroir*, Sweeney noted that "Eduardo Chillida's art comes from two traditions. That of the master ironworkers of the north of Spain, on the one hand, whose craftsmanship has stamped its mark on this part of the Iberian peninsula since the Middle Ages. And, on the other hand, the language of the contemporary plastic way of seeing transmitted by his immediate predecessors of the last seventy-five years, to which he has given a new direction and a personal inflection. From the former he draws the popular sap of his art, and from the lat- ter its imagination and metaphysical dimension."[55] A multiplicity of temporal and stylistic associations thus crystallized in the "disintegrating frontiers" of Chillida's artworks. Taken together, these disappearing boundaries conjoined fire and mat- ter, tension and softness, masses and transparent forms, virility and gentleness, and the traditional and the avant-garde in an interlaced *coincidentia oppositorum* that framed the open doorways of Chillida's sculptures.

Shifting Staircases and the Limits of Light: *Abesti gogora I*

The 1961 Galerie Maeght exhibition also included Chillida's most recent creation in wood, an oak sculpture entitled *Abesti gogora I* (1960–1961, figures 7.3, 7.9, 7.10, and plate 7). As Pilar Chillida explained to Sweeney, the source of the title "is a Basque phrase, meaning roughly 'robust song' or 'strong song.'"[56] In Basque, *abestu* is the transitive verb "to sing," while *abesti* forms the noun, "song." The adjec- tive *gogor* signifies a range of associations, including the qualities being hard or difficult, durable or solid, tenacious, persevering, constant, and patient.[57] These attributes can be seen as reflected in the distinctive features of oak, which is among the hardest of hardwoods. In undertaking *Abesti gogora I*, Chillida worked not only in an unaccustomed material, but on a significantly larger scale. This oak sculpture measures over five feet in height by eleven feet in length by five feet in width. While *Abesti gogora I* marked a substantial departure in both scale and materials from Chillida's previous iron work, it also evinces a similarity with sculptures such as *Lugar de silencios*. Just as *Lugar de silencios* apophatically counterpoises invisible

7.9 Eduardo Chillida, *Abesti gogora I* (*Song of Strength*), 1960–1961. Oak. The Museum of Fine Arts, Houston; Museum Purchase. ©2008 Artists Rights Society (ARS), New York/VEGAP, Madrid.

music and silent sound, in *Abesti gogora I* a robust song perches mutely in the sculpture's intertwined wooden limbs. Thus as the poet Octavio Paz remarked of Chillida's works, "The sculptures in iron, wood, granite and steel were traps to catch the uncatchable: wind, sound, music, silence–space."[58] Or, as Chillida wrote in his notebook pages, "Tout ce qui grandit vibre et s'emboîte" (Everything that grows vibrates and encloses).[59]

In *Abesti gogora I*, massive sections of solid oak are assembled into a constellation of interlocking forms that are visibly conjoined by exposed wooden pegs. This assemblage creates a *coincidentia oppositorum* of mass and grace, as the sculpture appears balanced yet bulky, strong yet delicate, robustly loud yet profoundly silent. Organic and abstract at once, its agglomeration of angular, geometric

7.10 Eduardo Chillida, *Abesti gogora I*
(*Song of Strength*), 1960–1961. Oak. The
Museum of Fine Arts, Houston; Museum
Purchase. ©2008 Artists Rights Society
(ARS), New York/VEGAP, Madrid.

elements is softened by the highly textured, natural grain of the wood, whose warm
brown and umber surfaces are internally infused with rings and veins that form
complementary patterns of encirclement and striation. And much like *Lugar de
silencios, Abesti gogora I* is balanced on a concentrated base of three points, while
the body of the sculpture is complemented by the projecting lateral extension of
a cantilevered leg. As a result, the work simultaneously appears geometrically
abstract and biomorphically creaturely, the armature of its body supporting what
appears to be either a long neck or an outstretched tail. Sweeney remarked on the
multifaceted character of the piece in a museum press release: "Characteristic of
[Chillida's] expression is the interplay of broad massive elements to which he gives
a sense of lightness through a subtle poising and a delicate contrast of open spaces

with the conviction of his solids. In a piece such as *Abestu Gogora I* a ton and a half of golden oak balances on three tiny points with the grace of a dancer or some gargantuan insect."[60] Or as Chillida enigmatically observed in his notebook pages, "One needs three jaws in order to conduct oneself and to 'eat' in space."[61]

Sweeney was especially fond of recounting the story of the initial installation of *Abesti gogora I* at the MFAH. As he observed:

We see its 1600 pounds of oak poised on three points giving it a lightness which is almost a *tour de force* of design, in no way a distraction from the general effect, but rather a lyric contribution.

And this "rightness" of organization was brought home to me in a simple way five years ago when we were first installing it. Because of its weight we had to call in three stevedores to help place it on its four-foot-high base. After it was in place I noticed the biggest of these handlers, a huge fellow of more than six feet, resting from his efforts with one foot on the extended leg of the sculpture. I asked one of the Museum guards to suggest tactfully to the workman that this was an exhibition piece not just so much lumber. He was unaware that I had been involved in the guard's remonstrance. But five or ten minutes later I was standing near the gallery exit as he was leaving. I noticed that, after opening the door, he stopped a moment to look round at the sculpture and said to me with a certain note of surprise "You know that's pretty good." I asked, "You like it?" He said "Yes." I asked "Why?" He hesitated for a moment, then said "Because it all works together."

For me the big handler hit the essential points—its "rightness" of organization, its unity-in-complexity, its *integrity*.

"Lightness" and "rightness" are the characteristics of Chillida's expression in no matter what material—no matter how heavy or how light, no matter how essentially opaque, or how open—a lightness and rightness he achieves through his sensibility to the basic architectonic relationships.[62]

Such a notion of internal reversibility imaginatively recurs in Bachelard's image of the staircase. As Chillida later noted in his symposium remarks, the topic of the gathering brought to mind

something about Gaston Bachelard, a curious thing that reveals how sensitive he was. He was a poet and a philosopher. He was a tremendous poet and says in his *Poetry of Space* something I think is marvelous, spiritual, and magnificent, expressed in terms of a more

pedestrian, more ordinary world. He explains that the average house should have three sto-
ries: the ground floor, the cellar and the attic. And he says that the stairs that connect the
ground floor with the attic are different than the stairs that link the ground floor to the cellar.
The stairs that lead to the attic always go up and the stairs that lead to the cellar always go
down. In other words, they work on your imagination so that you think the stairs that lead to
the attic go up and that the ones that lead to the cellar go down.

 This is the analysis of a poet, a philosopher, who knows perfectly well that stair-
cases go both up and down, but they still mark the imagination of a man like this, and anyone
who thinks about this will realize that this happens in a lot of life's situations.[63]

Thus despite its seemingly static symmetrical orientation, Bachelard's staircase–
like the internal structures of *Abesti gogora I*, or the wooden platform base of *Anvil
of Dreams V*–brings to light the ways in which abstract conceptual movement
becomes mapped onto physical spaces through a series of ascending and descend-
ing planes. In turn, this *coincidentia oppositorum* of ascent and descent forms a
dynamic pathway that leads in multiple directions simultaneously.

 Other contemporary critics also commented on the various *coincidentiae
oppositorum* that they perceived in the *Abesti gogora* series. Ashbery noted the
conjoined opposites that comprise *Abesti gogora I*, in which "an angular sheaf
of timbers rests lightly on the ground, its mass straining into the air. It gives an
impression of thistledown lightness because of the extraordinary way in which the
volume has been hollowed and mined. Nowhere is it solid: the obstinate wooden
locks are always giving way to slender crevasses which strike deep into the heart
of the sculpture. It is surrounded everywhere, buoyed up by light and air. The
'great cry' is one of exultation."[64] Pierre Volboudt echoed these themes when he
remarked that, in Chillida's art, "Pieces of wood which have a living structure of
their own are fitted into power systems, into a framework which sets like against
like. A power of attraction, running in straight lines, links them to an inaccessible
centre in which the weight of the masses is concentrated. Horizontal and diagonal
movement seems to impart a floating lightness to such pieces."[65]

 As the critics noted, Chillida was committed to preserving the open, inte-
rior spaces of his sculptures so that viewers could enter their invisible realms,
"at least in their spirit." When, after a sustained period of exploration with wood-
carving, this vital inner space collapsed, Chillida knew that he had completed the

series. As he later explained, "Wood, being less dense, made it possible for me to move to a large space and at the time to be able to approach the situation in relationship to the inside space. I then developed this work in wood for three years. I did big sculptures in Chicago and in Houston. But finally I had to leave wood because something incredible happened. When I was working on the last of the wood pieces, I suddenly felt that the approach to the interior space was closed. The spectator had no longer the possibility to understand what happened inside. The work became hermetic and I stopped working in wood."[66] This sense of completion further exemplifies Chillida's emphasis on the centrality of the void, the open interior space that forms the artwork's visible, exterior structure.[67] Interweaving these associations, in 1970 the artist again affirmed his sculpture as a process of knowing the unknown through the known: "I aspire, on my part, to define three-dimensional voids by means of three-dimensional solids, and with the same stroke establish a means of correlation and a dialogue between them. Thanks to such correlations, exterior volumes, to which we have ready access, more reliably become our guides towards apprehending, at least in their spirit, the hidden spaces."[68]

In *Derrière le Miroir,* Sweeney characterized the edges and boundaries of Chillida's artworks not as stable entities but as fluidly animate presences. Thus, commenting on *Abesti gogora I,* Sweeney noted that "the edges of the forms become more important than the volumes that they define. The masses, ample as they are, become subordinated to the orchestration of planes marked out by these characteristic sharp edges. In Chillida's sculpture it is the edges that are offset against one another. Between them, the texture of the wood contributes to the richness and interest of the whole. The basically massive nature of the material is always respected, never disguised. Even here, masses play a minor part in the interplay and clash of edges. They vanish into relative invisibility and it is their edges that form the essential framework in space."[69] By highlighting liminal edges over solid volumes–the latter of which "vanish into relative invisibility"–Sweeney identified a complex interlace of visible and invisible relationships: the presence that holds the absence, and the absence that holds the presence of "a spark of light darting through empty space." As discussed below, Sweeney's critical reading of Chillida resonated with the artist's own theoretical conceptions of the edge and the limit,

just as this interpretation turned on the mystical paradox of making the visible invisible so that the invisible could become visible.

Seen in these terms, *Abesti gogora I* is a modernist artwork that flexibly incorporates its frame into its own body. Unlike traditional frames, which characteristically delimit the established perimeters of the work, Chillida's intersecting internal frames have been suggestively left open. As a result, the interwoven spaces of *Abesti gogora I* can be envisioned as a mobile conglomeration of reversible frames, relational presences that simultaneously evoke interchangeable states of being, much like Bachelard's staircase or Duchamp's *Door*. Within his own technical terminology, Chillida characterized these transformative interfaces as "the limits," which he differentiated from "the edges": "Obviously, the edge is the end of something and the limit is the point where one thing turns into another. It's what separates two things that touch, but remain different."[70] According to the artist, the limit is a transitional zone, a site of transformational convergence, a shared membrane that marks liminal states of being. As such, the limit exemplifies a nondual conception of form that simultaneously incorporates the space that conjoins two masses and the light that connects two spaces. Or, to translate these concepts into his own architectonic metaphors, the limit can be imagined as a shifting staircase in a house whose front *and* back doors have purposefully been left open.

Heidegger's *Topos*: An Extraordinary Commonplace/ Common Place

During the mid-sixties, while he was collaborating with Sweeney on the *Abesti gogora* series, Chillida explored similar thematic issues with the philosopher Martin Heidegger. Heinrich Wiegand Petzet recalls that he initially met Chillida at the artist's exhibition in Switzerland in 1962, and later facilitated Chillida and Heidegger's meeting. From the outset, Petzet recognized key conceptual similarities between the artist and the philosopher, which he subsequently shared with Heidegger. In particular, Petzet was struck by Chillida's belief that, in his sculpture, "it is not the form with which I am concerned, but the relation of forms to one another—the relation that arises among them."[71] In turn, Heidegger acknowledged the resonance between Chillida's approach to the limits of relational space and

the questions that he had examined in his lecture "Building, Dwelling, Thinking" (Darmstadt, 1951), issues that the philosopher would continue to explore in "Die Kunst und der Raum" (Art and Space, 1969).

Chillida and Heidegger first met in 1968 at the Galerie im Erker in Saint-Gall, Switzerland. At the invitation of the gallery's director, Franz Larese, Heidegger wrote the text for "Die Kunst und der Raum" directly onto lithographic stone. That November, Heidegger invited Chillida to contribute seven lithocollages to accompany the essay, which was published the following year by Erker Presse in a deluxe limited edition of 150 copies.[72] Chillida and Heidegger met again in Saint-Gall in October of 1969 to celebrate the appearance of the volume, which carried the dedication "For Eduardo Chillida." Chillida, in turn, later produced two tributes to Heidegger, including a drypoint engraving, *Homage to Heidegger* (1982), and a steel composition entitled *Bauen, Wohnen, Denken: Homage à Heidegger* (1994).[73] As Chillida observed, "Philosophers such as Martin Heidegger and Gaston Bachelard . . . share the same ideas I have in my work. Heidegger wrote a book, *The Art and the Space*, that discussed my work: the idea of space as living space that is in relation to man, and the idea that sculpture reveals the exact character of a space. Heidegger asked for my thoughts because he was astonished to find so many relations between his ideas and my ideas, translated into sculpture."[74] Indeed, for both Heidegger and Chillida the spatial field represented a kind of animate presence that incorporated emptiness and fullness into an interwoven structure of being, a common place that the philosopher termed the topos.

As Petzet has observed, "above all else, [Heidegger] was concerned with the meaning of *place*, the Greek *topos*," and after the Darmstadt lecture, "from then on, it was the 'place' as represented in the plastic work of Chillida that concerned him." Petzet remarked that "the result, as it were, of the dialogue between the thinker and the sculptor" can be summarized in a statement from Aristotle's *Physics* which appears as an epigraph to "Art and Space": "But it seems to be something very powerful and difficult to grasp: the *topos*."[75] According to the *Oxford English Dictionary*, a topos (τόπος) is "a traditional motif or theme (in a literary composition); a rhetorical commonplace, a literary convention or formula." Moreover, topos is also closely related to the term "topic," which designates the title of

a work by Aristotle (*Topics*) that addressed general subjects or commonplaces.[76] The topos thus signifies a common place *and* a commonplace, the convergence of diverse subjects and the shared spaces that they inhabit.

In "Art and Space," Heidegger noted that "things are themselves places and do not merely belong to a place," just as "sculptural compositions are bodies" whose masses are shaped through "the process of demarcation as inclusion or exclusion."[77] Throughout this essay, Heidegger repeatedly inverted and collapsed reciprocal notions of emptiness and plentitude within the structural conception of the sculpture as topos. As the philosopher observed:

Sculpture would be the embodying of places which, opening an environment and maintaining it, gather about them a freeness which grants an abiding presence to each thing and a dwelling to man amidst those things.

If this is so, then what of the volume of the sculptural composition which in each case gives embodiment to a place? Presumably it will not continue to demarcate spaces in which surfaces entwine an inside against an outside. What is named with the word "volume" would have to lose its name, the meaning of which is only as old as modern science and technology.

The place-seeking and place-forming characteristics of sculptural embodying would for the time being remain nameless.

And what of the emptiness of space? Often enough it appears simply as a lack. Then emptiness is considered to be the lack of a filling of hollow and intervening spaces.

Yet emptiness is surely related directly with the particular nature of place and therefore is not a lack but a setting-forth.[78]

The philosopher's discussion raises many significant questions, perhaps most notably: What is the specific nature of this "setting forth" that forms place? For Heidegger, the process of "making space" is associated with the simultaneity of revelation and concealment, with the act of creating a place that can accommodate the simultaneous entrance and exit of divinity. As he wrote: "Making space is the clearing of places in which a God appears, places from which the Gods have fled, places where the appearance of the divine lingers. Making space creates a locality which in turn prepares for dwelling. . . . In 'making space' a happening speaks and at the same time conceals itself."[79]

As this suggests, Heidegger envisioned the places embodied in Chillida's artworks as exemplary schematic incarnations of nondual space, simultaneously encompassing subject and place, embodiment and disembodiment, presence and absence, place-seeking and place-forming, disclosure and hiddenness, speaking and unsaying–all collectively gathered in the common place of the sculptural topos. Thus underpinning the Heideggerian account in "Art and Space" is, once again, the flexible framework of the *coincidentia oppositorum.*[80] Just as Heidegger discerned the capacity for a "setting-forth" of numinous presence within the openness of seemingly empty sculptural forms, eight years earlier Sweeney had characterized the interior structures of Chillida's sculptures as an "absence [that] endows the language of sculpture with greater suppleness by multiplying the possibilities of contrasts between filled areas and arbitrary spaces or gaps, which draw their power from the tensions suggested; and these may be sufficiently evocative to force the attention of the observer, like a spark of light darting through empty space."[81] Thus both individually and collectively, Heidegger, Sweeney, and Chillida were concerned with accounting for the presences within absences, the unsaying within the saying, and the ways in which these apophatic aesthetic structures could form an open pathway for "all those who wander."[82] Given these conceptual concordances, it is not surprising that the images that Chillida produced to accompany "Art and Space" bear a striking resemblance to the drawings that appear throughout Sweeney's essay in *Derrière le Miroir.* In all instances, open passageways frame interwoven configurations of relational forms, just as their emptiness creates a luminous interlace that houses the largesse of their shared connections.

The Robust Sound of a Silent Song: *Abesti gogora V*

As evocative as these associations are, the plentitude of the topos is not yet fully emptied.[83] In its diminutive form, the Latin term *topia* denotes a type of interior wall decoration that features the depiction of place, such as found in ancient landscape scenes. *Topiarius* designates topiary, or the cultivation of the natural environment through ornamental gardening, particularly through the clipping and trimming of trees and shrubs into decorative or fantastic shapes.[84] Thus the common place formed by the variations of the term topos–that is, the topos of

the topos—encompasses the mystical and the philosophical, the aesthetic and the organic domains. These themes dramatically converge in Chillida's massive rose granite sculpture *Abesti gogora V* (*Song of Strength V*, 1966, figures 7.11, 7.12, plate 8).

As the Italian artist and critic Giovanni Carandente has observed, "*Abesti Gogora V*, by virtue of its urban situation in a green area of Houston, and its proximity to one of the most significant architectural works of this century (the clean-cut nature of Mies van der Rohe's architecture is well-known to all), may thus be considered the first truly monumental work to have been created by the hands of Eduardo Chillida on a civic scale."[85] Weighing approximately sixty tons and measuring nearly fifteen feet in height by eighteen and a half in length by fourteen in width, *Abesti gogora V* is indeed a monumental work. Thus it is not surprising that the artist was extremely concerned with the sculpture's physical placement on the museum's south garden lawn. However, when it came time to install the piece during the spring of 1966, Chillida became too ill to travel to supervise the installation in Houston. Instead, he requested several large photographs of the site, "of the place where the sculpture is going to be placed, from different angles," accompanied by "explanations about how the sun goes out and down, in order to be able to choose the perfect position."[86] Accompanied by Chillida's technical assistant, the stone carver Nicanor Carballo, Pilar Chillida personally traveled to Houston to supervise the placement of *Abesti gogora V* on the museum grounds.

In an interview with Ann Holmes for the *Houston Chronicle*, Mrs. Chillida noted that the sculpture "must rise from the grass like a flower . . . it may be heavy, but it will have a lightness."[87] The letters that Sweeney and the Chillidas exchanged indicate that considerable attention was devoted to the dynamics of solar movement and ambient illumination in the garden context, so that a transient play of light and shadow would appear to animate the seemingly stable surface of the monument. Moreover, just as Pilar Chillida emphasized an inherent sense of floral organicism in the sculpture's rose granite form, Sweeney similarly noted that "this ease of organic interflow of part into part is especially notable in his large granite piece, *Abesti gogora V*, 1966, and particularly in the paradoxical lightness of the cantilever leg which plays such lyric counterpoint with the massiveness of the stone out of which it has been carved."[88] Both practically and aesthetically, Sweeney

7.11 Eduardo Chillida, *Abesti gogora V* (*Song of Strength V*), 1966. Granite. The Museum of Fine Arts, Houston; Gift of the Houston Endowment, Inc. in memory of Mr. and Mrs. Jesse H. Jones. ©2008 Artists Rights Society (ARS), New York/ VEGAP, Madrid.

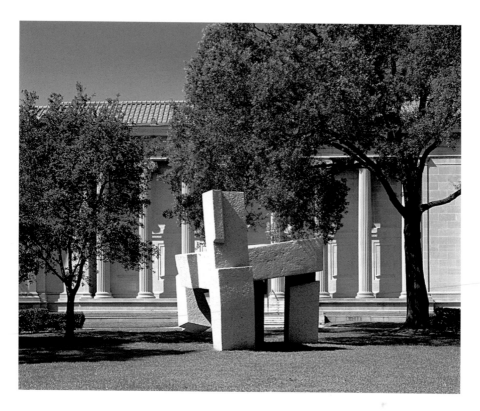

7.12 Eduardo Chillida, *Abesti gogora V* (*Song of Strength V*), 1966. Granite. The Museum of Fine Arts, Houston; Gift of the Houston Endowment, Inc. in memory of Mr. and Mrs. Jesse H. Jones. © 2008 Artists Rights Society (ARS), New York/ VEGAP, Madrid.

and Chillida's collaborative efforts to produce *Abesti gogora V* can be seen as comprising a multifaceted art historical topos. In the intricate construction and the careful placement of the sculpture on the museum's grounds, the organic became manifest within the aesthetic and the aesthetic within the organic, as the fantastic body of the work converged with the extraordinary "common place" of the public garden in which it is situated.

The installation of *Abesti gogora V* marked the culmination of Sweeney's efforts toward establishing monumental public sculpture in Houston. The unveiling of the sculpture was carefully timed to coincide with the inauguration of the

Jesse H. Jones Hall for the Performing Arts in downtown Houston. A multiday arts festival was organized to celebrate the occasion. On Monday, October 3, 1966, the Houston Symphony Orchestra officially opened Jones Hall, while Wednesday, October 5, marked the opening performance of the Houston Grand Opera. Slotted between these two dates, the evening of Tuesday, October 4 was designated for the preview of the Chillida retrospective.[89] Widely covered in the Arts and Society pages of the local press, these gala events showcased Houston's various cultural spectacles, and themselves constituted a kind of elite cultural performance.

Jesse Holman Jones (1874–1956) was a Texas industrialist who had made a fortune in the construction, banking, oil, and shipping industries; he later became the sole owner of the *Houston Chronicle* as well as an extremely influential politician, most notably serving as Secretary of Commerce under Franklin D. Roosevelt. In 1937 Jones and his wife, Mary Gibbs Jones, established the Houston Endowment Inc. as a vehicle for their civic philanthropy. Representatives from the Houston Endowment had initially approached Sweeney to request that the preview of the museum's major fall exhibition coincide with the Festival of the Arts celebrations. Immediately recognizing the considerable opportunity at hand, Sweeney raised the stakes and proposed that the Houston Endowment provide the funding for *Abesti gogora V*.

In a letter to the foundation dated January 26, 1966, Sweeney emphasized that he had long been considering the commission of a significant piece of sculpture that could function as "a major civic monument in a public place." He had discussed the matter with Chillida, and the artist had proposed that a monumental granite sculpture be erected on the MFAH grounds. Sweeney now suggested to the foundation that the Chillida exhibition be previewed on the Tuesday night of the Arts Festival, when Jones Hall would be dark. As Sweeney noted, the unveiling of the sculpture would contribute another dimension to the Jones' art patronage in Houston. As he put the matter to the Houston Endowment: "Why not a durable memorial to the Jones name through this monument which might be given to the Museum of Fine Arts and unveiled the night of the exhibition preview, the Tuesday of your Festival? The Jones Hall has its association with the theater, music and the dance, in this way it could also be concretely linked with

the visual arts and with the Museum, as it already is in sympathy and through earlier contributions." Sweeney artfully concluded by emphasizing the mutual benefit of the commission: "Chillida as you know is the foremost sculptor in his generation, internationally recognized as such. . . . The fact that Chillida is willing to allow such a piece as the projected granite sculpture to be purchased at such a relatively low price, provided it be placed as a civic monument in a public spot, is an indication of his interest in the prestige this would give him. At the same time his interest in the project is an assurance that he will take every care to make it a work which would enhance his reputation. And what would enhance Chillida's reputation internationally would certainly be to the prestige of Houston and of the Endowment. Particularly so, in view of the fact critics and writers from all quarters of the country will be here to recognize and publicize its unique character as a civic monument."[90]

Sweeney's letter struck just the right chord, as he had strategically mobilized an auspicious combination of philanthropic ideals, modernist artistic accomplishment, favorable public relations, pragmatic business acumen, and a shrewd bit of diplomatic flattery to his potential patrons. A subsequent museum press release provided the further details of the story. Shortly after sending this request to the Houston Endowment, Sweeney contacted Chillida, and "the location was discussed, the civic importance of the piece and the desirable scale and a wooden model was prepared. The Board of Houston Endowment Inc. then studied the proposed sculpture, approved it and authorized the commission some months ago."[91] It was mutually agreed that the gift would "commemorate the memory of Jesse H. Jones and Mary Gibbs Jones in virtue of their interest in the fine arts and regard for the Museum of Fine Arts, Houston in Texas."[92]

Yet Sweeney's success in securing the necessary support from the Houston Endowment represented only one dimension of the story. Much like the internal structures of *Abesti gogora V*, the final realization of the project entailed the orchestration of multiple spheres of being. On a practical level, Chillida faced the formidable challenges associated with the physical construction and shipment of this massive artwork. The artist related the details to Sweeney who, in turn, incorporated the elaborate story of the sculpture's construction into his exhibition

catalogue. As Sweeney recounted, he and Chillida first discussed the possibility of such a commission in Paris in July of 1965. In subsequent correspondence, the artist informed Sweeney, "As I told you in Paris, I think that this big sculpture can be of the maximum importance in my work. I know that I will finde many problemes before I arrived to its end, but I am sure that the result will be optimum."[93] Chillida's first major challenge was to locate a sufficient quantity and quality of stone. On February 15, 1966, he cabled Sweeney from San Sebastián, informing him: "Big work in way. Found wonderful granite in Galicia." A few days later, Sweeney received the following letter:

The day following your confirmation cable I went to Galicia the northwest part of Spain richest in granite . . . after going round a whole week I found a quarry which was abandoned but which was of the best color and of the quality I was looking for. . . . I came back to San Sebastián to find good stone cutters. On my return to Budino in Galicia the Monday following everything was upside down due to small-town quarrels. I had to start fighting again and I must say I am the most surprised by my ability. But that shows that when you really want something, you get it. I am sure that this work once finished is going to be the best sculpture I have ever done and all the trouble that it is going to give me counts for nothing. The work consists in three separate stones that will be combined to form a unit sculpture. The weight of a single block I need for realizing the pieces, is untrimmed nearly 100 tons. . . . Once carved this piece may have a weight of around 25 tons. The sculpture in its totality once in place, will be approximately 13′ ¾″ high, 16′ 3″ long and 13′ wide . . . the stone is rose granite and hard, but even if it is hard to work, it is very beautiful.[94]

That June, Chillida sent another letter expressing his happiness with the strength and quality of the granite, colorfully telling Sweeney, "Imagine, she gets so hot when worked, that you can light a cigarette on it!"[95] The final phase of the process, which Sweeney described at length in the exhibition catalogue, unfolded once the sculpture had been carved. Chillida then had to undertake another sustained effort to transport the three separate stone sections thirteen miles, over mountainous roads, from the quarry in Budino to the port of Vigo.

Meanwhile back in Houston, Sweeney was busy organizing his part of the program. He carefully publicized selected details of the project, while preserving an aura of mystery around the commission. Thus the curator cabled Chillida

on March 28, 1966, advising him: "Suggest you refuse give photographs of wood model to news media until unveiling of actual sculpture Stop. Confidential. Stop. Writing Sweeney."[96] Once the sculpture arrived in Houston, both the practical challenges and the public spotlight continued. Ann Holmes provided thorough press coverage in the *Houston Chronicle*, beginning with a story on September 27 that carried the headline: "Monumental Chillida Sculpture Arrives for Festival of the Arts." Holmes described something resembling a triumphal procession, in which "a monumental 60-ton sculpture in pink rose granite was to be toured on a flat-bed truck through the streets of Houston today from the Port of Houston to the south lawn of the Museum of Fine Arts. The work, in three pieces, is by Spain's foremost young sculptor, Eduardo Chillida. It is called 'Abesti Gogora 5,' and is an abstract work said to be of great beauty. It will be unveiled at 10 p.m. next Tuesday."[97]

Holmes followed up with an interview with Pilar Chillida, who provided further details of the sculpture's construction: "'Big things like this sculpture are never easy,' she remarked. 'Eduardo loves the challenge of big things. This sculpture is done in three parts. When it was suggested to him that it would have been easier to do it in many smaller parts and that nobody would have cared, Eduardo was outraged at the idea.'" After alluding to the practical difficulties of the stone quarrying, Holmes reported: "It was all done, tediously, by hand, with the carvers working at night with lights strung across the sides of the granite cliff. . . . Eight assistants worked six months there, some having moved their families to Budino for the duration. When 'Abesti' was finally finished a fiesta was held, celebrating the Houston sculpture. The name of the work, Pilar says, is a Basque phrase: 'Abesti is a melody or song and Gogora means great! Wonderful!'"[98] In the following day's *Chronicle*, two photographs of the partially assembled sculpture were accompanied by the caption: "Chillida Sculptured [*sic*] is Erected."[99] As Sweeney later commented, "with the assembling of those three parts on the South Garden lawn of the Museum of Fine Arts was another saga with two cranes capable of lifting 50 tons picking up elements, trying them in place, removing them for other adjustments– replacing them–on the prepared, underground, reinforced concrete bases reaching down to their bell shaped foundations twelve feet below the surface."[100] With a dramatic flourish, Sweeney concluded that, despite numerous preliminary reports

and photographs of the work in process, "the final realization was only disclosed when the last chain and block supports were removed the morning of the day on which it was to be dedicated, October 4, 1966."[101]

Preserved in the MFAH archives is a document outlining the intended program of the unveiling ceremony. On the evening of October 4, *Abesti gogora V* was to remain covered in a drop cloth and left in darkness until John Beck, vice president of the MFAH's board of trustees, and his wife, Audrey Jones Beck, the granddaughter of Jesse H. Jones, removed the veil and made a brief speech, at which point the sculpture was to be illuminated. The dedication would be followed by a party in the museum garden.[102] While a downpour precluded the outdoor portion of the program, Holmes reported in a front page story that "workmen had earlier taken the wraps off and throngs attending a reception at the museum for the unveiling and to see a retrospective of Chillida's works hailed the 60-ton work glistening in the rain, as a superb addition to the museum's growing collection."[103] Delighted with the final results, the following day Sweeney enthusiastically cabled Chillida: "*Abesti Gogora Five* magnificent stop Grateful to you Brilliant success Congratulations—Pilar's care invaluable Our Love Sweeney."[104]

The realization of *Abesti gogora V* represented not only a significant artistic accomplishment but an important source of public recognition, both within and beyond the city of Houston. Not surprisingly, the de Menils were extremely supportive throughout the exhibition process. Dominique de Menil assisted Sweeney in securing loans for the show, and once *Abesti gogora V* was mounted, John de Menil generously told him that he "thought the show was great, and the Chillida monument is greater."[105] A bit more unexpected was the appreciative letter that Edward Rotan, president of the museum's board of trustees, forwarded to Sweeney from the prominent art collector and philanthropist Ima Hogg. Miss Hogg also served on the museum's board of trustees, and she had recently donated her personal residence, Bayou Bend, to the MFAH; this twenty-eight-room house-museum currently serves as the MFAH's American decorative arts wing. In a letter dated February 3, 1967, Miss Hogg expressed her admiration to Rotan: "It happens that I was particularly moved by the work of Chillida. The sculpture in the garden and the massive wooden sculpture in the south hall are, by my way of thinking,

superb works of art. I think the Museum is to be congratulated on owning these two sculptures."[106]

The Chillida sculpture also received significant national attention. A photograph of Sweeney standing beside *Abesti gogora V* appeared in *Time* magazine, where the sculpture was hailed as "a fitting cornerstone to Houston's cultural boom."[107] In the *New York Times*, Hilton Kramer noted that Sweeney's retrospective provided a valuable context for *Abesti gogora V*, the sculpture emerging as "a culmination of certain abiding interests [of Chillida's] rather than a leap into an untried realm."[108] Henry J. Seldis published glowing reviews in both the *Los Angeles Times* and *Art International*; Sweeney had expressly invited Seldis to visit Houston on a stopover from New York to Los Angeles.[109] Seldis commented: "It is no exaggeration to say that this astounding work is the most imposing contemporary sculpture to become a public monument in any American city to date." He praised Sweeney as an "indefatigable champion of living art, whose contributions as curator and critic brought him wide fame long before his appointment to Houston," and concluded by asserting that, if Sweeney "had done nothing more on his new assignment than to leave these two permanent marks on the community [i.e., *Abesti gogora V* and Cullinan Hall], it would owe him a perennial debt."[110]

Once again, the dynamic formal qualities of the artwork display an interweaving of opposites. The rose granite stone appears warm and sweet, just as its textured surface is somehow rough and smooth at once. Like *Lugar de silencios* and *Abesti gogora I*, *Abesti gogora V* ranges from the abstractly architectonic to the suggestively zoomorphic. At first glance, the large, blocky stone structure appears emphatically angular, an interlocking configuration of diagonal posts and lintels that create a succession of geometric cutaways framing an imaginary array of internal doorways and windows. The solidity of the granite is lightened by the alternating rhythms of openings and voids that create a palpable interlace of presences and absences. Heightening these dramatic effects, a massive section of granite is sharply suspended at a 100-degree angle and appears to levitate from the back of the sculpture, forming a complement to the elongated granite section that hovers at an 80-degree angle at the opposite end of the work. Viewed as a whole, these forms once again call to mind an imaginary archetypal creature, one

that could be from either the past or the future, thereby alternatively evoking a prehistoric or a posthistoric presence.[111] Thus just as Sweeney perceived a sense of "unity-in-complexity" in *Abesti gogora I*, *Abesti gogora V* similarly instantiates a unified expression of internal multiplicity.

Finally, while recognizing the sculpture's strongly "virile" character, critics perceived gendered complexities as being inherent in the work.[112] Kramer characterized *Abesti gogora V* as displaying a synthesis of stylistic elements: "The solid granite masses are cut into severe cubist forms that are handsomely articulated by the changing light and shadow of the outdoor setting. The scale of the whole is monumental, yet the work's interior spaces confer an air of intimacy and lyricism upon its individual units. Without being gross, the sculpture boasts a very emphatic masculine presence. Without being stunningly original, it is nonetheless one of the most artistically successful outdoor sculptures of recent times."[113] Seldis extended Kramer's trope of a gendered dialectic threading through Chillida's work, observing: "We admire Chillida's vigor and assurance but we are equally moved by his poetry. In his work virility and lyricism are not exclusive of each other, and thrust and caress exist side by side." Recalling Sweeney's earlier comments on the alchemical fusion of virility and softness in Chillida's iron sculptures and their housing a vision of invisible presences, Seldis concluded that "Chillida emerges from Sweeney's broad presentation of his work as a moving and poetic artist whose grasp of the invisible is contained in his many-faceted graphic and sculptural expressions. His international reputation preceded him to Houston but no American city, at least, has yet had the opportunity to gauge the versatility and consistency of his talent."[114]

87 Houses Whose Doors Are Open: "Eduardo Chillida: Retrospective Exhibition"

In undertaking *Abesti gogora V*–a high-profile public commission that was not fully assembled until the day of its dedication–both Sweeney and Chillida demonstrated remarkable self-assurance as they took a substantial professional walk into the unknown. They emerged from their wanderings with an artwork that exemplifies a conjunction of layers of presence and absence, as the form that was not

yet in form passed into completion through its dramatic construction in a highly visible common place. In various ways this project, like the Tinguely sculptures exhibition, can be seen as a metaphor-in-microcosm for Sweeney's career in Houston, which entailed considerable daring in the "fitting together of pieces" and the skillful "interrelation of planes."[115] Indeed, the story of *Abesti gogora V* again exemplifies his remarkable ability to locate treasures; his sustained capacity for hard work and the practical negotiations that underpinned the project's realization as he moved—both physically and symbolically—a nearly unmovable weight; and the preceding air of mystery that was followed by the sensational moment of disclosure, culminating in the triumphant appearance of the public spectacle.

Extending these themes into the museum gallery, the Chillida retrospective featured eighty-seven artworks in various media, including drawings, prints, collages, and forty-two sculptures in materials ranging from metal and plaster to wood and stone (figure 7.13). In turn, the various artistic processes underpinning the creation of the assembled works can be seen as a meditation on presence and absence. Just as the iron sculptures began as amorphous metallic mixtures and the prints and drawings as blank sheets of paper, these artworks are additive compositions constructed through processes of building and accretion, as unformed blankness crystallized into material form. In contrast, Chillida's sculptures in wood and granite began with the solid presence of a block into which the artist carved voids to accommodate the reductive processes of elimination and subtraction. In the latter works, the starting point is not the generative absence of protean emptiness or molten fluidity, but the creative possibilities embedded within the plentitude of material density. Yet taken together, Chillida's artworks exemplify the density of lightness—the ability to see open, inner spaces as replete with multiple relational presences—and the lightness of density—the reciprocal capacity to perceive solid material objects as dynamic embodiments of open possibilities.

As this suggests, "Eduardo Chillida: Retrospective Exhibition" provided a comparative framework, not only for the individual presences of the assembled artworks but for an array of inner spaces to emerge through their collective display in Cullinan Hall. Inside the museum Sweeney, like Chillida, could also be seen as an "architect of inner space," as this exhibition enabled artworks and viewers to inhabit a shared dwelling that was openly enclosed in its own symbolic forms.

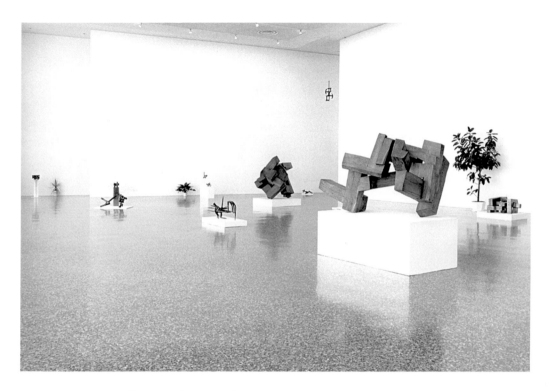

7.13 Installation shot of "Eduardo Chi-
llida: Retrospective Exhibition," 1966.
Photograph by Hickey and Robertson.
Museum of Fine Arts, Houston Archives.

Thus instead of presenting a single house whose door is open, the Chillida ret-
rospective can be seen as a composite structure of eighty-seven such houses, all
forming a continuous expanse of edges and voids that threaded through the gallery
like an unbroken piece of modernist lace. As Sweeney said of the show:

One of the selfish satisfactions that derive from the organization and installation of a retro-
spective exhibition of an artist's work is what one learns in doing it about both the artist and
his work. The selection and placing of works side by side for display and the process of com-
parison and contrast through which one must go make for the soundest form of critical con-
centration. A retrospective view of an artist's work should force one to focus on the elements
which make up his mature expression in their proper relationships; in other words to show
us the full artist through his work. In turn, this sense of the full artist is what should come

from such an exhibition to the visitor who approaches it seriously and is willing to make an effort to see the individual pieces in the inter-relationships in which they are given.[116]

Thus just as Chillida asserted that "the dialogue between forms, whatever it may be, is far more important than the forms themselves," in the exhibition catalogue Sweeney similarly observed, "It has also been said that art today is more interested in the relationships between things than in the things themselves."[117]

In its various interwoven dimensions, the Chillida retrospective exemplifies the ways in which Sweeney's mystically oriented curatorial practice entailed cultivating the composite art of the topos, as influential groups of people, significant bodies of artwork, and an accompanying array of metaphysical and poetic concepts were collectively assembled in the common place of the museum. For Sweeney, the open axis of curation lay in creating the conditions that made the otherwise invisible relations between these reference points visible. At the MFAH, viewers could wander into the gallery and gaze at the artworks' concordant, interlaced presences, and perhaps catch a transient glimpse of something that might otherwise have remained unseen, the sparks of light darting through what may initially have appeared only as empty space.

Notes

1 Modernism's Mystical Subjects: An Introduction

1. James Johnson Sweeney, "Alexander Calder," in *Calder* (Saint-Paul: Fondation Maeght, 1969), pp. 7–11.

2. James Johnson Sweeney, "Contemporary Art: The Generative Role of Play," *Review of Politics* 21 (April 1959): 400, 392–393.

3. On these themes, see Elliot R. Wolfson's texts *Language, Eros, Being: Kabbalistic Hermeneutics and Poetic Imagination* (New York: Fordham University Press, 2005); *Alef, Mem, Tau: Kabbalistic Musings on Time, Truth, and Death* (Berkeley: University of California Press, 2006); and *Footdreams & Treetales: Ninety-Two Poems* (New York: Fordham University Press, 2007).

4. Notably, Chillida later constructed a monumental hanging steel sculpture that was dedicated to Calder, *Homage to Calder* (1979). This work is illustrated in Peter Selz, *Chillida* (New York: Harry N. Abrams, 1986), p. 65.

5. Regarding the thematic complexities of framing structures, in his analysis of Kant's theorization of the conditions of aesthetic judgment Jacques Derrida offers an analysis of the multifaceted nature of

the frame as a site of saying and unsaying. In particular, Derrida identifies the frame, or "parergon," as the necessary supplemental space that both differentiates and connects that which is interior and that which is exterior to a work of art (the "ergon"). In so doing, the parergon simultaneously serves as a complex site of breakage and joining within the aesthetic domain. Thus as Derrida notes, through this paradox the "formality-effect is always tied to the possibility of a framing system that is both imposed and erased." See Jacques Derrida, *The Truth in Painting*, trans. Geoff Bennington and Ian McLeod (Chicago: University of Chicago Press, 1987), pp. 42–67.

6. See chapter 7 for a discussion of the relations between Heideggerian conceptions of the *topos* and Chillida's sculptures.

7. There are some exciting developments in this area. Ivan Gaskell presents a comparative discussion of three suggestive case studies in his essay "Sacred to Profane and Back Again," in Andrew Mc-Clellan, ed., *Art and Its Publics: Museum Studies at the Millennium* (Malden, MA: Blackwell, 2003), pp. 149–162. McClellan also addresses these complex themes in his study *The Art Museum: From Boullée to Bilbao* (Berkeley: University of California Press, 2008). For a cross-cultural comparativist perspective, see Francesco Pellizzi, ed., *Museums–Crossing Boundaries, Res* 52 (Autumn 2007). For a discussion of "The Museum as Sacred Space," see Victoria Newhouse, *Towards a New Museum* (New York: Monacelli Press, 1998), ch. 2. For a related historical reflection on museums as repositories of spiritual experience, see Dominique de Menil's foreword and her essay on "Art of Ancient Cultures" in *The Menil Collection: A Selection from the Paleolithic to the Modern Era* (New York: Harry N. Abrams, 1997), pp. 7–8, 14. Regarding the reevaluation of the museum as "art's sacred white cube" and the types of productive transgressions that can occur within the "sacrosanct zone of the museum," see Norman L. Kleeblatt, "The Nazi Occupation of the White Cube: Transgressive Images/Moral Ambiguity/Contemporary Art," and Reesa Greenberg, "Playing It Safe? The Display of Transgressive Art in the Museum," both in Norman L. Kleeblatt, ed., *Mirroring Evil: Nazi Imagery/Recent Art* (New York: Jewish Museum; New Brunswick: Rutgers University Press, 2001). For a discussion of the relationship between Christian worship and the exhibition of modern art, see Daniel A. Siedell, *God in the Gallery: A Christian Embrace of Modern Art* (Grand Rapids, MI: Baker Academic, 2008). For related discussions of religious art and explorations of the relationship between art and theology, see Crispin Paine, ed., *Godly Things: Museums, Objects, and Religion* (London: Leicester University Press, 2000); Ena Giurescu Heller, ed., *Reluctant Partners: Art and Religion in Dialogue* (New York: Gallery at the American Bible Society, 2004); David Morgan and Sally M. Promey, eds., *The Visual Culture of American Religions* (Berkeley: University of California Press, 2001); and Promey's review article "The Return of Religion in the Scholarship of American Art," *Art Bulletin* 85 (September 2003): 581–603.

8. It should be noted that readers today may find St. John of the Cross a somewhat controversial and even intolerant figure, particularly with regard to issues of anti-Semitism and their subsequent historical implications. Neither Sweeney nor Eduardo Chillida, who also engaged extensively with St. John of the Cross's writings, seem to have addressed the problematic aspects of his corpus.

9. James Johnson Sweeney, *Vision and Image: A Way of Seeing* (New York: Simon and Schuster, 1967), pp. 112, 33, 22, 73, 188. In part, Sweeney was drawing on the curator Ernest Fenollosa's study *The Chinese Written Character as a Medium for Poetry* (1920) for this formulation of works of art functioning

as a bridge between the seen and the unseen realms. For a slightly earlier discussion of these concepts in Fenollosa's writings, see James Johnson Sweeney, "New Directions in Painting," *Journal of Aesthetics and Art Criticism* 18 (March 1960): 368–377. Some of these metaphors are generally familiar in museum practice. As McClellan has noted, "from the Renaissance onward, the museum has been envisioned as a compendium of the world, a microcosm of the macrocosm, and a symbol of a harmonious, well-ordered society." See McClellan, *The Art Museum*, p. 16.

10. See Evelyn Underhill, *Mysticism: A Study in the Nature and Development of Man's Spiritual Consciousness* (1910; New York: E. P. Dutton, 1926), esp. pp. 184–193. For an insightful analysis of Underhill's comparative discussions of mysticism, see Jeffrey J. Kripal, *Roads of Excess, Palaces of Wisdom: Eroticism and Reflexivity in the Study of Mysticism* (Chicago: University of Chicago Press, 2001), ch. 1. Kripal has devoted several volumes to the study of mysticism in America, including not only *Roads of Excess* but *The Serpent's Gift: Gnostic Reflections on the Study of Religion* (Chicago: University of Chicago Press, 2007); and *Esalen: America and the Religion of No Religion* (Chicago: University of Chicago Press, 2007).

11. Author's interviews with Dick Wray, Jack Boynton, and Richard Stout, Houston, Texas, April 8, 2008.

12. Biographical information on Sweeney can be found in his curriculum vita, a copy of which, dated April 1964, is on file in the Archives of the University of Notre Dame [CLit 48/02]. See also Grace Glueck's obituary, "James Johnson Sweeney Dies; Art Critic and Museum Head," *New York Times* (April 15, 1986): B 8; Ann Holmes, "The Art World of Director James Sweeney," *Houston Chronicle* (December 3, 1961): Zest section, 1, 7, 20; Denys Sutton, "James Johnson Sweeney," *Burlington Magazine* 128 (November 1986): 809–810; *Property from the Estate of the Late James Johnson Sweeney* (New York: Sotheby's, 1986); and the entry on Sweeney in *Who Was Who in America* (Wilmette, IL: Marquis, 1989), vol. 9, pp. 348–349. Two further important sources for information on Sweeney are Toni Ramona Beauchamp, "James Johnson Sweeney and the Museum of Fine Arts, Houston, 1961–67," M.A. thesis, University of Texas, Austin, 1983; and the conference organized by Ciaran Bennett and Helen Harrison, "The Poetry of Vision: James Johnson Sweeney and the Twilight of Modernism," sponsored by the Pollock-Krasner House and Study Center, East Hampton, New York, April 25, 2008.

13. See "Arbiter of Modern Art: James Johnson Sweeney," *New York Times* (October 22, 1959).

14. Author's interview with Dick Wray, Houston, Texas, April 8, 2008.

15. In response to this development, several prominent artists wrote a letter to the *New York Times* expressing their support of Sweeney, affirming his expertise in contemporary painting and sculpture, and protesting his departure from the Museum of Modern Art. See "Artists Uphold Sweeney," *New York Times* (November 3, 1946).

16. For an extended description of the modernist ambience that Sweeney created in the Guggenheim galleries and in his own New York apartment, see Aline B. Saarinen, "Lively Gallery for Living Art," *New York Times* (May 30, 1954): 16, 26–27.

17. A checklist of the exhibitions held at the Guggenheim during Sweeney's tenure can be found in Angelica Zander Rudenstine, *The Guggenheim Collection: Paintings 1880–1945* (New York: Solomon R. Guggenheim Museum, 1976), vol. 2, pp. 705–709.

18. Glueck, "James Johnson Sweeney Dies," p. B 8. Regarding Sweeney's resignation from the Guggenheim, see also Sanka Knox, "Guggenheim Museum Director Resigns in Difference of 'Ideals,'" *New York Times* (July 21, 1960): 1, 18; and David Lyle, "Guggenheim Museum Head Quits," *New York Herald Tribune* (July 21, 1960): 1, 12.

19. "12 Famous Museum Directors, as They Would Look if Their Favourite Portraitists Painted Them," *Vogue* 128 (July 1956): 88–89.

20. A brief description of the film and a list of participating national theaters can be found in the James Johnson Sweeney Administrative Papers, The Solomon R. Guggenheim Museum Archives.

21. See the typescript of James Johnson Sweeney's opening remarks for the panel "The Place of Painting in Contemporary Culture," American Federation of the Arts, Shamrock-Hilton Hotel, Houston, Texas, April 4, 1957, pp. 3–4, in the collection of the Brown Fine Arts Library at the Fondren Library, Rice University, Houston, Texas. Other members of Sweeney's panel included the art historian Meyer Schapiro, the poet and critic Randall Jarrell, and the painter Stuart Davis.

22. Sweeney, "Contemporary Art," pp. 395–396. Sweeney's discussion of "sacred play" is indebted to Johan Huizinga, *Homo Ludens: A Study of the Play-Element in Culture* (New York: Roy Publishers, 1950). In addition, as discussed in *Vision and Image*, Sweeney's formulations of the heightened, abstracted visions that emerged from the aestheticization of nature were shaped by contemporary critical discussions of mysticism and romantic poetry, such as W. H. Auden's *The Enchafèd Flood, or The Romantic Iconography of the Sea* (New York: Random House, 1950), esp. ch. 2; and Austin Warren's essay "William Butler Yeats: The Religion of a Poet," in his *Rage for Order: Essays in Criticism* (Chicago: University of Chicago Press, 1948), ch. 5.

23. "Just What I Like," *Newsweek* (January 23, 1961): 60. Regarding Sweeney's appointment as museum director, see also "People in the Arts," *Arts* 35 (February 1961): 10.

24. James Johnson Sweeney, "Le Cullinan Hall de Mies van der Rohe, Houston," *L'Oeil* 99 (March 1963): 38–43, 82.

25. James Johnson Sweeney, foreword to Henry Heydenryk, *The Art and History of Frames: An Inquiry into the Enhancement of Paintings* (New York: James H. Heineman, 1963), n.p. See also Piet Mondrian's suggestive comments to Sweeney on the approaches to and effects of framing, as quoted in Rudenstine, *The Guggenheim Collection*, pp. 577–578.

26. William Camfield used this phrase to characterize the status of the Museum of Fine Arts, Houston under Sweeney's leadership in "Modern Art in Houston: Movers and Shakers in the 1950s, 1960s, and 1970s," a lecture delivered at the Rice University Art Gallery, Houston, Texas, on November 18, 2003.

27. See Ann Holmes, "Riddle of Olmecs in Major Exhibit," *Houston Chronicle* (June 16, 1963): 11; "Art: Sweeney's Way," *Time* (June 14, 1963): 74; and "Heavy Find on Display in Houston," *New York Times* (June 19, 1963): 34.

28. This exhibition comprised over 240 items ranging from painting, sculpture, and illustrated books to examples of fashion and theater design. According to the museum archives, a catalogue for the show was never published and the exhibition did not travel. For a copy of the unpublished checklist, see Beauchamp, "James Johnson Sweeney," pp. 234–235. For reviews of the exhibition, see Campbell

Geeslin, "Art: Good Old Days," *Houston Post* (October 24, 1965): 24; Ann Holmes, "The Paris of 1908–14 . . . Brilliant Bacchanal," *Houston Chronicle* (October 24, 1965): 22; Ann Holmes, "The Spotlight," *Houston Chronicle* (December 5, 1965): 22; and Lucy R. Lippard, "Heroic Years from Humble Treasures: Notes on African and Modern Art," *Art International* 10 (September 1966): 16–25.

29. Author's interview with Edward Mayo, Houston, Texas, June 5, 2002.

30. James J. Meeker, "Cultural Boom in Texas," *Art Voices* (Winter 1966): 26, 27.

31. "Art in America Annual Award," *Art in America* 51, no. 6 (1963): 24. Along with Sweeney, Andrew Wyeth also received this award in 1963.

32. Civic Affairs Committee of the Houston Chamber of Commerce, "The Arts in Houston," *Houston Magazine* (December 1963): 44.

33. Sweeney subsequently entered into a brief arrangement with the museum in which he was retained as a part-time consultant director (until 1968). Regarding Sweeney's resignation, see Ann Holmes, "Museum Cuts Activity; Limits Director's Job," *Houston Chronicle* (July 6, 1967): 1–2; Eleanor Freed, "Museum's Plans," *Houston Post* (July 16, 1967): Spotlight section, 22; and Freed's "Art: Museum Outlook," *Houston Post* (December 31, 1967): Spotlight section, 9.

34. For a discussion of this work, see William A. Camfield, *More Than a Constructive Hobby: The Paintings of Frank Freed* (Houston: Museum of Fine Arts, Houston, 1996), p. 34.

35. See Sibyl Gordon Kantor, *Alfred H. Barr, Jr., and the Intellectual Origins of the Museum of Modern Art* (Cambridge, MA: MIT Press, 2002).

36. William C. Seitz, "Abstract-Expressionist Painting in America: An Interpretation Based on the Work and Thought of Six Key Figures," Ph.D. thesis, Princeton University, 1955 (reproduced by University Microfilms, Ann Arbor, 1956), pp. ii, 275–276, 278. I am grateful to Michael Leja for bringing this source to my attention.

37. Alfred H. Barr, Jr., to James Johnson Sweeney, March 2, 1948, in the Alfred H. Barr, Jr., Papers [AAA: 2176; 608–609], Museum of Modern Art Archives, New York.

38. James Johnson Sweeney to Alfred H. Barr, Jr., March 4, 1948, in the Alfred H. Barr, Jr., Papers [AAA: 2172; 683], Museum of Modern Art Archives, New York. In the published proceedings of the Conference on Science, Philosophy, and Religion in Their Relation to the Democratic Way of Life, Sweeney is not listed as a national symposium participant, while Barr is listed as having participated in the 1948 and 1949 meetings. See *Conference on Science, Philosophy and Religion in Their Relation to the Democratic Way of Life* (New York: Harper, 1948, 1949).

39. Alfred H. Barr, Jr., to Louis Finkelstein, March 11, 1948, in the Alfred H. Barr, Jr., Papers [AAA: 2172; 682], Museum of Modern Art Archives, New York.

40. A brief article on this organization can be found in the *New York Times* (December 29, 1959). I am grateful to Jet Prendeville for identifying this source.

41. Two works in which Sweeney addressed the subject of Christian mysticism include his article "L'art chrétien primitif en Irlande," *Cahiers d'Art* 6–7 (1932): 243–248; and his study *Irish Illuminated Manuscripts of the Early Christian Period* (New York: Collins and UNESCO, 1965).

42. Alfred H. Barr, Jr., to George Kubler, December 24, 1946, in the Alfred H. Barr, Jr., Papers [AAA: 2172; 716], Museum of Modern Art Archives, New York.

43. See Michel de Certeau, "Mysticism," *Diacritics* 22 (1992): esp. 14, as discussed in Kripal, *Roads of Excess*, pp. 33–34.

44. Regarding American historical and literary conceptions of spirituality from the modern and postmodern periods, see Leigh Eric Schmidt, *Restless Souls: The Making of American Spirituality* (New York: HarperCollins, 2005).

45. On these themes, see my study *Painting Gender, Constructing Theory: The Alfred Stieglitz Circle and American Formalist Aesthetics* (Cambridge, MA: MIT Press, 2001). The flowchart that Barr famously constructed for the Museum of Modern Art's "Cubism and Abstract Art" exhibition (1936), discussed in chapter 2 below, can be seen as just such an example of the strategic modernist creation of a "usable past," one that conjoined strong aesthetic and spiritual overtones. For a discussion of Barr's flowchart as an example of a "usable past," see Elizabeth Hutchinson's review of the conference "Usable Pasts? American Art from the Armory Show to Art of This Century" at the University of Pennsylvania and the Philadelphia Museum of Art, March 23–24, 2007. Hutchinson's review can be accessed at http://www.caareviews.org/reviews/1060. My contribution to this symposium was a paper on the androgynous nature of Barr's flowchart.

46. James Johnson Sweeney, "Recent Trends in American Painting," *Bennington College Alumnae Quarterly* 7 (Fall 1955): 11.

47. Sweeney, *Vision and Image*, p. 109.

48. Steven M. Wasserstrom, *Religion after Religion: Gershom Scholem, Mircea Eliade, and Henry Corbin at Eranos* (Princeton: Princeton University Press, 1999), pp. 9, 5. Notably, throughout this text Wasserstrom offers a decidedly critical reading of the mystical traditions that he analyzes.

49. For a discussion of the *coincidentia oppositorum*, see Michiko Yusa, "Paradox and Riddles," in Lindsay Jones, ed., *Encyclopedia of Religion*, 2nd ed. (Detroit: Macmillan Reference, 2005), vol. 10, pp. 6986–6992. In addition, Bryan Rennie traces the significance of this concept in Eliade's thought, noting that, for Eliade, the *coincidentia oppositorum* represents a quality of mythic language that signified precosmic totality and the transcendence of contraries. See Bryan S. Rennie, *Reconstructing Eliade: Making Sense of Religion* (Albany: SUNY Press, 1996), pp. 33–40.

50. See Michael A. Sells, *Mystical Languages of Unsaying* (Chicago: University of Chicago Press, 1994), pp. 1–13.

51. See Robert L. Nelson, "Art and Religion: Ships Passing in the Night?," in Heller, *Reluctant Partners*, p. 105.

52. In *The Fragile Absolute*, Slavoj Žižek discusses the ways in which excrement and trash are associated with "the sacred place, the void in which sublime beauty can be featured" in postmodern art. He concludes that spirit is only sustainable through the oppositional presence of debased materiality that "resists spiritual sublation," such that "awareness of the incongruity between spirit and bones *is* the spirit" (emphasis in original). See Slavoj Žižek, *The Fragile Absolute, or Why Is the Christian Legacy Worth Fighting For?* (London: Verso, 2000), pp. 29–30. On these subjects, see also Mark C. Taylor, *Disfiguring: Art, Architecture, Religion* (Chicago: University of Chicago Press, 1992). For a discussion of related issues, with a brief reference to the apophatic, see James Elkins, *On the Strange Place of Religion in Contemporary Art* (New York: Routledge, 2004).

53. Rosalind E. Krauss, "Grids," in her *The Originality of the Avant-Garde and Other Modernist Myths* (Cambridge, MA: MIT Press, 1985), p. 12.

54. Notably, Donald Kuspit discusses Daniel Bell's *The Cultural Contradictions of Capitalism* (1976), Jacques Barzun's *The Use and Abuse of Art* (1975), and Wallace Stevens's *The Necessary Angel: Essays on Reality and the Imagination* (1951) in his essay "A Critical History of 20th-Century Art" (2005). Kuspit posits that "the irony of avant-garde art is that it transcends whatever it critiques, indicating that it is neither entirely of the modern world nor exactly art. The subliminal point of avant-garde innovation—and in the history of twentieth-century art it is the avant-garde innovators who made the spiritual as well as artistic difference, that is, who showed that to take an artistic risk was also to take a spiritual risk, that one ventured into unknown artistic territory to make spiritual discoveries—is to express dissatisfaction with both, finally dismissing them as beside the larger spiritual point." Kuspit ultimately concludes that "avant-garde art only comes into its own through this nihilistic dialectic of immanent and transcendent critique—this pushing to artistic and social extremes to find a spiritual center that does not exist." See Donald Kuspit, "A Critical History of 20th-Century Art," in *Artnet* at http://www.artnet.com/magazineus/features/kuspit/kuspit12-14-05.asp

55. Some of the most prominent expressions of these themes include the sublimated, spiritual underpinnings of aestheticism and symbolism, as displayed in the suggestively dematerialized forms of Whistler's paintings, the early photographs of the first Stieglitz circle, and Gauguin's iconographically syncretic representations of Oceanic deities; Kandinsky's expressionist and Mondrian's iconographic engagements with theosophy; and slightly later, the flickering voids of Mark Rothko's color field paintings and Morris Louis's engagement with Jewish mystical conceptions of sacred fire in his *Charred Journal* series and in the prismatic light of his abstractions. One of the most important primary period sources for these developments is Wassily Kandinsky's *Concerning the Spiritual in Art* (1912; trans. Francis Golffing, New York: Wittenborn, 1963). On the relationship between spirituality and modern art in general, see especially Maurice Tuchman et al., *The Spiritual in Art: Abstract Painting 1890–1985* (New York: Abbeville Press, 1986). While this catalogue valuably reconstructs many of the ways in which modernist artists engaged the spiritual in their aesthetic practice, its methodological approach is primarily historical and iconographic rather than theoretical. For more recent treatments of these themes, see Kathleen Pyne, "Response: On Feminine Phantoms: Mother, Child, and Woman-Child," *Art Bulletin* 88 (March 2006): 44–61; June Hargrove, "*Woman with a Fan*: Paul Gauguin's Heavenly Vairaumati—A Parable of Immortality," *Art Bulletin* 88 (September 2006): 552–566; and Mark Godfrey, *Abstraction and the Holocaust* (New Haven: Yale University Press, 2007).

56. For a critique of the various rituals associated with establishing and securing the sacred status of the museum, see Carol Duncan and Alan Wallach, "The Museum of Modern Art as Late Capitalist Ritual: An Iconographic Analysis," in Donald Preziosi and Claire Farago, eds., *Grasping the World: The Idea of the Museum* (Burlington, VT: Ashgate, 2004), pp. 483–499; and Duncan's study *Civilizing Rituals: Inside Public Art Museums* (London: Routledge, 1995). An especially polemical example of this critique can be found in Thomas McEvilley's introduction to Brian O'Doherty's collection of essays *Inside the White Cube*. In this piece, McEvilley overtly acknowledged the sacralizing effects of the modernist art gallery, noting that "such ritual spaces are symbolic reestablishments of the

ancient umbilicus which, in myths worldwide, once connected heaven and earth." Yet he posited that the underlying purpose of such ritual spaces centered on "the political interests of a class or ruling group attempting to consolidate its grip on power by seeking ratification from eternity." In so doing, he advances a critique of the myth of eternity and the transcendence of pure form associated with the demonstrative sterility of the white cube, privileging instead a contextualist defense of historical temporality that exposed the practical workings of social power within the domain of the real. See Thomas McEvilley, introduction to Brian O'Doherty, *Inside the White Cube: The Ideology of the Gallery Space* (Berkeley: University of California Press, 1986), pp. 7–12.

57. These dynamics thread through Sweeney and Duchamp's final collaboration, for the exhibition "Not Seen and/or Less Seen of/by Marcel Duchamp/Rrose Sélavy 1904–64" at the Museum of Fine Arts, Houston (February 23 to March 28, 1965). This show is discussed in detail in chapter 3 of this study.

2 The Nude Descending a Flowchart: Alfred H. Barr, Jr., and Marcel Duchamp

1. In her biographical study of Barr, Sybil Gordon Kantor comments on Barr's chart's unique position in modernist art history: "Barr's diagrammatic scheme has become an icon. Its basic premise, little altered, has maintained the aura of an artifact." See Sybil Gordon Kantor, *Alfred H. Barr, Jr., and the Intellectual Origins of the Museum of Modern Art* (Cambridge, MA: MIT Press, 2002), p. 327. For additional discussions of *Cubism and Abstract Art*, see Alice Goldfarb Marquis, *Alfred H. Barr, Jr.: Missionary for the Modern* (Chicago: Contemporary Books, 1989), pp. 150–156; and Irving Sandler's introduction to *Defining Modern Art: Selected Writings of Alfred H. Barr, Jr.*, ed. Irving Sandler and Amy Newman (New York: Harry N. Abrams, 1986), esp. pp. 22–27.

2. See Robert Rosenblum's foreword to Alfred H. Barr, Jr., *Cubism and Abstract Art* (1936; New York: Museum of Modern Art and Harvard University Press, 1986), pp. 3–4; Griselda Pollock, *Vision and Difference: Femininity, Feminism, and the Histories of Art* (London: Routledge, 1988), pp. 50–51; and W. J. T. Mitchell, "*Ut Pictura Theoria*: Abstract Painting and the Repression of Language," *Critical Inquiry* 15 (Winter 1989): 366, 367. Resonating with Mitchell, in his critical response to the controversial exhibition "'Primitivism' in 20th Century Art: Affinity of the Tribal and the Modern" (Museum of Modern Art, 1984), Hal Foster commented on the various ways in which the discourses of primitivism have been deployed to support the patriarchal project of modern Western culture. See Hal Foster, "The 'Primitive' Unconscious of Modern Art," *October* 34 (Fall 1985): 58–70. Regarding primitivism's longstanding association with Western colonial practices, see also Mark Antliff and Patricia Leighten, "Primitive," in Robert S. Nelson and Richard Shiff, eds., *Critical Terms for Art History* (Chicago: University of Chicago Press, 1996), pp. 170–184. For a historical overview of the cultural debates surrounding primitivism, see Jack Flam, introduction to *Primitivism and Twentieth-Century Art: A Documentary History*, ed. Jack Flam with Miriam Deutch (Berkeley: University of California Press, 2003), pp. 1–22.

3. James Johnson Sweeney, *Plastic Redirections in 20th Century Painting* (Chicago: University of Chicago Press, 1934).

4. Barr, *Cubism and Abstract Art*, pp. 7–8.

5. A black and white reproduction of this work can be found in my essay "The Multiple Masculinities of Canonical Modernism: James Johnson Sweeney and Alfred H. Barr, Jr., in the 1930s," in Anna

Brzyski, ed., *Partisan Canons: Discursive and Institutional Sites* (Durham: Duke University Press, 2005), p. 183. For imagery and provenance information, see Joop M. Joosten, *Piet Mondrian: Catalogue Raisonné of the Work of 1911–1944* (New York: Harry N. Abrams, 1998), vol. 2, pp. 163, 292–293. This painting was one of four works by Mondrian in Sweeney's collection.

6. Sweeney and Barr's correspondence of the 1930s can be found in the Alfred H. Barr, Jr., Papers of the Museum of Modern Art.

7. Duchamp's comments are reproduced in Lanier Graham, *Duchamp and Androgyny: Art, Gender, and Metaphysics* (Berkeley: No-Thing Press, 2003), p. 43. For a Jungian-inflected discussion of the extensive iconographic symbolism associated with alchemy and the image of the androgyne in Duchamp's works, see Arturo Schwarz, "The Alchemist Stripped Bare in the Bachelor, Even," in Anne D'Harnoncourt and Kynaston McShine, eds., *Marcel Duchamp* (1973; New York: Museum of Modern Art, 1989), pp. 81–98. Notably, Schwarz's discussion is primarily devoted to two of Duchamp's works, *Young Man and Girl in Spring* (1911) and *The Bride Stripped Bare by Her Bachelors, Even* (1915–1923).

8. For a discussion of the androgynous symbolism of this work, see Arturo Schwarz, *The Complete Works of Marcel Duchamp* (New York: Delano Greenridge, 1997), vol. 1, pp. 202–204.

9. As John F. Moffitt points out, the figure of the Bride in *The Large Glass*, which represents a "modesty mechanism," turns out to be a "hermaphrodite." See John F. Moffitt, "Marcel Duchamp: Alchemist of the Avant-Garde," in Maurice Tuchman et al., *The Spiritual in Art: Abstract Painting 1890–1985* (New York: Abbeville Press, 1986), p. 265. Moffitt notes Duchamp's equivocal comments on alchemy, particularly his 1959 remark to Robert Lebel, "If I have practiced alchemy, it was in the only way it can be done now, that is to say, without knowing it [*sans le savoir*]" (p. 269). Moffitt provides an extensive discussion of alchemy and its occult iconography in Duchamp's art, both in this essay and in his book *Alchemist of the Avant-Garde: The Case of Marcel Duchamp* (Albany: SUNY Press, 2003). In the latter, Moffitt presents an extended discussion of Duchamp's female persona, Rrose Sélavy, as an androgyne (pp. 255–258).

10. Sweeney was also engaged with this film, as his critical praise for Fernand Léger and Alexander Calder is quoted in the promotional materials that accompanied Richter's cinematic release. See *Dreams That Money Can Buy* (New York: Art of This Century Films, 1947), n.p.

11. Duchamp, quoted in Graham, *Duchamp and Androgyny*, p. 43. Duchamp's creative engagement with androgyny productively complicates the already complex phenomenon of the gendering of mysticism. Indeed, much of the material analyzed in this study is predicated on historical understandings of mysticism as a masculine enterprise, albeit one that is not always, or necessarily, confined to a speculative or disembodied register. For a discussion of the ways in which twentieth-century intellectuals have identified corporeal, affective, visionary, and ecstatic structures as distinguishing characteristics of gendered mystical expression and feminist ethical practices, see Amy Hollywood, *Sensible Ecstasy: Mysticism, Sexual Difference, and the Demands of History* (Chicago: University of Chicago Press, 2002).

12. See Dieter Daniels, "Often Neglected–but One of the Greats: Interview with Jean Tinguely by Dieter Daniels, Cologne, 12 January 1987," in *Marcel Duchamp* (Ostfildern-Ruit: Hatje Cantz Verlag, 2002), p. 163.

13. *The Oxford English Dictionary*, 2nd ed. (Oxford: Clarendon Press, 1989), vol. 1, p. 452.

14. I am grateful to Jeff Kripal for pointing out the cultural connotations respectively attached to the terms androgyne and hermaphrodite.

15. Wendy Doniger and Mircea Eliade, "Androgynes," in Lindsay Jones, ed., *Encyclopedia of Religion*, 2nd ed. (Detroit: Thomson Gale, 2005), vol. 1, p. 337. See also Doniger's extended discussion of this typology in Wendy Doniger O'Flaherty, *Women, Androgynes, and Other Mythical Beasts* (Chicago: University of Chicago Press, 1980), pp. 283–334. In this study, she notes that eunuchs, transvestites, pregnant males, and twins are not actually androgynes. She also notes the predominance of male androgynes over female, the latter of whom are often associated with morally questionable natures and the dangerous sexuality of the phallic woman. Furthermore, she differentiates psychical and psychological androgynes, as well as the notion of two-in-one, the latter referring to the divine hierogamy of the mating couple, a symbol of the *conjunctio oppositorum*. Finally, she distinguishes the "negative chaos" associated with splitting androgynes from the "positive chaos" connected with fusing androgynes. In particular, while splitting androgynes must be severed in order to be creative, fusing androgynes typically consist of a male and a female created in isolation who then must fuse. Significantly, she also notes that the figure of the androgyne can alternatively represent ecstasy or barrenness, just as the typology can simultaneously express love in union or in separation.

16. Albert Béguin, "L'androgyne," *Minotaure* 11 (Spring 1938): 10–13, 66. For additional historical and alchemical images of androgynes, see Alexander Rob, *Alchemy and Mysticism* (Cologne: Taschen, 2006).

17. Slightly later, in the account of the creation of woman from the rib of Adam, readers encounter a figure who "shall be called Woman, because she was taken out of Man" (Genesis 2:23).

18. For an extensive discussion of the androgyne in kabbalistic sources, see Elliot R. Wolfson, *Language, Eros, Being: Kabbalistic Hermeneutics and Poetic Imagination* (New York: Fordham University Press, 2005), esp. ch. 4.

19. In Plato's account, the androgyne occupied a circular body that could walk upright, backward or forward, or "roll over and over at a great pace." See Plato, "The Symposium," in *Dialogues*, trans. Benjamin Jowett (Chicago: Encyclopedia Britannica, 1955), vol. 7, p. 157.

20. The androgyne is also a recurrent figure in medieval and early modern mysticism, as well as in German romanticism, symbolist and decadent imagery, and modernist art ranging from Balzac and Baudelaire to Brancusi and Klee. Moreover, as Patricia Mathews has observed, during the fin de siècle the androgyne served as a prevailing image that "denied sexual difference: the nondesiring but desirable androgyne" whose presence signified a "transcendent body . . . [that] offered an alluring promise of imagined wholeness and coherency in the face of the decentered, unboundaried experience of modernity." See Patricia Mathews, *Passionate Discontent: Creativity, Gender, and French Symbolist Art* (Chicago: University of Chicago Press, 1999), pp. 111, 114.

21. Duchamp, quoted in Nixola Greely-Smith, "Cubist Depicts Love in Brass and Glass," New York *Evening World* (April 4, 1916): 3. It should be noted that, three decades later, Duchamp asserted that the nude was "definitely feminine." See Duchamp's comments to Jennifer Gough-Cooper and Jacques Caumont, *Ephemerides*, October 19, 1949, reproduced in Calvin Tomkins, *Duchamp: A Biography*

(New York: Henry Holt, 1996), p. 81. For Duchamp's later, iconoclastic reflections on this painting during the fiftieth anniversary of the Armory Show, see Francis Steegmuller, "Duchamp: Fifty Years Later," *Show* 2 (February 1963): 29–30.

22. Duchamp, quoted in D'Harnoncourt and McShine, *Marcel Duchamp*, p. 256. Interestingly, Tomkins notes that Duchamp's images of nudes descending staircases grew out of drawings to illustrate a poem by Jules Laforgue. One of the sketches is titled *Encore à cet astre* (Once Again to This Star). As Duchamp remarked in an interview with Tomkins, "It was just a vague, simple pencil sketch of a nude climbing a staircase . . . and probably looking at it gave me the idea, why not make it descending instead? You know, in musical comedies, those enormous staircases." See Tomkins, *Duchamp: A Biography*, p. 80.

23. For Duchamp's comments on the cubist precedents for *Nude Descending a Staircase*, see D'Harnoncourt and McShine, *Marcel Duchamp*, p. 258; and the artist's interview with Sweeney, "The Great Trouble with Art in This Country" (1946), reproduced in *Salt Seller: The Writings of Marcel Duchamp/Marchand du sel*, ed. Michel Sanouillet and Elmer Peterson (New York: Oxford University Press, 1973), pp. 125–126.

24. In the Renaissance Society exhibition catalogue, this work is listed as *Object with Red Disks* and dated 1931. Sweeney acquired the sculpture directly from Calder some time after the Renaissance Society exhibition. For provenance information on this work, see *Property from the Estate of the Late James Johnson Sweeney* (New York: Sotheby's, 1986), item #1, n.p. The Sweeney family's personal art collection contained additional works by Calder, including several ink drawings and the sculpture *Spherical Triangle (Maquette)*, a standing mobile of ca. 1939 in painted sheet metal and wire, which Sweeney gifted to his son Siadhal. See the catalogue for the auction held on November 2, 1994, *Contemporary Art, Part II* (New York: Sotheby's, 1994), n.p., lots 81, 93, 103, 104, and 112.

25. Meyer Schapiro to Alfred H. Barr, Jr., March 8, 1935, in the Alfred H. Barr, Jr., Papers [AAA: 2165; 981], Museum of Modern Art Archives, New York.

26. Alfred H. Barr, Jr., to Meyer Schapiro, March 11, 1935, in the Alfred H. Barr, Jr., Papers [AAA: 2165; 980], Museum of Modern Art Archives, New York.

27. In the biographical entry for *Who's Who in American Art*, Sweeney is listed as holding a position as visiting lecturer at New York University's Institute of Fine Arts until 1940. See Dorothy B. Gilbert, ed., *Who's Who in American Art* (New York: R. R. Bowker, 1953), p. 415.

28. This course description appears in the *New York University Graduate School of Arts and Science Bulletin* (1934–1935), New York University Archives, p. 88. I am grateful to Edwina Ashie-Nikoi, the archival assistant at the New York University Archives, for her assistance in locating this material.

29. *New York University Graduate School of Arts and Science Bulletin* (1936–1937), New York University Archives, p. 99.

30. In the spring of 1927 Barr had taught an art history class at Wellesley College that examined the development of modern art from nineteenth-century painting through the influence that "primitive and barbaric art" exerted on contemporary visual production. See Kantor, *Alfred H. Barr, Jr.*, pp. 103–104.

31. Alfred H. Barr, Jr., to James Johnson Sweeney, September 11, 1934, in the Alfred H. Barr, Jr., Papers [AAA: 2165; 582], Museum of Modern Art Archives, New York.

32. Sweeney, *Plastic Redirections*, p. 75.

33. Ibid., p. 3.

34. Ibid.

35. Ibid., p. 35.

36. Ibid., pp. 4, 7.

37. Ibid., p. 9.

38. Ibid., pp. 10, 11, 12, 14.

39. Expanded versions of this dialogical model of modernism would continue to inform Sweeney's approach to contemporary art for the next three decades. For example, in the interview that George Culler, director of the San Francisco Museum of Art, conducted with Sweeney for *Artforum* (June 1962), Sweeney differentiated two primary pictorial strands in contemporary painting, one of which included "certain types of younger French painters who were adopting the older tradition, the cubist, the rectilinear, the architectural tradition of Cézanne, Mondrien [*sic*], Braque, Picasso, men such as Soulage [*sic*]. They were keeping to this rectilinear, structural organization of their canvas." Sweeney then noted, "whereas one [group] was rectilinear and structural, emphasizing three dimensions on a flat surface, the other, the American influence that attracted the younger Europeans, was calligraphic" and emphasized "the rhythmic gesture of the artist." See George Culler, "Interview: James Johnson Sweeney," *Artforum* 1 (June 1962): 27–29.

40. Sweeney, *Plastic Redirections*, p. 17.

41. See Barr, *Cubism and Abstract Art*, pp. 32–33. William Rubin juxtaposed the same two images as Sweeney had used on facing pages of his essay on Picasso in William Rubin, ed., *"Primitivism" in 20th Century Art: Affinity of the Tribal and the Modern* (New York: Museum of Modern Art, 1984), vol. 1, pp. 268–269.

42. Sweeney, *Plastic Redirections*, p. 23.

43. Ibid. A preliminary version of these arguments can be found in Sweeney's essay "Painting" (October 1933), which was published in *Museum of Living Art: A. E. Gallatin Collection* (New York: George Grady Press, 1936), n.p. For a pointed discussion of Sweeney's indebtedness to the writings of the museum director Alexander Dorner for key aspects of this theorization of modernism, particularly Dorner's text "Considérations sur la signification de l'art abstrait," see Joan Ockman, "The Road Not Taken: Alexander Dorner's Way beyond Art," in R. E. Somol, ed., *Autonomy and Ideology: Positioning an Avant-Garde in America* (New York: Monacelli Press, 1997), p. 333, n. 18.

44. Sweeney, *Plastic Redirections*, p. 30.

45. Ibid., p. 35.

46. Information regarding the exhibition history and provenance of the Miró painting can be found in *Property from the Estate of the Late James Johnson Sweeney*, item #4, n.p. This painting is now in the collection of the Musée National d'Art Moderne, Centre Georges Pompidou, as Pierre Matisse donated the work to the French state in 1991. See Jacques Dupin, *Joan Miró: Catalogue Raisonné: Paintings*, trans. Cole Swensen and Unity Woodman (Paris: Daniel Lelong, 1999–2004), vol. 2, p. 72.

47. Sweeney's statement, originally published in *Cahiers d'Art* (1932), was quoted at length in the foreword to E. W. Schütze, *A Selection of Works by Twentieth Century Artists* (Chicago: Renaissance Society

of the University of Chicago, catalogue of the summer exhibition, June 20 to August 20, 1934), n.p. During the mid-thirties Sweeney reiterated many of his views on modern art in several other articles published in the *New Republic*. For example, in an article on Miró and Dalí, Sweeney praised the "fertility of invention" that underpinned Miró's art, a quality that became evident in its "quaint whimsicality of form-concept, a dream character–a sort of mysticism-of-the-familiar." Sweeney thus identified artistic generativity and mystical spirituality as being coextensive presences in Miró's biomorphic compositions. In "A Note on Abstract Painting," Sweeney critiqued contemporary American abstract painters for their wholesale adoption of the pictorial strategies of the European modernists, thereby forgoing the rigorous processes that produced original artistic results. Sweeney was equally critical of the Grant Wood retrospective held that spring at the Ferargil Galleries in New York, dismissing Wood's paintings for their lack of "plastic quality" and for their promotion of "sentimental" and "hackneyed" imagery that provided a nostalgic public with little more than "a sort of visual pasture-ground for associations and reminiscences." See Sweeney's essays "Miró and Dali," *New Republic* 81 (February 6, 1935), p. 360; "A Note on Abstract Painting," *New Republic* 83 (July 17, 1935): 280; and "Grant Wood," *New Republic* 83 (May 29, 1935): 76.

48. James Johnson Sweeney, "African Negro Art," *New Republic* 82 (April 10, 1935): 244. This article was written to publicize Sweeney's next major show, "African Negro Art," at the Museum of Modern Art (spring 1935). For a review of the catalogue, see Frank Jewett Mather, Jr., "The New Books," *Saturday Review of Literature* (May 11, 1935): 25. For notices of this exhibition and related period commentary, see the *Bulletin of the Museum of Modern Art*, vols. 5 and 6–7 (February 1935 and March-April 1935). Sweeney would republish much of this material and further develop the arguments in his book *African Sculpture* (Princeton: Princeton University Press, 1952). The latter volume was reissued in 1964.

49. For a gendered theorization of the decorative in the art of Paul Klee, see Jenny Anger, *Paul Klee and the Decorative in Modern Art* (Cambridge: Cambridge University Press, 2004).

50. Barr, *Cubism and Abstract Art*, p. 19.

51. Ibid. On the ambivalent nature of Barr's aesthetic interests, see Kantor, *Alfred H. Barr, Jr.*, p. 120.

52. Friedrich Nietzsche, *The Birth of Tragedy*, trans. Francis Golffing (1871; New York: Doubleday, 1956), p. 19. Despite their distinct characteristics, both Apollo and Dionysus are deities associated with healing, prophecy, and fertility.

53. The other artists Barr identified were Picasso, Mondrian, the Bauhaus artists, Kandinsky, Picabia, Arp, and Calder. Regarding this stylistic intermingling, see pp. 98, 142, 156, 172, 186, 190, and 197 of *Cubism and Abstract Art*.

54. For archival reproductions of Barr's preliminary diagrams of the flowchart, see Michelle Elligott, "Modern Artifacts #1: Charting Modernism," *Esopus* 7 (Fall 2006): 75–86. I am grateful to Gordon Hughes for bringing this article to my attention.

55. The other works include Duchamp's *The Bride* (1912), *The Bachelors* (1914), *Disturbed Balance* (1918), and a set of six *Rotoreliefs* (1934). Barr would also include eleven works by Duchamp, the "French artist and anti-artist," in his groundbreaking "Fantastic Art, Dada, Surrealism" exhibition; see Albert H. Barr, Jr., *Fantastic Art, Dada, Surrealism* (New York: Museum of Modern Art, 1936), pp. 260–261. According to Barr, the early thirties represented the beginning of his and Duchamp's

friendship. During the forties, Barr enthusiastically endorsed Duchamp's application renewal for a fellowship awarded by the Southern Educational and Charitable Trust. And during the early fifties, Barr worked with Duchamp on the dispersal of Katherine Dreier's artworks; and the two men collaborated on the limited-edition publication of an original print of Duchamp's *Bride* by the artist's brother Jacques Villon. Perhaps most significantly, Barr's archival papers indicate that, during the mid-fifties, the curator was instrumental in supporting Duchamp's petition to become a naturalized American citizen, even going so far as to appeal to Nelson Rockefeller to intercede on Duchamp's behalf. As Barr explained to Rockefeller, in March of 1954 he and James Thrall Soby had originally sponsored Duchamp's petition for American citizenship. However, due to Duchamp's previous involvement with the controversial movement of surrealism and his subsequent denunciation by Congressman George Dondero in the *Congressional Record*, the Immigration and Naturalization Service undertook a lengthy investigation which had delayed approval of Duchamp's application. In his letter to Rockefeller, Barr personally vouched for Duchamp's character, and he glowingly praised his art. See the Alfred H. Barr, Jr., Papers [AAA: 2182; 121–126, 135–157, 174–194], Museum of Modern Art Archives, New York.

56. Interestingly, during the following decade Clement Greenberg would also draw on these Nietzschean signifiers in his discussion of modern art. It was precisely this contrasting yet complementary notion of Apollonian balance, classicism, and logic, coupled with a Dionysian sense of "great passion," that Greenberg referenced in his critical essay "The Present Prospects of American Painting and Sculpture" (*Horizon*, October 1947); reprinted in Clement Greenberg, *The Collected Essays and Criticism*, ed. John O'Brian (Chicago: University of Chicago Press, 1986), vol. 2, pp. 160–170.

57. Notably, in *Cubism and Abstract Art* women artists are included in the sections on theater, typography, and posters. Although their works are not treated at the same level of detail as their male counterparts', Barr offered brief discussions of the female Russian modernists Lyubov Popova, Natalia Gonchorova, and Varvara Stepanova.

58. Regarding issues of interpretive valuation, see Steven Connor, *Theory and Cultural Value* (Oxford: Blackwell, 1992).

59. Regarding the displacement of the feminine in twentieth-century aesthetics, see Wendy Steiner, *Venus in Exile: The Rejection of Beauty in Twentieth Century Art* (New York: Free Press, 2001), ch. 2.

60. In this context, it is important to note the nineteenth-century precedents for the gendering of aesthetic characteristics. For example as Sarah Burns has discussed in her comparative analysis of the American impressionist painters John Singer Sargent and Cecilia Beaux, the male subject position is historically characterized as being objective, analytical, penetrating, authoritative, brilliant, aggressive, vigorous, rational, and civilized; while the feminine is emotional, sensitive, sympathetic, understanding, tender, intimate, charming, spiritual, and poetic. Where Barr later merged the two sides into a unified ideal, Burns points out that turn-of-the-century ideology and language naturalized and maintained the distinctions between these gendered binarisms. See Sarah Burns, "The 'Earnest, Untiring Worker' and the Magician of the Brush: Gender Politics in the Criticism of Cecilia Beaux and John Singer Sargent," in Marianne Doezema and Elizabeth Milroy, eds., *Reading American Art* (New Haven: Yale University Press, 1998), pp. 177–198.

61. Interestingly, like Barr's flowchart, the gendered parameters of *The Large Glass* can be read both vertically and horizontally. Read vertically, the work implies a reciprocal, ascending and descending relation between the lower level of the bachelors and the upper level of the bride. Read horizontally, the glass panes that simultaneously connect and separate the bachelors' and the bride's domains seem to reinforce their separateness by constituting an unbridgeable boundary between the masculine and feminine realms. Yet when *The Large Glass* is viewed as a whole, it can be seen–much like Barr's flowchart–as a complex, ambivalent androgyne that is somehow internally fractured yet integrally interwoven.

62. "Modern 'Redirections,'" *New York Times* (August 26, 1934): 6x.

63. Edward Alden Jewell, "New Books on the Arts," *New York Times Book Review* (November 25, 1934): 21.

64. Daniel Catton Rich's review appeared in the *Chicago Daily Tribune* (August 25, 1934): 6.

65. Barry Byrne's review was published in *Commonweal* 21 (November 23, 1934): 125.

66. Erwin Panowsky [*sic*], "Book Comment," *Bulletin of the Museum of Modern Art* 2 (November 1934): 3.

67. Significantly, the one genuinely negative response came from Thomas Craven, a vociferously antimodernist critic and partisan of the regionalist painters Thomas Hart Benton and Grant Wood. Writing in the *Nation*, Craven dismissed Sweeney's book as an elitist "show of erudition," claiming that "his tract is a museum dish for pallid aesthetes with no stomach for an art enriched by the impurities of the real world, a morsel of consolation for those whose convictions and investments are at stake." See Thomas Craven, "Art," *Nation* 139 (September 26, 1934): 360. Regarding the tensions that played out during the thirties between the critical proponents of modernism and the more traditional regionalist artists and critics, see note 47 above, and my study *Painting Gender, Constructing Theory: The Alfred Stieglitz Circle and American Formalist Aesthetics* (Cambridge, MA: MIT Press, 2001), ch. 7.

68. Jewell tempered his comments by concluding: "The exegesis is scholarly, never 'popular.' Perhaps some readers will find his presentation overabstruse, and a good many of us are likely also to feel than [*sic*] an overintense seriousness often attaches to the analysis of developments trivial in nature and of but ephemeral significance." See Edward Alden Jewell, "The Anatomy of Cubism and Abstract Art," *New York Times Book Review* (June 7, 1936): 8.

69. This unsigned review appears in *Commonweal* 24 (July 3, 1936): 272.

70. Meyer Schapiro, "Nature of Abstract Art," *Marxist Quarterly* (January-March 1937): 77–98, reprinted in Meyer Schapiro, *Modern Art, 19th and 20th Centuries: Selected Papers* (New York: George Braziller, 1982), p. 187. Regarding Schapiro's response to Barr, see Kantor, *Alfred H. Barr, Jr.,* pp. 328–331.

71. Schapiro, "Nature of Abstract Art," pp. 186, 200.

72. For a thematically related discussion of the surrealists' protest of French colonial practices through their polemical exhibition "The Truth about the Colonies" (1931), see Janine Mileaf, "Body to Politics: Surrealist Exhibition of the Tribal and the Modern at the Anti-Imperialist Exhibition and the Galerie Charles Ratton," *Res* 40 (Autumn 2001): 239–254.

73. Schapiro, "Nature of Abstract Art," p. 201. Not surprisingly, after the publication of Schapiro's essay in *Marxist Quarterly*, the volume of personal correspondence that Barr and Schapiro exchanged during

the thirties dropped off sharply. Only a handful of subsequent letters are preserved in the Alfred H. Barr, Jr., Papers at the Museum of Modern Art (which are also available on microfilm through the Archives of American Art). These include a rather formal note of May 11, 1937, in which Schapiro provided a letter of introduction to Barr on behalf of a scholarly colleague; and a letter dated October 7, 1937, in which Schapiro invited Barr to attend his lectures at the New School of Social Research and requested that students from the Young Men's Hebrew Association be allowed access to books in the museum's library. See Meyer Schapiro to Alfred H. Barr, Jr., May 11, 1937 and October 7, 1937, in the Alfred H. Barr, Jr., Papers [AAA: 2166; 625–627], Museum of Modern Art Archives, New York.

74. Barr, *Cubism and Abstract Art*, pp. 9, 15.

75. On this subject, see Anna Brzyski, "Foreword: Metaphors, Interpretations, and Power Positions," in Brzyski, *Partisan Canons*. Regarding the categorical relations between modernism and postmodernism, see also Maurice Berger, ed., *Postmodernism: A Virtual Discussion* (New York: Distributed Art Publishers, 2003).

76. One of the central characteristics of shamanic objects is the notion that supernatural beings can inhabit their physical structures, thereby establishing a sense of reciprocity between the material and spiritual domains. Along these lines, the philosopher Charles Taylor has located such beliefs within a premodern worldview, since "the boundary between the psychic and the physical [worlds] had not yet been sharply drawn" but remained suggestively open. Taylor has characterized the conceptual shift away from this position as a pivotal point within the formation of modern selfhood: "The revolution which produced the modern idea of the psyche and its strong localization had not only to sweep aside traditional theories of ontic logos; it had also to undermine and replace a deeply rooted popular way of understanding human life and its place in nature, that which underlay and made possible a serious belief in magic." See Charles Taylor, *Sources of the Self: The Making of the Modern Identity* (Cambridge, MA: Harvard University Press, 1989), p. 191.

77. James Johnson Sweeney, *African Negro Art* (New York: Museum of Modern Art, 1935), p. 19. For a discussion of related works, see Bérénice Geoffroy-Schneiter, *Tribal Arts: Africa, Oceania, Southeast Asia* (New York: Vendome Press, 2000). Regarding additional works of classical, African, and New Guinean sculpture in Sweeney's personal art collection, see Rita Reif, "Auctions," *New York Times* (November 21, 1986).

78. See the entry for "canon" in *The Oxford English Dictionary*, 2nd ed., vol. 2, p. 838.

79. In addition to Nietzsche's *The Birth of Tragedy*, an engagement with the ambivalent themes of modernity, particularly relating to subjective boundaries and intersubjective joinings, is famously found in Sigmund Freud's studies *Three Essays on the Theory of Sexuality* (1905) and *Civilization and Its Discontents* (1930). In the latter, published just four years before Sweeney's *Plastic Redirections*, Freud observed that "towards the outside [world], at any rate, the ego seems to maintain clear and sharp lines of demarcation. There is only one state—admittedly an unusual state, but not one that can be stigmatized as pathological—in which it does not do this. At the height of being in love the boundary between ego and object threatens to melt away. Against all the evidence of his senses, a man who is in love declares that 'I' and 'you' are one, and is prepared to behave as if it were a fact." Thus in a state of love, masculine identity is described in androgynous terms as encompassing a

melted boundary that incorporates the feminine into itself. See Sigmund Freud, *Civilization and Its Discontents*, trans. James Strachey (1930; New York: W. W. Norton, 1961), pp. 12–13.

3 Seeing the One "Less Seen": James Johnson Sweeney, in Light of Marcel Duchamp

1. The previously unseen artworks were formerly in the collections of H. P. Roché and Gustave Candel.

2. James Johnson Sweeney, *Vision and Image: A Way of Seeing* (New York: Simon and Schuster, 1967), p. 33.

3. James Johnson Sweeney to Marcel Duchamp, July 9, 1936. Papers of the magazine *Transition* bMS Am 2068 (81). By permission of the Houghton Library, Harvard University. In a letter to the artist dated September 15, 1936, in this same archival folder, Sweeney reconstructed the chronology of his and Duchamp's interactions.

4. Regarding Duchamp's *Comb* (1916), see Anne D'Harnoncourt and Kynaston McShine, eds., *Marcel Duchamp* (New York: Museum of Modern Art, 1973), p. 279, no. 115.

5. Duchamp would later use the term "transmutation" to describe "the creative act" in the talk that he presented at the American Federation of the Arts conference (1957), as discussed below.

6. Extending this paradox, Calvin Tomkins has noted Duchamp's disavowal of any specific meaning to be attributed to the inscription. According to Duchamp, "The idea was to write something that had nothing to do with dogs or combs. . . . Something as nonsensical as possible. It's not easy to be non-sensical, because nonsensical things so often turn out to make sense." See Calvin Tomkins, "Profiles: Not Seen and/or Less Seen," *New Yorker* 40 (February 6, 1965): 62.

7. See Arturo Schwarz, *The Complete Works of Marcel Duchamp*, 3rd ed. (New York: Delano Greenridge, 1997), vol. 2, p. 732, no. 443.

8. For an extended discussion of this exhibition, see Lewis Kachur, *Displaying the Marvelous: Marcel Duchamp, Salvador Dalí, and Surrealist Exhibition Installations* (Cambridge, MA: MIT Press, 2001), ch. 4.

9. Peggy Guggenheim, *Out of This Century: The Informal Memoirs of Peggy Guggenheim* (New York: Dial Press, 1946), p. v. Regarding these collaborations, see also Mary V. Dearborn, *Mistress of Modernism: The Life of Peggy Guggenheim* (Boston: Houghton Mifflin, 2004); and Anton Gill, *Art Lover: A Biography of Peggy Guggenheim* (New York: Harper Collins, 2002). Gill notes that, in 1967, Sweeney and Barr represented two of the eight trustees whom Guggenheim selected to serve on the foundation that managed her art collection (p. 399).

10. Calvin Tomkins, *Duchamp: A Biography* (New York: Henry Holt, 1996), p. 352.

11. Regarding Museum of Modern Art acquisitions, see ibid., p. 358. In 1952, Duchamp persuaded the Arensbergs to lend *Nude Descending a Staircase* and *The Bride* to Sweeney's "Masterpieces of the Twentieth Century" exhibition at the Musée d'Art Moderne, Paris (May-June 1952). The following year, Duchamp advised Sweeney on the "Dada 1916–23" exhibition at the Sidney Janis Gallery, New York (April-May 1953); and that summer and fall Duchamp helped to persuade Constantin Brancusi to collaborate with Sweeney on the Brancusi retrospective that Sweeney staged at the Guggenheim (October 1955 to January 1956). For a discussion of the latter exhibition, see Anna C. Chave,

Constantin Brancusi: Shifting the Bases of Art (New Haven: Yale University Press, 1994). Regarding these various projects, see also Tomkins, *Duchamp: A Biography*, p. 379; and Francis M. Naumann and Hector Obalk, eds., *Affectionately, Marcel: The Selected Correspondence of Marcel Duchamp*, trans. Jill Taylor (Ghent: Ludion Press, 2000), pp. 310, 318–320, 325–326.

12. Marcel Duchamp to Henri-Pierre Roché, August 21, 1945, quoted in Naumann and Obalk, *Affectionately, Marcel*, pp. 249–251.

13. James Johnson Sweeney to Alfred H. Barr, Jr., January 12, 1949, in the Alfred H. Barr, Jr., Papers [AAA: 2182; 158–165], Museum of Modern Art Archives, New York.

14. James Johnson Sweeney, *Plastic Redirections in 20th Century Painting* (Chicago: University of Chicago Press, 1934), p. 75.

15. Duchamp, quoted in the entry on "Marcel Duchamp" in James Johnson Sweeney, *Eleven Europeans in America*, special issue of *Bulletin of the Museum of Modern Art* 13, nos. 4–5 (1946): 19. The artist noted that Jules Laforgue's poem "Encore à cet astre" served as an initial source of inspiration for the painting. While Laforgue's figure ascends a stair, Duchamp reversed the direction of the figure's trajectory.

 In this interview Duchamp dismissed the notion that futurism exerted a formative influence on his early painting, even as he affirmed the importance of chronophotography, noting that "my interest in painting the *Nude* was closer to the cubists' interest in decomposing forms than to the futurists' interest in suggesting movement, or even to Delaunay's *Simultaneist* suggestions of it. My aim was a static representation of movement—a static composition of indications of various positions taken by a form in movement—with no attempt to give cinema effects through painting" (ibid.).

16. Duchamp, quoted in Sweeney, *Eleven Europeans in America*, pp. 20–21.

17. For a discussion of the formation and exhibition history of the Société Anonyme collection, as well as color reproductions of numerous artworks, see Jennifer R. Gross, ed., *The Société Anonyme: Modernism for America* (New Haven: Yale University Press, 2006). See especially David Joselit's essay in that catalogue, "The Artist Readymade: Marcel Duchamp and the Société Anonyme," for a complex and intriguing meditation on the mutually reflective, and often categorically transgressive, relations between corporeality and desire, markets and frames, in Duchamp's oeuvre.

18. Sweeney's brother, John L. Sweeney, was a friend of T. S. Eliot and served as curator of Harvard Library's Poetry Room, and as curator of the Farnsworth Room at Harvard University's Lamont Library.

19. In his talk, Sweeney also identified the Russian constructivist sculptor Naum Gabo as exemplifying an alternative, vital current in modern art through his engagement with a construction of spirituality that was achieved through aesthetic "de-materialization." See James Johnson Sweeney, "Modern Art and Tradition," in *Three Lectures on Modern Art* (New York: Philosophical Library, 1949), p. 47.

20. T. S. Eliot, "Tradition and the Individual Talent," in his *The Sacred Wood: Essays on Poetry and Criticism* (London: Methuen, 1920), quoted in http://www.bartleby.com/200/sw4.html, p. 3.

21. Ibid., p. 2.

22. Ibid., p. 6.

23. Sweeney, "Modern Art and Tradition," p. 35.

24. Ibid., p. 33.

25. Ibid., pp. 35–37.

26. Interestingly, Francis M. Naumann has also identified a pattern of "a reconciliation of opposites" in the works of Marcel Duchamp. Tracing the history and recurrence of this idea, Naumann discusses the writings of Heraclitus, Nicholas Cusanus, Hegel, Max Stirner, and Jung, and he references the archetypalism of this model in the writings of Alan W. Watts and Mircea Eliade. See Francis M. Naumann, "Marcel Duchamp: A Reconciliation of Opposites," in Rudolf Kuenzli and Francis M. Naumann, eds., *Marcel Duchamp: Artist of the Century* (Cambridge, MA: MIT Press, 1990), pp. 20–40.

27. Sweeney, "Modern Art and Tradition," p. 50.

28. Ibid., p. 41.

29. Ibid., p. 45. Notably, in the collection catalogue that the Société Anonyme published the following year, Katherine Dreier reiterated the liberating impetus underpinning the strategic disruptions that marked Duchamp's creativity. As Dreier observed, "If [Duchamp] meets with the slightest danger of [artists] being dull and static, he throws a bomb shocking them back to life. Sometimes the bomb is caustic, sometimes shocking to the sensibilities, but in general, effective." See Katherine S. Dreier, "Marcel Duchamp," in *Collection of the Société Anonyme: Museum of Modern Art 1920* (New Haven: Yale University Art Gallery, 1950), p. 148.

30. Sweeney also presented the corollary idea that works of modern art, as exemplified by Duchamp, not only became invested with spiritual values but could impart these values to their audience, since "individual works of art, through their quality and integrity, offer patterns for the emotional and spiritual organization of the observer." Sweeney, "Modern Art and Tradition," p. 54.

31. For a period discussion of this work and the rotoreliefs, see K. G. Pontus Hultén, *The Machine as Seen at the End of the Mechanical Age* (New York: Museum of Modern Art, 1968), pp. 103–105.

32. *Dreams* represented only one of Duchamp and Richter's cinematic collaborations. Another project, dating to the spring of 1948, involved Richter's inviting Duchamp to write a script for an educational film on the history of modern art from the turn of the century to the present. Duchamp also collaborated with Richter on *Dadascope* (1961), "in which Duchamp symbolically smashed a pane of glass while reciting his observations on painting and the 'beauty of indifference.'" See Marcel Duchamp, "Plans for work for the year beginning March 1, 1948," a fellowship report prepared for the Southern Educational and Charitable Trust administered by Fulbright, Crooker, Freeman, and White, a copy of which can be found in the Alfred H. Barr, Jr., Papers [AAA: 2182; 177], Museum of Modern Art Archives, New York; and Hans Richter, "In Memory of a Friend," *Art in America* 57 (July–August 1969): 40.

33. For a historical account that situates *Dreams That Money Can Buy* within contemporary developments in cinematic production, see Sarah Wilson, "Hans Richter: Dreams That Money Can Buy," in *Peinture-cinéma-peinture* (Marseille: Centre de la Vieille Charité Marseille, 1989), pp. 216–231. Wilson notes that, while French critics attacked the film's popularization of surrealist aesthetics, *Dreams* was widely screened during the forties and received the prize for the best contribution to the progress of cinematography in the Venice Biennale Film Festival of 1947.

34. *Dreams That Money Can Buy* (New York: Art of This Century Films, 1947), n.p. The film received mixed reviews in the press. Bosley Crowther of the *New York Times* characterized it as Richter's

"boldly arrang[ing] a screen wedding of modern art and psychiatry," yet he dismissed Duchamp's "comprehension of a gangster's dream world" as "just tame pornography. . . . Maybe you'll get the connection between a misty nude descending a pair of stairs, multiplied by a prismatic focus, and a cascade of coal, but we don't." See Bosley Crowther, "The Screen: 'Dreams That Money Can Buy,' Psychology Study, at 5th Ave. Playhouse," *New York Times* (April 24, 1948): 11.

35. *Dreams That Money Can Buy*, n.p. Notably, Duchamp's dream sequence was accompanied by music composed for the piano by John Cage. As Cage stated, "The rhythmic structure for the music which accompanies the Duchamp sequence is, as is true of all my compositions since 1938, prismatic in character: in this case, each 11 measures of 5/4 (and the whole which is 11 × 11 measures) is phrased (and the whole divided into parts) according to the following relationship: 3, 1, 3, 1, 2, 1. These numbers were derived from the time lengths given by the film itself as related to a pulse of 120 to the minute. By 'derived,' I mean: arrived at from a desire to be *with* the film phrases at certain points and against or in 'contrapuntal' relationship with it at other points."

36. Duchamp, quoted in D'Harnoncourt and McShine, *Marcel Duchamp*, p. 256.

37. The dreamer even sees afterimages of the nude as trace presences as he awakens and experiences transitional modes of consciousness.

38. On these themes, see Michael A. Sells, *Mystical Languages of Unsaying* (Chicago: University of Chicago Press, 1994), esp. pp. 1–21.

39. See Lanier Graham, *Duchamp and Androgyny: Art, Gender, and Metaphysics* (Berkeley: No-Thing Press, 2003), p. 43.

40. Duchamp, quoted in Graham, *Duchamp and Androgyny*, p. 43.

41. Winthrop Sargeant, "Dada's Daddy: A New Tribute Is Paid to Duchamp, Pioneer of Nonsense and Nihilism," *Life* 32 (April 28, 1952): 100.

42. Duchamp, quoted in Tomkins, *Duchamp: A Biography*, p. 379.

43. Sargeant, "Dada's Daddy," pp. 104, 106, 108, 111.

44. While futurism was popular ca. 1912, Duchamp again emphasized his lack of awareness of the movement at that time. As he noted, "There is a coincidence there. Of course, you might say Futurism was in the air, but I didn't intimately know the Futurists. I did this painting [*Nude Descending a Staircase*] with the idea of using movement as one of the elements." See "Marcel Duchamp," interview with James Johnson Sweeney (1956), published in James Nelson, ed., *Wisdom: Conversations with the Elder Wise Men of Our Day* (New York: W. W. Norton, 1958), p. 92.

45. Duchamp, quoted in Nelson, *Wisdom*, p. 97

46. Duchamp, quoted in Nelson, *Wisdom*, pp. 92–99.

47. Duchamp, quoted in Tomkins, "Profiles: Not Seen," p. 40.

48. Yet Duchamp immediately backtracked as he added, "and even this is a dubious term. Anything is dubious." See William Seitz, "What's Happened to Art? An Interview with Marcel Duchamp on Present Consequences of New York's 1913 Armory Show," *Vogue* (February 15, 1963): 113.

49. Cleve Gray, "The Great Spectator," *Art in America* 57 (July-August 1969): 20.

50. During the late 1940s the "Three Brothers" exhibition had originally been planned for the Museum of Modern Art, and Duchamp was to have contributed research for the catalogue and assisted with

the presentation of the show. See Duchamp's fellowship report in the Alfred H. Barr, Jr., Papers [AAA: 2182; 1177], Museum of Modern Art Archives, New York. For a positive critical review of the Guggenheim exhibition, see Robert M. Coates, "The Art Galleries: *Three Brothers*," *New Yorker* (March 2, 1957). See also the extended, congenial interview with Duchamp that appeared in the April 6, 1957, issue of that magazine.

51. See the exhibition feature in the *Art Newsletter* (American Federation of the Arts, March 1957), n.p.

52. James Johnson Sweeney, foreword to *Three Brothers: Jacques Villon, Raymond Duchamp-Villon, Marcel Duchamp* (New York: Solomon R. Guggenheim Museum, 1957), n.p.

53. The panel on which Duchamp spoke also included the distinguished art historians William Seitz and Rudolf Arnheim and the anthropologist Gregory Bateson. (For Sweeney's panel, see note 21 of chapter 1.) The actor and art collector Vincent Price served as a guest speaker at the conference; in his address, he discussed the potential of television to foster a wider appreciation of the fine arts.

54. For a discussion of this essay, see Tomkins, *Duchamp: A Biography*, pp. 396–398. As if exemplifying the creative passivity he described, Tomkins notes that Duchamp "spent very little time writing the Houston speech, according to [the artist's wife] Teeny. 'Marcel did everything so easily,' Teeny recalled. 'The ideas were there to begin with, pretty much worked out in his head'" (p. 396).

55. Marcel Duchamp, "The Creative Act" (April 1957), reproduced in *Salt Seller: The Writings of Marcel Duchamp/Marchand du sel*, ed. Michel Sanouillet and Elmer Peterson (New York: Oxford University Press, 1973), p. 138.

56. Ibid., pp. 139–140.

57. One index of the affection that Sweeney and Duchamp shared during the early sixties can be seen in the artist's letter to Sweeney of October 31, 1961. Responding to an informational inquiry on the painter André Derain, Duchamp closed his letter by asking Sweeney when he would be back in New York, and sending "love from us both, Marcel Duchamp." See Marcel Duchamp to James Johnson Sweeney, October 31, 1961, Records of the Office of the Director, James Johnson Sweeney, Correspondence, Museum of Fine Arts, Houston (hereafter MFAH Director Records).

58. See James Johnson Sweeney to Marcel Duchamp, October 15, 1964, in the exhibition file for "Not Seen and/or Less Seen of/by Marcel Duchamp/Rrose Sélavy 1904–64"(February 24–March 28, 1965), Archives, Museum of Fine Arts, Houston (hereafter MFAH Archives). For advance press coverage of the exhibition and reporting of the gala opening, see "Art: Marcel Duchamp's *Comb*," *Houston Post* (February 21, 1965): Spotlight section, 6; and Edith Honholt, "Duchamp at Museum," *Houston Post* (February 24, 1965): sec. 2, 5.

59. See James Johnson Sweeney to James Nelson of NBC Television, March 24, 1965, in the exhibition file for "Not Seen and/or Less Seen of/by Marcel Duchamp/Rrose Sélavy 1904–64" (February 24–March 28, 1965), MFAH Archives.

60. James Johnson Sweeney, "Marcel Duchamp," press release dated February 24, 1965, in the exhibition file for "Not Seen and/or Less Seen of/by Marcel Duchamp/Rrose Sélavy 1904–64" (February 24–March 28, 1965), MFAH Archives.

61. Ibid.

62. Indeed, by the mid-sixties Duchamp's lineage was widely seen as extending both backward, to impressionism, and forward, to abstract expressionism, pop art, op art, and various other contemporary artistic developments. These genealogical themes appeared prominently in the reviews of the Cordier & Ekstrom exhibition in New York. Writing in *Art in America*, Cleve Gray observed that "Duchamp appears more and more to be the father of contemporary esthetic attitudes." Along these lines, *Time* magazine labeled Duchamp "Pop's Dada" and identified his work as seminal for modern artists ranging from Jasper Johns and Jackson Pollock to Louise Nevelson and Joseph Cornell. *Time* also described the rotoreliefs, "dazzling eye bafflers that run at 33 r.p.m. [as] the ancestors of today's kinetic op art." In short, Duchamp emerged as a venerable modernist old master who perpetuated an artistic genealogy while simultaneously deconstructing it. See Cleve Gray, "Retrospective for Marcel Duchamp," *Art in America* 53 (February 1965): 103; and "Pop's Dada," *Time* (February 5, 1965): 78, 85. Notably, Thomas B. Hess raised related issues in his review of the Cordier & Ekstrom show in *Artnews* when he observed that "Duchamp organized and agitated a middle-brow cult of anti-art," yet "in order to remain creative, modern art needs a critical destructive side." See Hess, "J'accuse Marcel Duchamp," *Artnews* 63 (February 1965): 52. For an extended analysis of the ways in which Duchamp has been identified as the key source for postmodern artistic production, see Amelia Jones, *Postmodernism and the En-gendering of Marcel Duchamp* (New York: Cambridge University Press, 1995).

63. For coverage of the opening in the Houston press, see Campbell Geeslin, "Art: Talk with a Lively Legend: Marcel Duchamp," *Houston Post* (February 28, 1965): Spotlight section, 9, 11; and Ann Holmes, "Rose Sélavy May Sneeze: Duchamp Show This Week," *Houston Chronicle* (February 21, 1965): Zest section, 25.

64. Marcel Duchamp to Arne Ekstrom, August 16, 1964, in Naumann and Obalk, *Affectionately, Marcel*, pp. 385–387. See also Duchamp's letter to Ekstrom of September 6, 1964, following up on this matter (ibid., pp. 387–388).

65. See Richard Hamilton's entry for *Door: 11 rue Larrey, Paris* in *Not Seen and/or Less Seen of/by Marcel Duchamp/Rrose Sélavy 1904–64* (Houston: Museum of Fine Arts, 1965), cat. no. 76, n.p.

66. André Breton, "Lighthouse of the Bride" (1935), in Sweeney, *Three Brothers*, n.p.

67. André Breton, "Lighthouse of the Bride," *View* (March 1945): 7.

68. Viewed in Derridean terms, Duchamp's *Door* can be seen as a type of hymen. In his literary and philosophical study *Dissemination* (1972), Jacques Derrida characterized the hymen as a fragile membrane, a site where difference becomes inscribed as mutually enfolded yet undecidable, both in the literal and symbolic architecture of female anatomy and the act of marital joining. For a reprint of this text and an accompanying discussion of the philosophical implications of this motif in Derrida's oeuvre, see Peggy Kamuf's "Introduction: Reading between the Blinds," in Peggy Kamuf, ed., *A Derrida Reader: Between the Blinds* (New York: Columbia University Press, 1991).

4 Blood Miracles and Fire Magic: The Transmutational Arts of Alberto Burri

1. "Excerpts from U.N. Report on Massacre of Italians," *New York Times* (November 17, 1961): 2. Regarding this story, see also "Congolese Slay Italian Airmen," *New York Times* (November 17, 1961): 1, 3.

2. James Johnson Sweeney, press release in the exhibition file for "Alberto Burri Exhibition" (October 16 to December 1, 1963), Archives, Museum of Fine Arts, Houston (hereafter MFAH Archives).

3. Charlene Steen, "Reviews: Houston," *Artforum* 2 (December 1963): 45.

4. Maurizio Calvesi famously related Burri's *sacchi* both to the existential climate of postwar Italy and to the artist's biographical context, the latter of which Calvesi reads through the interpretive prism of Freud: "Form and action are inseparable in a psychological as well as an aesthetic sense. The destructive action turns against itself, as if to prove Freud's theory of the death wish; and this destructiveness expresses itself outwardly as an instinct of aggression, in active opposition to the constructive instinct of self-preservation. In this sense, Burri's aesthetic approach is a radical exposure of psychic reality. His ambiguity is born, not out of the dualism of form and formlessness, but directly out of the encounter, on the psychological plane, of deep, primordial urges." See Maurizio Calvesi, *Alberto Burri*, trans. Robert E. Wolf (New York: Abrams, 1975), p. 17. For Calvesi's later comments on his interpretation of Burri, see "Interview with Maurizio Calvesi," in Carolyn Christov-Bakargiev and Maria Grazia Tolomeo, *Burri: 1915–1995 Retrospektive* (Milan: Electa, 1997), pp. 135–136.

5. Matthew Gale and Renato Miracco, *Beyond Painting: Burri, Fontana, Manzoni* (London: Tate Publishing, 2005), p. 74. Gale further notes that "the artist himself recalled the disapproval voiced by the Communists, who considered the material [burlap sacking] degrading in another sense, but whom he suspected of acknowledging that it could be a thing of beauty." For additional scholarly and critical interpretations that locate Burri's *sacchi* within American Cold War political and economic policies, see Calvesi, *Alberto Burri*, pp. 11–13; and Jaimey Hamilton, "Alberto Burri's *Sacchi* and Cold War Capitalism's Accursed Share," *College Art Association Abstracts* (New York: College Art Association, 2005), pp. 207–208. Various exhibitions have showcased the influential roles played by Burri and his colleague Lucio Fontana in the development of Arte Povera and Arte Informale. See Midori Matsui's review of "Arte Italiana 1945–1995: The Visible and the Invisible," an exhibition held at the Museum of Contemporary Art, Tokyo (1998), in *Flash Art* (International Edition) 200 (May-June 1998): 69. Another exhibition highlighting Burri's influential position in postwar Italian culture is "The Italian Metamorphosis, 1943–1968," organized by the Guggenheim Museum (1994). For an extensive review of this show, see Raphael Rubinstein, "Vita Nuova," *Art in America* 83 (June 1995): 74–81.

6. Burri's comments appear in Hunter Drohojowska, "Alberto Burri's Umbrian Collage: The Artist's Multifaceted Realm near Perugia," *Architectural Digest* 47 (January 1990): 121. As Giuliano Serafini succinctly put it, Burri was "a master without disciples." Along these lines, Shaun Caley aptly observed, "Purported to have been the catalyst between Informel and Arte Povera–Burri prefers a strictly autonomous position, inscribing himself, moreover, in the tradition of classical painting." See Giuliano Serafini, *Burri: The Measure and the Phenomenon* (Milan: Edizioni Charta, 1999), p. 116; and Shaun Caley, "Burri," *Flash Art* 147 (Summer 1989): 97. From a somewhat different philosophical perspective, Carolyn Christov-Bakargiev also discusses Burri's complex and ambivalent relation to modernism. On the one hand, she notes, "Burri remained a modern artist through and through, never renouncing the bounds of the canvas and the confines of the unitary and central self." Yet on the other hand, his work clearly transgresses and transcends neo-Kantian conceptions of "purely

visual" modernist painting: "Burri went beyond the distinction between form and content and beyond the modernist debate over those categories, setting him radically apart from the reductionism of formalist abstraction. His is a 'realism' that goes beyond representation, a 'tactile' art where every fragment of the real, once gathered and incorporated into the work like a fragment of unexpected experience, becomes the signifier of itself and only itself, free of linguistic mediation." See Carolyn Christov-Bakargiev, "Alberto Burri: The Surface at Risk," in Christov-Bakargiev and Tolomeo, *Burri: 1915–1995 Retrospektive*, pp. 89–90.

7. Drohojowska, "Alberto Burri's Umbrian Collage," p. 119.

8. Burri's comments, made during a 1956 conversation with the artists Afro, Capogrossi, Scialoja, and Chiaramonte, are quoted in Gale and Miracco, *Beyond Painting*, p. 122.

9. In displaying these paradoxical aesthetic qualities, *Grande sacco: Congo Binga* notably resonates with other contemporary works that Sweeney acquired for the MFAH's permanent collection, such as Carrado Marca-Relli's *Plan B* (1962), a vinyl plastic composition on wood; Lee Bontecou's enigmatic sculptural construction *Untitled* (1962); and especially, Fontana's *Concetto spaziale: Attese*, a painting in oil on slit canvas that Sweeney purchased in 1965. For comparative discussions of the artists, see Gale and Miracco, *Beyond Painting*; and Marco Vallora, *Marca-Relli: L'amico americano: Sintonie e dissonanze con Afro e Burri* (Parma: Galleria d'Arte Niccoli, 2002).

10. Building on these themes, Cesare Brandi presented a formally oriented, stylistic, and structural account of the ambivalent appeal of Burri's artworks, which he saw as simultaneously attracting and repelling the viewer's gaze. See Cesare Brandi, *Burri* (1963), trans. Martha Leeb Hadzi (Rome: Editalia, 1964).

11. See Christov-Bakargiev and Tolomeo, *Burri: 1915–1995 Retrospektive*, p. 259. In preparing this exhibition catalogue, Christov-Bakargiev and Tolomeo worked in collaboration with the Burri Foundation, particularly the archives of the Fondazione Palazzo Albizzini in Città di Castello, to compile an extensive and intricate chronology documenting the historical details of Burri's oeuvre.

12. Serafini, *Burri*, pp. 168–169.

13. Various other writers have noted that his meeting with Sweeney initiated Burri's critical recognition in America. In a retrospective catalogue on Burri assembled by the New York art gallery Mitchell-Innes & Nash, for example, Sweeney is given prominent credit as "the first promoter and champion of Burri's work in the United States, organizing major exhibitions and writing seminal catalogue essays and texts on the artist." The catalogue also repeats several of Sweeney's critical tropes on Burri, particularly focusing on metaphors of wounded flesh and alchemical transformations, and passages of Sweeney's 1955 monograph on Burri are cited directly in the text. See Germano Celant, "Alberto Burri and Material" and "Minsa Craig Burri: A Tribute," in *Alberto Burri* (New York: Mitchell-Innes & Nash, 2007), pp. 5–16. Furthermore, Calvesi has noted that "at first Italy virtually dismissed Burri. This was so until about 1955, when James Johnson Sweeney published his brief monograph and the artist exhibited at the Rome Quadriennale." See Calvesi, *Alberto Burri*, p. 7. For a summary of Sweeney's contribution to the predominant motifs in Burri art criticism, see "Notes on the Critical Vicissitudes of Alberto Burri," in Christov-Bakargiev and Tolomeo, *Burri: 1915–1995 Retrospektive*, p. 128.

14. See James Johnson Sweeney, *Younger European Painters: A Selection* (New York: Solomon R. Guggenheim Museum, 1953), pp. 4–5; and Sweeney's compilation of the collection guide *The Solomon R. Guggenheim Museum* (New York: Solomon R. Guggenheim Museum, 1958), n.p. For reviews of the exhibition, see James Fitzsimmons, "New York: A Glittering Constellation," *Art Digest* 28 (December 1953): 7–8, 25–26; and Robert Goldwater, "These Promising Younger Europeans," *Artnews* 52 (December 1953): 15.

15. James Johnson Sweeney, *Images at Mid-Century* (Ann Arbor: University of Michigan Museum of Art, 1960), n.p.

16. This information appears in the section on "Acquisitions" in James Johnson Sweeney's typescript of the annual Director's Report for 1957, presented to Harry F. Guggenheim on May 9, 1958. This document can be found in the James Johnson Sweeney Administrative Papers (1951–1961), The Solomon R. Guggenheim Museum Archives.

17. Fitzsimmons, "New York: A Glittering Constellation," p. 25.

18. Fairfield Porter, "Alberto Burri," *Artnews* 52 (December 1953): 41. The critic further noted that some of Burri's surfaces resembled aerial views of eroded landscapes.

19. See Serafini, *Burri*, p. 114; and *Burri: Contributi al catalogo sistematico* (Città di Castello: Fondazione Palazzo Albizzini, 1990), nos. 626 and 627.

20. James Johnson Sweeney to Alberto Burri, March 2, 1967, Records of the Office of the Director, James Johnson Sweeney, Correspondence, Museum of Fine Arts, Houston (hereafter MFAH Director Records).

21. Sweeney retained close ties to Ireland, and he and his wife maintained residences in both County Mayo and New York City.

22. James Johnson Sweeney to Minsa and Alberto Burri, March 13, 1962, in the MFAH Director Records. Interestingly, in a 1967 letter to Valeria Sissa, the wife of the Italian modernist painter Afro, Sweeney mentioned that he has "been working on the Burri book." Unfortunately, this project seems never to have materialized, although Sweeney did write the introduction for the monograph *Afro: Paintings, Gouaches, Drawings* (Rome: Modern Art Editions, 1961). See James Johnson Sweeney to Valeria Sissa, June 23, 1967, in the MFAH Director Records.

23. James Johnson Sweeney, *Burri* (Rome: L'Obelisco, 1955).

24. James Johnson Sweeney, *Paintings by Alberto Burri* (Pittsburgh: Carnegie Institute, 1957).

25. See Biennale di Venezia, *Biennale d'Arte catalogo 29* (Venice: Biennale, 1958), pp. 110–111.

26. James Johnson Sweeney to Rev. Anthony J. Lauck, C.S.C., Director of the Art Gallery at the University of Notre Dame, November 6, 1963, in the MFAH Director Records.

27. Walter Hopps to James Johnson Sweeney, September 29, 1964, in the exhibition file for "Alberto Burri Exhibition" (October 16 to December 1, 1963), MFAH Archives.

28. James Johnson Sweeney to Alberto Burri, December 19, 1962, in the exhibition file for "Alberto Burri Exhibition" (October 16 to December 1, 1963), MFAH Archives. There seems to be some confusion regarding the museum's acquisitions of Burri's works. The 1963 MFAH exhibition catalogue lists Burri's *Grande plastica I* (1962) as part of the museum's collection. Yet the museum records reflect a payment to the Marlborough Gallery in Rome, not for this work, but for a metal work by Burri,

Grande ferro (1958), which was also included in the 1963 exhibition. Indeed, the Burri catalogue raisonné erroneously lists this work as being in the collection of the MFAH (see cat. no. 667). Yet neither *Grande plastica I* nor *Grande ferro* remained in the MFAH's collection. I am grateful to Lorraine Stuart and Alison Greene of the MFAH for researching this issue and generously sharing their findings from relevant correspondence and Accession Committee reports.

29. Alberto Burri, "Words Are No Help," in Andrew Carnduff Ritchie, ed., *The New Decade* (New York: Museum of Modern Art, 1955), p. 82.

30. James Johnson Sweeney to Martin Friedman, November 26, 1963, in the exhibition file for "Alberto Burri Exhibition" (October 16 to December 1, 1963), MFAH Archives.

31. Sweeney, *Burri* (1955), p. 5. In the same year as Sweeney's monograph was published, the one-man exhibition "The Collages of Alberto Burri" opened at the Colorado Springs Fine Arts Center before traveling to its organizing institution, the Oakland Art Museum. In the accompanying catalogue, the Colorado museum's James P. Byrnes emphasized related themes in Burri's art, particularly the spiritual transmutation of physical suffering. Byrnes's essay is reproduced in Christov-Bakargiev and Tolomeo, *Burri: 1915–1995 Retrospektive*, pp. 265–266. For another period commentary on the "wounded" flesh of Burri's collages, see Werner Haftmann's discussion of Burri in *Painting in the Twentieth Century* (New York: Praeger, 1965), reproduced on p. 300 of Christov-Bakargiev and Tolomeo's volume.

32. On the aesthetic and spiritual reclamation of debased materiality in Burri's art, see also Paul Wember's introduction to the "Alberto Burri" retrospective held at the Museum Haus Lange in Krefeld, Germany, in 1955 (reprinted in Christov-Bakargiev and Tolomeo, *Burri: 1915–1995 Retrospektive*, pp. 277–278).

33. For related discussions of embodied formalist critical discourses in modernist aesthetics, see my studies *Painting Gender, Constructing Theory: The Alfred Stieglitz Circle and American Formalist Aesthetics* (Cambridge, MA: MIT Press, 2001); and *Modernism's Masculine Subjects: Matisse, the New York School, and Post-Painterly Abstraction* (Cambridge, MA: MIT Press, 2004).

34. See Michael A. Sells, *Mystical Languages of Unsaying* (Chicago: University of Chicago Press, 1994).

35. Sweeney, *Burri* (1955), p. 5.

36. See Herbert Thurston's entry on St. Januarius in *The Catholic Encyclopedia* (New York: Robert Appleton, 1907–1912), vol. 8, pp. 295–297.

37. My thanks to Sarah McGavran for bringing this idea to my attention in relation to the poet Rainer Maria Rilke's notion of *Weltinnenraum*, or world-inner space.

38. Sweeney, *Burri* (1955), p. 6.

39. Ibid.

40. Notably, in 1952 the Italian critic Lorenza Trucchi briefly used the adjective "alchemical" to describe Burri's synthesis of artistic materials, characterizing "his materials [as] at once horrible and splendid, abject and rich, an alchemical admixture of glue, ceruse, paint and mystery, felt almost physically." See Lorenza Trucchi, review of "Neri e muffe" (January 16, 1952), quoted in Christov-Bakargiev and Tolomeo, *Burri: 1915–1995 Retrospektive*, p. 95.

41. *The Oxford English Dictionary*, 2nd ed. (Oxford: Clarendon Press, 1989), vol. 1.

42. Sweeney did not quote the entire sentence, which reads: "The asshes of a cokatrice be acountyd good and proffytable in working Alkamye: and namely in tornynge and chaungynge of metalle." Sweeney may have come across this evocative sentence as part of the entry for "alchemy" in the *Oxford English Dictionary*. Notably, a cockatrice is a mythic hybrid creature, "a legendary serpent with deadly glance hatched by a reptile from a cock's egg on a dunghill." See *Webster's Seventh New Collegiate Dictionary* (Springfield, MA: Merriam, 1969), p. 159.

43. Sweeney, *Paintings by Alberto Burri*, n.p.

44. Herbert Read, introduction to *Alberto Burri* (London: Hanover Gallery, 1960), n.p. See also Read's brief essay on Burri in the London *Observer* (October 30, 1960), reproduced in Christov-Bakargiev and Tolomeo, *Burri: 1915–1995 Retrospektive*, p. 283. For a critical response to Read's analysis, see Lawrence Alloway's "London Letter: Alberto Burri," *Art International* 4 (May 1960): 52–53.

45. For a formally and phenomenologically oriented account of Burri's works, including the *Legni* series, see Massimo Carboni, "Medium Hot: Alberto Burri," *Artforum International* 29 (December 1990): 108–114.

46. Eleanor Kempner Freed, "In Review: New Works and Old at Museum," *Houston Post* (February 20, 1966): Spotlight section, 33.

47. For an account that locates Burri's art within the scope of informalist production, with a related discussion of the fusion of constructive and destructive elements in the *plastiche*, see Maurizio Calvesi, "El camino de Burri," in *Alberto Burri* (Madrid: Museo Nacional Centro de Arte Reina Sofía, 2006), pp. 17–29.

48. Harriet Janis and Rudi Blesh, *Collage: Personalities, Concepts, Techniques* (Philadelphia: Chilton, 1962), quoted in Christov-Bakargiev and Tolomeo, *Burri: 1915–1995 Retrospektive*, p. 290. Regarding Burri's plastic compositions, see also the review of "Plastiche" at the Marlborough Fine Arts Gallery, London (December 1962 to January 1963), and at the Marlborough-Gerson Gallery in New York (1963–1964), in "Artists Discover Themselves," *Studio International* 166 (December 1963): 247–248; and Vivien Raynor, "In the Galleries: Alberto Burri," *Arts Magazine* 38 (May/June 1964): 38.

49. Both Sweeney's mystical metaphors and Burri's experiments in plastic resonate with the contemporary insights of Roland Barthes. In 1957, the same year as the Carnegie Institute exhibition, Barthes described plastic as "the stuff of alchemy." As Matthew Gale has pointed out, in *Mythologies* Barthes observed that "plastic is the very idea of its infinite transformation; as its everyday name indicates, it is ubiquity made visible. And it is this, in fact, which makes it a miraculous substance: a miracle is always a sudden transformation of nature." See Roland Barthes, *Mythologies* (1957), quoted in Gale and Miracco, *Beyond Painting*, p. 116.

50. James Johnson Sweeney, *Alberto Burri* (Houston: Museum of Fine Arts, Houston, 1963), n.p. In a slightly later critical review, Eleanor Freed noted the contrasting elements of sensualism and death in *Bianco B.4*, writing that the "painting displays a sensuous surface created by an overlay of clear plastic on painted board. The texture is wrinkled and sculptural with a funeral motif achieved through charring and burning." See Eleanor Freed, "Art: International," *Houston Post* (February 19, 1967): Spotlight section, 7.

51. Significantly, critics have persisted in describing Burri's *plastiche* as expressions of eroticism. Thus in the 2007 Burri retrospective, Germano Celant described this body of work as "the form of a sexual sign, an organic, impure spirit that explodes from below and rises up as a current of energy." Celant reads Burri's burnt forms not as vaginal, however, but as expressions of phallic power. See Celant, "Alberto Burri and Material," p. 14.

52. For a later recapitulation of these themes, see Shaun Caley's comment, "In Burri's lacerations of the 'Sacchi' (Sacks); or his subjugation of the 'Combustioni' (Combustions/Burnings), 'Plastiche' (Plastics), and 'Ferro' (Iron) to the torch, or his artificial stimulation of the decay and decomposition in the 'Muffe' (Mould/Mildew), he continually enters into an intimate dialogue with the materials that renders the transcendent, sacred artwork through a Bataillian act of violence. . . . Rather than dehumanization and destruction, Burri's intimate dialogue with his materials renders the monumental sacralization of his artworks." Slightly later in the essay, Caley quotes Sweeney directly on Burri's artwork. See Caley, "Burri," p. 97.

53. Eloise Knapp Hay, *T. S. Eliot's Negative Way* (Cambridge, MA: Harvard University Press, 1982), p. 1. Notably, Hay later challenges an aspect of the interpretation put forth by Sweeney and other literary critics during the forties in their conflation of the two "dark nights" of the *via negativa*. (These are the dark night of the sense, which is active and is the way for spiritual beginners, and the dark night of the soul, which is the passive way and is reserved for those who are spiritually proficient.) As Hay writes, "even Sweeney, [Leonard] Unger, and [Louis] Martz, it seems to me, were confused about two of St. John's works–the *Ascent of Mount Carmel* and the *Dark Night of the Soul* (which is properly the fourth part of the *Ascent*)–in their otherwise excellent studies. When St. John wrote of 'the divine union' and its possession through the way of dispossession, he was describing a twofold path, one for beginners (whether religious or lay novices) and the other for experienced contemplatives. On the latter 'way' was the way of the 'dark night of the soul,' although both 'ways' belong to the one *via negativa*, which St. John had found described in the earliest Christian writers, especially St. Augustine and the Pseudo-Dionysius the Areopagite (hereafter referred to as Dionysius.) In Eliot's religious plays and poems, he sometimes treats one side of this twofold path and sometimes the other, as we shall see" (pp. 154–155). Hay argues that, in the *Four Quartets*, Eliot is writing of the first night of the negative way–the dark night of the sense–even though both types of dark nights follow the same pattern of purgation, illumination, and ultimately union with God (p. 156). As I trace throughout this study, Sweeney's application of these theological and poetic concepts to the visual arts complicates precisely any such dichotomized reading between the sensual and spiritual domains.

54. James Johnson Sweeney, "'East Coker': A Reading," *Southern Review* (1941); reprinted in Bernard Bergonzi, ed., *T. S. Eliot: Four Quartets: A Casebook* (London: Macmillan, 1969), p. 41.

55. Ibid., p. 48.

56. Ibid., p. 49.

57. Ibid.

58. James Johnson Sweeney, "'Little Gidding': Introductory to a Reading," *Poetry: A Magazine of Verse* 62 (April-September 1943): 222–223.

59. Sweeney, "'East Coker,'" p. 50.

60. Ibid., p. 51. As Hay points out, the complementary philosophies of Heraclitus, Aquinas, and St. John of the Cross, as reflected in Eliot's poetics, also resonate strongly with Augustine's *Confessions* (4:10): "Descend that ye may ascend." See Hay, *T. S. Eliot's Negative Way*, pp. 2, 188.

61. Sweeney was not the only critic to allude to these themes in Burri's artworks. In a review of Burri's monographic show at the Stable Gallery, Martica Sawin similarly invoked the symbolic transcendence of torn flesh in Burri's collages. In the process, Sawin described a sense of grace that incorporates and surmounts physical destruction. As she wrote, "Like another European doctor, Louis-Fernand Céline, Burri has made the horrendous 'journey to the End of the Night,' but his full knowledge of horror is transcended by the terms of sheer beauty in which it is expressed." See Martica Sawin, "Burri Patches a Picture," *Art Digest* 28 (December 1, 1953): 11, 13. Louis-Fernand Céline's novel *Journey to the End of the Night* was published in 1932.

62. Drohojowska, "Alberto Burri's Umbrian Collage," p. 123.

63. Sweeney, *Paintings by Alberto Burri*, n.p.

64. Sweeney, *Alberto Burri* (1963), n.p.

65. Sweeney, *Paintings by Alberto Burri*, n.p.

66. Ibid.

67. I am extremely grateful to Shirine Hamadeh for helping me to think through the various plays of meaning embedded within this complex quotation.

68. Sweeney, *Alberto Burri* (1963), n.p.

69. See for example the writings of the German medieval mystic Hildegard of Bingen, particularly *Scivias* (*Know the Way*) from 1151.

70. Ann Holmes, "Important American Show of Burri at Museum Here," *Houston Chronicle* (October 13, 1963): 9.

71. Steen, "Reviews: Houston," p. 45.

72. Campbell Geeslin, "Art: Intense Expression," *Houston Post* (October 20, 1963): sec. 9, 6.

73. In the Houston retrospective, these categories also included Burri's "pitch paintings" or *catrami*, and his *muffe* or "mould pictures."

74. For biblical allusions to the firmament, see especially the books of Genesis and Ezekiel. On this subject, see James F. Driscoll's entry on "firmament" in the *Catholic Encyclopedia*, vol. 6. For an extended discussion of the firmament in Hekhalot mysticism, see C. R. A. Morray-Jones, *A Transparent Illusion: The Dangerous Vision of Water in Hekhalot Mysticism* (Leiden: Brill, 2002). In an extended analysis of the Hekhalot Zutari, Morray-Jones writes: "It thus seems that the visionary is looking down through the floor of the [celestial] palace, which is evidently transparent, into the air of the world below. From the perspective of the ethereal realm in which he is standing, this air looks as dense and substantial as water. At the same time, the floor of the palace is the firmament dividing this celestial level from the one beneath it and, since the inhabitants of this realm are able to walk upon it, it is for them something solid, like stone. Thus 'the pure marble stones with which the palace was paved' could also be said to be 'high' or 'light' and 'transparent,' and are not water but solid air. The

visionary traveler is literally 'walking on air'" (p. 96). I am grateful to April DeConick for bringing this important source to my attention.

5 Illuminating the Void, Displaying the Vision: Pierre Soulages

1. Sweeney's studies include *Soulages: Paintings since 1963* (New York: M. Knoedler, 1968), and *Soulages* (Greenwich, CT: New York Graphic Society, 1972). The latter text is reprinted in Pierre Daix and James Johnson Sweeney, *Pierre Soulages* (Neuchâtel: Ides et Calendes, 1991).

2. For a comparative study of the historical installation strategies featured in one of the most prominent modernist white cubes, the galleries of the Museum of Modern Art, see Mary Anne Staniszewski, *The Power of Display: A History of Exhibition Installations at the Museum of Modern Art* (Cambridge, MA: MIT Press, 1998).

3. Soulages, quoted in Eleanor Kempner Freed, "Art: Soulages in Perspective," *Houston Post* (April 24, 1966): 31. In the Soulages catalogue raisonné, Pierre Encrevé has noted that, during this initial visit in late 1948, Sweeney purchased one of the artist's early works, a small painting in walnut stain on paper. See Pierre Encrevé, *Soulages: L'oeuvre complète, peintures* (Paris: Seuil, 1994–1998), vol. 2, p. 82. Encrevé does not indicate which work Sweeney obtained from Soulages during this initial visit. Regarding Soulages's paintings, see also Encrevé's study *Soulages: Les peintures, 1946–2006* (Paris: Seuil, 2007).

4. Sweeney characterized the show as featuring a "frankly personal selection" of the vital developments that he perceived in European art. See James Johnson Sweeney, *Younger European Painters* (New York: Solomon R. Guggenheim Museum, 1953), n.p. For an extended review of this exhibition, see James Fitzsimmons, "New York: A Glittering Constellation," *Art Digest* 28 (December 1, 1953): 7–8, 25–26. It was also in 1953 that the dealer Samuel Kootz put Soulages under contract to the Kootz Gallery; see the interview that Dorothy Seckler conducted with Samuel Kootz on April 13, 1964, for the Archives of American Art, Smithsonian Institution, at www.aaa.si.edu/oralhist/kootz64.htm.

5. William Rubin, "Letter from New York," *Art International* 11, no. 9/10 (1959): 27.

6. See James Johnson Sweeney, *Images at Mid-Century* (Ann Arbor: University of Michigan Museum of Art, 1960); and the *Guggenheim International Award* exhibition catalogues (New York: Solomon R. Guggenheim Foundation, 1958, 1960).

7. See the entries in Encrevé, *Soulages: L'oeuvre complète*, vol. 2, p. 44, cat. no. 420; and p. 92, cat. no. 474. In late 1961 the MIT Museum requested the loan of Sweeney's painting *August 27, 1961* for the Soulages exhibition assembled at MIT's Hayden Gallery in January of 1962. While this painting was not included in the show, the exhibition did include Soulages's *November 1956*, which Sweeney had acquired for the Guggenheim Museum. According to the accompanying catalogue, the show featured eighteen of Soulages's oil paintings, dating from 1953 to 1961. See *Soulages Catalogue* (Cambridge, MA: MIT Museum, 1962). All documents relating to the exhibition, including accompanying installation photographs, are housed in the Archives of the MIT Museum Committee, MIT Museum Collection, Cambridge.

8. Although the Sweeney family paintings were exhibited in Houston as anonymous loans, the exhibition histories and related provenance information can be found in the Soulages catalogue raisonné, as in note 7 above.

9. James Johnson Sweeney to Colette and Pierre Soulages, March 13, 1962, Records of the Office of the Director, James Johnson Sweeney, Correspondence, Museum of Fine Arts, Houston (hereafter MFAH Director Records).

10. Dorothy Rodgers to James Johnson Sweeney, March 17, 1966, in the exhibition file for "Pierre Soulages: Retrospective Exhibition" (April 20 to May 22, 1966), Archives, Museum of Fine Arts, Houston (hereafter MFAH Archives). The Premingers loaned the painting *August 13, 1959* to the Soulages retrospective.

11. Author's interview with Edward Mayo, June 5, 2002.

12. Ibid.

13. See Mies van der Rohe, "Museum," *Architectural Forum* 78 (May 1943): 84–85. Peter Blake adopted a version of Mies's design for his unbuilt project, "Museum for Jackson Pollock." In this imaginary museum, an open floor plan contained replicas of Pollock's unframed paintings, which, as Victoria Newhouse has noted, "would be set at right angles to mirrored wall segments that reflected them to infinity." Thus in both Mies's and Blake's museum designs, paintings largely served as walls in the otherwise open space of the galleries. See Victoria Newhouse, *Towards a New Museum* (New York: Monacelli Press, 2006), p. 131. I am grateful to Andrew McClellan for bringing these sources to my attention. A related installation technique—though one that created a markedly different effect—can be found in Frederick Kiesler's interior designs of the Surrealist Gallery and the Abstract Gallery at Peggy Guggenheim's Art of This Century museum-gallery, which opened in October of 1942. As Jennifer Blessing has noted: "Kiesler felt that walls were repressive; thus, the partitions of the Abstract Gallery, consisting of ultramarine stretched-canvas sheets battened down with cord, appeared to float since they did not meet either the floor or ceiling. Paintings, mounted on tripods, suspended by cord, seemed to hover in space, adding to the gallery's gravity-defying atmosphere. . . . Considered the most unconventional of the spaces, the Surrealist Gallery exhibited frameless paintings mounted on baseball bats—Kiesler likened them to outstretched arms—that protruded from the curving gumwood walls." Coupled with his intentionally disorienting systems for sound and lighting, Kiesler's installation methods creatively enhanced the destabilizing effects of the surrealist artworks displayed in the galleries. See Jennifer Blessing, "Peggy's Surreal Playground," in Thomas Krens, ed., *Art of This Century: The Guggenheim Museum and Its Collection* (New York: Solomon R. Guggenheim Foundation, 1993), p. 205. Regarding Kiesler's curatorial designs, see also Cynthia Goodman, "Frederick Kiesler: Designs for Peggy Guggenheim's Art of This Century Gallery," *Arts Magazine* 51 (June 1977): 90–95; and Edgar Kaufmann, Jr., "The Violent Art of Hanging Pictures," *Magazine of Art* 39 (March 1946): 108–113. Finally, it should be noted that Soulages's dealer, Samuel Kootz, suspended two of the artist's paintings back to back in his New York City apartment. On this subject see Encrevé, *Soulages: L'oeuvre complète,* vol. 2, p. 122.

14. Regarding Deer's suggestions concerning installation designs in Cullinan Hall, see the interviews conducted by Toni Ramona Beauchamp in "James Johnson Sweeney and the Museum of Fine Arts,

Houston, 1961–67," M.A. thesis, University of Texas, Austin, 1983, pp. 92, 130, esp. nn. 15, 16. For a brief comparative discussion of the installation strategies that Sweeney and the curator Jermayne MacAgy adopted for Cullinan Hall, see Lynne M. Herbert, "Seeing Was Believing: Installations of Jermayne MacAgy and James Johnson Sweeney," *Cite* 40 (Winter 1997–1998): 31–34.

15. Author's interview with Richard Stout, April 8, 2008.

16. For Sweeney's comments on the challenges and opportunities of staging curatorial installations in Cullinan Hall, see James Johnson Sweeney, "Le Cullinan Hall de Mies van der Rohe, Houston," *L'Oeil* 99 (March 1963): 38–43, 82.

17. While the Soulages retrospective was held during the spring of 1966, Sweeney's first sustained textual account of the artist did not appear until the following year, in a catalogue that accompanied an exhibition of the California abstract painter Sam Francis that Sweeney curated at the MFAH from October 12 to December 3, 1967. According to the exhibition files in the MFAH Archives, a Soulages catalogue was planned but never published. Significantly, the archives contain no research file, notes, or preliminary manuscript for the Soulages catalogue, yet they do contain the printer's bills for the production of both the color plates and black and white illustrations that were to have accompanied the catalogue.

18. James Johnson Sweeney, *Sam Francis* (Houston: Museum of Fine Arts, 1967), p. 15.

19. Sweeney, *Soulages: Paintings since 1963*, p. 8.

20. Soulages, quoted in Bernard Ceysson, "Interview with Pierre Soulages," in *Soulages* (New York: Crown, 1979), p. 57. For a commentary on the relations the artist perceives between his place of origin and his paintings, see "Entretien public de Pierre Soulages," in *Une oeuvre de Pierre Soulages* (Marseille: Éditions Muntaner, 1998), p. 51.

21. James Johnson Sweeney, *Soulages: Paintings since 1963*, p. 10. Encrevé maintains that this story, frequently repeated after the publication of Sweeney's early text, represents an overly simplified image of the artist's background. Thus Encrevé presents an alternative account of the origins of Soulages's painting career, one that pointedly challenges notions of Celtic fatalism or predestination. (See Encrevé, *Soulages: L'oeuvre complète*, vol. 1, pp. 15–17.) However, it should be noted that an emphasis on the early, formative influence of local Celtic and Romanesque monuments had represented a leitmotif in the construction of the artist's public identity from at least the mid-fifties; hence, versions of these ideas predated the publication of Sweeney's texts. See for example "Knockout Blow," *Time* 70 (December 2, 1957): 60; and Hubert Juin, *Soulages* (Paris: Georges Fall, 1959). Thus while Sweeney is clearly constructing a poetically inflected account of Soulages's career, it should be noted that Soulages himself directly participated in crafting this aspect of his public persona. Sweeney also acknowledged instances where Soulages's interpretations differed from his own.

22. Regarding the sacred aspects of phallic stone menhirs, see Carola Giedion-Welcker, "Prehistoric Stones," trans. Eugene Jolas, *Transition* 27 (April-May 1938): 335–343. Sweeney would have been familiar with this essay, as he served as associate editor of the journal at the time of the article's publication.

23. In part, Sweeney explained these motifs by oriental cross-influences that entered Ireland through commercial trade routes and the intellectual exchanges that characterized Irish monastic

traditions. See James Johnson Sweeney, "L'art chrétien primitif en Irlande," *Cahiers d'Art* 6–7 (1932): 243–248.

24. Alexander Calder and James Johnson Sweeney, *Three Young Rats and Other Rhymes* (1944; New York: Museum of Modern Art, 1946), pp. viii–ix, 98–100. Sweeney's knowledge of foundation sacrifices, magic, and primitivism was indebted to the Oxford anthropologist Edward B. Tylor's study *Primitive Culture: Researches in the Development of Mythology, Philosophy, Religion, Language, Art, and Custom* (1871; London: John Murray, 1913), esp. pp. 104–108; and the Cambridge anthropologist Alfred C. Haddon's discussion of "London Bridge: Foundation Sacrifice" in *The Study of Man* (London: Bliss, Sands, & Co., 1898), ch. 12.

25. See my essay "Seeing the Unseen: James Johnson Sweeney and the de Menils," in Marcia Brennan et al., *A Modern Patronage: De Menil Gifts to American and European Museums* (Houston: Menil Collection; New Haven: Yale University Press, 2007), pp. 21–39.

26. Regarding the work in Soulages's collection, see *Arts primitifs dans les ateliers d'artistes* (Paris: Musée de l'Homme, 1967), cat. no. 34.

27. For a discussion of the ways in which the subjective connotations of darkness and light are negotiated in Soulages's abstract paintings, particularly in relation to the negation of the decorative as an affirmation of the radical difference of identity, see Donald B. Kuspit, "Negatively Sublime Identity: Pierre Soulages's Abstract Paintings" (1996), in his *The Rebirth of Painting in the Late Twentieth Century* (New York: Cambridge University Press, 2000), pp. 80–90.

28. James Johnson Sweeney to Pierre and Colette Soulages, December 15, 1967, in the MFAH Director Records.

29. Sweeney, *Soulages* (1972), p. 25.

30. I am grateful to James Clifton for bringing this expressive quality to my attention.

31. Sweeney, "Le Cullinan Hall," p. 82.

32. Ann Holmes, "Soulages Retrospective: An Emergence of Style," *Houston Chronicle* (April 24, 1966): 25.

33. Freed, "Art: Soulages in Perspective," p. 31. Pierre Encrevé has further observed that the artist was so impressed with the freedom and flexibility afforded by this hanging arrangement that it was often repeated in other museums. See Encrevé, *Soulages: L'oeuvre complète*, vol. 2, pp. 121–122.

34. Author's correspondence with Dr. Natalie Adamson of the University of St. Andrews, June 16, 2006, based on comments made during Adamson's visit with Pierre and Colette Soulages in May of 2006. Adamson has further noted that "the question of a 'religious' aura within the museum, promoted by the mode of display, did not disturb [Soulages]," and that the artist himself was "certainly very close to Sweeney."

35. Sweeney, *Soulages* (1972), p. 23. The original context of this statement is a television interview that the artist gave in 1961. For a fuller elaboration of the interview, see Henri Meschonnic with Pierre Soulages, *Le rythme et la lumière* (Paris: Éditions Odile Jacob, 2000), p. 57. Regarding the conjoined associations of temporality and sacrality in Soulages's paintings, see Bernard Dorival, *Soulages* (Paris: Musée National d'Art Moderne, 1967). And for a discussion of time and presence

in Soulages's oeuvre, see Jean-Michel Le Lannou, *Soulages, la plénitude du visible* (Paris: Éditions Kimé, 2001), ch. 3.

36. Ivan Gaskell, "Sacred to Profane and Back Again," in Andrew McClellan, ed., *Art and Its Publics: Museum Studies at the Millennium* (Malden, MA: Blackwell, 2003), p. 149. I am grateful to Jeffrey Abt for bringing this essay to my attention.

37. Ivan Gaskell, "Secularization and Consecration: Museum, Artifacts, and the Transformation through Use," a response paper delivered at the conference session "Temples of Art? Museums and Religious Objects," College Art Association, February 24, 2006, as subsequently quoted in my essay "Illuminating the Void, Displaying the Vision: On the Romanesque Church, the Modern Museum, and Pierre Soulages's Abstract Art," *Res* 52 (Autumn 2007): 126.

38. James Johnson Sweeney, *Vision and Image: A Way of Seeing* (New York: Simon and Schuster, 1967), p. 33.

6 Studies in Self-Creation and Creative Destruction: Jean Tinguely

1. In the transaction with the Iolas Gallery, John and Dominique de Menil provided funds for the purchase of nine Tinguely sculptures, and they donated a tenth work, *Méta-matic no. 9 (Scorpion)* (1959), to the MFAH collection. Alexander Iolas included Tinguely's *Radio Drawing* (1963) as a gift to the museum, and it was agreed that Tinguely would later donate an additional piece. In 1968 the museum acquired Tinguely's mixed-media sculpture *La bascule VII* (1967) from the artist. Sweeney publicly acknowledged these gifts in the exhibition catalogue *Jean Tinguely: Sculptures* (Houston: Museum of Fine Arts, Houston, 1965), n.p.

2. Author's interview with Ann Holmes, June 22, 2002. Sharing his memories of this event, William Camfield recalled the vivid contrast between Niki de Saint Phalle's appearance and Tinguely's: while Saint Phalle looked beautiful and rather delicate, Tinguely was conspicuously shaggy and constantly sported a five o'clock shadow. Author's conversation with William Camfield, January 21, 2005.

3. This phrase can be found in the brief essay that K. G. Pontus Hultén wrote to accompany the Tinguely exhibition at the Alexander Iolas Gallery, Paris. (Hultén's name is given inconsistently in the primary sources; for the purposes of this study, he will be referred to as K. G. Pontus Hultén.) See K. G. Pontus Hultén, "Tinguely," in *Méta* (Paris: Alexander Iolas Gallery, December 10, 1964 to January 9, 1965), n.p. In invoking this phrase, Hultén was paraphrasing Apollinaire's 1913 commentary on Marcel Duchamp. His comments would also have been resonant with contemporary discourses that associated energy with the machine age. On this, see Bruce Clarke and Linda Dalrymple Henderson's introduction to *From Energy to Information: Representation in Science and Technology, Art and Literature* (Stanford: Stanford University Press, 2002), pp. 1–15.

4. Regarding the leitmotifs of self-creation and self-destruction in Tinguely's work, see also Pontus Hultén's discussion of Tinguely in *The Machine as Seen at the End of the Mechanical Age* (New York: Museum of Modern Art, 1968), esp. p. 166.

5. Calvin Tomkins noted Sylvester's characterization of this event in his lengthy article on Tinguely, "Profiles: Beyond the Machine," *New Yorker* 37 (February 10, 1962): 82. During the early sixties,

other critics also evoked Duchamp and Dada in their discussions of Tinguely's works; see John Canaday, "Art and Destruction: Thoughts Following a Suicide in a Garden," in his *Embattled Critic: Views on Modern Art* (New York: Farrar, Straus and Cudahy, 1962), pp. 80–86; Thomas B. Hess, "Jean Tinguely," *Artnews* 59 (April 1960): 16, 54; Barbara Butler, "Monet and Others," *Art International* 4 (May 1960): 69; Jules Langsner, "Art News from Los Angeles," *Artnews* 61 (May 1962): 46; Gerald Nordland, "Neo-Dada Goes West," *Arts Magazine* 36 (May–June 1962): 102; and "Styles: The Movement Movement," *Time* (January 28, 1966): 64. For a discussion of the use of the terms "Dada" and "neo-Dada" and the name of Duchamp as value-laden signifiers within the critical reception of Tinguely's works, see Stephanie Jennings Hanor, "Jean Tinguely: Useless Machines and Mechanical Performers, 1955–1970," Ph.D. thesis, University of Texas, Austin, 2003, ch. 3.

6. Niki de Saint Phalle, "A Little of My Story with You Jean," in *Museum Jean Tinguely Basel: The Collection* (Basel: Museum Jean Tinguely, 1996), p. 18.

7. Tomkins, "Profiles: Beyond the Machine," pp. 44, 46.

8. Eugénie de Keyser, "Sculpteurs de l'éphémère," *Revue Belge d'Archéologie et d'Histoire de l'Art* 65 (1996): 256.

9. Alfred H. Barr, Jr., "Statement," in *Homage to New York: A Self-Constructing and Self-Destroying Work of Art Conceived and Built by Jean Tinguely* (New York: Museum of Modern Art, 1960), quoted in Irving Sandler, introduction to *Defining Modern Art: Selected Writings of Alfred H. Barr, Jr.*, ed. Irving Sandler and Amy Newman (New York: Harry N. Abrams, 1986), pp. 25–26.

10. Regarding the *deus ex machina*, see *The Oxford English Dictionary*, 2nd ed. (Oxford: Clarendon Press, 1989); and William Rose Benét, *The Reader's Encyclopedia* (New York: Crowell, 1965), p. 266.

11. I am indebted to my classicist colleagues Caroline Quenemoen and Scott McGill, who generously translated this phrase and provided important philological and historical insight into its original context and meaning.

12. Along these lines, J. W. (Billy) Klüver, a research scientist and acquaintance of Tinguely's who assisted the artist with the assembly of *Homage to New York*, noted that Tinguely's art "creates a direct connection between the creative act of the artist and the receptive act of the audience, between the construction and the destruction. It forces us out of the inherited image and into contact with the ever-changing reality." Similarly, when commenting on the impact of Tinguely's sculpture, Pontus Hultén observed: "The work of art creates its own life with the aid of the spectator and becomes either a creator or a destroyer. It is for this reason, among so many others, that Tinguely has made his painting and drawing machine and his self-destroying sculpture." See J. W. Klüver, "The Garden Party," in *Zero* (Cambridge, MA: MIT Press, 1973), p. 124; and Hultén, "Tinguely," n.p.

13. At the same time, some reviewers took issue with the fashionableness of Tinguely's neo-Dada performance. In particular, the critic for the *Nation* lamented: "This is what protest has fallen to in our day–a garden party. Can any champion of irreverence think of a gesture M. Tinguely might make that would turn Mr. Barr gray with rage and send the museum's benefactors twittering in consternation back to their penthouses?" See "Tinguely's Contraption," *Nation* 190 (March 26, 1960): 267.

14. John de Menil to Edward Rotan, February 22, 1965, Records of the Office of the Director, James Johnson Sweeney, Correspondence, Museum of Fine Arts, Houston (hereafter MFAH Director Records).

15. The Iolas Gallery exhibition in Paris featured a decade of the artist's work. An expanded version of this show, "'Méta II,'" opened the following March at Iolas's New York gallery. The latter exhibition represented a collaborative venture between the Alexander Iolas Gallery of New York and the Dwan Gallery of Los Angeles. For a checklist of the exhibited works, see K. G. Pontus Hultén, *Jean Tinguely: A Magic Stronger Than Death* (New York: Abbeville, 1987), p. 357.

16. Sweeney, quoted in Campbell Geeslin, "Museum Buys 12 Sculptures by Swiss Artist," *Houston Post* (February 25, 1965): sec. 5, 19.

17. John de Menil to James Johnson Sweeney, December 20, 1964, MFAH Director Records.

18. This document can be found in the exhibition file for "Jean Tinguely: Sculptures" (April 3 to May 30, 1965), Archives, Museum of Fine Arts, Houston (hereafter MFAH Archives). According to the *Museum of Fine Arts, Houston Visitor Guide*, the de Menils sent Sweeney a telegram instructing him to "Buy the show!" See Janet Landay, *The Museum of Fine Arts, Houston Visitor Guide* (Houston: Museum of Fine Arts, 2000), p. 342. However, it should be noted that the files in the museum archive do not contain a copy of this telegram.

19. Western Union telegram from James Johnson Sweeney to John and Dominique de Menil, Houston, January 7, 1965, in the exhibition file for "Jean Tinguely: Sculptures" (April 3 to May 30, 1965), MFAH Archives.

20. In a letter of January 14, 1965, Bénédicte Pesle confirmed to John and Dominique de Menil that it was her suggestion to Sweeney that "the show should be bought at once as an ensemble." I am grateful to William Middleton for confirming the family relationship between Pesle and de Menil (based on a telephone interview that Middleton conducted with Pesle on March 29, 2004). Author's correspondence with William Middleton, January 24, 2005.

21. James Johnson Sweeney to Alexander Iolas, January 30, 1965, in the exhibition file for "Jean Tinguely: Sculptures" (April 3 to May 30, 1965), MFAH Archives.

22. See the correspondence that Alexander Iolas and James Johnson Sweeney exchanged on February 12, 17 and 22, 1965, in the exhibition file for "Jean Tinguely: Sculptures" (April 3 to May 30, 1965), MFAH Archives.

23. See the Western Union telegram that Jean Tinguely sent to James Johnson Sweeney from Paris, dated February 1965, in the exhibition file for "Jean Tinguely: Sculptures" (April 3 to May 30, 1965), MFAH Archives.

24. James Johnson Sweeney to Jean Tinguely, March 4, 1965, in the exhibition file for "Jean Tinguely: Sculptures" (April 3 to May 30, 1965), MFAH Archives.

25. "Investment," *New York Times* (March 7, 1965): sec. 2, 19.

26. James Johnson Sweeney, "Jean Tinguely," in *Jean Tinguely: Sculptures*, n.p.

27. Ibid.

28. Portions of Sweeney's analysis are informed by Pontus Hultén's account of Tinguely's sculpture, which was published in the catalogue that accompanied the Paris exhibition at the Iolas Gallery. In particular, Hultén observed that Tinguely's sculptures simultaneously incorporated the contradictory elements of repetitive certainty and "mechanical waywardness," precision and haphazardness, continuousness and transformation, stability and ephemerality, pessimism and hilarity, the

beautiful and the frightening. Hultén further attributed a sublimated sexual dimension to Tinguely's machines: "Their wires seem to pulsate with wantonness and succeed in communicating their sensuality to the beholder." In the Houston exhibition catalogue essay, Sweeney directly quoted Hultén's insight that a piece of scrap metal "has its own shape," and he paraphrased Hultén's observation that Tinguely has rediscovered key relationships in his exploration of movement. The original copy of the Iolas Gallery exhibition catalogue, containing Hultén's essay with annotations marked in Sweeney's hand, can be found in the exhibition file for "Jean Tinguely: Sculptures" (April 3 to May 30, 1965), MFAH Archives.

Hultén recapitulated many of these themes the following year in the essay that he wrote for the exhibition catalogue *2 Kinetic Sculptors: Nicolas Schöffer and Jean Tinguely* (New York: Jewish Museum, 1965), pp. 12–15. Among the ideas expressed in this latter piece is the notion that Tinguely's sculptures incorporate the contradictory energies of optimism and pessimism, permanence and transformation, and that these works exemplify the "irrational and religious potential" of the machine. Notably, the Jewish Museum exhibition contained three works from the MFAH collection, including *Prayer Wheel, Polychrome Relief,* and *M.K. III.* For a suggestive account of Tinguely's sculpture, see Sam Hunter's essay, "Two Kinetic Sculptors," in the same catalogue. For a particularly critical review of Tinguely's contribution to this exhibition, see Hilton Kramer, "One Inventor, One Pasticheur," *New York Times* (November 28, 1965): 15x. In this piece Kramer dismissed Tinguely's art as "the expression of a minor pasticheur rummaging around the debris of fashionable ideas."

29. Sweeney, "Jean Tinguely," n.p. The artist's own statements shed further light on the considerable extent to which contradictory structures informed his thinking during this period. In one of his most famous pronouncements, Tinguely wrote: "Let us contradict ourselves because we change. Let us be good and evil, true and false, beautiful and loathsome. We are all of these anyway. Let us admit it by accepting movement. Let us be static! Be static!" Tinguely's statement is reproduced in *Zero*, p. 119.

30. Sweeney, "Jean Tinguely," n.p.

31. As Daniel Soutif has aptly observed, in works such as *Prayer Wheel*, the mechanical sculpture's turning wheels engender a type of movement that results in the production of virtual volumes that become dematerialized just as they are produced. See Daniel Soutif, "Tinguely Ltd. ou le crépuscule des machines," *Artstudio* 22 (1991): 63–65.

32. Alain Jouffroy's interview with Tinguely in *L'Oeil* (1966) is reprinted in "Aus einem Interview mit Alain Jouffroy," in *Tinguely* (Basel: Kunsthalle, 1972), n.p. Heidi Violand-Hobi has remarked that *Eos* and *M.K. III* "mimic intimate human activities. In their endlessly repeated to and fro of a bent form poking against a more contained body of wheels, the viewer witnesses a bedroom drama that proceeds in virtual silence." See Heidi E. Violand-Hobi, *Jean Tinguely: Life and Work* (Munich: Prestel, 1995), p. 60; and Hultén, *A Magic Stronger Than Death*, p. 138.

33. In another contemporary interview, Tinguely again invoked the myth of Sisyphus to describe the "coming and going" movements of his machines. See Laura Mathews, "The Designs for Motion of Jean Tinguely: A Portfolio and an Interview," *Paris Review* 34 (Spring/Summer 1965): 84.

34. Regarding the title of this work, see Christina Bischofberger, *Jean Tinguely: Catalogue Raisonné: Sculptures and Reliefs, 1954–1968* (Zurich: Galerie Bruno Bischofberger, 1982), vol. 1, p. 237, no. 348.

35. Tinguely later discussed his interest in Duchamp with Dieter Daniels; see Daniels, "Often Neglected– but One of the Greats: Interview with Jean Tinguely by Dieter Daniels, Cologne, 12 January 1987," in *Marcel Duchamp* (Ostfildern-Ruit: Hatje Cantz Verlag, 2002), pp. 155–167. This volume contains many important discussions of various facets of the two artists' relationship. For further discussions of Tinguely's relationship with Duchamp and the various references to Duchamp in his works, see Hultén, *A Magic Stronger Than Death*; and Bischofberger, *Jean Tinguely: Catalogue Raisonné*.

36. Sweeney, "Jean Tinguely," n.p.

37. Regarding Tinguely's *Méta-Matic* devices, see Pamela M. Lee, *Chronophobia: On Time in the Art of the 1960s* (Cambridge, MA: MIT Press, 2004), pp. 111–116; Hultén's volumes *The Machine as Seen at the End of the Mechanical Age*, pp. 166–167, and *A Magic Stronger Than Death*, pp. 55–63; and Hanor, "Useless Machines," ch. 2.

38. In automatic drawing, the surrealist artists allowed their hands to travel freely over a sheet of paper so that images could emerge from the subconscious. Furthermore, according to Niki de Saint Phalle, Tinguely's drawing machines "enchanted Duchamp" even as they "angered the Abstract Expressionists." See Saint Phalle, "A Little of My Story," p. 18.

39. As quoted in Mathews, "The Designs for Motion," p. 85.

40. On these themes, see Walter Benjamin's classic essay "The Work of Art in the Age of Mechanical Reproduction" (1936), reprinted in Charles Harrison and Paul Wood, eds., *Art in Theory, 1900–1990: An Anthology of Changing Ideas* (Malden, MA: Blackwell, 1992), pp. 512–520.

41. Violand-Hobi, *Jean Tinguely*, p. 51. Regarding this series, see also *Museum Jean Tinguely Basel*, p. 49; and Hultén, *A Magic Stronger Than Death*, pp. 72–73.

42. Franz Meyer, introduction to Bischofberger, *Jean Tinguely: Catalogue Raisonné*, vol. 1, p. 9.

43. Ann Holmes, "Art Circles: Wild Spasms, Rituals of Tinguely's Sculptures," *Houston Chronicle* (April 4, 1965): 25. Notably, later that year Sam Hunter admired the "animal energy and vitalism" of Tinguely's works, while Pontus Hultén praised the uninhibited and even amoral quality of Tinguely's "ecstatic" animated sculptures. See Hultén, "Tinguely"; and Hunter, "Two Kinetic Sculptors," pp. 9, 15.

44. For an excellent overview of the prevalence of these themes in the early twentieth century, including the analogical associations of Duchamp's imagery with machine forms and scientific equipment and related discourses that characterized the human body in mechanistic, chemical, and electrical terms, see Linda Dalrymple Henderson's study *Duchamp in Context: Science and Technology in the Large Glass and Related Works* (Princeton: Princeton University Press, 1998), esp. pp. 33–37.

45. Tinguely, telegram to Sweeney, February 1965, in the exhibition file for "Jean Tinguely: Sculptures" (April 3 to May 30, 1965), MFAH Archives.

46. Mathews, "The Designs for Motion," p. 83. For a suggestive discussion of the carnivalesque theatricality of Tinguely's machines, particularly in their performances of the rituals of life and death, see Daniel Soutif, "La parade et le carnaval: Vie et mort des machines selon Rebecca Horn et Jean Tinguely," *Cahiers du Musée National d'Art Moderne* 60 (Summer 1997): 96–111.

47. Along these lines, Lucy Lippard noted the anthropomorphic qualities of Tinguely's recent sculptures in her "New York Letter" in *Art International* 9 (May 1965): 58.

48. "Two Motion Sculptors: Tinguely and Rickey," *Artforum* 1 (June 1962): 18.

49. Hultén, "Tinguely," n.p.

50. Sweeney, "Jean Tinguely," n.p.

51. "Sculptures in Motion," *Life* 61 (August 12, 1966): 40–41, 44–45.

52. Frank Popper, *Origins and Development of Kinetic Art*, trans. Stephen Bann (Greenwich, CT: New York Graphic Society, 1968), p. 131.

53. James Johnson Sweeney, "Some Ideas on Exhibition Installation," *Curator* 2 (1959): 152.

54. Ann Holmes, "Art Circles: Wild Spasms," p. 25.

55. In this statement, Tinguely could well be paraphrasing the sculptor László Moholy-Nagy's influential conception of kinetic sculpture as an art form that is new yet classic. See Moholy-Nagy's statements in Carola Giedion-Welcker, *Contemporary Sculpture: An Evolution in Volume and Space* (New York: G. Wittenborn, 1955), p. xviii.

56. Campbell Geeslin, "Art from the Scrap Yard: Tinguely Mechanizes Museum," *Houston Post* (April 1, 1965): sec. 1, 1, 17.

57. Author's interview with David Warren, September 19, 2002.

58. Hultén, *The Machine as Seen at the End of the Mechanical Age*, pp. 6, 13.

59. The prefix "meta" signifies change, transformation, and transcendence, while "matic" derives from the Greek *matos*, "acting." Hultén has noted that, during the fifties, he suggested to Tinguely that his sculptures should be called "meta-mechanical," since this term held an "analogy with metaphysical." See Hultén, *A Magic Stronger Than Death*, p. 27. On this subject, see also the curator's commentary on Tinguely in *The Machine as Seen at the End of the Mechanical Age*, p. 165.

60. Ann Holmes, "Fine Arts: Museum: Vivid, Controversial," *Houston Chronicle* (July 11, 1965): 16. In this article, Holmes further noted that some museum visitors "flinch" at the prominent display of tribal and ethnographic works, while others accused Sweeney of relegating Old Master paintings to the museum basement and showing instead "all the kooks he could find."

61. Regarding these drawings, see James Johnson Sweeney's internal memo to Edward Mayo of September 14, 1965, in the exhibition file for "Jean Tinguely: Sculptures" (April 3 to May 30, 1965), MFAH Archives.

62. See Edward Mayo's correspondence with the museum's insurance agent W. B. Abbott of Langham, Langston, and Dyer, April 13, 1965. Regarding issues pertaining to the condition and conservation of the drawing, see Mayo's correspondence of April 1965. The insurance company covered the bill for the conservation of the drawing. For these documents, see the exhibition file for "Jean Tinguely: Sculptures" (April 3 to May 30, 1965), MFAH Archives.

63. See the correspondence exchanged between C. Gilbertson of the Alexander Iolas Gallery and James Johnson Sweeney, April 17 and April 24, 1965, in the exhibition file for "Jean Tinguely: Sculptures" (April 3 to May 30, 1965), MFAH Archives.

64. This cartoon is reproduced in "Art: The Movement Movement," *Time* 87 (January 28, 1966): 69.

7 "A Spark of Light Darting through Empty Space": Eduardo Chillida

1. Eduardo Chillida, "Notebook Pages," in *Chillida*, trans. Mary Ann Witt (Paris: Maeght, 1979), n.p.

2. James Johnson Sweeney, *Eduardo Chillida* (Houston: Museum of Fine Arts, 1966), n.p. Sweeney presented a version of this essay to the Houston Chapter of the American Institute of Architects; the text was later reprinted in *Texas Architect* 17 (February 1967): 8–12.

3. Sandra Wagner, "An Interview with Eduardo Chillida," *Sculpture* 16, no. 9 (1997): 25–26. Three decades earlier, Chillida had similarly remarked that "these two sets of space, one of which one might call negative/empty and the other positive/full, are closely correlated and I would even say they converse." Chillida, quoted in Carola Giedion-Welcker, "Sculptures, Drawings, Graphic Work" (1969), in Kosme de Barañano et al., *Eduardo Chillida: Elogio del hierro / Praise of Iron* (Valencia: Institut Valencià d'Art Modern, 2002), p. 203.

4. Chillida, quoted in Pierre Volboudt, *Chillida*, trans. Vivienne Menkès (New York: Harry N. Abrams, 1967), pp. 8, 11. Reviewing Chillida and Richard Serra's 1999 exhibition at the Guggenheim Museum in Bilbao, Alan Powers similarly noted that Chillida "is overtly mystical in some of his utterances (but never pretentious)." See Alan Powers, "Sculptural Synergy," *Architects' Journal* 210 (July 15, 1999): 47.

5. Jose Tasende of the Tasende Gallery, La Jolla, in conversation with the author, June 13, 2007. For a critical account that situates the reception of Chillida's artwork in relation to three of his Basque colleagues–the sculptors Jorge de Oteiza, Agustín Ibarrola, and Néstor Basterretxea–while locating the artists within a contextualized account of contemporary political history, see Kim Bradley, "Basque Modern," *Art in America* 86 (June 1998): 88–97, 121.

6. Peter Selz, ed., "The Eduardo Chillida Symposium," *Arts Magazine* 61 (January 1987): 18.

7. In addition to *Desde dentro*, Sweeney exhibited Chillida's forged iron sculptures *Tremblement de fer, no. 2* and *From the Horizon*, as well as an unnamed selection of drawings. See James Johnson Sweeney, *Sculptures and Drawings from Seven Sculptors* (New York: Solomon R. Guggenheim Museum, 1958), n.p.

8. Peter Selz, *Chillida* (New York: Harry N. Abrams, 1986), p. 27.

9. Sweeney mentions the artist's visit, including attending a dinner with the Chillidas, in a letter to Joan Miró dated October 20, 1958, in the James Johnson Sweeney Administrative Papers, The Solomon R. Guggenheim Museum Archives.

10. Galerie Maeght to James Johnson Sweeney, 1959, in the James Johnson Sweeney Administrative Papers, The Solomon R. Guggenheim Museum Archives. This sculpture, which was subsequently featured in the Galerie Maeght's 1961 exhibition, is now in the collection of Ida Chagall, Paris.

11. James Johnson Sweeney, *Three Spaniards: Picasso, Miró, Chillida* (Houston: Museum of Fine Arts, Houston, 1962), n.p.

12. Author's interview with Edward Mayo, Houston, Texas, June 5, 2002.

13. Sweeney, *Three Spaniards*, n.p.

14. Author's interview with Edward Mayo, Houston, Texas, June 5, 2002.

15. As Campbell Geeslin noted, Sweeney "built a 20-foot-long pool outside the museum's entrance to display Picasso's six bronze Bathers. Inside he hung three enormous Miró paintings (the blue series)

and one large Picasso painting. A ton-and-a-half oak construction made by Chillida, called *Abestu gogora*, was included in the exhibit and purchased for the permanent collection while on view." See Campbell Geeslin, "Sweeney in Houston," *Art in America* 50, no. 3 (1962): 131.

16. See James Johnson Sweeney, "Postscript: The Wind Combs–An Explication," in Selz, *Chillida*, pp. 119–122; Selz's dedication to Sweeney appears on p. 4.

17. A checklist of exhibited works appears at the end, followed by a supplementary selection of photographs.

18. See the entries on "concordance" and "concord" in *Webster's Seventh New Collegiate Dictionary* (Springfield, MA: Merriam, 1969), p. 172.

19. Chillida's statement is quoted in Dave Hickey, "Eduardo Chillida's Lost Generation," in *Chillida* (Los Angeles: Tasende Gallery, 1997), p. 8. I am grateful to Jose Tasende for providing me with a copy of this catalogue.

20. Chillida, quoted in Sabine Maria Schmidt, "Borderlines: Eloquent Silence in Fulfilled Emptiness," in Hatje Cantz, ed., *Art Projects/Synagoge Stommeln, Kunstprojekte* (New York: Distributed Art Publishers, 2000), p. 96.

21. See the entries on "lace" and "delight" in *Webster's Seventh New Collegiate Dictionary*, pp. 471, 218.

22. James Johnson Sweeney, "Eduardo Chillida," *Derrière le Miroir* 124 (Paris: Maeght, March 1961), p. 7.

23. Chillida, quoted in Volboudt, *Chillida*, p. 8.

24. Eduardo Chillida, "L'espace, la limite," *Derrière le Miroir* 183 (Paris: Maeght, February 1970), p. 16. Notably, in the April 1964 edition of *Derrière le Miroir*, Carola Giedion-Welcker characterized Chillida's words as a "mystical evocation of the secret regions of [the artwork's] origin." See Carola Giedion-Welcker, "The Poetry of Space in Eduardo Chillida," *Derrière le Miroir* 143 (Paris: Maeght, April 1964), reprinted in Barañano et al., *Eduardo Chillida*, p. 183.

25. Eduardo Chillida, letter to Peter Selz, October 1984, quoted in Selz, *Chillida*, p. 6.

26. Chillida, quoted in Volboudt, *Chillida*, p. 10.

27. Chillida, "L'espace, la limite," p. 19.

28. Chillida, in *Chillida* (1979), n.p.

29. Chillida, in Selz, "The Eduardo Chillida Symposium," p. 20.

30. Chillida, quoted in Nicholas Shrady, "Affirmations in Iron and Steel," *Architectural Digest* 45 (January 1988): 58.

31. Chillida, quoted in ibid., p. 59.

32. Suzanne Muchnic, "Asking Questions in Steel and Stone," *Artnews* 96 (October 1997): 150–152.

33. Eduardo Chillida, "Reflections on the Theme of This Symposium," in Joseph J. Schildkraut and Aurora Otero, eds., *Depression and the Spiritual in Modern Art* (New York: John Wiley and Sons, 1996), p. 108.

34. Volboudt, *Chillida*, p. 6.

35. For a related discussion of the integration of Chillida's artworks into sacred sites–including the four iron doors made for the Franciscan basilica of Santa María de Aránzazu in Guipúzcoa, Spain (1954), and for the synagogue in Stommeln, Germany (1995)–see Giovanni Carandente, *Eduardo Chillida:*

Open-Air Sculptures, trans. Richard Rees (New York: Distributed Art Publishers, 2003), esp. pp. 84–87; and Schmidt, "Borderlines," pp. 93–103. For a fascinating discussion of the shifting status of Chillida's altar at the parish church of St. Peter in Cologne, Germany as a once-consecrated and subsequently desacralized site, see Guido Schlimbach, "Der Kreuzaltar von Eduardo Chillida in Köln," *Das Munster* 57 (2004): 96–108.

36. Chillida, quoted in Volboudt, *Chillida,* p. 8.

37. On these themes, José Ángel Valente has written: "Here we might mention that it is especially that 'interstitial void' (which Lilian Siburn speaks of as regards the void, the nothing, the abyss) which is the non-place where mystical tradition situates God. In that tradition, the opposites, which complement each other, are used for denoting unity, the original unity, Master Eckhart's 'simple unity.' I believe that those processes of spiritual development are not alien to the artistic progression in the Basque sculptor's work." See José Ángel Valente, "Chillida or Transparency," in *Chillida 1948–1998* (Bilbao: Museo Guggenheim Bilbao, 1999), p. 108.

38. Notably, when *Lugar de silencios* was exhibited in the "New Spanish Painting and Sculpture" show at the Museum of Modern Art (1960), Frank O'Hara characterized it as one of Chillida's "singular and highly metaphysical expressions." See Frank O'Hara, *New Spanish Painting and Sculpture* (New York: Museum of Modern Art, 1960), p. 10.

39. In 1967 Pierre Volboudt linked "the two worlds of music and silence" in Chillida's sculptures to the mysticism of St. John of the Cross: "At the very heart of the material, weighed down as it is by shapes and forms, the space foils all attempts to penetrate it; instead, it is the space which penetrates the material. This inner sanctuary of radiant emptiness which constitutes the hidden soul of the work can only be reached by a dark fissure. The negative form is immured in a shell formed by the volumes, and no longer vibrates in the midst of the tensions to which it is exposed. It is sealed among the haunts of a labyrinth which is filled with its noiseless language. The positive elements are illuminated from within by this darkness, by this prison which is both finite and infinite. So, too, the spirit creates with itself the void from which its visions emanate. We might draw an analogy between the secret confines of the soul, which has renounced all external images, between what St. John of the Cross calls the 'mighty emptiness of the powers of the soul as its fullness overflows,' and the withdrawal of the form in favour of the immanence which is its true goal." (Volboudt, *Chillida,* p. xvii.)

40. Sweeney, "Eduardo Chillida," pp. 3, 6.

41. Ibid., p. 6.

42. Chillida, quoted in Volboudt, *Chillida,* pp. 7–8.

43. Ibid., p. 23.

44. Ibid., p. 8.

45. On these themes, see José Corredor-Matheos, "Spirituality in the Work of Eduardo Chillida," in Schildkraut and Otero, *Depression and the Spiritual in Modern Art,* p. 98.

46. Volboudt, *Chillida,* p. vii.

47. While this sculpture was not included in the 1966 Chillida retrospective, Sweeney exhibited four other examples of the *Anvils of Dreams* series at the MFAH, including numbers 7, 8, 11, and 13.

48. John Ashbery, "Paris Notes," *Art International* 5 (May 1961): 63. Notably, Chillida constructed a series of sculptures entitled *Spirit of the Birds I* (1952) and *Spirit of the Birds II* (1955) that explore similar spatial relations through the counterpoised intersections of wrought-iron forms.

49. Gaston Bachelard, "The Cosmos of Iron," *Derrière le Miroir* 90–91 (Paris: Maeght, October-November 1956), reprinted Barañano et al., *Eduardo Chillida*, p. 163. For Bachelard's extensive contemporary theorization of fire and the blacksmith's art, see his study *The Flame of a Candle*, trans. Joni Caldwell (1961; Dallas: Dallas Institute Publications, 1988). I am grateful to Roger Conover for bringing this source to my attention.

50. Bachelard, "The Cosmos of Iron," p. 132.

51. Sweeney, "Eduardo Chillida," p. 1.

52. Ibid., p. 6.

53. As the poet Octavio Paz wrote of the *Anvil of Dreams* series, "They are called *anvils* but, though made of iron, they dissolve like dreams: they are pure space, bodiless and nameless." See Octavio Paz, "Chillida: From Iron to Light," in *Chillida* (1979), n.p.

54. As Pierre Volboudt noted in 1967, in the *Anvil of Dreams* series "the volumes become enmeshed with the void once more; it surrounds it by tracing a rising spiral in the air and is itself enveloped by the circular movement; it seems to have hardened into a permanently rotating movement. The individual segments are grooved so that they can intersect and at the same time dissect space. The anatomy of these explosive rhythms makes us think of the schematic statements of some cosmic mechanism or of the individual components of a primeval and half-broken machinery." See Volboudt, *Chillida*, p. xv.

55. Sweeney, "Eduardo Chillida," pp. 1, 9.

56. Sweeney explained these meanings in a letter to S. Lane Faison, Jr. See James Johnson Sweeney to S. Lane Faison, Jr., Records of the Office of the Director, James Johnson Sweeney, Correspondence, Museum of Fine Arts, Houston (hereafter MFAH Director Records).

57. See the entries for "abesti," "abestu," and "gogor" in Gorka Aulestia, *Basque-English Dictionary* (Reno: University of Nevada Press, 1989), pp. 3, 245.

58. Paz, "Chillida: From Iron to Light," n.p. As Paz wrote of the wooden *Abesti gogora* works: "the four sculptures are a song and this song is strong, harsh: a wind among trees. A hymn not of sounds and words but of forms and masses. The song is an edifice of air that rises from the earth on sonorous wings; Chillida's sculptures are beams coupled and assembled, compact constructions and sudden open spaces; immobilized music. Space, mute, sings a song that we hear with our eyes, not our ears."

59. Chillida, "L'espace, la limite," p. 18.

60. James Johnson Sweeney, "A City Monument," press release dated March 30, 1966, in the exhibition file for "Eduardo Chillida: Retrospective Exhibition" (October 5 to November 20, 1966), Archives, Museum of Fine Arts, Houston (hereafter MFAH Archives).

61. Chillida, "Notebook Pages," n.p.

62. Sweeney, *Eduardo Chillida*, p. 16.

63. Chillida, "Reflections on the Theme of This Symposium," p. 107.

64. Ashbery, "Paris Notes," pp. 63–64. On this work, see also Selz, *Chillida*, pp. 27–32.

65. Volboudt, *Chillida*, p. 12.

66. Chillida, quoted in Selz, "The Eduardo Chillida Symposium," p. 21.

67. In 1967 Chillida commented extensively on the unseen forces that guided his creations in the physical world. As he noted: "This force which I detect in wood and iron is merely the beat and rhythm of something which I feel to be immanent. Although I am the one who determines the outer form, I am simply obeying, in and through the form, that necessity which decrees the development of all living forms. When I begin I have no idea where I'm going. All I can see is a certain spatial constellation from which lines of strength gradually emerge. A direction makes itself felt; and sometimes it leads me where I have never penetrated before, compels me to take first one new direction, and then another–both equally unexpected. I always trust to instinct, the feeling for plastic which I feel within me. At first this feeling is barely perceptible, but as it grows clearer it becomes all the more compelling. I am pursuing a path; I perceive something that I call, for want of a more appropriate word, the 'emanation' of a form; I gradually absorb it and as it were inhale it." Chillida, quoted in Volboudt, *Chillida*, p. 11.

68. Chillida, "L'espace, la limite," p. 17. For a related critical discussion of the various spatial dynamics in Chillida's works, see Dina Sorenson, "Eduardo Chillida," *Arts Magazine* 64 (March 1990): 95.

69. Sweeney, "Eduardo Chillida," p. 9.

70. Chillida, "Reflections on the Theme of This Symposium," p. 104.

71. Chillida, quoted in Heinrich Wiegand Petzet, *Encounters and Dialogues with Martin Heidegger, 1929–1976*, trans. Parvis Emad and Kenneth Maly (1983; Chicago: University of Chicago Press, 1993), p. 156. In this text Petzet claims to have met Chillida at the artist's "grand exhibition in Zurich" during the spring of 1962. However, in 1962 Arnold Rüdlinger organized two concurrent one-man exhibitions, for Eduardo Chillida and Mark Rothko, at the Kunsthalle Basel.

72. For a contemporary commentary on the project, see Erhart Kästner, *Martin Heidegger/Eduardo Chillida: Die Kunst und der Raum* (St. Gallen: Erker Verlag, 1970). For a reproduction of Heidegger's handwritten text, with a selection of accompanying illustrations, see Martin Heidegger and Eduardo Chillida, *Die Kunst und der Raum* (Munich: F. Bruckmann, 1984). My comments on the history of this collaborative project are based in part on information presented in this volume, and on the commentaries of Kästner, Petzet, and Barañano. In the introduction to his translation of "Die Kunst und der Raum," Barañano has fleshed out the publication history of the text. He notes that the initial luxury printing was made on velin de rives, and included a recorded disk of Heidegger reading the text. As Barañano has observed, "A few weeks later the same publishers produced a plain edition, without Chillida's lithographs, and with a translation in French by Jean Beaufret and François Fédier. In October 1972 the magazine *Die Kunst und das schöne Heim* (vol. 10) reproduced two pages and five lithocollages." See Barañano, "Die Kunst und der Raum," in Barañano et al., *Eduardo Chillida*, p. 210.

73. For illustrations of these artworks, see Kosme de Barañano et al., *Homage to Chillida* (Bilbao: FMGB Guggenheim Bilbao Museoa, 2006), pp. 136–137. This exhibition catalogue also contains illustrations of Chillida's homages to Bachelard, Paz, and St. John of the Cross.

74. Wagner, "An Interview with Eduardo Chillida," pp. 25–26.

75. Petzet, *Encounters and Dialogues*, pp. 157–158.

76. See the entries on "topos" and "topic" in the *Oxford English Dictionary*, 2nd ed. (Oxford: Oxford University Press, 1989); and in *Webster's Seventh New Collegiate Dictionary*, p. 952.

77. Martin Heidegger, "Die Kunst und der Raum," trans. Kosme de Barañano, in Barañano et al., *Eduardo Chillida*, pp. 223, 217.

78. Ibid., pp. 224–225.

79. Ibid., pp. 220–221. Octavio Paz also commented on the sacrality of inner space in Chillida's sculptures. As Paz wrote, Chillida's "sculptures are the home of space and are inhabited by one sole, plural being. Chillida calls it 'inner space,' but it could also be called emptiness or god or spirit or logos or proportion. It bears all names and no name. It is the invisible interlocutor he has been confronting since he began to create." Yet throughout this essay, Paz identified oppositional dialectics as the structuring leitmotif of Chillida's artistic production: "Immersed in this changing reality in which so many dualities and oppositions confront each other, the artist's eye and hand seek a moment of equilibrium. Form is equilibrium, convergence of antagonistic forces and impulses." Thus Paz argues that Chillida's sculpture "aspires to express this duality, not to dissolve it." See Paz, "Chillida: From Iron to Light," n.p. It should be noted that in 1983 Chillida produced an etching entitled *Homage to Octavio Paz*.

80. Petzet noted that when Heidegger sent "Die Kunst und der Raum" to Chillida, "he wrote that these observations dealt with the riddle of art, with the riddle that art itself is. He also pointed out that the issue is not to solve the riddle; rather, the task consists in seeking it." See Petzet, *Encounters and Dialogues*, p. 158.

81. Sweeney, "Eduardo Chillida," p. 6.

82. On the relations between Heideggerian thought and negative theology, such as found in the writings of St. John of the Cross, see Irene Gilsenan Nordin, "Nihilism in Seamus Heaney," *Philosophy and Literature* 26, no. 2 (2002): esp. 407–408. For an extended discussion of Heidegger's engagement with mysticism and metaphysics, see John D. Caputo, *The Mystical Element in Heidegger's Thought* (New York: Fordham University Press, 1986).

83. Chillida's engagement with the topos would extend into the mid-1980s, when he constructed a series of five steel sculptures bearing this title. Reproductions of all five works can be found in Selz, *Chillida*, pp. 165–169.

84. For the etymology and definitions of *topia* and topiary, see the entries in the *Oxford English Dictionary* and in *Webster's Seventh New Collegiate Dictionary*, p. 952.

85. Carandente, *Eduardo Chillida: Open-Air Sculptures*, p. 9. For striking photographs of this work, see pp. 178–183 of this volume.

86. Pilar Chillida to James Johnson Sweeney, May 9, 1966, in the exhibition file for "Eduardo Chillida: Retrospective Exhibition" (October 5 to November 20, 1966), MFAH Archives. The sculptor had developed a stomach ulcer, and the Chillidas offered to postpone the dedication of the monument so that the artist could be present. Sweeney declined, due to the tight scheduling of the other civic events, as discussed below.

87. Pilar Chillida, quoted in Ann Holmes, "Monumental Chillida Sculpture Arrives for Festival of the Arts," *Houston Chronicle* (September 27, 1966): sec. 6, 5.

88. Sweeney, *Eduardo Chillida*, p. 16.

89. See the correspondence between Sweeney and Alvin Busse, an associate at the Houston public relations firm Ruder and Finn, on December 13, 1965, and February 7, 1966, in the exhibition file for "Eduardo Chillida: Retrospective Exhibition" (October 5 to November 20, 1966), MFAH Archives.

90. James Johnson Sweeney to The Houston Endowment Inc., January 26, 1966, in the exhibition file for "Eduardo Chillida: Retrospective Exhibition" (October 5 to November 20, 1966), MFAH Archives.

91. Sweeney, "A City Monument," press release, MFAH Archives.

92. See J. H. Creekman, president of the Houston Endowment Inc., in a letter announcing the gift to James Johnson Sweeney (February 2, 1966), and Sweeney's response (February 5, 1966), in the exhibition file for "Eduardo Chillida: Retrospective Exhibition" (October 5 to November 20, 1966), MFAH Archives.

93. Eduardo Chillida to James Johnson Sweeney, July 6, 1965, in the exhibition file for "Eduardo Chillida: Retrospective Exhibition" (October 5 to November 20, 1966), MFAH Archives.

94. Eduardo Chillida to James Johnson Sweeney, February 1966, quoted in Sweeney, *Eduardo Chillida*, p. 19.

95. Quoted in Sweeney, *Eduardo Chillida*, p. 21.

96. James Johnson Sweeney to Eduardo Chillida, March 28, 1966, in the exhibition file for "Eduardo Chillida: Retrospective Exhibition" (October 5 to November 20, 1966), MFAH Archives. The exhibition catalogue featured a photograph of the preliminary wooden sketch of *Abesti gogora V*.

97. Holmes, "Monumental Chillida Sculpture Arrives for Festival of the Arts," p. 5.

98. Ibid.

99. "Chillida Sculptured [*sic*] Is Erected," *Houston Chronicle* (September 28, 1966): sec. 6, 1. The upcoming opening was also previewed in the Sunday edition of the *Chronicle*, "Art Circles: Museum Unveiling Chillida Sculpture, Showing Works," *Houston Chronicle* (October 2, 1966): Zest section, 26.

100. Sweeney, *Eduardo Chillida*, p. 21.

101. Ibid.

102. The program outlining the unveiling ceremony, which included comments by Houston's Mayor Welch as well as Edward Rotan, Sweeney, Pilar Chillida, and the Becks, can be found in the exhibition file for "Eduardo Chillida: Retrospective Exhibition" (October 5 to November 20, 1966), MFAH Archives.

103. Ann Holmes, "Gigantic New Sculpture Hailed–Even in Downpour," *Houston Chronicle* (October 5, 1966): sec. 1, 1. For Holmes's review of the Chillida retrospective, see her article "Chillida: Elegance in Strength," *Houston Chronicle* (October 9, 1966): Zest section, 22. The following Sunday, the *Houston Post* covered the story of the sculpture's unveiling as a fait accompli. See "Metamorphosis," *Houston Post* (October 9, 1966): Spotlight section, 7, 27. Later that month, the *Post* positioned models in ball gowns in front of the sculpture for a fashion shot, "The Faces of Houston," *Houston Post Woman's World* (October 24, 1966): sec. 2, p. 1.

104. James Johnson Sweeney to Eduardo Chillida, October 6, 1966, in the exhibition file for "Eduardo Chillida: Retrospective Exhibition" (October 5 to November 20, 1966), MFAH Archives. In turn, Chillida expressed his happiness that "Abesti Gogora V is what you expected," and he sent the Sweeneys a collage in gratitude for the kindness they extended to Pilar during her visit. Shortly thereafter, Sweeney thanked Chillida for sending "your handsome print at Christmas." And on May 29, 1967, Sweeney sent the Chillidas installation photographs of the sculpture on the museum grounds. See James Johnson Sweeney to Eduardo Chillida, January 13, 1967, and May 29, 1967, in the exhibition file for "Eduardo Chillida: Retrospective Exhibition" (October 5 to November 20, 1966), MFAH Archives.

105. John de Menil to James Johnson Sweeney, November 28, 1966, in the exhibition file for "Eduardo Chillida: Retrospective Exhibition" (October 5 to November 20, 1966), MFAH Archives.

106. Ima Hogg to Edward Rotan, February 3, 1967, MFAH Director Records. Sweeney warmly acknowledged this letter on February 6, 1967. Interestingly, the other piece of correspondence that Rotan exchanged with Sweeney concerned the ways in which the costs associated with the Chillida sculpture exceeded the budget projections the museum trustees had set for 1966. Sweeney responded by assuring Rotan that "I am confident that granted normal conditions the 1967 exhibitions can be kept within the budget figure set." James Johnson Sweeney to Edward Rotan, December 16, 1966, MFAH Director Records.

107. "Challenge to Apollo," *Time* (October 14, 1966): 90.

108. Hilton Kramer, "Sculpture: Eduardo Chillida in Houston," *New York Times* (October 15, 1966): 25.

109. James Johnson Sweeney to Henry J. Seldis, September 25, 1966, MFAH Director Records.

110. Henry J. Seldis, "Houston Pulls Its Weight in Art Matters," *Los Angeles Times* (October 16, 1966), in the exhibition file for "Eduardo Chillida: Retrospective Exhibition" (October 5 to November 20, 1966), MFAH Archives. See also Seldis's review in *Art International*, December 1966.

111. Ann Holmes similarly noted, "It even suggests in a way an animal form, with head raised, moving across the museum garden." See Holmes, "Gigantic New Sculpture Hailed–Even in Downpour," sec. 1, p. 4.

112. Octavio Paz characterized *Abesti gogora V* as a saturnine meteor, "a sculpture of huge dimensions now installed in a garden in the Houston Museum. It is made of granite, not wood. Among the trees and plants it looks like an aerolite fallen from Saturn, planet of melancholics and mystics. The mental music has ended; this sculpture is made of silence. The vast silence of space." See Paz, "Chillida: From Iron to Light," n.p.

113. Kramer, "Sculpture: Eduardo Chillida in Houston."

114. Henry J. Seldis, "Letter from Houston," *Art International* 10 (December 1966): 45, 48.

115. Sweeney, *Eduardo Chillida*, p. 21.

116. Ibid., p. 14.

117. Chillida, "L'espace, la limite," n.p.; Sweeney, *Eduardo Chillida*, p. 18.

Selected Bibliography

Primary Sources

Archives of American Art, Smithsonian Institution, Washington, D.C. Oral History Interviews.

Fondren Library, Rice University, Houston, Texas. The Brown Fine Arts Library and the Woodson Research Center Special Collections and Archives.

Houghton Library, Harvard University, Cambridge, Massachusetts. Papers of the magazine *Transition*, bMS AM 2068 (81).

Massachusetts Institute of Technology Museum Collection, Cambridge, Massachusetts. Archives of the MIT Museum Committee.

Museum of Fine Arts, Houston Archives. RG02:03:01 Office of the Director, James Johnson Sweeney Records, Correspondence.

Museum of Fine Arts, Houston Archives. RG05:01 Office of the Registrar, Exhibition files.

Museum of Modern Art Archives, New York, New York. The Alfred H. Barr, Jr. Papers of the Museum of Modern Art.

New York University Archives, New York, New York.

Pollock-Krasner House and Study Center, East Hampton, New York.

The Solomon R. Guggenheim Museum Archives, New York, New York. The James Johnson Sweeney Records. A0001.

University of Notre Dame Archives, Notre Dame, Indiana. Manuscripts of the Liturgical Arts Society.

Yale Collection of American Literature, Beinecke Rare Book and Manuscript Library, Yale University, New Haven, Connecticut. The Alfred Stieglitz/Georgia O'Keeffe Archive and the Katherine S. Dreier Papers/Société Anonyme Archive.

Secondary Sources

Alloway, Lawrence. "London Letter: Alberto Burri." *Art International* 4 (May 1960): 52–53.

Anger, Jenny. *Paul Klee and the Decorative in Modern Art.* Cambridge: Cambridge University Press, 2004.

"Art Circles: Museum Unveiling Chillida Sculpture, Showing Works." *Houston Chronicle* (October 2, 1966): Zest section, 26.

"Art in America Annual Award." *Art in America* 51, no. 6 (1963): 24.

"Artists Discover Themselves." *Studio International* 166 (December 1963): 247–248.

"Art: Marcel Duchamp's *Comb.*" *Houston Post* (February 21, 1965): Spotlight section, 6.

Art Newsletter. New York: American Federation of the Arts, March 1957.

Arts primitifs dans les ateliers d'artistes. Paris: Musée de l'Homme, 1967.

"Art: Sweeney's Way." *Time* (June 14, 1963): 74.

Ashbery, John. "Paris Notes." *Art International* 5 (May 1961): 63.

Auden, W. H. *The Enchafèd Flood, or The Romantic Iconography of the Sea.* New York: Random House, 1950.

Aulestia, Gorka. *Basque-English Dictionary.* Reno: University of Nevada Press, 1989.

Bachelard, Gaston. "The Cosmos of Iron." *Derrière le Miroir* 90–91 (Paris: Maeght, 1956).

Bachelard, Gaston. *The Flame of a Candle.* Trans. Joni Caldwell. Dallas: Dallas Institute Publications, 1988.

Barañano, Kosme de, et al. *Eduardo Chillida: Elogio del hierro / Praise of Iron.* Valencia: Institut Valencià d'Art Modern, 2002.

Barañano, Kosme de, et al. *Homage to Chillida.* Bilbao: Guggenheim Bilbao Museoa, 2006.

Barr, Alfred H., Jr. *Cubism and Abstract Art*. New York: Museum of Modern Art, 1936; rpt., Cambridge, MA: Harvard University Press, 1986.

Barr, Alfred H., Jr. *Fantastic Art, Dada, Surrealism*. New York: Museum of Modern Art, 1936.

Barthes, Roland. *Mythologies*. Trans. Annette Lavers. New York: Hill and Wang, 1972.

Beauchamp, Toni Ramona. "James Johnson Sweeney and the Museum of Fine Arts, Houston, 1961–67." M.A. thesis, University of Texas, Austin, 1983.

Béguin, Albert. "L'androgyne." *Minotaure* 11 (Spring 1938): 10–13, 66.

Benét, William Rose. *The Reader's Encyclopedia*. New York: Crowell, 1965.

Benjamin, Walter. "The Work of Art in the Age of Mechanical Reproduction." In Charles Harrison and Paul Wood, eds., *Art in Theory, 1900–1990: An Anthology of Changing Ideas*. Malden, MA: Blackwell, 1992.

Bennett, Ciaran, and Helen Harrison. "The Poetry of Vision: James Johnson Sweeney and the Twilight of Modernism." A conference sponsored by the Pollock-Krasner House and Study Center, East Hampton, NY, April 25, 2008.

Berger, Maurice, ed. *Postmodernism: A Virtual Discussion*. New York: Distributed Art Publishers, 2003.

Biennale di Venezia. *Biennale d'Arte catalogo 29* (Venice: Biennale, 1958).

Bischofberger, Christina. *Jean Tinguely: Catalogue Raisonné: Sculptures and Reliefs, 1954–1968*. 2 vols. Zurich: Galerie Bruno Bischofberger, 1982.

Bradley, Kim. "Basque Modern." *Art in America* 86 (June 1998): 88–97, 121.

Brandi, Cesare. *Burri*. Trans. Martha Leeb Hadzi. Rome: Editalia, 1963.

Brennan, Marcia. "Illuminating the Void, Displaying the Vision: On the Romanesque Church, the Modern Museum, and Pierre Soulages's Abstract Art." *Res* 52 (Autumn 2007): 116–127.

Brennan, Marcia. *Modernism's Masculine Subjects: Matisse, the New York School, and Post-Painterly Abstraction*. Cambridge, MA: MIT Press, 2004.

Brennan, Marcia. *Painting Gender, Constructing Theory: The Alfred Stieglitz Circle and American Formalist Aesthetics*. Cambridge, MA: MIT Press, 2001.

Brennan, Marcia. "Seeing the Unseen: James Johnson Sweeney and the de Menils." In *A Modern Patronage: De Menil Gifts to American and European Museums*. Houston: Menil Collection; New Haven: Yale University Press, 2007.

Breton, André. "Lighthouse of the Bride." *View* (March 1945): 6–9.

Brzyski, Anna, ed. *Partisan Canons: Discursive and Institutional Sites*. Durham: Duke University Press, 2005.

Burns, Sarah. "The 'Earnest, Untiring Worker' and the Magician of the Brush: Gender Politics in the Criticism of Cecilia Beaux and John Singer Sargent." In Marianne Doezema and Elizabeth Milroy, eds., *Reading American Art*. New Haven: Yale University Press, 1998.

Burri: Contributi al catalogo sistematico. Città di Castello: Fondazione Palazzo Albizzini, 1990.

Butler, Barbara. "Monet and Others." *Art International* 4 (May 1960): 69.

Calder, Alexander. *Calder*. Saint-Paul: Fondation Maeght, 1969.

Calder, Alexander, and James Johnson Sweeney. *Three Young Rats and Other Rhymes*. New York: Museum of Modern Art, 1946.

Caley, Shaun. "Burri." *Flash Art* 147 (Summer 1989): 97.

Calvesi, Maurizio. *Alberto Burri*. Trans. Robert E. Wolf. New York: Abrams, 1975.

Calvesi, Maurizio. "El camino de Burri." In *Alberto Burri*. Madrid: Museo Nacional Centro de Arte Reina Sofía, 2006.

Camfield, William A. *More Than a Constructive Hobby: The Paintings of Frank Freed*. Houston: Museum of Fine Arts, Houston, 1996.

Canaday, John. "Art and Destruction: Thoughts Following a Suicide in a Garden." In Canaday, *Embattled Critic: Views on Modern Art*. New York: Farrar, Straus and Cudahy, 1962.

Caputo, John D. *The Mystical Element in Heidegger's Thought*. New York: Fordham University Press, 1986.

Carandente, Giovanni. *Eduardo Chillida: Open-Air Sculptures*. Trans. Richard Rees. New York: Distributed Art Publishers, 2003.

Carboni, Massimo. "Medium Hot: Alberto Burri." *Artforum International* 29 (December 1990): 108–114.

Celant, Germano. *Alberto Burri*. New York: Mitchell-Innes & Nash, 2007.

Ceysson, Bernard. "Interview with Pierre Soulages." In *Soulages*. New York: Crown, 1979.

"Challenge to Apollo." *Time* (October 14, 1966): 90.

Chave, Anna. *Constantin Brancusi: Shifting the Bases of Art*. New Haven: Yale University Press, 1994.

Chave, Anna. "New Encounters with *Les Demoiselles d'Avignon*: Gender, Race, and the Origins of Cubism." *Art Bulletin* 76 (December 1994): 597–611.

Chillida, Eduardo. "L'espace, la limite." *Derrière le Miroir* 183 (Paris: Maeght, 1970).

Chillida, Eduardo. "Reflections on the Theme of This Symposium." In Joseph J. Schildkraut and Aurora Otero, eds., *Depression and the Spiritual in Modern Art*. New York: John Wiley and Sons, 1996.

Chillida. Trans. Mary Ann Witt. Paris: Maeght, 1979.

"Chillida Sculptured [*sic*] Is Erected." *Houston Chronicle* (September 28, 1966): sec. 6, 1.

Christov-Bakargiev, Carolyn, and Maria Grazia Tolomeo, eds. *Burri: 1915–1995 Retrospektive*. Milan: Electa, 1997.

Civic Affairs Committee of the Houston Chamber of Commerce. "The Arts in Houston." *Houston Magazine* (December 1963): 44.

Clarke, Bruce, and Linda Dalrymple Henderson, eds. *From Energy to Information: Representation in Science and Technology, Art and Literature*. Stanford: Stanford University Press, 2002.

"Congolese Slay Italian Airmen." *New York Times* (November 17, 1961): 1, 3.

Connor, Steven. *Theory and Cultural Value*. Oxford: Blackwell, 1992.

Corredor-Matheos, José. "Spirituality in the Work of Eduardo Chillida." In Joseph J. Schildkraut and Aurora Otero, eds., *Depression and the Spiritual in Modern Art*. New York: John Wiley and Sons, 1996.

Craven, Thomas. "Art." *Nation* 139 (September 26, 1934): 360.

Crowther, Bosley. "The Screen: 'Dreams That Money Can Buy,' Psychology Study, at 5th Ave. Playhouse." *New York Times* (April 24, 1948): 11.

Culler, George. "Interview: James Johnson Sweeney." *Artforum* 1 (June 1962): 27–29.

Daniels, Dieter. "Often Neglected–but One of the Greats: Interview with Jean Tinguely by Dieter Daniels, Cologne, 12 January 1987." In *Marcel Duchamp*. Ostfildern-Ruit: Hatje Cantz Verlag, 2002.

Dearborn, Mary V. *Mistress of Modernism: The Life of Peggy Guggenheim*. Boston: Houghton Mifflin, 2004.

Derrida, Jacques. *A Derrida Reader: Between the Blinds*. Ed. Peggy Kamuf. New York: Columbia University Press, 1991.

Derrida, Jacques. *The Truth in Painting*. Trans. Geoff Bennington and Ian McLeod. Chicago: University of Chicago Press, 1987.

D'Harnoncourt, Anne, and Kynaston McShine, eds. *Marcel Duchamp*. New York: Museum of Modern Art, 1973.

Doniger [O'Flaherty], Wendy. *Women, Androgynes, and Other Mythical Beasts*. Chicago: University of Chicago Press, 1980.

Doniger, Wendy, and Mircea Eliade. "Androgynes." In Lindsay Jones, ed., *Encyclopedia of Religion*. 2nd ed., vol. 1. Detroit: Thomson Gale, 2005.

Dorival, Bernard. *Soulages*. Paris: Musée National d'Art Moderne, 1967.

Dreier, Katherine S. *Collection of the Société Anonyme: Museum of Modern Art 1920*. New Haven: Yale University Art Gallery, 1950.

Driscoll, James F. "Firmament." In *The Catholic Encyclopedia*, vol. 6. New York: Robert Appleton, 1907–1912.

Drohojowska, Hunter. "Alberto Burri's Umbrian Collage: The Artist's Multifaceted Realm near Perugia." *Architectural Digest* 47 (January 1990): 121.

Duchamp, Marcel. *Salt Seller: The Writings of Marcel Duchamp/Marchand du sel*, ed. Michel Sanouillet and Elmer Peterson. New York: Oxford University Press, 1973.

Duncan, Carol. *Civilizing Rituals: Inside Public Art Museums*. London: Routledge, 1995.

Duncan, Carol, and Alan Wallach. "The Museum of Modern Art as Late Capitalist Ritual: An Iconographic Analysis." In Donald Preziosi and Claire Farago, eds., *Grasping the World: The Idea of the Museum*. Burlington, VT: Ashgate, 2004.

Dupin, Jacques. *Joan Miró: Catalogue Raisonné: Paintings*. Trans. Cole Swensen and Unity Woodman. Paris: Daniel Lelong, 1999–2004.

Eliot, T. S. *Four Quartets*. New York: Harvest Books, 1968.

Eliot, T. S. "Tradition and the Individual Talent." In *The Sacred Wood: Essays on Poetry and Criticism*. London: Methuen, 1920.

Elkins, James. *On the Strange Place of Religion in Contemporary Art*. New York: Routledge, 2004.

Elligott, Michelle. "Modern Artifacts #1: Charting Modernism." *Esopus* 7 (Fall 2006): 75–86.

Encrevé, Pierre. *Soulages: Les peintures, 1946–2006*. Paris: Seuil, 2007.

Encrevé, Pierre. *Soulages: L'oeuvre complète, peintures*. 3 vols. Paris: Seuil, 1994–1998.

"Entretien public de Pierre Soulages." In *Une oeuvre de Pierre Soulages*. Marseille: Éditions Muntaner, 1998.

"Excerpts from U.N. Report on Massacre of Italians." *New York Times* (November 17, 1961): 2.

"The Faces of Houston." *Houston Post Woman's World* (October 24, 1966): sec. 2, 1.

Fitzsimmons, James. "New York: A Glittering Constellation." *Art Digest* 28 (December 1953): 7–8, 25–26.

Flam, Jack, ed., with Miriam Deutch. *Primitivism and Twentieth-Century Art: A Documentary History*. Berkeley: University of California Press, 2003.

Foster, Hal. "The 'Primitive' Unconscious of Modern Art." *October* 34 (Fall 1985): 58–70.

Freed, Eleanor. "Art: International." *Houston Post* (February 19, 1967): Spotlight section, 7.

Freed, Eleanor. "Art: Museum Outlook." *Houston Post* (December 31, 1967): Spotlight section, 9.

Freed, Eleanor. "Art: Soulages in Perspective." *Houston Post* (April 24, 1966): 31.

Freed, Eleanor. "In Review: New Works and Old at Museum." *Houston Post* (February 20, 1966): Spotlight section, 33.

Freed, Eleanor. "Museum's Plans." *Houston Post* (July 16, 1967): Spotlight section, 22.

Freud, Sigmund. *Civilization and Its Discontents.* Trans. and ed. James Strachey. New York: W. W. Norton, 1961.

Freud, Sigmund. *Three Essays on the Theory of Sexuality.* Trans. and ed. James Strachey. New York: Basic Books, 1962.

Gale, Matthew, and Renato Miracco. *Beyond Painting: Burri, Fontana, Manzoni.* London: Tate Publishing, 2005.

Gaskell, Ivan. "Sacred to Profane and Back Again." In Andrew McClellan, ed., *Art and Its Publics: Museum Studies at the Millennium.* Malden, MA: Blackwell, 2003.

Geeslin, Campbell. "Art from the Scrap Yard: Tinguely Mechanizes Museum." *Houston Post* (April 1, 1965): sec. 1, 1, 17.

Geeslin, Campbell. "Art: Good Old Days." *Houston Post* (October 24, 1965): 24.

Geeslin, Campbell. "Art: Intense Expression." *Houston Post* (October 20, 1963): sec. 9, 6.

Geeslin, Campbell. "Art: Talk with a Lively Legend: Marcel Duchamp." *Houston Post* (February 28, 1965): Spotlight section, 9, 11.

Geeslin, Campbell. "Museum Buys 12 Sculptures by Swiss Artist." *Houston Post* (February 25, 1965): sec. 5, 19.

Geeslin, Campbell. "Sweeney in Houston." *Art in America* 50, no. 3 (1962): 131.

Geoffroy-Schneiter, Bérénice. *Tribal Arts: Africa, Oceania, Southeast Asia.* New York: Vendome Press, 2000.

Giedion-Welcker, Carola. *Contemporary Sculpture: An Evolution in Volume and Space.* New York: G. Wittenborn, 1955.

Giedion-Welcker, Carola. "The Poetry of Space in Eduardo Chillida." *Derrière le Miroir* 143 (Paris: Maeght, 1964).

Giedion-Welcker, Carola. "Prehistoric Stones." Trans. Eugene Jolas. *Transition* 27 (April-May 1938): 335–343.

Gilbert, Dorothy B., ed. *Who's Who in American Art.* New York: R. R. Bowker, 1953.

Gill, Anton. *Art Lover: A Biography of Peggy Guggenheim.* New York: HarperCollins, 2002.

Glueck, Grace. "James Johnson Sweeney Dies; Art Critic and Museum Head." *New York Times* (April 15, 1986): B 8.

Godfrey, Mark. *Abstraction and the Holocaust.* New Haven: Yale University Press, 2007.

Goldwater, Robert. "These Promising Younger Europeans." *Artnews* 52 (December 1953): 15.

Goodman, Cynthia. "Frederick Kiesler: Designs for Peggy Guggenheim's Art of This Century Gallery." *Arts Magazine* 51 (June 1977): 90–95.

Graham, Lanier. *Duchamp and Androgyny: Art, Gender, and Metaphysics.* Berkeley: No-Thing Press, 2003.

Gray, Cleve. "The Great Spectator." *Art in America* 57 (July-August 1969): 20.

Gray, Cleve. "Retrospective for Marcel Duchamp." *Art in America* 53 (February 1965): 102–105.

Greely-Smith, Nixola. "Cubist Depicts Love in Brass and Glass." New York *Evening World* (April 4, 1916): 3.

Greenberg, Clement. *The Collected Essays and Criticism.* Ed. John O'Brian. 4 vols. Chicago: University of Chicago Press, 1986–1993.

Gross, Jennifer R., ed. *The Société Anonyme: Modernism for America.* New Haven: Yale University Press, 2006.

Guggenheim, Peggy. *Out of This Century: The Informal Memoirs of Peggy Guggenheim.* New York: Dial Press, 1946.

Haddon, Alfred C. *The Study of Man.* London: Bliss, Sands, & Co., 1898.

Hamilton, Jaimey. "Alberto Burri's *Sacchi* and Cold War Capitalism's Accursed Share." *College Art Association Abstracts.* New York: College Art Association, 2005.

Hamilton, Richard. *Not Seen and/or Less Seen of/by Marcel Duchamp/Rrose Sélavy 1904–64.* Houston: Museum of Fine Arts; New York: Cordier & Ekstrom Gallery, 1965.

Hanor, Stephanie Jennings. "Jean Tinguely: Useless Machines and Mechanical Performers, 1955–1970." Ph.D. thesis, University of Texas, Austin, 2003.

Hargrove, June. "*Woman with a Fan*: Paul Gauguin's Heavenly Vairaumati–A Parable of Immortality." *Art Bulletin* 88 (September 2006): 552–566.

Hay, Eloise Knapp. *T. S. Eliot's Negative Way.* Cambridge, MA: Harvard University Press, 1982.

"Heavy Find on Display in Houston." *New York Times* (June 19, 1963): 34.

Heidegger, Martin, and Eduardo Chillida. *Die Kunst und der Raum.* Munich: F. Bruckmann, 1984.

Heller, Ena Giurescu, ed. *Reluctant Partners: Art and Religion in Dialogue.* New York: Gallery at the American Bible Society, 2004.

Henderson, Linda Dalrymple. *Duchamp in Context: Science and Technology in the Large Glass and Related Works.* Princeton: Princeton University Press, 1998.

Heraclitus. *Fragments: The Collected Wisdom of Heraclitus.* Trans. Brooks Haxton. New York: Viking, 2001.

Herbert, Lynne M. "Seeing Was Believing: Installations of Jermayne MacAgy and James Johnson Sweeney." *Cite* 40 (Winter 1997–1998): 31–34.

Hess, Thomas B. "J'accuse Marcel Duchamp." *Artnews* 63 (February 1965): 44–52.

Hess, Thomas B. "Jean Tinguely." *Artnews* 59 (April 1960): 16, 54.

Heydenryk, Henry. *The Art and History of Frames: An Inquiry into the Enhancement of Paintings.* New York: James H. Heineman, 1963.

Hickey, Dave. "Eduardo Chillida's Lost Generation." In *Chillida.* Los Angeles: Tasende Gallery, 1997.

Hollywood, Amy. *Sensible Ecstasy: Mysticism, Sexual Difference, and the Demands of History.* Chicago: University of Chicago Press, 2002.

Holmes, Ann. "Art Circles: Wild Spasms, Rituals of Tinguely's Sculptures." *Houston Chronicle* (April 4, 1965): 25.

Holmes, Ann. "The Art World of Director James Sweeney." *Houston Chronicle* (December 3, 1961): Zest section, 7, 20.

Holmes, Ann. "Chillida: Elegance in Strength." *Houston Chronicle* (October 9, 1966): Zest section, 22.

Holmes, Ann. "Fine Arts: Museum: Vivid, Controversial." *Houston Chronicle* (July 11, 1965): 16.

Holmes, Ann. "Gigantic New Sculpture Hailed–Even in Downpour." *Houston Chronicle* (October 5, 1966): sec. 1, 1.

Holmes, Ann. "Important American Show of Burri at Museum Here." *Houston Chronicle* (October 13, 1963): 9.

Holmes, Ann. "Monumental Chillida Sculpture Arrives for Festival of the Arts." *Houston Chronicle* (September 27, 1966): sec. 6, 5.

Holmes, Ann. "Museum Cuts Activity; Limits Director's Job." *Houston Chronicle* (July 6, 1967): 1–2.

Holmes, Ann. "The Paris of 1908–14 . . . Brilliant Bacchanal." *Houston Chronicle* (October 24, 1965): 22.

Holmes, Ann. "Riddle of Olmecs in Major Exhibit." *Houston Chronicle* (June 16, 1963): 11.

Holmes, Ann. "Rose Sélavy May Sneeze: Duchamp Show This Week." *Houston Chronicle* (February 21, 1965): Zest section, 25.

Holmes, Ann. "Soulages Retrospective: An Emergence of Style." *Houston Chronicle* (April 24, 1966): 25.

Holmes, Ann. "The Spotlight." *Houston Chronicle* (December 5, 1965): 22.

Honholt, Edith. "Duchamp at Museum." *Houston Post* (February 24, 1965): sec. 2, 5.

Huizinga, Johan. *Homo Ludens: A Study of the Play-Element in Culture.* New York: Roy Publishers, 1950.

Hultén, K. G. Pontus. *Jean Tinguely: A Magic Stronger Than Death.* New York: Abbeville, 1987.

Hultén, K. G. Pontus. *The Machine as Seen at the End of the Mechanical Age.* New York: Museum of Modern Art, 1968.

Hultén, K. G. Pontus. "Tinguely." In *Méta.* Paris: Alexander Iolas Gallery, 1964.

Hunter, Sam. "Two Kinetic Sculptors." In *2 Kinetic Sculptors: Nicolas Schöffer and Jean Tinguely*. New York: Jewish Museum, 1965.

Hutchinson, Elizabeth. "Usable Pasts? American Art from the Armory Show to Art of This Century." http://www.caareviews.org/reviews/1060

"Investment." *New York Times* (March 7, 1965): sec. 2, 19.

Janis, Harriet, and Rudi Blesh. *Collage: Personalities, Concepts, Techniques*. Philadelphia: Chilton, 1962.

Jewell, Edward Alden. "The Anatomy of Cubism and Abstract Art." *New York Times Book Review* (June 7, 1936): 8.

Jewell, Edward Alden. "New Books on the Arts." *New York Times Book Review* (November 25, 1934): 21.

Jones, Amelia. *Postmodernism and the En-gendering of Marcel Duchamp*. New York: Cambridge University Press, 1995.

Joosten, Joop M. *Piet Mondrian: Catalogue Raisonné of the Work of 1911–1944*. 2 vols. New York: Harry N. Abrams, 1998.

Jouffroy, Alain. "Aus einem Interview mit Alain Jouffroy." In *Tinguely*. Basel: Kunsthalle, 1972.

Juin, Hubert. *Soulages*. Paris: Georges Fall, 1959.

"Just What I Like." *Newsweek* (January 23, 1961): 60.

Kachur, Lewis. *Displaying the Marvelous: Marcel Duchamp, Salvador Dalí, and Surrealist Exhibition Installations*. Cambridge, MA: MIT Press, 2001.

Kandinsky, Wassily. *Concerning the Spiritual in Art*. Trans. Francis Golffing. New York: Wittenborn, 1963.

Kantor, Sybil Gordon. *Alfred H. Barr, Jr. and the Intellectual Origins of the Museum of Modern Art*. Cambridge, MA: MIT Press, 2002.

Kästner, Erhart. *Martin Heidegger/Eduardo Chillida: Die Kunst und der Raum*. St. Gallen: Erker Verlag, 1970.

Kaufmann, Edgar, Jr. "The Violent Art of Hanging Pictures." *Magazine of Art* 39 (March 1946): 108–113.

Keyser, Eugénie de. "Sculpteurs de l'éphémère." *Revue Belge d'Archéologie et d'Histoire de l'Art* 65 (1996): 256.

Kleeblatt, Norman L., ed. *Mirroring Evil: Nazi Imagery/Recent Art*. New York: Jewish Museum; New Brunswick: Rutgers University Press, 2001.

Klüver, J. W. "The Garden Party." In *Zero*. Cambridge, MA: MIT Press, 1973.

"Knockout Blow." *Time* 70 (December 2, 1957): 60.

Knox, Sanka. "Guggenheim Museum Director Resigns in Difference of 'Ideals.'" *New York Times* (July 21, 1960): 1, 18.

Kramer, Hilton. "One Inventor, One Pasticheur." *New York Times* (November 28, 1965): 15x.

Kramer, Hilton. "Sculpture: Eduardo Chillida in Houston." *New York Times* (October 15, 1966): 25.

Krauss, Rosalind E. *The Originality of the Avant-Garde and Other Modernist Myths.* Cambridge, MA: MIT Press, 1985.

Krens, Thomas, ed. *Art of This Century: The Guggenheim Museum and Its Collection.* New York: Solomon R. Guggenheim Foundation, 1993.

Kripal, Jeffrey J. *Esalen: America and the Religion of No Religion.* Chicago: University of Chicago Press, 2007.

Kripal, Jeffrey J. *Roads of Excess, Palaces of Wisdom: Eroticism and Reflexivity in the Study of Mysticism.* Chicago: University of Chicago Press, 2001.

Kripal, Jeffrey J. *The Serpent's Gift: Gnostic Reflections on the Study of Religion.* Chicago: University of Chicago Press, 2007.

Kuspit, Donald B. "A Critical History of 20th-Century Art." *Artnet.* http://www.artnet.com/magazineus/features/kuspit/kuspit12-14-05.asp

Kuspit, Donald B. *The Rebirth of Painting in the Late Twentieth Century.* New York: Cambridge University Press, 2000.

Landay, Janet. *The Museum of Fine Arts, Houston Visitor Guide.* Houston: Museum of Fine Arts, 2000.

Langsner, Jules. "Art News from Los Angeles." *Artnews* 61 (May 1962): 46.

Lee, Pamela M. *Chronophobia: On Time in the Art of the 1960s.* Cambridge, MA: MIT Press, 2004.

Le Lannou, Jean-Michel. *Soulages, la plénitude du visible.* Paris: Éditions Kimé, 2001.

Lippard, Lucy R. "Heroic Years from Humble Treasures: Notes on African and Modern Art." *Art International* 10 (September 1966): 16–25.

Lippard, Lucy R. "New York Letter." *Art International* 9 (May 1965): 58.

Lyle, David. "Guggenheim Museum Head Quits." *New York Herald Tribune* (July 21, 1960): 1, 12.

Marcel Duchamp. Basel: Museum Jean Tinguely and Hatje Cantz Verlag, 2002.

Marquis, Alice Goldfarb. *Alfred H. Barr, Jr.: Missionary for the Modern.* Chicago: Contemporary Books, 1989.

Mather, Frank Jewett, Jr. "The New Books." *Saturday Review of Literature* (May 11, 1935): 25.

Mathews, Laura. "The Designs for Motion of Jean Tinguely: A Portfolio and an Interview." *Paris Review* 34 (Spring/Summer 1965): 84.

Mathews, Patricia. *Passionate Discontent: Creativity, Gender, and French Symbolist Art.* Chicago: University of Chicago Press, 1999.

McClellan, Andrew. *The Art Museum: From Boullée to Bilbao.* Berkeley: University of California Press, 2008.

Meeker, James J. "Cultural Boom in Texas." *Art Voices* (Winter 1966): 26, 27.

Menil, Dominique de, et al. *The Menil Collection: A Selection from the Paleolithic to the Modern Era.* New York: Harry N. Abrams, 1997.

Meschonnic, Henri, and Pierre Soulages. *Le rythme et la lumière.* Paris: Éditions Odile Jacob, 2000.

"Metamorphosis." *Houston Post* (October 9, 1966): Spotlight section, 7, 27.

Mies van der Rohe, Ludwig. "Museum." *Architectural Forum* 78 (May 1943): 84–85.

Mileaf, Janine. "Body to Politics: Surrealist Exhibition of the Tribal and the Modern at the Anti-Imperialist Exhibition and the Galerie Charles Ratton." *Res* 40 (Autumn 2001): 239–254.

Mitchell, W. J. T. "*Ut Pictura Theoria*: Abstract Painting and the Repression of Language." *Critical Inquiry* 15 (Winter 1989): 347–371.

"Modern 'Redirections.'" *New York Times* (August 26, 1934): 6x.

Moffitt, John F. *Alchemist of the Avant-Garde: The Case of Marcel Duchamp.* Albany: SUNY Press, 2003.

Morgan, David, and Sally M. Promey, eds. *The Visual Culture of American Religions.* Berkeley: University of California Press, 2001.

Morray-Jones, C. R. A. *A Transparent Illusion: The Dangerous Vision of Water in Hekhalot Mysticism.* Leiden: Brill, 2002.

Muchnic, Suzanne. "Asking Questions in Steel and Stone." *Artnews* 96 (October 1997): 150–152.

Museum Jean Tinguely Basel: The Collection. Basel: Museum Jean Tinguely, 1996.

Naumann, Francis M. "Marcel Duchamp: A Reconciliation of Opposites." In Rudolf Kuenzli and Francis M. Naumann, eds., *Marcel Duchamp: Artist of the Century.* Cambridge, MA: MIT Press, 1990.

Naumann, Francis M., and Hector Obalk, eds. *Affectionately, Marcel: The Selected Correspondence of Marcel Duchamp.* Trans. Jill Taylor. Ghent: Ludion Press, 2000.

Nelson, James, ed. *Wisdom: Conversations with the Elder Wise Men of Our Day.* New York: W. W. Norton, 1958.

Nelson, Robert S., and Richard Shiff, eds. *Critical Terms for Art History.* Chicago: University of Chicago Press, 1996.

Newhouse, Victoria. *Towards a New Museum.* New York: Monacelli Press, 1998.

Nietzsche, Friedrich. *The Birth of Tragedy.* Trans. Francis Golffing. New York: Doubleday, 1956.

Nordland, Gerald. "Neo-Dada Goes West." *Arts Magazine* 36 (May-June 1962): 102.

Ockman, Joan. "The Road Not Taken: Alexander Dorner's Way Beyond Art." In R. E. Somol, ed., *Autonomy and Ideology: Positioning an Avant-Garde in America.* New York: Monacelli Press, 1997.

O'Doherty, Brian. *Inside the White Cube: The Ideology of the Gallery Space*. Berkeley: University of California Press, 1986.

O'Hara, Frank. *New Spanish Painting and Sculpture*. New York: Museum of Modern Art, 1960.

Oxford English Dictionary, The. 2nd ed. Oxford: Clarendon Press, 1989.

Paine, Crispin, ed. *Godly Things: Museums, Objects, and Religion*. London: Leicester University Press, 2000.

Panofsky, Erwin. "Book Comment." *Bulletin of the Museum of Modern Art* 2 (November 1934): 3.

Paz, Octavio. "Chillida: From Iron to Light." In *Chillida*. Trans. Mary Ann Witt. Paris: Maeght, 1979.

Pellizzi, Francesco, ed. *Museums–Crossing Boundaries*. *Res* 52 (Autumn 2007).

"People in the Arts." *Arts* 35 (February 1961): 10.

Petzet, Heinrich Wiegand. *Encounters and Dialogues with Martin Heidegger, 1929–1976*. Trans. Parvis Emad and Kenneth Maly. Chicago: University of Chicago Press, 1983.

Plato. "The Symposium." In *Dialogues*. Trans. Benjamin Jowett. Chicago: Encyclopedia Britannica, 1955.

Pollock, Griselda. *Vision and Difference: Femininity, Feminism, and the Histories of Art*. London: Routledge, 1988.

Popper, Frank. *Origins and Development of Kinetic Art*. Trans. Stephen Bann. Greenwich, CT: New York Graphic Society, 1968.

"Pop's Dada." *Time* (February 5, 1965): 78, 85.

Porter, Fairfield. "Alberto Burri." *Artnews* 52 (December 1953): 41.

Powers, Alan. "Sculptural Synergy." *Architects' Journal* 210 (July 15, 1999): 47.

Promey, Sally M. "The Return of Religion in the Scholarship of American Art." *Art Bulletin* 85 (September 2003): 581–603.

Property from the Estate of the Late James Johnson Sweeney. New York: Sotheby's Auction Catalogue for November 18, 1986.

Pyne, Kathleen. "Response: On Feminine Phantoms: Mother, Child, and Woman-Child." *Art Bulletin* 88 (March 2006): 44–61.

Raynor, Vivien. "In the Galleries: Alberto Burri." *Arts Magazine* 38 (May/June 1964): 38.

Read, Herbert. *Alberto Burri*. London: Hanover Gallery, 1960.

Rennie, Bryan S. *Reconstructing Eliade: Making Sense of Religion*. Albany: SUNY Press, 1996.

Richter, Hans. "In Memory of a Friend." *Art in America* 57 (July-August 1969): 40.

Richter, Hans, et al. *Dreams That Money Can Buy*. New York: Art of This Century Films, 1947.

Ritchie, Andrew Carnduff, ed. *The New Decade*. New York: Museum of Modern Art, 1955.

Rob, Alexander. *Alchemy and Mysticism*. Cologne: Taschen, 2006.

Rubin, William. "Letter from New York." *Art International* 11, no. 9/10 (1959): 27.

Rubin, William, ed. *"Primitivism" in 20th Century Art: Affinity of the Tribal and the Modern*. 2 vols. New York: Museum of Modern Art, 1984.

Rubinstein, Raphael. "Vita Nuova." *Art in America* 83 (June 1995): 74–81.

Rudenstine, Angelica Zander. *The Guggenheim Collection: Paintings 1880–1945*. 2 vols. New York: Solomon R. Guggenheim Museum, 1976.

Runciman, Walter G., ed. *Max Weber: Selections in Translation*. Trans. E. Matthews. Cambridge: Cambridge University Press, 1978.

Saarinen, Aline B. "Lively Gallery for Living Art." *New York Times* (May 30, 1954): 16, 26–27.

Saint Phalle, Niki de. "A Little of My Story with You Jean." *Museum Jean Tinguely Basel: The Collection*. Basel: Museum Jean Tinguely, 1996.

Sandler, Irving, and Amy Newman, eds. *Defining Modern Art: Selected Writings of Alfred H. Barr, Jr*. New York: Harry N. Abrams, 1986.

Sargeant, Winthrop. "Dada's Daddy: A New Tribute Is Paid to Duchamp, Pioneer of Nonsense and Nihilism." *Life* 32 (April 28, 1952): 100, 104, 106, 108, 111.

Sawin, Martica. "Burri Patches a Picture." *Art Digest* 28 (December 1, 1953): 11, 13.

Schapiro, Meyer. *Modern Art, 19th and 20th Centuries: Selected Papers*. New York: George Braziller, 1982.

Schlimbach, Guido. "Der Kreuzaltar von Eduardo Chillida in Köln." *Das Munster* 57 (2004): 96–108.

Schmidt, Leigh Eric. *Restless Souls: The Making of American Spirituality*. New York: HarperCollins, 2005.

Schmidt, Sabine Maria. "Borderlines: Eloquent Silence in Fulfilled Emptiness." In Hatje Cantz, ed., *Art Projects/Synagoge Stommeln, Kunstprojekte*. New York: Distributed Art Publishers, 2000.

Schütze, E. W. *A Selection of Works by Twentieth Century Artists*. Chicago: Renaissance Society of the University of Chicago, 1934.

Schwarz, Arturo. "The Alchemist Stripped Bare in the Bachelor, Even." In Anne D'Harnoncourt and Kynaston McShine, eds., *Marcel Duchamp*. New York: Museum of Modern Art, 1989.

Schwarz, Arturo. *The Complete Works of Marcel Duchamp*. 2 vols. New York: Delano Greenridge, 1997.

"Sculptures in Motion." *Life* 61 (August 12, 1966): 40–41, 44–45.

Seitz, William C. "Abstract-Expressionist Painting in America: An Interpretation Based on the Work and Thought of Six Key Figures." Ph.D. thesis, Princeton University, 1955; Ann Arbor: University Microfilms, 1956.

Seitz, William C. "What's Happened to Art? An Interview with Marcel Duchamp on Present Consequences of New York's 1913 Armory Show." *Vogue* (February 15, 1963): 110–112, 129–131.

Seldis, Henry J. "Letter from Houston." *Art International* 10 (December 1966): 45, 48.

Sells, Michael A. *Mystical Languages of Unsaying.* Chicago: University of Chicago Press, 1994.

Selz, Peter. *Chillida.* New York: Harry N. Abrams, 1986.

Selz, Peter, ed. "The Eduardo Chillida Symposium." *Arts Magazine* 61 (January 1987): 18–21.

Serafini, Giuliano. *Burri: The Measure and the Phenomenon.* Milan: Edizioni Charta, 1999.

Shrady, Nicholas. "Affirmations in Iron and Steel." *Architectural Digest* 45 (January 1988): 58.

Siedell, Daniel A. *God in the Gallery: A Christian Embrace of Modern Art.* Grand Rapids, MI: Baker Academic, 2008.

Sorenson, Dina. "Eduardo Chillida." *Arts Magazine* 64 (March 1990): 95.

Soulages Catalogue. Cambridge, MA: MIT Museum, 1962.

Soutif, Daniel. "La parade et le carnaval: Vie et mort des machines selon Rebecca Horn et Jean Tinguely." *Cahiers du Musée National d'Art Moderne* 60 (Summer 1997): 96–111.

Soutif, Daniel. "Tinguely Ltd. ou le crépuscule des machines." *Artstudio* 22 (1991): 63–65.

Staniszewski, Mary Anne. *The Power of Display: A History of Exhibition Installations at the Museum of Modern Art.* Cambridge, MA: MIT Press, 1998.

Steegmuller, Francis. "Duchamp: Fifty Years Later." *Show* 2 (February 1963): 29–30.

Steen, Charlene. "Reviews: Houston." *Artforum* 2 (December 1963): 45.

Steiner, Wendy. *Venus in Exile: The Rejection of Beauty in Twentieth-Century Art.* Chicago: University of Chicago Press, 2001.

"Styles: The Movement Movement." *Time* (January 28, 1966): 64–69.

Sutton, Denys. "James Johnson Sweeney." *Burlington Magazine* 128 (November 1986): 809–810.

Sweeney, James Johnson. "African Negro Art." *New Republic* 82 (April 10, 1935): 244.

Sweeney, James Johnson. *African Negro Art.* New York: Museum of Modern Art, 1935.

Sweeney, James Johnson. *Afro: Paintings, Gouaches, Drawings.* Rome: Modern Art Editions, 1961.

Sweeney, James Johnson. *Alberto Burri.* Houston: Museum of Fine Arts, Houston, 1963.

Sweeney, James Johnson. "L'art chrétien primitif en Irlande." *Cahiers d'Art* 6–7 (1932): 243–248.

Sweeney, James Johnson. *Burri.* Rome: L'Obelisco, 1955.

Sweeney, James Johnson. "Contemporary Art: The Generative Role of Play." *Review of Politics* 21 (April 1959): 389–401.

Sweeney, James Johnson. "Le Cullinan Hall de Mies van der Rohe, Houston." *L'Oeil* 99 (March 1963): 38–43, 82.

Sweeney, James Johnson. "'East Coker': A Reading." *Southern Review* (1941). Reprinted in Bernard Bergonzi, ed., *T. S. Eliot: Four Quartets: A Casebook.* London: Macmillan, 1969.

Sweeney, James Johnson. "Eduardo Chillida." *Derrière le Miroir* 124 (Paris: Maeght, 1961).

Sweeney, James Johnson. *Eduardo Chillida.* Houston: Museum of Fine Arts, 1966.

Sweeney, James Johnson. *Eleven Europeans in America.* New York: Museum of Modern Art, 1946.

Sweeney, James Johnson. *Guggenheim International Award Exhibitions.* New York: Solomon R. Guggenheim Foundation, 1958, 1960.

Sweeney, James Johnson. *Images at Mid-Century.* Ann Arbor: University of Michigan Museum of Art, 1960.

Sweeney, James Johnson. *Irish Illuminated Manuscripts of the Early Christian Period.* New York: Collins and UNESCO, 1965.

Sweeney, James Johnson. *Jean Tinguely: Sculptures.* Houston: Museum of Fine Arts, 1965.

Sweeney, James Johnson. "'Little Gidding': Introductory to a Reading." *Poetry: A Magazine of Verse* 62 (April-September 1943): 214–223.

Sweeney, James Johnson. "Modern Art and Tradition." In *Three Lectures on Modern Art.* New York: Philosophical Library, 1949.

Sweeney, James Johnson. "New Directions in Painting." *Journal of Aesthetics and Art Criticism* 18 (March 1960): 368–377.

Sweeney, James Johnson. "A Note on Super-Realist Painting." *Arts* 16 (May 1930): 611–613.

Sweeney, James Johnson. "Painting." In *Museum of Living Art: A. E. Gallatin Collection.* New York: George Grady Press, 1936.

Sweeney, James Johnson. *Paintings by Alberto Burri.* Pittsburgh: Carnegie Institute, 1957.

Sweeney, James Johnson. *The Place of Painting in Contemporary Culture.* Houston: American Federation of the Arts, 1957.

Sweeney, James Johnson. *Plastic Redirections in 20th Century Painting.* Chicago: University of Chicago Press, 1934.

Sweeney, James Johnson. "Recent Trends in American Painting." *Bennington College Alumnae Quarterly* 7 (Fall 1955): 8–11.

Sweeney, James Johnson. *Sam Francis.* Houston: Museum of Fine Arts, 1967.

Sweeney, James Johnson. *Sculptures and Drawings from Seven Sculptors.* New York: Solomon R. Guggenheim Museum, 1958.

Sweeney, James Johnson. *The Solomon R. Guggenheim Museum.* New York: Solomon R. Guggenheim Museum, 1958.

Sweeney, James Johnson. "Some Ideas on Exhibition Installation." *Curator* 2 (1959): 151–156.

Sweeney, James Johnson. *Soulages.* Greenwich, CT: New York Graphic Society, 1972.

Sweeney, James Johnson. *Soulages: Paintings since 1963.* New York: M. Knoedler, 1968.

Sweeney, James Johnson. *Three Brothers: Jacques Villon, Raymond Duchamp-Villon, Marcel Duchamp.* New York: Solomon R. Guggenheim Museum, 1957.

Sweeney, James Johnson. *Three Spaniards: Picasso, Miró, Chillida.* Houston: Museum of Fine Arts, Houston, 1962.

Sweeney, James Johnson. *Vision and Image: A Way of Seeing.* New York: Simon and Schuster, 1967.

Sweeney, James Johnson. "The Word Was His Oyster." *Hudson Review* 5 (Autumn 1952): 404–408.

Sweeney, James Johnson. *Younger European Painters: A Selection.* New York: Solomon R. Guggenheim Museum, 1953.

Taylor, Charles. *Sources of the Self: The Making of the Modern Identity.* Cambridge, MA: Harvard University Press, 1989.

Thurston, Herbert. "Januarius." In *The Catholic Encyclopedia*, vol. 8. New York: Robert Appleton, 1907–1912.

"Tinguely's Contraption." *Nation* 190 (March 26, 1960): 267.

Tomkins, Calvin. *Duchamp: A Biography.* New York: Henry Holt, 1996.

Tomkins, Calvin. "Profiles: Beyond the Machine." *New Yorker* 37 (February 10, 1962): 44–91.

Tomkins, Calvin. "Profiles: Not Seen and/or Less Seen." *New Yorker* 40 (February 6, 1965): 37–93.

Tuchman, Maurice, et al. *The Spiritual in Art: Abstract Painting 1890–1985.* New York: Abbeville Press, 1986.

"12 Famous Museum Directors, as They Would Look if Their Favourite Portraitists Painted Them." *Vogue* 128 (July 1956): 88–89.

"Two Motion Sculptors: Tinguely and Rickey." *Artforum* 1 (June 1962): 18.

Tylor, Edward B. *Primitive Culture: Researches in the Development of Mythology, Philosophy, Religion, Language, Art, and Custom.* London: John Murray, 1913.

Underhill, Evelyn. *Mysticism: A Study in the Nature and Development of Man's Spiritual Consciousness.* New York: E. P. Dutton, 1910.

Valente, José Ángel. "Chillida or Transparency." In *Chillida 1948–1998.* Bilbao: Museo Guggenheim Bilbao, 1999.

Vallora, Marco. *Marca-Relli: L'amico americano: Sintonie e dissonanze con Afro e Burri.* Parma: Galleria d'Arte Niccoli, 2002.

Violand-Hobi, Heidi E. *Jean Tinguely: Life and Work.* Munich: Prestel, 1995.

Volboudt, Pierre. *Chillida.* Trans. Vivienne Menkès. New York: Harry N. Abrams, 1967.

Wagner, Sandra. "An Interview with Eduardo Chillida." *Sculpture* 16, no. 9 (1997): 25–26.

Warren, Austin. *Rage for Order: Essays in Criticism.* Chicago: University of Chicago Press, 1948.

Wasserstrom, Steven M. *Religion after Religion: Gershom Scholem, Mircea Eliade, and Henry Corbin at Eranos.* Princeton: Princeton University Press, 1999.

Webster's Seventh New Collegiate Dictionary. Springfield, MA: Merriam, 1969.

Wilson, Sarah. "Hans Richter: Dreams That Money Can Buy." In *Pienture-cinéma-peinture.* Marseille: Centre de la Vieille Charité Marseille, 1989.

Wolfson, Elliot R. *Alef, Mem, Tau: Kabbalistic Musings on Time, Truth, and Death.* Berkeley: University of California Press, 2006.

Wolfson, Elliot R. *Footdreams & Treetales: Ninety-Two Poems.* New York: Fordham University Press, 2007.

Wolfson, Elliot R. *Language, Eros, Being: Kabbalistic Hermeneutics and Poetic Imagination.* New York: Fordham University Press, 2005.

Yusa, Michiko. "Paradox and Riddles." In Lindsay Jones, ed., *Encyclopedia of Religion.* 2nd ed., vol. 10. Detroit: Macmillan Reference, 2005.

Žižek, Slavoj. *The Fragile Absolute, or Why Is the Christian Legacy Worth Fighting For?* London: Verso, 2000.

Index